Iceland

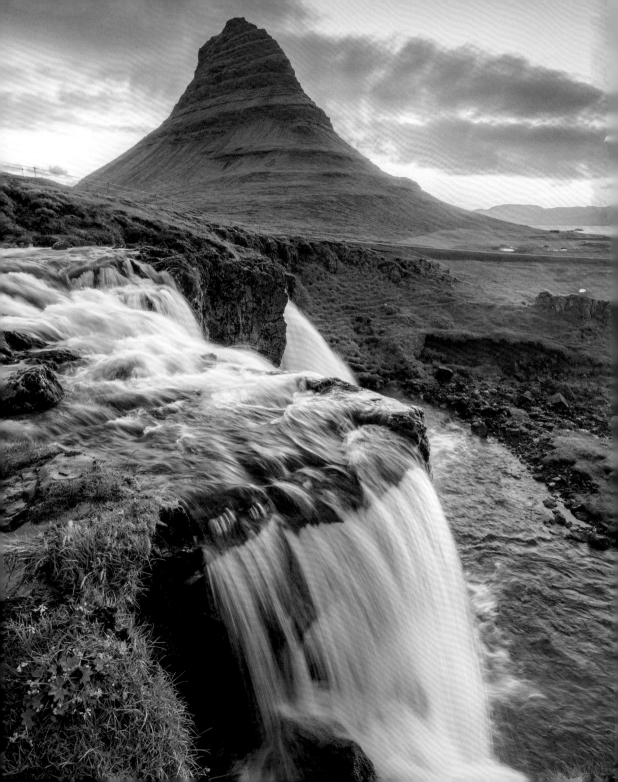

Iceland

Petra Ender
Bernhard Mogge
Christian Nowak

ÉDITIONS
PLACE DES
VICTOIRES

KÖNEMANN

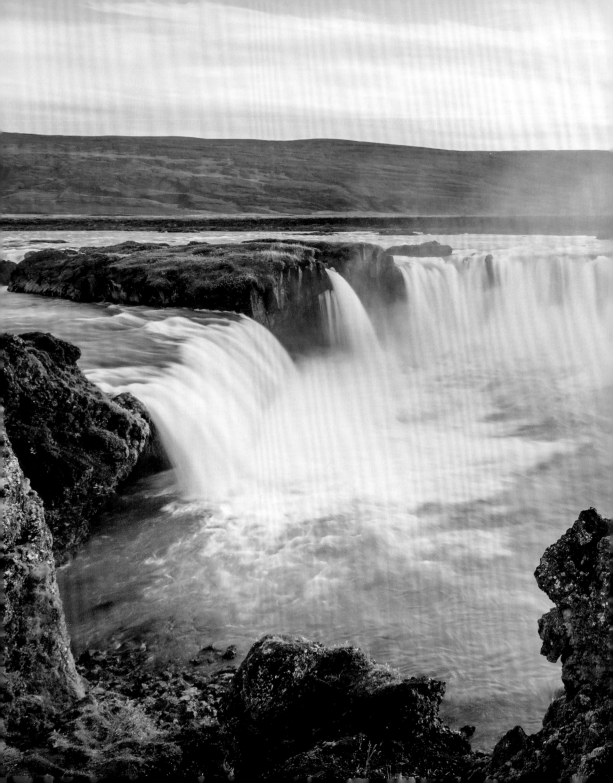

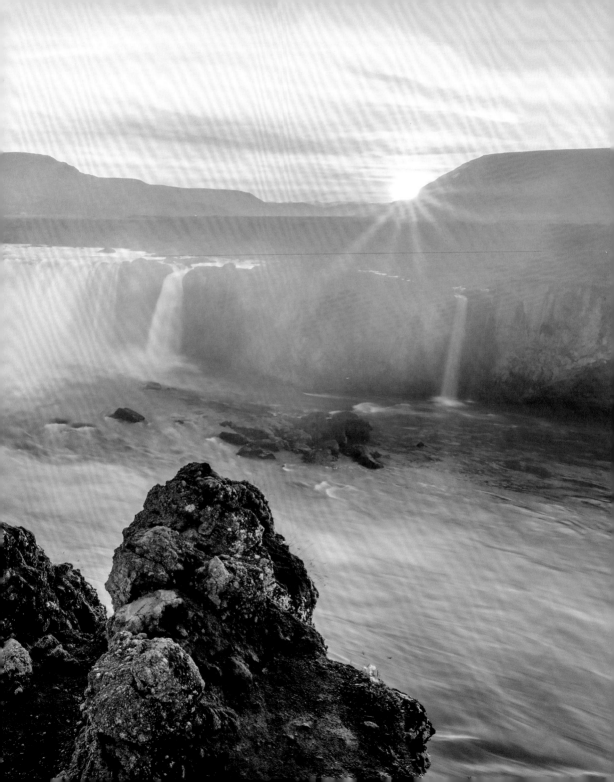

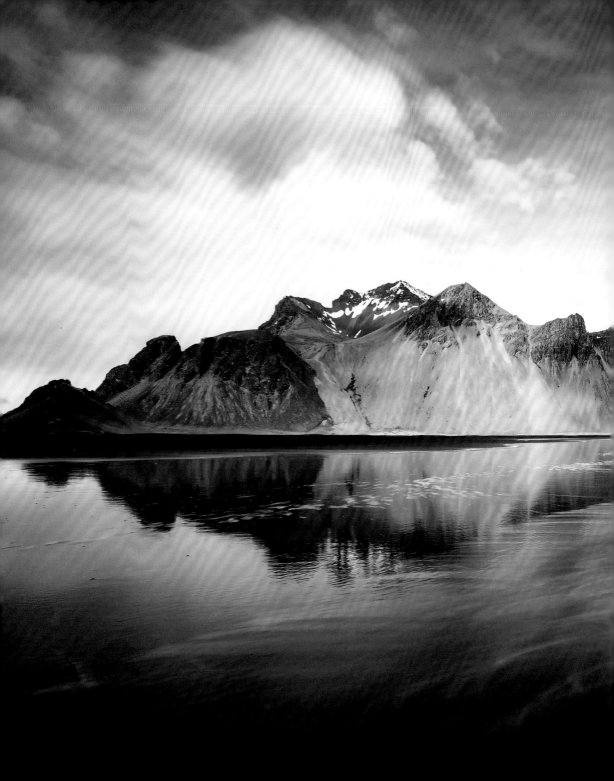

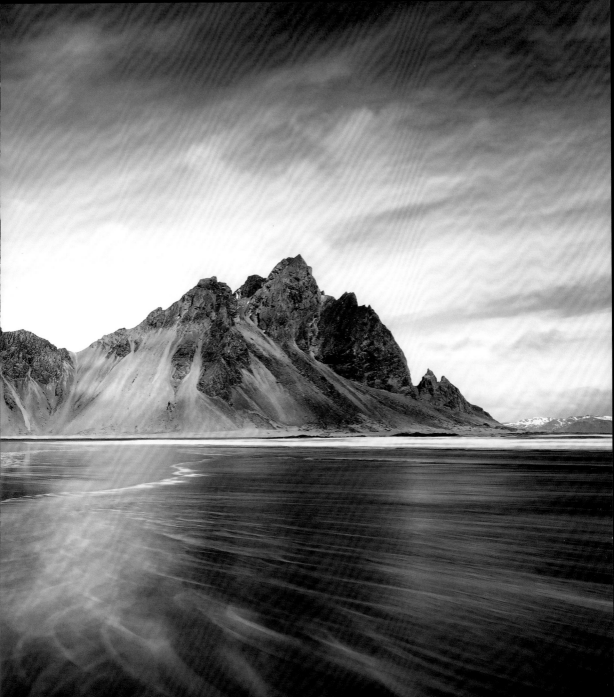

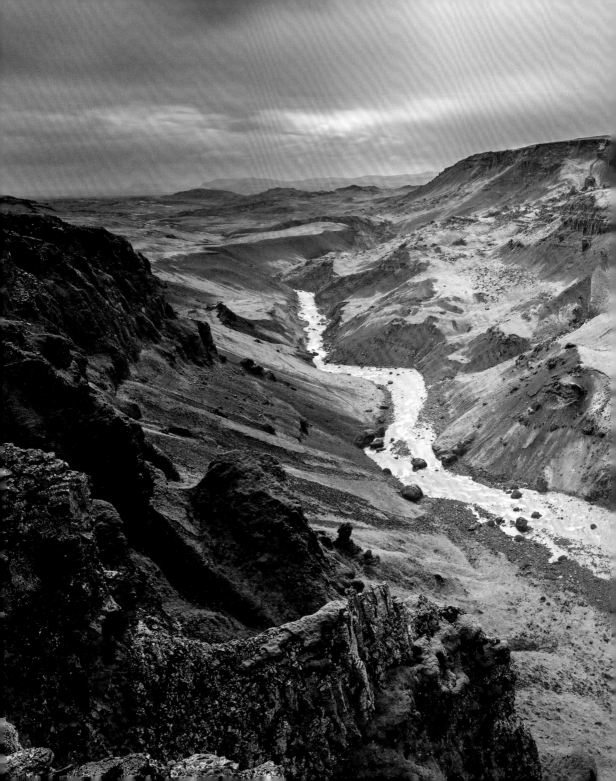

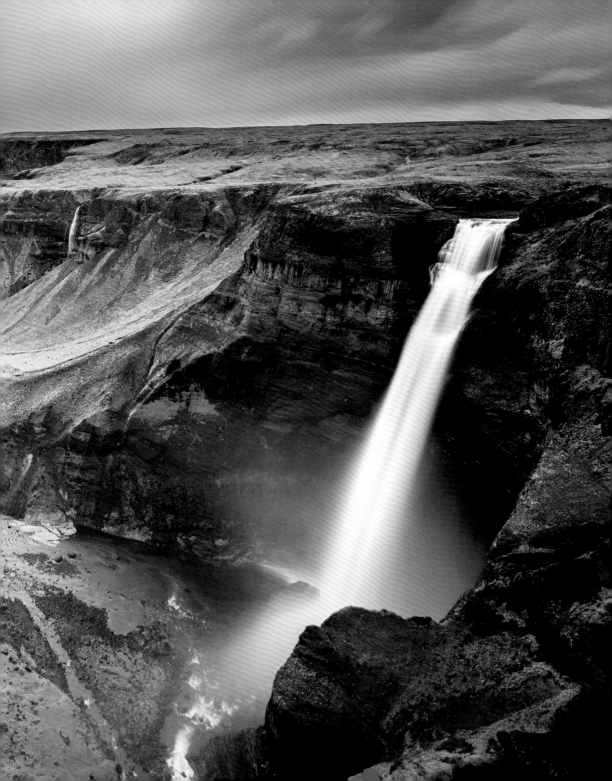

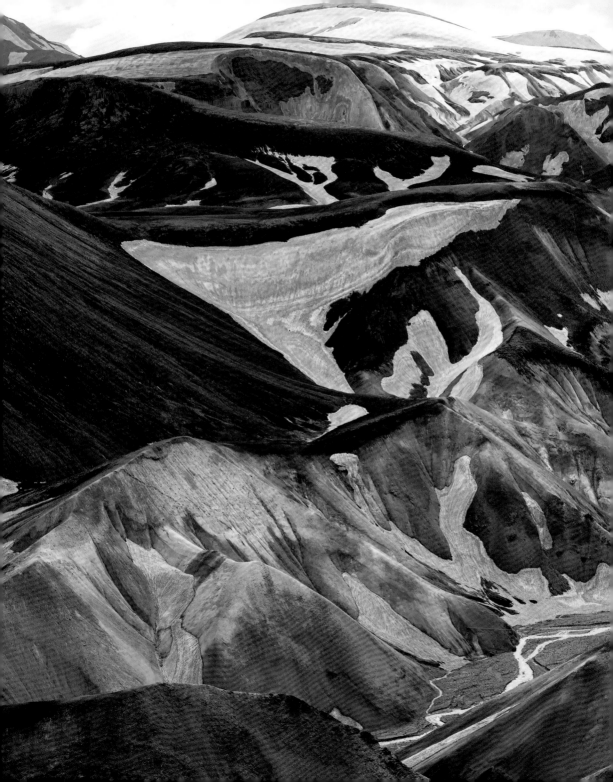

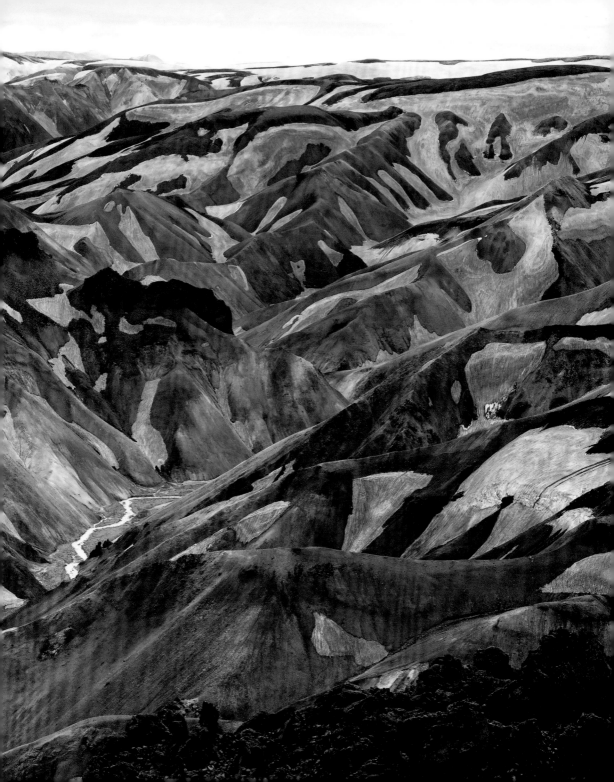

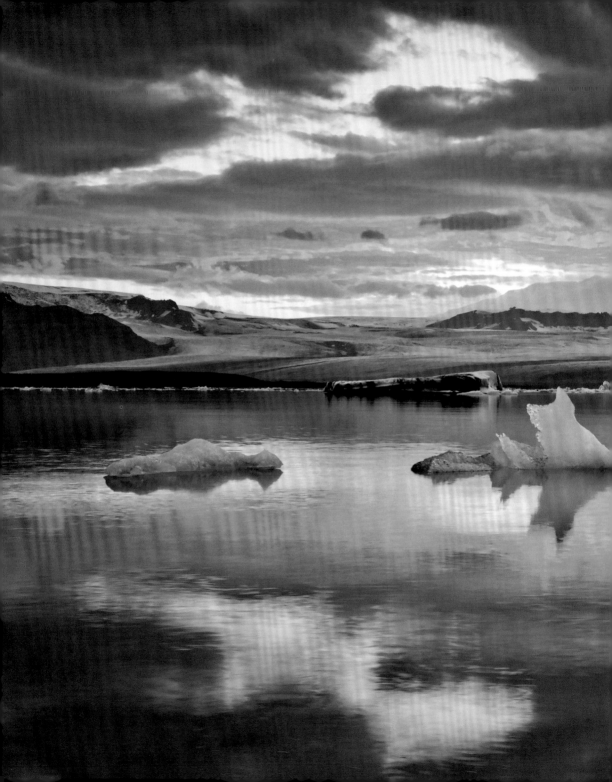

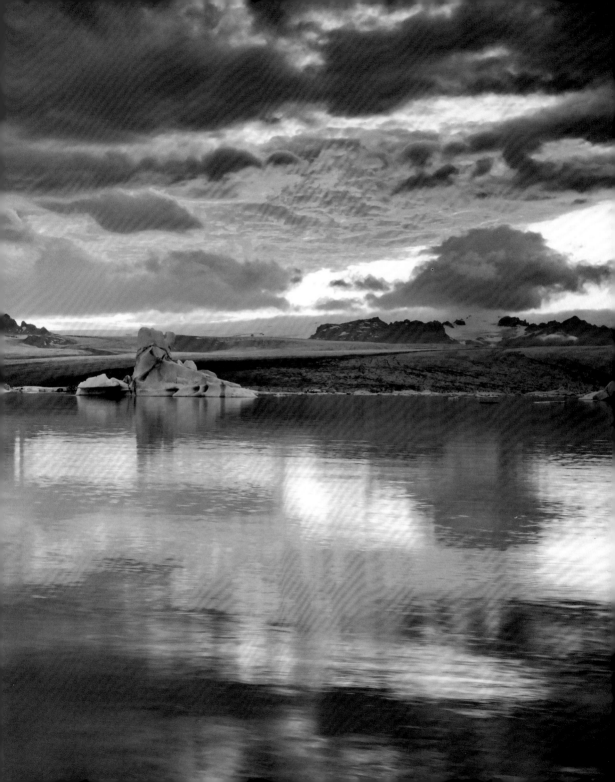

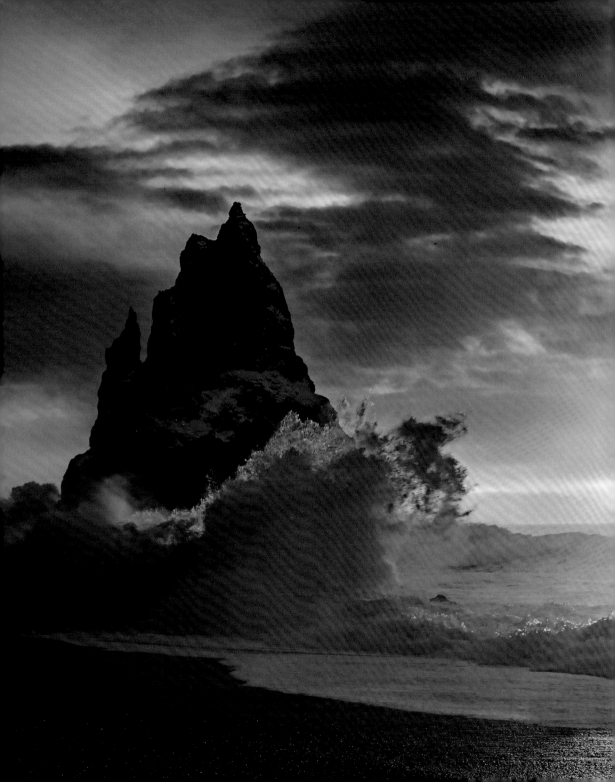

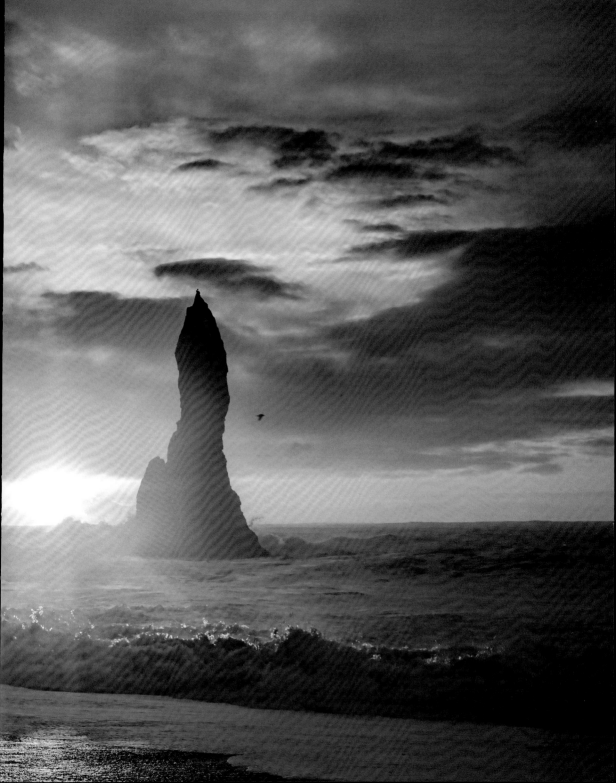

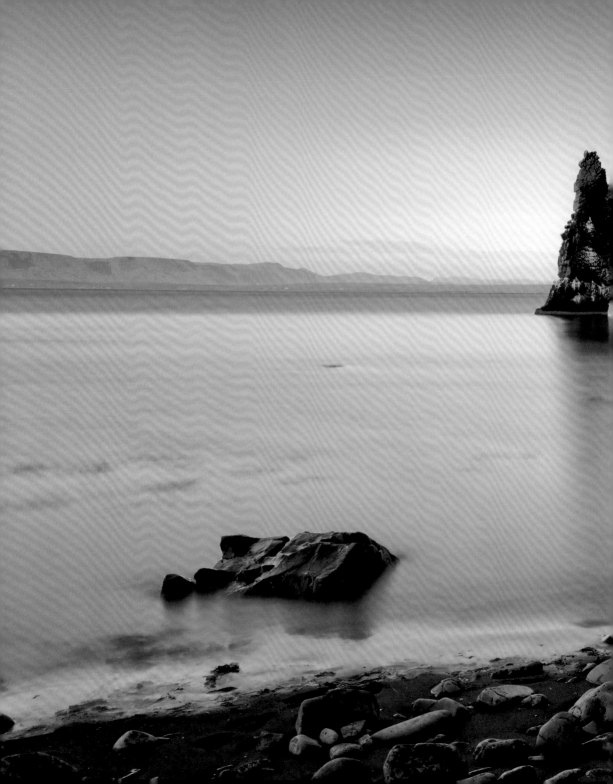

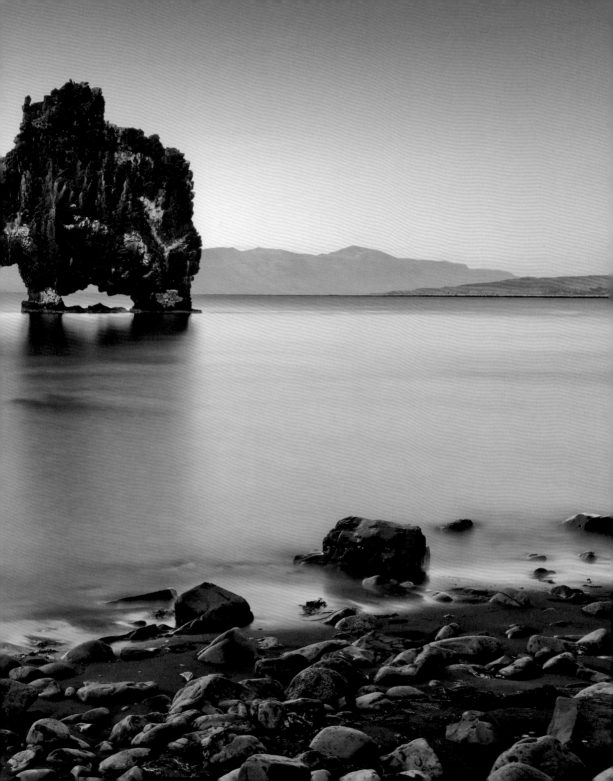

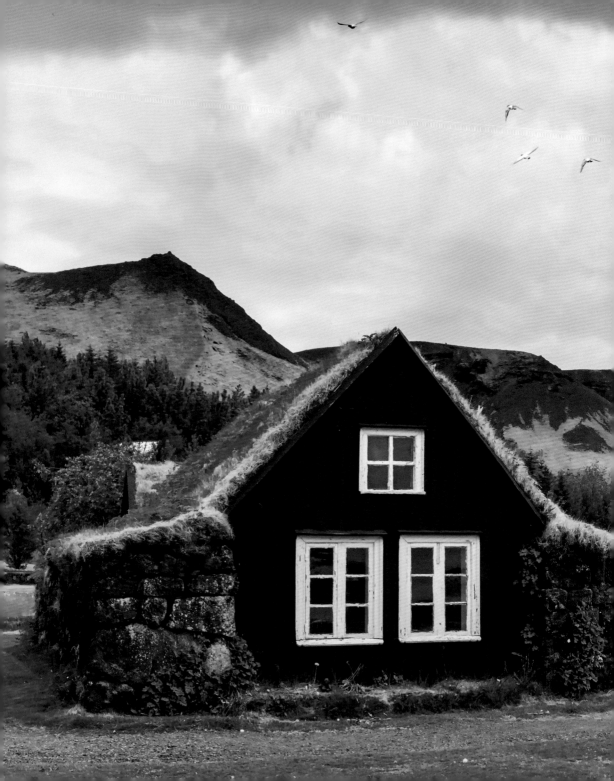

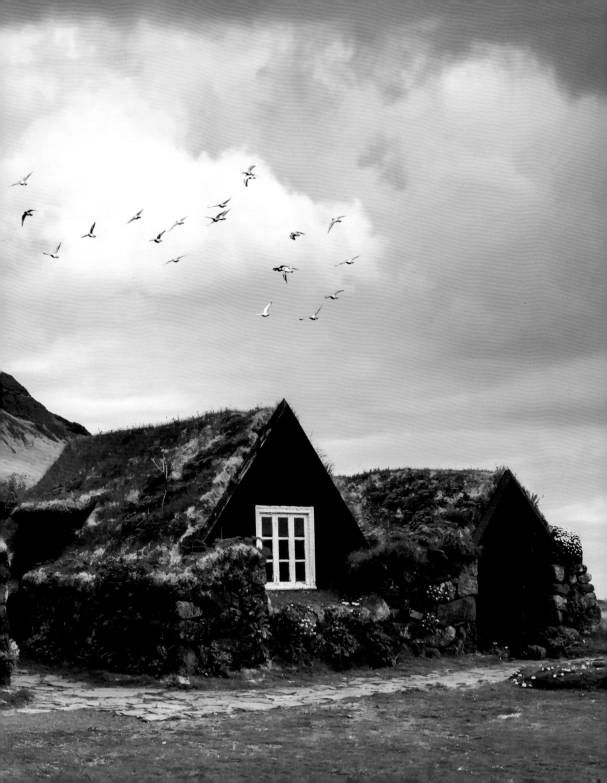

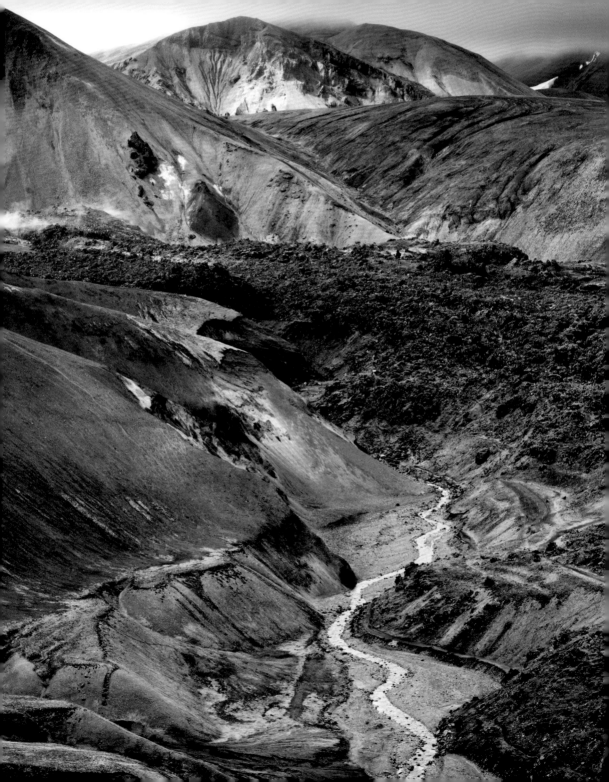

Contents · Sommaire · Inhalt · Índice · Indice · Inhoud

Iceland

No other country in Europe has as many dramatic landscapes as Iceland. This volcanic island, poised in the middle of the Atlantic between the Old and New World, is known as the land of fire and ice. Its deserts, volcanoes, and glaciers are as fascinating as they are inhospitable. Wastelands cover roughly two-thirds of the island; only about a quarter of the land can sustain sparse vegetation, and only two percent is cultivatable. But there are also oases so green as to make you forget that you are almost at the Arctic Circle. Surrounded by the Gulf Stream, heated by volcanoes, and rich in thermal waters, Iceland is home to human and animal life in spite of its challenges. Iceland boasts cutting-edge technology, yet still adheres to many old traditions, such as the belief in elves. Its landscapes are enchanting, but even the first settlers had to contend with the island's harsh climate and various natural disasters. With 350,000 inhabitants, two-thirds of whom live in or near Reykjavík, modern Iceland is still sparsely populated, and the interior is completely deserted. Crossing the highlands is therefore a lonely and dangerous venture, and even with an all-wheel-drive vehicle, the raging, unbridged rivers and the dusty desert paths pose formidable obstacles. Reykjavík offers a stark contrast, with numerous museums, restaurants, and a legendary nightlife scene.

Islande

Aucun pays d'Europe n'offre autant de paysages spectaculaires que l'Islande. Au beau milieu de l'océan Atlantique, l'île volcanique navigue entre l'ancien et le nouveau monde comme entre le feu et la glace. Les déserts, les volcans et les glaciers sont à la fois fascinants et inhospitaliers. Environ les deux tiers de l'île sont composés de terrains non-cultivables, seulement un quart de son territoire peut permettre une végétation clairsemée, et deux pour cent peuvent être utilisés pour l'agriculture. La nature y est fascinante, mais même les premiers colons ont dû faire face à son climat rude et à diverses catastrophes naturelles. Pour autant, certaines oasis vertes vous feront parfois oublier que vous êtes presque au cercle polaire arctique. Entourée par le Gulf Stream, chauffée par les volcans et gâtée par l'eau thermale, l'île sait en effet se rendre agréable malgré son aridité. L'Islande est dotée de la technologie la plus moderne, mais ses habitants restent également fidèles à de nombreuses traditions anciennes, comme la croyance en les elfes. Avec 350 000 habitants, dont les deux tiers vivent dans la région de Reykjavík, l'Islande est encore peu peuplée et l'intérieur de ses terres est complètement déserté. La traversée des Hauts Plateaux se fait donc sans beaucoup de compagnie, et même avec un véhicule à traction intégrale, les rivières déchaînées sans ponts et les routes désertiques poussiéreuses restent des défis. Reykjavík, la capitale, offre un programme bien différent avec ses nombreux musées, ses restaurants variés et une vie nocturne légendaire le week-end.

Island

Kein Land in Europa hat so viele dramatische Landschaften wie Island. Vor allem Feuer und Eis prägen die Vulkaninsel mitten im Atlantik zwischen der Alten und der Neuen Welt. Wüsten, Vulkane und Gletscher sind gleichermaßen faszinierend wie unwirtlich. Rund zwei Drittel der Insel sind Ödland, nur auf rund einem Viertel kann sich meist karge Vegetation halten, und landwirtschaftlich zu nutzen sind sogar nur zwei Prozent. Es gibt aber auch grüne Oasen, die vergessen lassen, dass man sich fast am Polarkreis befindet. Vom Golfstrom umflossen, von Vulkanen beheizt und von Thermalwasser verwöhnt, lässt es sich trotz aller Widrigkeiten leben. Island ist eine Insel mit modernster Technologie und hält trotzdem an so manchen althergebrachten Traditionen wie dem Elfenglauben fest. Die Natur ist faszinierend, doch schon die ersten Siedler mussten dem harten Klima und vielfältigen Naturkatastrophen trotzen. Mit 350 000 Einwohnern, von denen rund zwei Drittel im Großraum Reykjavík leben, ist Island bis heute äußerst dünn besiedelt, das Landesinnere ist vollkommen menschenleer. Wer das Hochland durchquert, ist deshalb völlig auf sich allein gestellt, und selbst mit einem Allradfahrzeug stellen die reißenden Flüsse ohne Brücken und die staubigen Wüstenpisten eine Herausforderung dar. In Reykjavík wartet dann das Kontrastprogramm mit zahlreichen Museen, einer vielfältigen Restaurantszene und einem legendären Nachtleben am Wochenende.

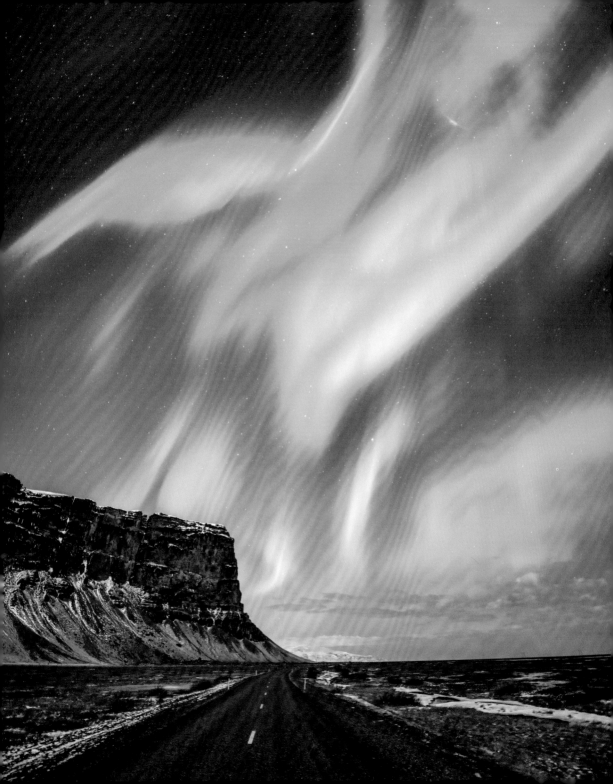

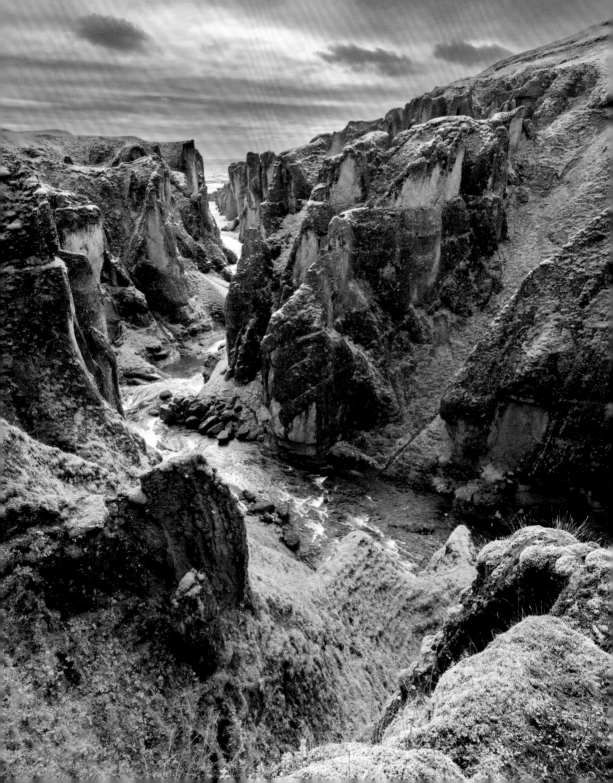

Islandia

Ningún otro país de Europa tiene tantos paisajes espectaculares como Islandia. El fuego y el hielo caracterizan, principalmente, esta isla volcánica en medio del Océano Atlántico, entre el Viejo y el Nuevo Mundo. Desiertos, volcanes y glaciares son tan fascinantes como inhóspitos. Aproximadamente dos tercios de la isla son terrenos baldíos, solo una cuarta parte de la isla puede sobrevivir una vegetación escasa y solo el 2% puede utilizarse para la agricultura. Sin embargo, también hay oasis verdes que te hacen olvidar que estás casi en el Círculo Polar Ártico. Rodeada por la Corriente del Golfo, calentada por los volcanes y mimada por las aguas termales, la isla sobrevive a pesar de todas las adversidades. Islandia es una isla con la tecnología más moderna, pero todavía se adhiere a muchas tradiciones antiquísimascomo la creencia en los elfos. La naturaleza es fascinante, pero incluso los primeros pobladores tuvieron que enfrentarse al duro clima y los diversos desastres naturales. Con 350 000 habitantes, dos tercios de los cuales viven en la zona de Reikiavik, Islandia sigue estando poco poblada y el interior está completamente desierto. Por lo tanto, el que quiera cruzar el altiplano depende completamente de sí mismo e, incluso con un vehículo todo terreno, los ríos enfurecidos sin puentes y las polvorientas carreteras del desierto representan un desafío. En Reikiavik hay un programa alternativo con numerosos museos, una variada gama de restaurantes y una vida nocturna mítica durante los fines de semana.

Islanda

Nessun altro paese in Europa ha paesaggi drammatici come l'Islanda. Il fuoco e il ghiaccio in particolare caratterizzano l'isola vulcanica al centro dell'Oceano Atlantico tra il Vecchio e il Nuovo Mondo. Deserti, vulcani e ghiacciai sono allo stesso tempo affascinanti e inospitali. Circa i due terzi dell'isola sono deserti, solo circa un quarto dell'isola può mantenere una scarsa vegetazione, e solo il due per cento può essere utilizzata per l'agricoltura. Ma ci sono anche oasi verdi che fanno dimenticare di essere quasi al Circolo Polare Artico. Circondato dalla Corrente del Golfo, riscaldato dai vulcani e bagnato dalle acque termali, si lascia vivere nonostante tutte le avversità. L'Islanda è un'isola con la tecnologia più moderna, ma segue ancora a molte tradizioni popolari come la credenza degli elfi. La natura è affascinante, ma i primi coloni hanno dovuto affrontare il clima rigido e diverse catastrofi naturali. Con 350 000 abitanti, due terzi dei quali vivono nella zona di Reykjavík, l'Islanda è ancora scarsamente popolata e la zona interna è completamente deserta. Chi volesse attraversare gli altipiani si ritroverà completamente da solo, e anche con un fuoristrada, i fiumi in furia senza ponti e le strade polverose del deserto rappresentano una sfida. A Reykjavík c'è un programma alternativo con numerosi musei, molti ristoranti alla moda e una leggendaria vita notturna durante il fine settimana.

IJsland

Geen enkel ander land in Europa heeft zo veel dramatische landschappen als IJsland. Vooral vuur en ijs kenmerken het vulkanische eiland midden in de Atlantische Oceaan tussen de Oude en de Nieuwe Wereld. Woestijnen, vulkanen en gletsjers zijn even fascinerend als onherbergzaam. Ongeveer twee derde van het eiland is woestenij, slechts op een kwart van het eiland is een schaarse vegetatie aanwezig en slechts twee procent kan worden gebruikt voor landbouwdoeleinden. Maar er zijn ook groene oases die je doen vergeten dat je bijna op de poolcirkel bent. Omringd door de Golfstroom, verwarmd door vulkanen en verwend door warmwaterbronnen is het ondanks alle ontberingen bewoonbaar. IJsland is een eiland met de modernste technologie, maar houdt ook nog steeds vast aan allerlei eeuwenoude tradities, zoals het geloof in elfen. De natuur is fascinerend, maar zelfs de eerste kolonisten moesten al het hoofd bieden aan het barre klimaat en de veelvuldige natuurrampen. Met 350 000 inwoners, van wie twee derde in Reykjavik woont, is IJsland nog steeds dunbevolkt en het binnenland is zelfs volledig uitgestorven. Wie door het hoogland reist, is dus helemaal op zichzelf aangewezen, en zelfs met een voertuig met vierwielaandrijving vormen de woeste rivieren zonder bruggen en de stoffige woestijnwegen een uitdaging. In Reykjavik wacht dan een contrasterend programma met talrijke musea, een gevarieerd restaurantaanbod en een legendarisch nachtleven in het weekend.

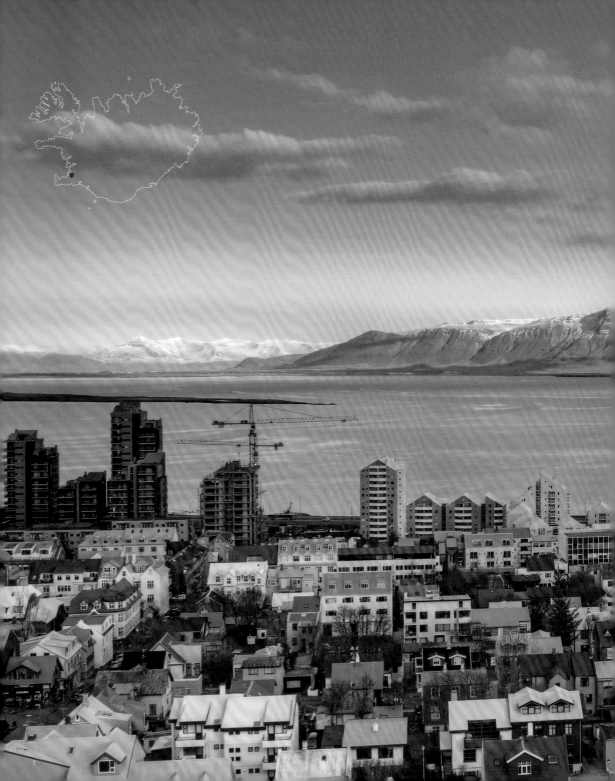

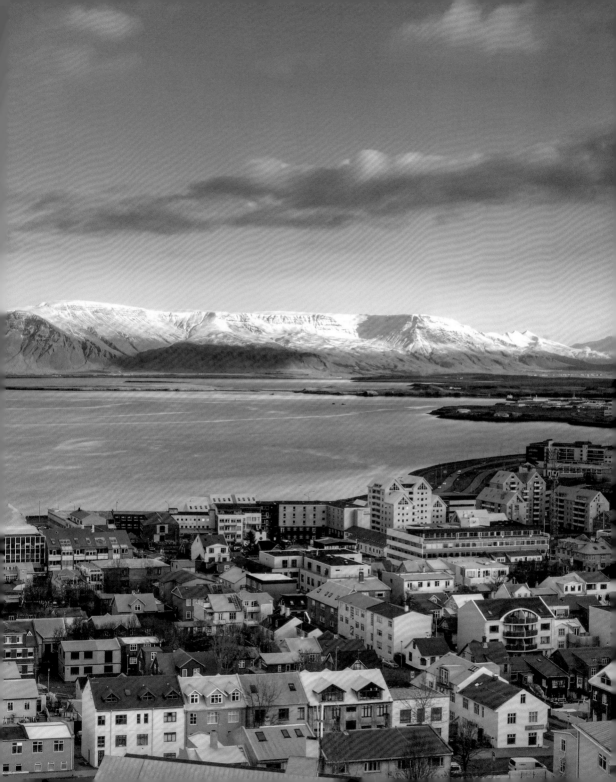

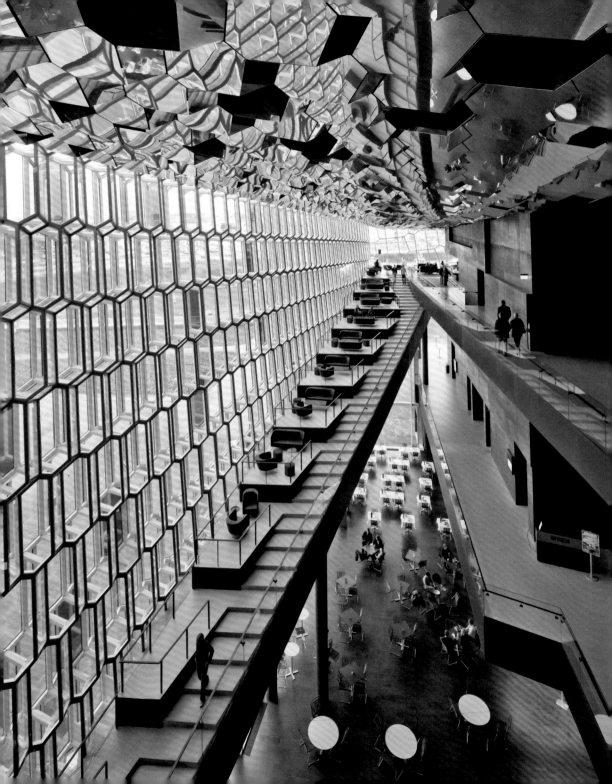

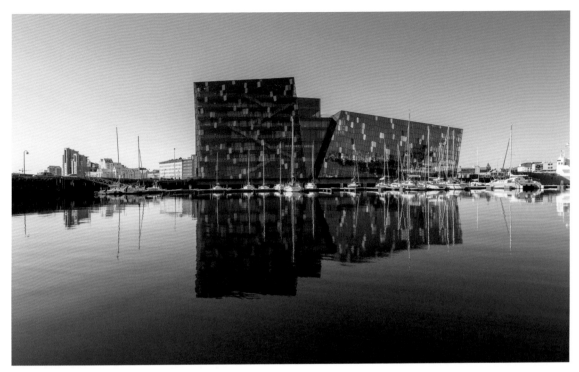

Harpa cultural centre

Reykjavík

Reykjavík is the oldest settlement on Iceland and still its economic and cultural centre. The Hallgrímskirkja Church has long been the city's most prominent landmark. In recent years, more modern architecture has also come to define the urban landscape, especially the Harpa Concert and Conference Centre. Opened in 2011, Harpa's spectacular glass façade was designed by the Danish-Icelandic artist Ólafur Elíasson.

Reykjavík

Reykjavík est le plus ancien pôle urbain, économique et culturel de l'île. Pendant longtemps, la Hallgrímskirkja a été le monument le plus représentatif de la ville. Entre-temps, le tableau a été complété par une architecture plus moderne : en premier lieu, la salle de concert et centre de congrès Harpa, qui a ouvert ses portes en 2011 et dont la spectaculaire façade vitrée a été conçue par l'artiste dano-islandais Ólafur Elíasson.

Reykjavík

Reykjavík ist die älteste Siedlung, wirtschaftliches und kulturelles Zentrum der Insel. Lange Zeit war die Hallgrimskirche markantes Wahrzeichen der Stadt. Inzwischen bestimmt auch modernere Architektur das Bild: an erster Stelle das 2011 eröffnete Konzert- und Kulturhaus Harpa, dessen spektakuläre Glasfassade von dem dänisch-isländischen Künstler Ólafur Elíasson gestaltet wurde.

Reikiavik

Reikiavik es el centro económico y cultural más antiguo de la isla. Durante mucho tiempo la Hallgrímskirkja ('la iglesia de Hallgrímur') fue un hito destacado de la ciudad. Mientras tanto, la imagen de la ciudadtambién está determinada por una arquitectura más moderna: en primer lugar el edificio Harpa, centro de conciertos y conferencias, que abrió sus puertas en 2011 y cuya espectacular fachada de cristal fue diseñada por el artista danés-islandés Ólafur Elíasson.

Reykjavík

Reykjavík è il più antico insediamento, centro economico e culturale dell'isola. Per molto tempo la Hallgrímskirkja è stata un punto di riferimento suggestivo della città. Nel frattempo, il panorama è dominato anche da un'architettura più moderna: in primo luogo la casa per concerti e conferenze Harpa, inaugurata nel 2011 e la cui spettacolare facciata in vetro è stata progettata dall'artista danese-islandese Ólafur Elíasson.

Reykjavik

Reykjavik is de oudste nederzetting en het economische en culturele centrum van het eiland. Lange tijd was de Hallgrímskirkja een opvallend herkenningspunt van de stad. Intussen bepaalt ook modernere architectuur het beeld: in de eerste plaats het grote congres- en concertcentrum Harpa, dat in 2011 werd geopend en waarvan de spectaculaire glazen gevel werd ontworpen door de Deens-IJslandse kunstenaar Ólafur Elíasson.

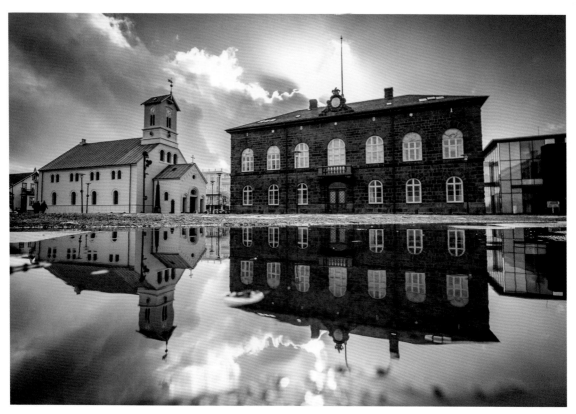

Icelandic Parliament, Dómkirkja church

Parliament

A small parliament for a small country: Alþingishúsið is a simple building made of grey basalt. Its current home was inaugurated in 1881, although the history of the parliament itself dates back to 930 CE, when the goðar (leaders) of the Icelandic Commonwealth held the first legislative assembly in Þingvellir. The Althing is the oldest existing parliament in the world.

Parlement

Un petit parlement pour un petit pays: l'Alþingishúsið («la maison du parlement») est un simple bâtiment en basalte gris, inauguré en 1881. L'histoire de l'institution qui y siège remonte à 930, lorsque les habitants qui peuplaient l'île ont décidé de se réunir pour la première fois à Þingvellir pour donner naissance à une assemblée législative commune. L'Althing est le plus ancien parlement existant dans le monde.

Parlament

Ein kleines Parlament für ein kleines Land: Das Alþingishúsið ist ein schlichter Bau aus grauem Basalt. Er wurde im Jahr 1881 eingeweiht. Die Geschichte des Parlaments reicht aber zurück bis ins Jahr 930, als sich die Goden Islands erstmals in Þingvellir zur gesetzgebenden Versammlung trafen. Das Althing ist das älteste bestehende Parlament der Welt.

Parlamento

Un parlamento pequeño para un país pequeño: el Alþingishúsið es un edificio sencillo de basalto gris. Se inauguró en 1881. La historia del parlamento se remonta al año 930, cuando los goðar de la isla se reunieron por primera vez en Þingvellir para la asamblea legislativa. El Althing es el parlamento más antiguo del mundo.

Parlamento

Un piccolo parlamento per un piccolo paese: Alþingishúsið è un edificio semplice in basalto grigio. Fu inaugurato nel 1881. La storia del parlamento risale all'anno 930, quando i goðar dell'isola si riunirono per la prima volta a Þingvellir per l'assemblea legislativa. L'Althing è il più antico parlamento esistente al mondo.

Volksvertegenwoordiging

Een klein parlement voor een klein land: het Alþingishúsið is een eenvoudig gebouw van grijze basaltstenen. Het werd ingehuldigd in 1881. De geschiedenis van het parlement gaat terug tot 930, toen de clanhoofden van IJsland voor het eerst in Þingvellir bijeenkwamen voor een wetgevende vergadering. Het Althing is het oudste parlement ter wereld.

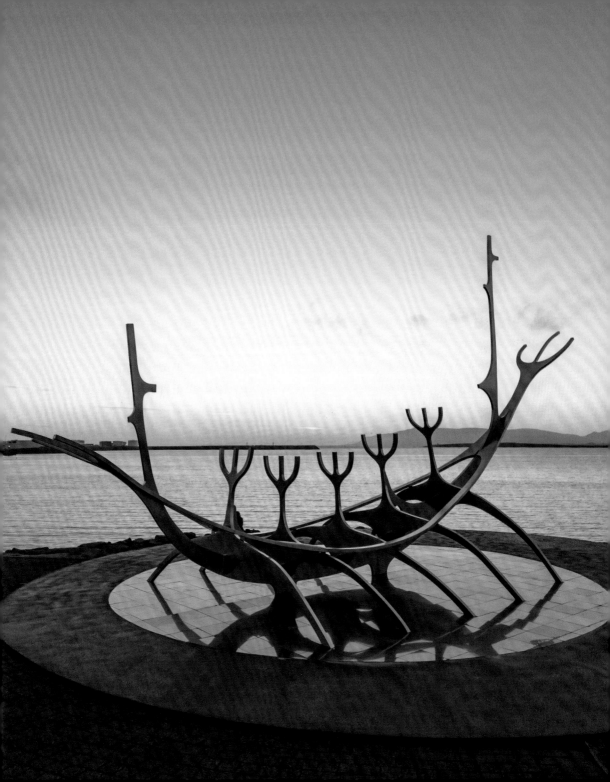

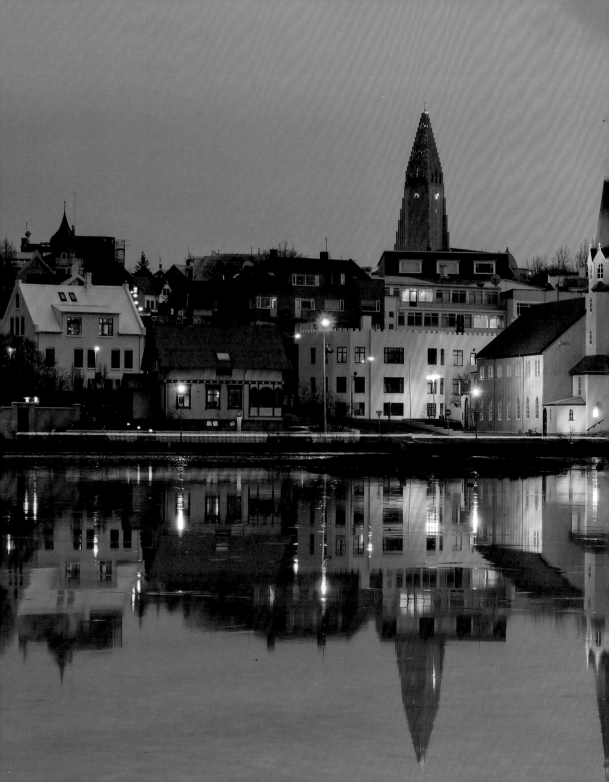

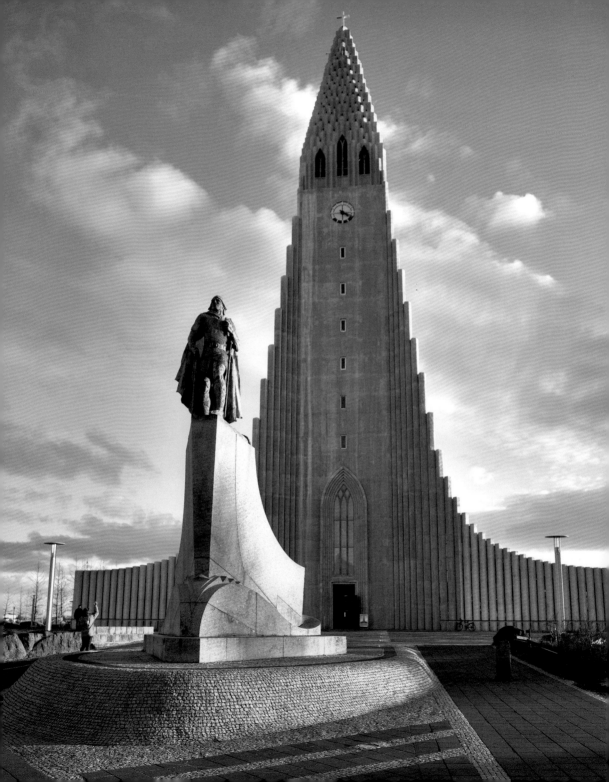

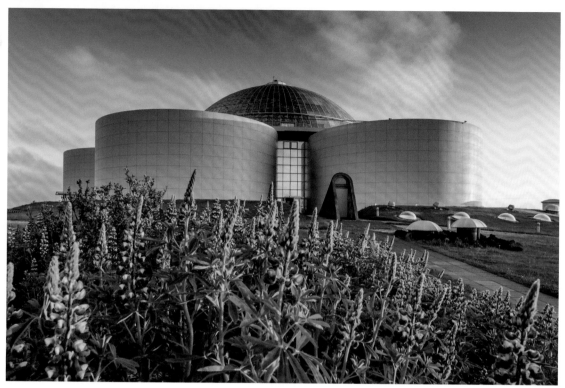

Perlan

Hallgrímskirkja Church

Reykjavík's most famous landmark is the Hallgrímskirkja Church, designed by the state architect Guðjón Samúelsson. Begun in 1945 and inaugurated in 1986, the Hallgrímskirkja is the largest church in Iceland. Its façade is dominated by symmetrical rows of concrete pillars, which almost give the building the appearance of a space shuttle. The pillars resemble basalt columns, and thus allude to the volcanic nature of the island.

Hallgrímskirkja

La Hallgrimskirkja, la plus grande église d'Islande, est un projet de l'architecte national Guðjón Samúelsson. Devenu l'un des monuments les plus emblématiques de Reykjavík, sa construction a duré de 1945 à 1986. Les piliers de béton qui la font presque ressembler à une navette spatiale sont caractéristiques : ils symbolisent les colonnes de basalte, courantes dans ce pays si volcanique.

Hallgrimskirche

Das Wahrzeichen Reykjavíks ist die Hallgrimskirche, ein Entwurf des Staatsarchitekten Guðjón Samúelsson. Der Bau begann 1945, eingeweiht wurde die größte Kirche Islands 1986. Bestimmend sind die Betonpfeiler, die sie fast wie ein Space Shuttle aussehen lassen. Sie symbolisieren Basaltsäulen und verweisen so auf den vulkanischen Charakter Islands.

La iglesia de Hallgrímur

El punto de referencia de Reikiavik es la Hallgrímskirkja, diseño del arquitecto nacional Guðjón Samúelsson. La construcción comenzó en 1945 y en 1986, se inauguró, como la iglesia más grande de Islandia. Los pilares de hormigón que la hacen parecer casi un transbordador espacial son imponentes. Simbolizan columnas de basalto y hacen referencia al carácter volcánico de Islandia.

La chiesa di Hallgrímur

Il punto di riferimento di Reykjavík è la Hallgrímskirkja, un progetto dell'architetto nazionale Guðjón Samúelsson. La costruzione è iniziata nel 1945, ma la più grande chiesa d'Islanda è stata inaugurata nel 1986 e i pilastri in cemento che la rendono quasi una navetta spaziale sono imponenti. Simboleggiano colonne di basalto e fanno riferimento al carattere vulcanico dell'Islanda.

Hallgrímskirkja

Het symbool van Reykjavik is de Hallgrímskirkja, een ontwerp van staatsarchitect Guðjón Samúelsson. De bouw begon in 1945, maar de grootste kerk in IJsland werd pas in 1986 ingehuldigd. Kenmerkend zijn de betonnen pilaren, waardoor het gebouw er bijna uitziet als een spaceshuttle. Ze symboliseren basaltzuilen en verwijzen naar het vulkanische karakter van IJsland.

Viðey Island

Just north-west of Reykjavík lies the island of Viðey in Kollafjörður, a popular destination for hiking and bird watching. Although uninhabited today, Viðey was settled as early as the 10th century and housed an Augustinian monastery. Every year from 9 October to 8 December, John Lennon's memory is honoured in the light installation *Imagine Peace Tower,* which is visible from a great distance.

Viðey

Au large de Reykjavík se trouve l'île Viðey, dans le Kollafjörður. C'est une destination populaire pour la randonnée et l'observation des oiseaux. Aujourd'hui désertée, Viðey était pourtant déjà habitée au xe siècle et a notamment abrité un monastère augustinien. Chaque année, du 9 octobre au 8 décembre, John Lennon y est commémoré avec une installation lumineuse, l'*Imagine Peace Tower,* visible même depuis la capitale.

Viðey

Unmittelbar vor Reykjavík liegt im Kollafjörður die Insel Viðey. Sie ist ein beliebtes Ausflugsziel für Wanderungen und zur Vogelbeobachtung. Viðey war bereits im zehnten Jahrhundert besiedelt und Sitz eines Augustinerklosters, heute ist die Insel unbewohnt. Mit der weithin sichtbaren Lichtinstallation *Imagine Peace Tower* wird alljährlich vom 9. Oktober bis zum 8. Dezember an John Lennon erinnert.

Viðey

Justo antes de Reikiavik se encuentra la isla Viðey en el fiordo Kollafjörður. Es un destino popular para el senderismo y la observación de aves. Viðey ya estaba habitada en el siglo X y fue sede de un monasterio agustiniano, hoy la isla está deshabitada. Cada año, del 9 de octubre al 8 de diciembre, John Lennon es recordado con la instalación de luz *Imagine Peace Tower,* que es visible desde lejos.

Viðey

Poco prima di Reykjavík si trova l'isola Viðey a Kollafjörður. È una destinazione popolare per escursioni e bird watching. Abitata già nel X secolo e sede di un monastero agostiniano, oggi l'isola di Viðey è disabitata. Ogni anno, dal 9 ottobre all'8 dicembre, John Lennon viene ricordato con l'installazione luminosa *Imagine Peace Tower,* visibile da lontano.

Viðey

Vlak voor Reykjavik ligt het eiland Viðey in de Kollafjörður. Het is een populaire bestemming voor wandelingen en vogelspotten. Viðey was al in de 10e eeuw bewoond en de zetel van een augustijner klooster, maar tegenwoordig is het eiland onbewoond. Elk jaar van 9 oktober tot 8 december wordt John Lennon herdacht met de lichtinstallatie *Imagine Peace Tower,* die al van verre zichtbaar is.

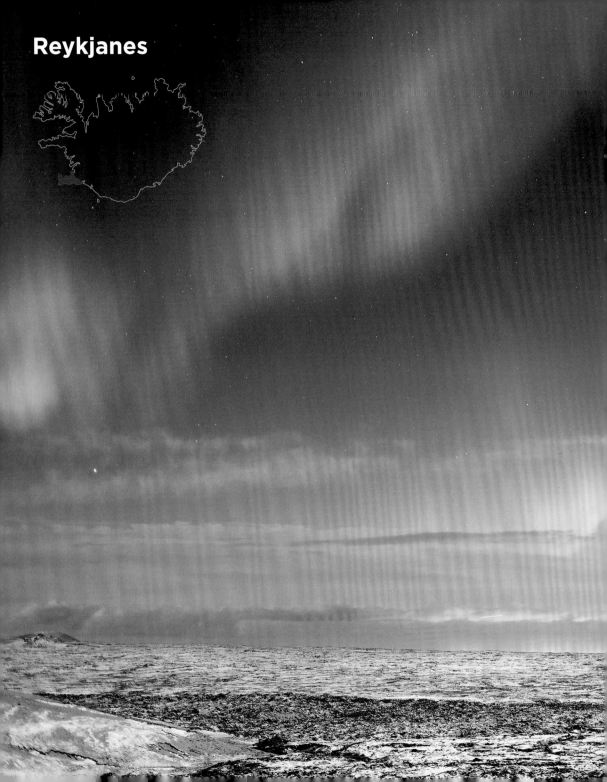

Reykjanes

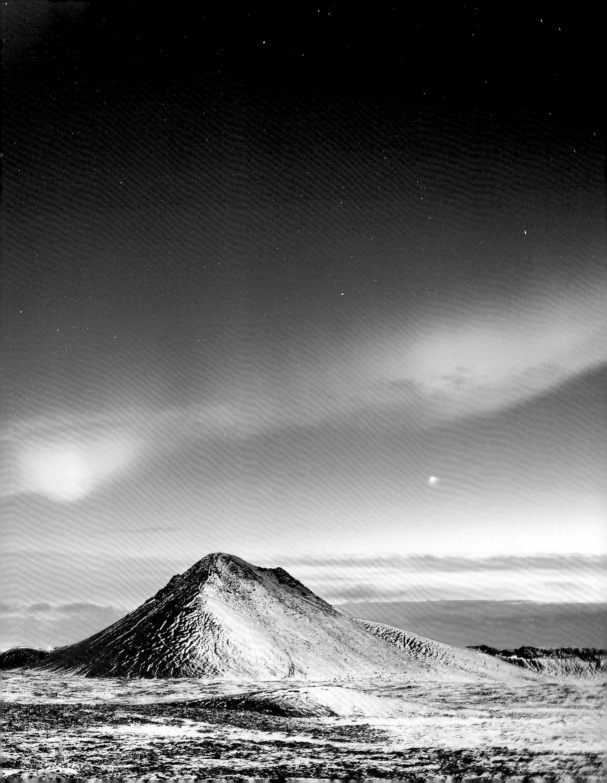

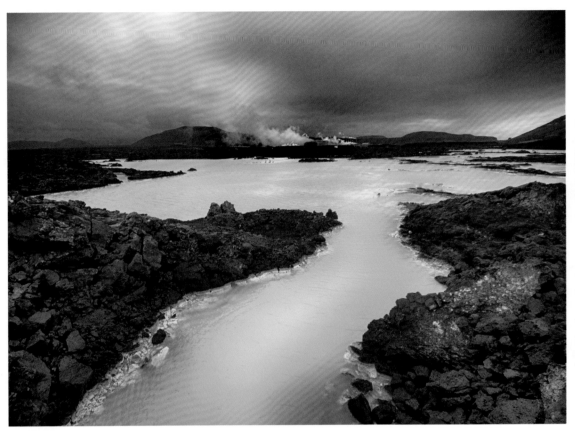

Bláa Lónið (Blue Lagoon)

Reykjanes

The Reykjanes peninsula, located to
the south-west of Reykjavík, is volcanic
territory. Visitors driving from Keflavík
International Airport (at the end of the
peninsula) toward the capital will see a
lunar landscape of lava fields scattered
with sparse vegetation. One of Iceland's
biggest attractions, the Blue Lagoon, is the
result of volcanic activity: hot water from
a geothermal power plant feeds the blue-
white salt-water pool, keeping it at a fairly
steady 40 degrees Celsius.

Reykjanes

La péninsule de Reykjanes, au sud-ouest
de Reykjavík, est une terre volcanique.
Depuis l'aéroport international de Keflavík,
à l'extrémité de la péninsule, jusqu'à la
capitale, les champs de lave couverts
principalement de végétation clairsemée
ressemblent à un paysage lunaire. L'une
des plus grandes attractions de l'Islande,
le Blue Lagoon, est également due à
cette activité volcanique : l'eau chaude
d'une centrale géothermique alimente le
lac de baignade bleu-blanc, qui est à une
température d'environ 40 degrés.

Reykjanes

Die Halbinsel Reykjanes südwestlich von
Reykjavík ist vulkanisches Gebiet. Wenn
man vom internationalen Flughafen
Keflavík am Ende der Halbinsel in die
Hauptstadt fährt, sieht man überwiegend
von schütterer Vegetation bedeckte
Lavafelder, die an eine Mondlandschaft
erinnern. Eine der größten Attraktionen
Islands, die Blaue Lagune, verdankt sich
vulkanischer Aktivität: Heißes Wasser
aus einem Geothermalkraftwerk speist
den etwa 40 Grad warmen, blau-weißen
Salzwasser-Badesee.

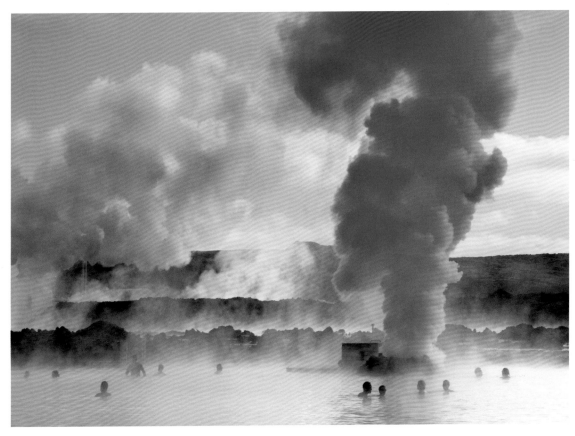

Bláa Lónið (Blue Lagoon)

Reykjanes

La península de Reykjanes, al suroeste de Reikiavik, es territorio volcánico. Cuando se conduce desde el Aeropuerto Internacional de Keflavík, en un extremo de la península, hasta la capital, se observan campos de lava cubiertos principalmente de escasa vegetación que recuerda a un paisaje lunar. Uno de los mayores atractivos de Islandia, la Laguna Azul, se debe a la actividad volcánica: el agua caliente de una central geotérmica alimenta el lago de agua salada de color blanco azulado que está a unos 40 grados de temperatura.

Reykjanes

La penisola di Reykjanes a sud-ovest di Reykjavík è un territorio vulcanico. Quando si guida dall'aeroporto internazionale di Keflavík, alla fine della penisola alla capitale, si vedono campi di lava coperti principalmente da una vegetazione rada, che ricorda un paesaggio lunare. Una delle maggiori attrazioni dell'Islanda è la Laguna Blu, merito dell'attività vulcanica: l'acqua calda proveniente da una centrale geotermica alimenta il lago balneabile di acqua salata bianco-blu, calda circa 40 gradi.

Reykjanes

Het schiereiland Reykjanes ten zuidwesten van Reykjavik is vulkanisch gebied. Als u van de luchthaven Keflavík op de punt van het schiereiland naar de hoofdstad rijdt, ziet u overwegend met schaarse vegetatie bedekte lavavelden die doen denken aan een maanlandschap. Een van de grootste attracties van IJsland, de Blue Lagoon, is er dankzij vulkanische activiteit: heet water uit een geothermische energiecentrale voedt het blauw-witte, circa 40 graden warme zoutwatermeer.

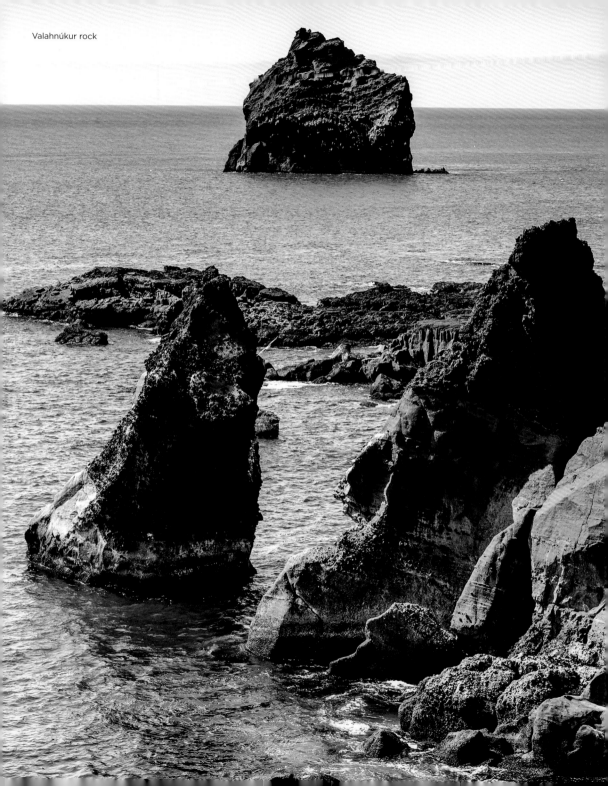

Valahnúkur rock

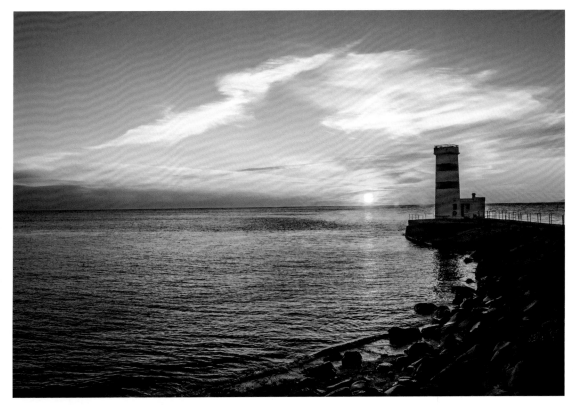

Garður lighthouse

Garður Lighthouse

Two lighthouses sit on the north-western tip of Reykjanes. The first, a white tower with red stripes, was built in 1897. Because it was endangered by the surf and not always visible during heavy storms, a new, taller lighthouse was added next door in 1944. While both are photogenic, when it comes to romantic charm, the older lighthouse still wins out.

Phare de Garður

À la pointe nord-ouest de Reykjanes, il y a deux phares. Le premier, rouge et blanc, a été construit en 1897. Parce qu'il n'était pas toujours visible pendant les fortes tempêtes et qu'il était également menacé par les vagues, un nouveau phare, plus grand, a été construit juste à côté en 1944. Les deux sont photogéniques, mais le plus ancien reste le plus romantique.

Garður-Leuchtturm

An der Nordwestspitze von Reykjanes stehen gleich zwei Leuchttürme. Der erste, rot-weiße wurde im Jahr 1897 errichtet. Weil er bei schweren Stürmen nicht immer sichtbar und außerdem durch die Brandung gefährdet war, wurde 1944 gleich nebenan ein neuer, höherer Leuchtturm gebaut. Fotogen sind beide, in punkto Romantik schneidet der alte deutlich besser ab.

Faro de Garður

En la puntanoroeste de Reykjanes hay dos faros. El primero, rojo y blanco, se construyó en 1897. Dado que no siempre era visible por las fuertes tormentas y que también estaba en peligro por el oleaje, se construyó un nuevo faro más alto justo al lado en 1944. Ambos son fotogénicos, pero cuando se trata de romanticismo, el antiguo gana la partida.

Faro di Garður

All'estremità nord-occidentale di Reykjanes si trovano due fari. Il primo rosso e bianco, fu costruito nel 1897. Non sempre visibile in caso di forti tempeste e minacciato anche dai frangenti, nel 1944 fu costruito un nuovo faro più alto proprio accanto ad esso. Entrambi sono belli da vedere, ma il più antico è quello più romantico.

Sveitarfélagið Garður

Op het noordwestelijke puntje van Reykjanes staan twee vuurtorens. De eerste, rood-witte werd gebouwd in 1897. Omdat hij niet altijd zichtbaar was bij hevige stormen en bovendien bedreigd werd door de branding, werd er in 1944 een nieuwe, hogere vuurtoren vlak naast gebouwd. Beide zijn fotogeniek, maar als het op romantiek aankomt, brengt de oude het er duidelijk beter van af.

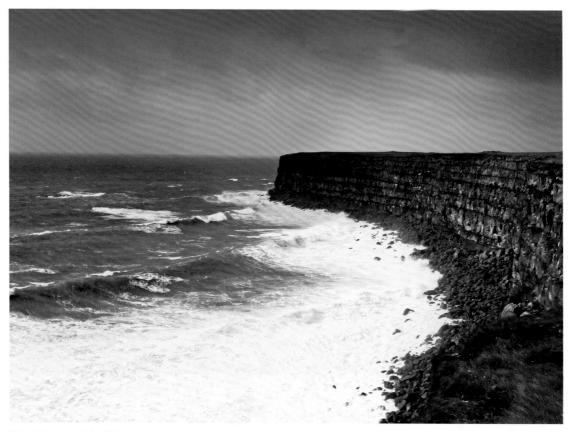

Krýsuvíkurbjarg, birds cliff

Krýsuvíkurbjarg

In the south of Reykjanes, the coast breaks off steeply along a six-kilometre stretch of cliffs. The rocks reveal the different layers of lava, the result of multiple eruptions over thousands of years. The basalt coast, like the cliffs rising from the sea, is a breeding ground for tens of thousands of seabirds, especially puffins and seagulls.

Krýsuvíkurbjarg

Au sud de Reykjanes, la côte se détache abruptement sur un tronçon de 6 km de long. Les différentes couches de lave y sont clairement visibles – c'est le résultat de plusieurs éruptions s'étalant sur des milliers d'années. La côte de basalte, comme les falaises qui s'élèvent au large, sont des lieux de reproduction privilégiés pour des dizaines de milliers d'oiseaux de mer, en particulier les macareux et les mouettes.

Krýsuvíkurbjarg

Im Süden von Reykjanes bricht die Küste auf einem 6 km langen Stück steil ab. Deutlich sind die unterschiedlichen Lavaschichten zu erkennen – Ergebnis mehrerer Eruptionen im Lauf von Tausenden von Jahren. Die Basaltküste ist, so wie die vor der Küste aufragenden Klippen, Brutplatz für zehntausende Seevögel, vor allem Papageitaucher und Möwen.

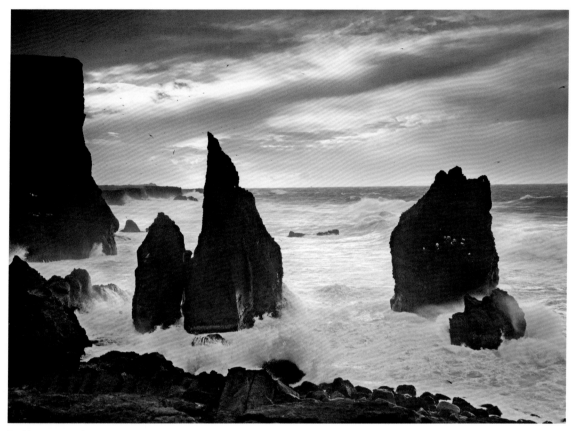

Reykjanes peninsula

Krýsuvíkurbjarg

En el sur de Reykjanes la costa queda abruptamente sesgada en un tramo de 6 km de longitud. Las diferentes capas de lava son claramente visibles y son el resultado de varias erupciones a lo largo de miles de años. La costa de basalto, al igual que los acantilados que se elevan frente a esta, son el lugar de cría de decenas de miles de aves marinas, especialmente frailecillos y gaviotas.

Krýsuvíkurbjarg

A sud di Reykjanes la costa si stacca ripidamente su un tratto di 6 km. I diversi strati di lava sono chiaramente visibili - il risultato di diverse eruzioni nel corso di migliaia di anni. La costa basaltica, come le scogliere che si ergono al largo della costa, è un terreno fertile per decine di migliaia di uccelli marini, in particolare pulcinelle di mare e gabbiani.

Krýsuvíkurbjarg

In het zuiden van Reykjanes loopt de kust over 6 km lengte steil af. De verschillende lavalagen zijn duidelijk herkenbaar – het resultaat van meerdere uitbarstingen in de loop van duizenden jaren. De basaltkust is, net als de klippen die voor de kust oprijzen, een broedplaats voor tienduizenden zeevogels, vooral papegaaiduikers en meeuwen.

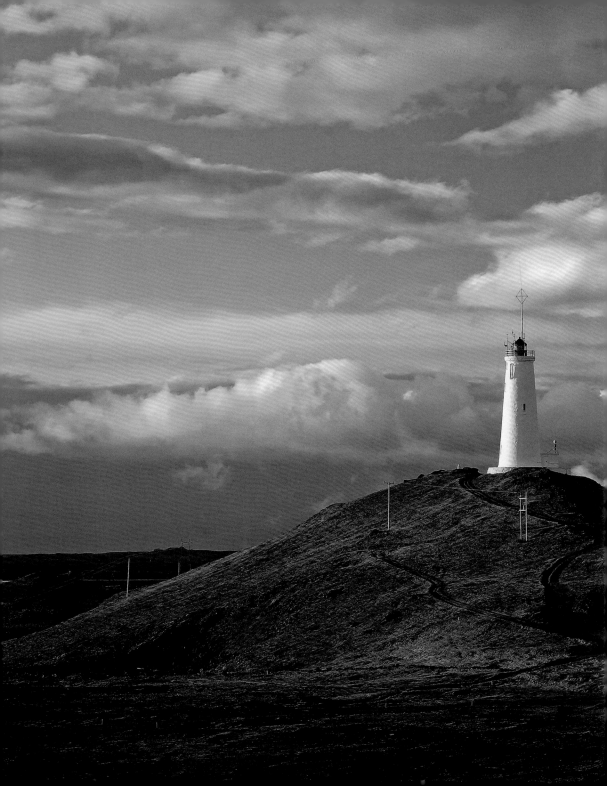

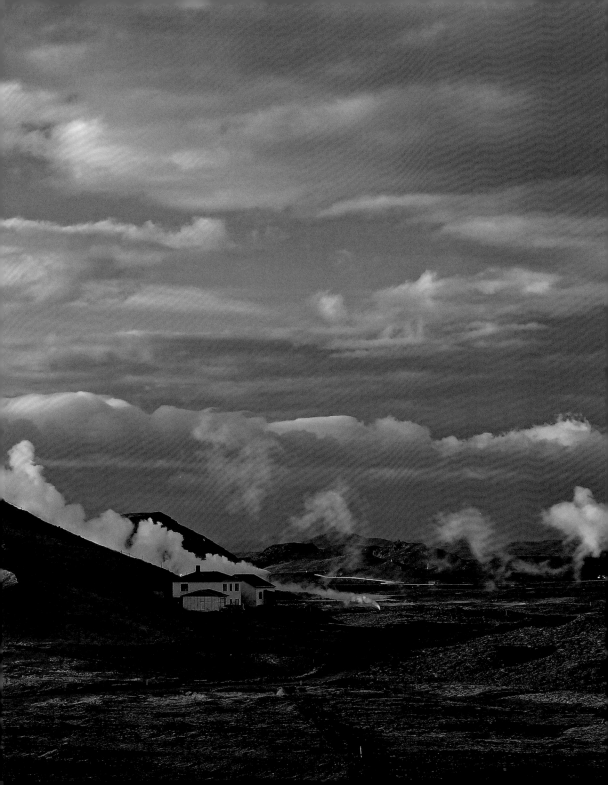

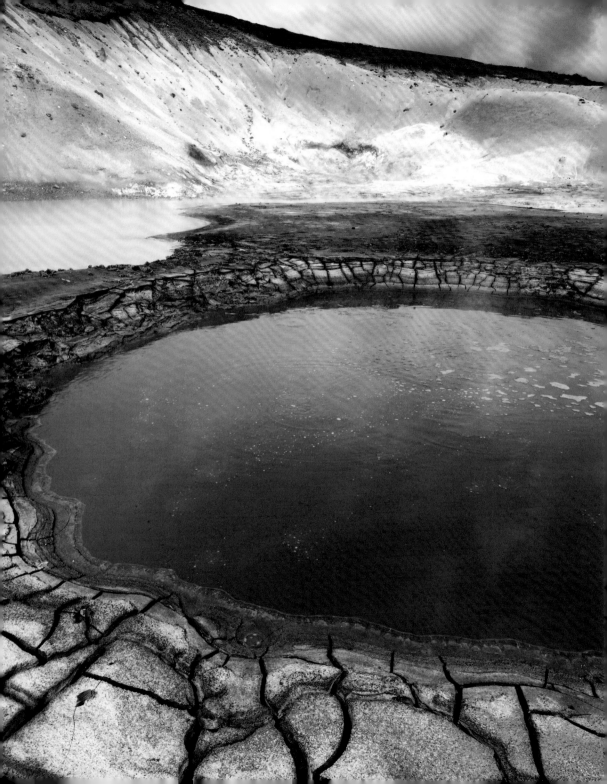

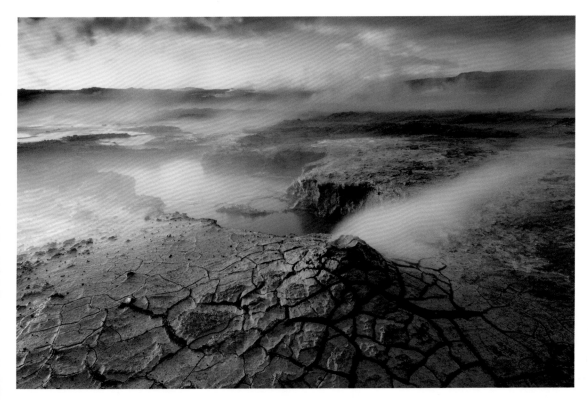

Gunnuhver

Krysuvík-Seltun and Gunnuhver

If you want to hike through the geothermal areas of the Reykjanes peninsula, it helps not to have a sensitive nose: the whole place smells like sulphur. All around, mud pools boil and bubble, hot springs hiss, and fumaroles puff—it's like observing the early formation of the earth. The heat from the earth's interior is used, among other things, to generate energy in a geothermal power plant.

Krysuvík-Seltun et Gunnuhver

Pour effectuer une randonnée à travers les zones géothermiques de la péninsule de Reykjanes, il ne faut pas avoir le nez sensible car l'odeur de soufre y est particulièrement puissante. Partout des mares de boue bouillonnent, des sources chaudes sifflent, des fumerolles soufflent, donnant l'impression d'assister à la formation de la terre. La chaleur de l'intérieur est utilisée, entre autres, pour produire de l'énergie dans une centrale géothermique.

Krysuvík-Seltun und Gunnuhver

Für eine Wanderung durch die Geothermalgebiete der Halbinsel Reykjanes darf man keine empfindliche Nase haben: Es stinkt nach Schwefel. Überall blubbern Schlammtöpfe, zischen heiße Quellen, wehen Fumarolen – man beobachtet die Erde bei ihrer Entstehung. Die Hitze aus dem Erdinnern wird u. a. zur Energiegewinnung in einem Geothermalkraftwerk genutzt.

Krysuvík-Seltun y Gunnuhver

Si se opta por una caminata a través de las áreas geotérmicas de la península de Reykjanes no se debe tener un olfato sensible: huele a azufre. Por todas partes burbujean las piscinas de barro, silban las aguas termales, soplan las fumarolas y seobserva la formación de la tierra. El calor del interior se utiliza, entre otras cosas, para generar energía en una central geotérmica.

Krysuvík-Seltun e Gunnuhver

Per fare un'escursione attraverso le zone geotermiche della penisola di Reykjanes non si deve avere un naso sensibile: odora di zolfo. Ovunque pozze di fango che ribollono, sorgenti calde sibilanti, fumarole che soffiano – si osserva la terra durante la sua formazione. Il calore proveniente dall'interno della terra viene utilizzato, tra l'altro, per produrre energia in una centrale geotermica.

Krysuvík-Seltun en Gunnuhver

Voor een wandeling door de geothermische gebieden van het schiereiland Reykjanes kunt u beter geen gevoelige neus hebben: het stinkt er naar zwavel. Overal in de modder borrelen luchtbellen, sissen warmwaterbronnen, dampen fumarolen – je observeert de aarde tijdens haar ontstaan. De warmte uit het binnenste van de aarde wordt onder andere gebruikt om energie op te wekken in een geothermische centrale.

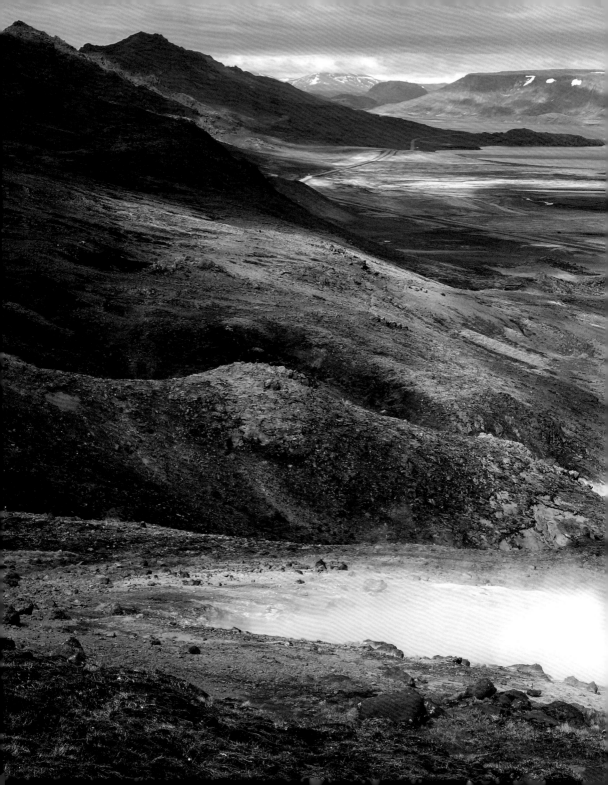

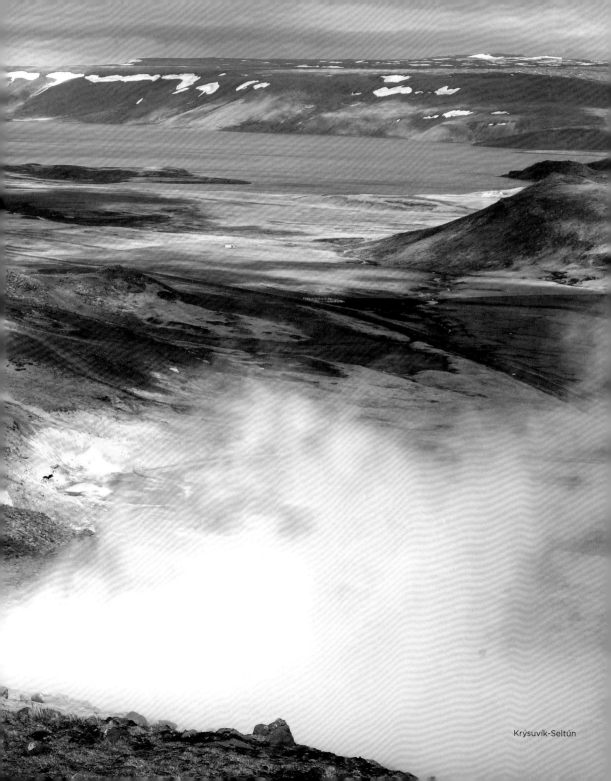

Krýsuvík-Seltún

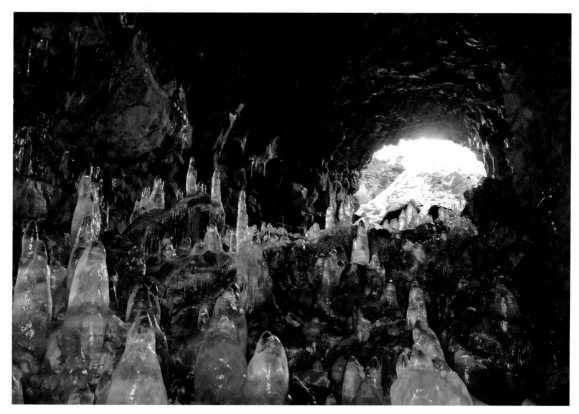
Raufarhólshellir

Reykjanesviti
At the south-western end of the peninsula stands the 31-metre-tall lighthouse of Reykjanes, built in 1907/1908 after its predecessor had been damaged by an earthquake and threatened to tumble into the sea. Waves break against the steep coast nearby, and the highest cliff is only a short walk away.

Reykjanes
À l'extrémité sud-ouest de la péninsule, le phare de 31 m de haut de Reykjanes a été construit en 1907/1908, après que le bâtiment précédent a été endommagé par un tremblement de terre et, trop proche du bord, a menacé de tomber dans la mer. Sur la côte escarpée voisine, les vagues se brisent et une courte marche mène à la falaise la plus haute.

Reykjanesviti
Am südwestlichen Ende der Halbinsel wurde 1907/1908 der 31 m hohe Leuchtturm von Reykjanes errichtet, nachdem der Vorgängerbau durch ein Erdbeben beschädigt worden war und zudem wegen der Nähe zur Abbruchkante ins Meer zu stürzen drohte. An der nahen Steilküste brechen sich die Wellen gischtend, ein kurzer Spaziergang führt auf die höchste Klippe.

Reykjanesviti
En el extremo suroccidental de la península, el faro de Reykjanes, de 31 m de altura, fue construido en 1907-1908, después de que un terremoto dañara el edificio anterior pudiendo este caer al mar por estar tan próximo al borde. En la costa escarpada las olas rompen y una breve caminata conduce al acantilado más alto.

Reykjanesviti
All'estremità sud-occidentale della penisola, il faro di Reykjanes, alto 31 m, fu costruito nel 1907/1908, dopo che l'edificio precedente era stato danneggiato da un terremoto e che minacciava di franare in mare a causa della sua vicinanza alla sponda. Sulla vicina costa scoscesa si infrangono le onde e una breve passeggiata conduce alla scogliera più alta.

Reykjanesviti
Aan de zuidwestkant van het schiereiland werd in 1907/1908 de 31 meter hoge vuurtoren van Reykjanes gebouwd, nadat de vorige was beschadigd door een aardbeving en door zijn nabijheid bij de rand bovendien in zee dreigde te vallen. Aan de nabijgelegen steile kust breken de golvenschuimend, en een korte wandeling leidt naar de hoogste klip.

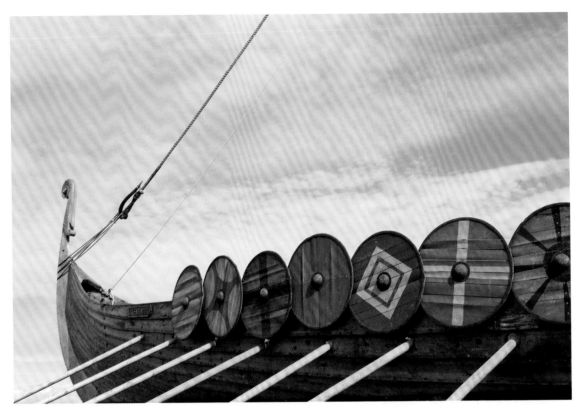

Replica of viking ship, Keflavik

Viking Ship

Built of oak and 23 metres long, the Viking ship *Íslendingur* (The Icelander), a replica of the Gokstad ship excavated in Norway, is on display in the Viking World museum in Keflavík. The ship is still seaworthy: its builder, Gunnar Marel Eggertsson, sailed it from Iceland to New York in 2000 to commemorate Leif Erikson's discovery of America a thousand years earlier.

Bateau viking

Construit en chêne et long de 23 m, le navire viking *Íslendingur* (L'Islandais), réplique du bateau de Gokstad en Norvège, est exposé au musée Viking World à Keflavík. Il est en état de naviguer: son constructeur Gunnar Marel Eggertsson a traversé l'Atlantique depuis l'Islande en 2000 pour commémorer la découverte de l'Amérique par Leif Erikson, 1000 ans plus tôt.

Wikingerschiff

Aus Eiche gebaut und 23 m lang, ist das im Museum Wikingerwelt in Keflavík ausgestellte Wikingerschiff *Íslendingur* (Der Isländer), ein Nachbau des norwegischen Gokstad-Schiffes. Es ist seetüchtig: Sein Erbauer Gunnar Marel Eggertsson segelte damit im Jahr 2000 von Island über den Atlantik, um an Leif Erikssons Entdeckung Amerikas 1000 Jahre zuvor zu erinnern.

Barco vikingo

Construido en roble y con una eslora de 23 m, el barco vikingo *Íslendingur* (el islandés) es una réplica del barco de Gokstad en Noruega. Está expuesto en el museo dedicado al mundo vikingo, en Keflavík. Es apto para la navegación: su constructor, Gunnar Marel Eggertsson, navegó desde Islandia a través del Atlántico en el año 2000 para conmemorar el descubrimiento de América por Leif Erikson mil años antes.

Nave vichinga

Costruita in quercia e lunga 23 metri, la nave vichinga *Íslendingur* (l'islandese), replica della nave di Gokstad in Norvegia, è esposta nel museo del mondo dei Vichinghi di Keflavík. È adatta alla navigazione: nel 2000 il suo costruttore Gunnar Marel Eggertsson è salpato dall'Islanda attraversando l'Atlantico per commemorare la scoperta dell'America da parte di Leif Erikson 1000 anni prima.

Vikingschip

Het eikenhouten, 23 meter lange vikingschip *Íslendingur* (de IJslander), een replica van het Noorse Gokstadschip, is te ze zien in het museum Viking World in Keflavík. Het is zeewaardig: de bouwer Gunnar Marel Eggertsson zeilde er in 2000 vanuit IJsland mee over de Atlantische Oceaan om de ontdekking van Amerika door Leif Eriksson duizend jaar daarvoor te herdenken.

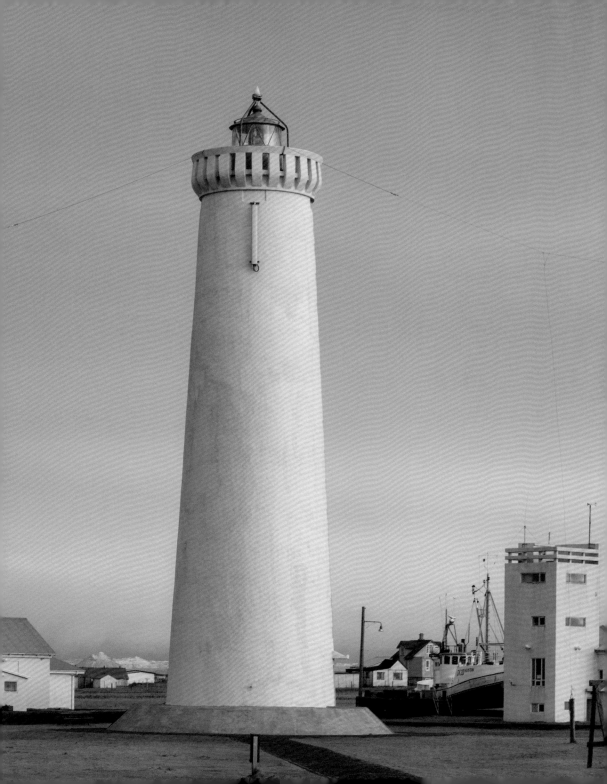

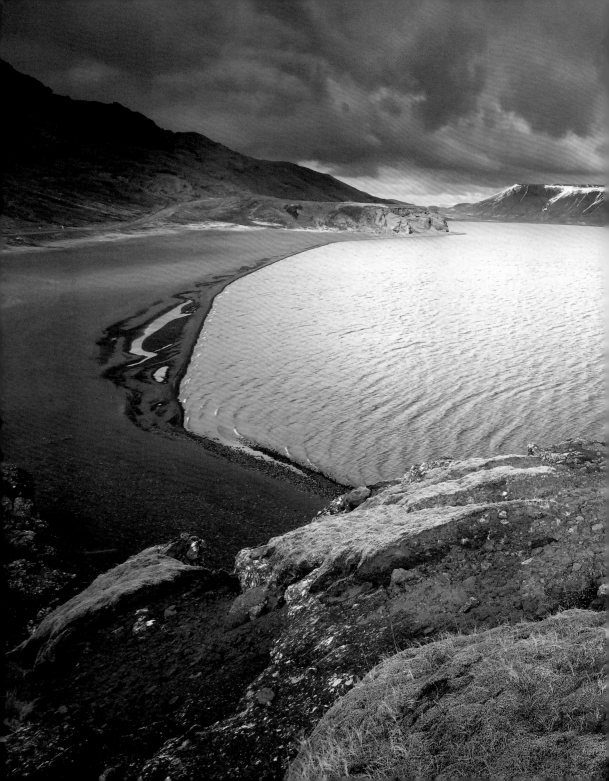

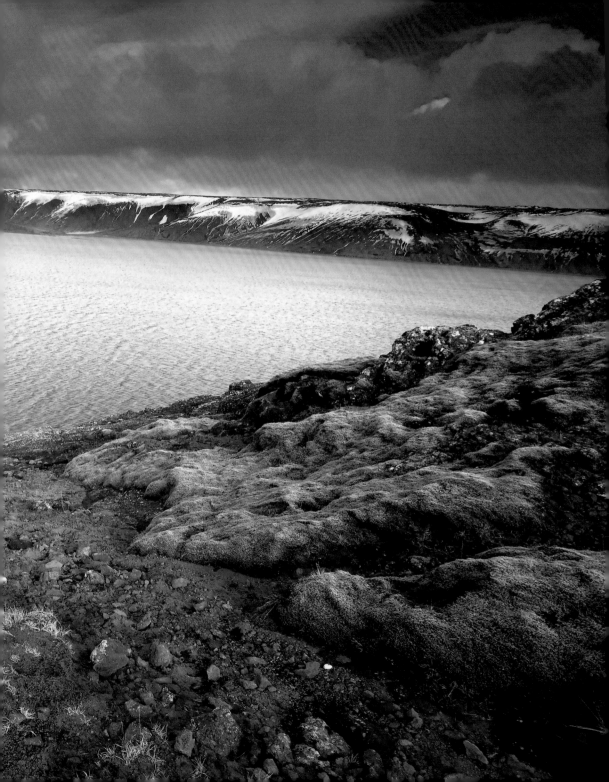

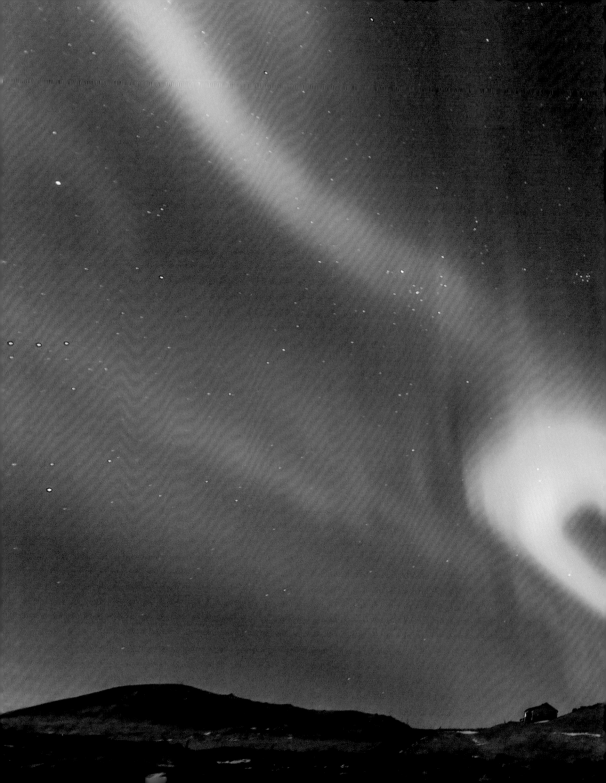

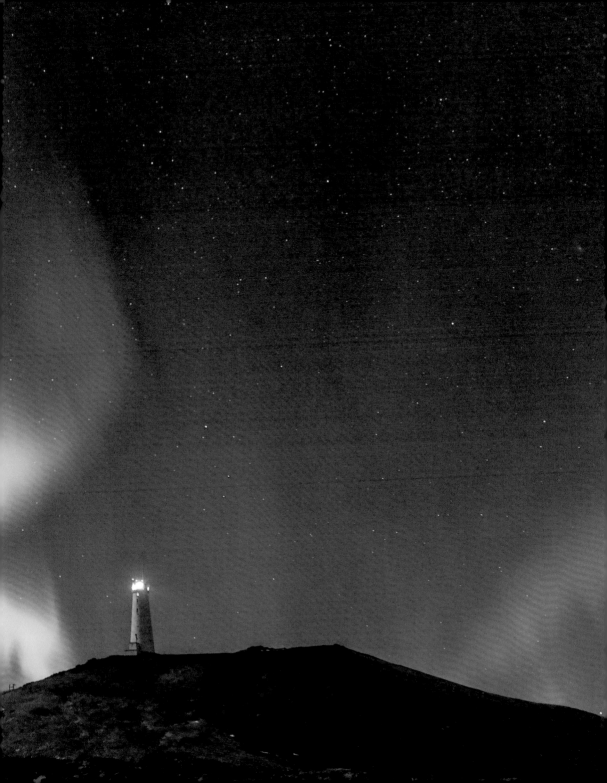

Whale bone

Hvalsneskirkja Church

Consecrated in 1887, the "Church of the Whale Peninsula" is built of black basalt; its interior is made of driftwood. It commemorates the famous psalmist and preacher Hallgrímur Pétursson, who was a pastor here in the 17th century. The church contains a tombstone with an inscription for his daughter Steinunn, who died at a young age.

Hvalsneskirkja

Consacrée en 1887, l'église de la péninsule aux baleines, Hvalsneskirkja, a été construite en basalte noir, et son intérieur est en bois flotté. Il commémore le célèbre psalmiste et prédicateur Hallgrímur Pétursson, pasteur dans la région au XVIIe siècle. On peut également y observer une pierre tombale avec une inscription destinée à sa fille Steinunn, décédée prématurément.

Hvalsneskirkja

Die 1887 geweihte „Kirche der Walhalbinsel" wurde aus schwarzem Basalt errichtet, die Inneneinrichtung ist aus Treibholz. Sie erinnert an den bekannten Psalmendichter und Prediger Hallgrímur Pétursson, der im 17. Jahrhundert hier Pfarrer war. Der Grabstein mit einer Inschrift für seine früh verstorbene Tochter Steinunn ist in der Kirche zu sehen.

Hvalsneskirkja

Inaugurada en 1887, la "Iglesia de la Península de la Ballena" fue construida de basalto negro, el interior está hecho de madera flotante. Conmemora al famoso salmista y predicador Hallgrímur Pétursson, que fue pastor aquí en el siglo XVII. En la iglesia se puede ver la lápida con la inscripción de su hija Steinunn, fallecida de manera precoz.

Hvalsneskirkja

Consacrata nel 1887, la "chiesa della penisola baleniera" è stata costruita in basalto nero, l'interno è realizzato in legname galleggiante. Ricorda il famoso salmista e predicatore Hallgrímur Pétursson, che qui fu pastore nel XVII secolo. La lapide con un'iscrizione per la figlia Steinunn, deceduta in tenera età, è conservata all'interno della chiesa.

Hvalsneskirkja

De 'kerk van het walvisschiereiland' werd in 1887 ingewijd en is gebouwd van zwarte basaltstenen. Het interieur is van drijfhout. Het gebouw herdenkt de beroemde psalmdichter en predikant Hallgrímur Pétursson, die hier in de 17e eeuw voorganger was. In de kerk is de grafsteen met een inscriptie voor zijn jong overleden dochter Steinunn te zien.

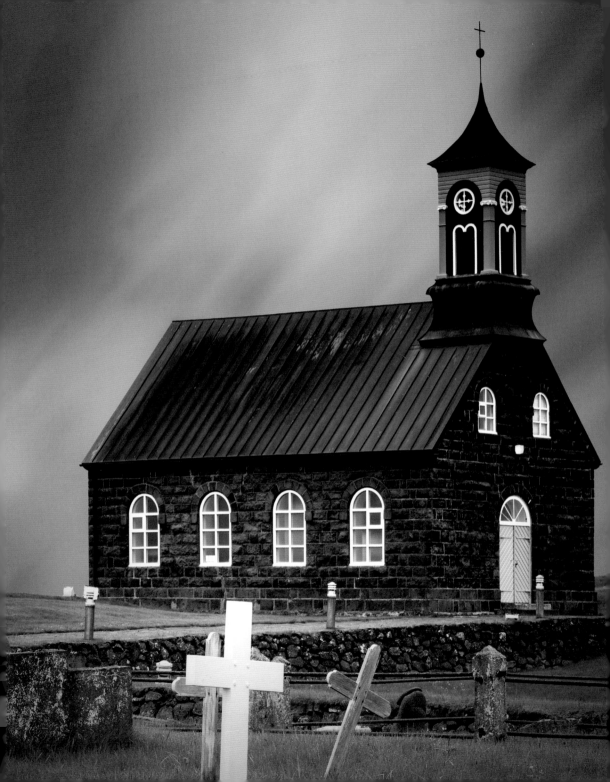

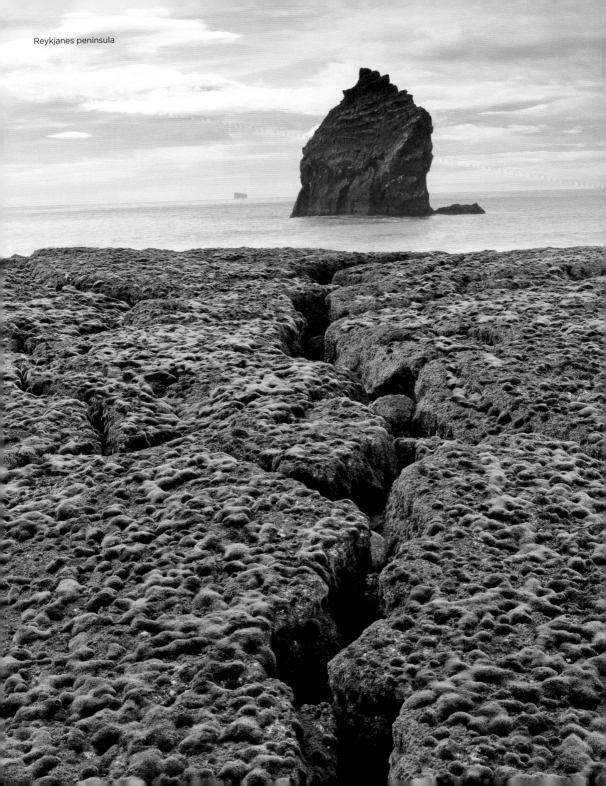

Reykjanes peninsula

Hot river near Reykjanesviti

Eldey

South-west of Reykjanes, the island of Eldey rises up out of the sea with steep cliffs up to 70 metres high. The "Fire Island" has been a nature reserve since 1940, and is a popular breeding ground for seabirds. Up to 40,000 gannets form one of the largest colonies of the species; the legendary great auk, which died out around 175 years ago, also made its home on Eldey.

Eldey

Au sud-ouest de Reykjanes, l'île d'Eldey s'élève hors de la mer avec des falaises abruptes atteignant 70 m de haut. L'«île du Feu» est une réserve naturelle depuis 1940. C'est un lieu de reproduction populaire pour les oiseaux de mer. Jusqu'à 40 000 fous de Bassan forment ici l'une des plus grandes colonies du genre; le légendaire grand pingouin, qui s'est éteint il y a environ 175 ans, était aussi chez lui sur Eldey.

Eldey

Südwestlich von Reykjanes ragt die Insel Eldey mit bis zu 70 m hohen Steilklippen aus dem Meer. Die „Feuerinsel" steht seit 1940 unter Naturschutz. Sie ist ein beliebter Brutplatz für Seevögel. Bis zu 40 000 Basstölpel bilden hier eine der größten Kolonien ihrer Art. Auch der legendäre, vor rund 175 Jahren ausgestorbene Riesenalk war auf Eldey zu Hause.

Eldey

Al suroeste de Reykjanes, la isla de Eldey se eleva sobre el mar con acantilados de hasta 70 m de altura. La "Isla del Fuego" es una reserva natural desde 1940. Es popular lugar de cría para las aves marinas. Hasta 40 000 alcatraces forman una de las colonias más grandes de su clase aquí. Eldey también era el hogar del legendario alca gigante, que se extinguió hace unos 175 años.

Eldey

A sud-ovest di Reykjanes, l'isola di Eldey si erge dal mare con ripide scogliere alte fino a 70 m. L'"Isola del Fuoco" è una riserva naturale dal 1940. È una zona di riproduzione per gli uccelli marini. Qui fino a 40 000 sule formano una delle più grandi colonie della loro specie. Anche la leggendaria alca impenne, estinta circa 175 anni fa, popolava Eldey.

Eldey

Ten zuidwesten van Reykjanes stijgt het eiland Eldey met steile klippen tot wel 70 meter hoog op uit zee. Het 'Vuureiland' is sinds 1940 een natuurreservaat. Het is een geliefde broedplaats voor zeevogels. Zo'n 40 000 jan-van-genten vormen hier een van de grootste kolonies in hun soort. De legendarische reuzenalk, die zo'n 175 jaar geleden uitstierf, was ook thuis op Eldey.

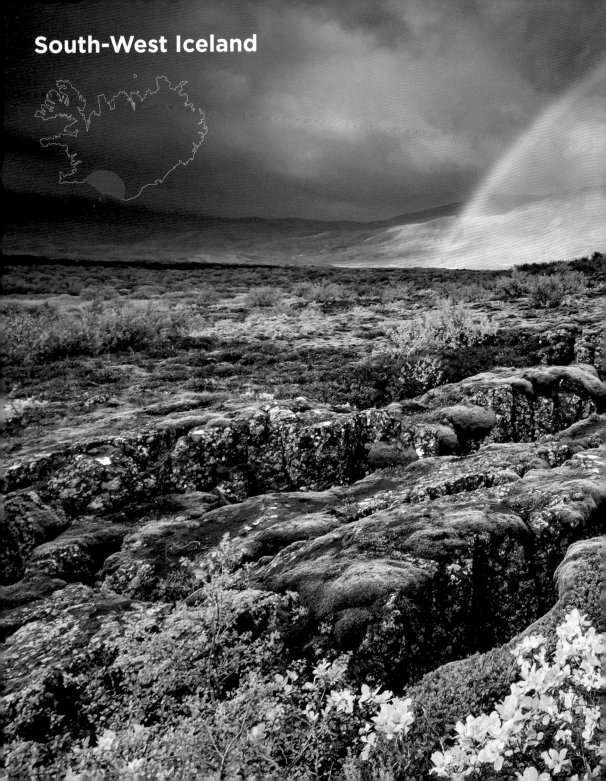

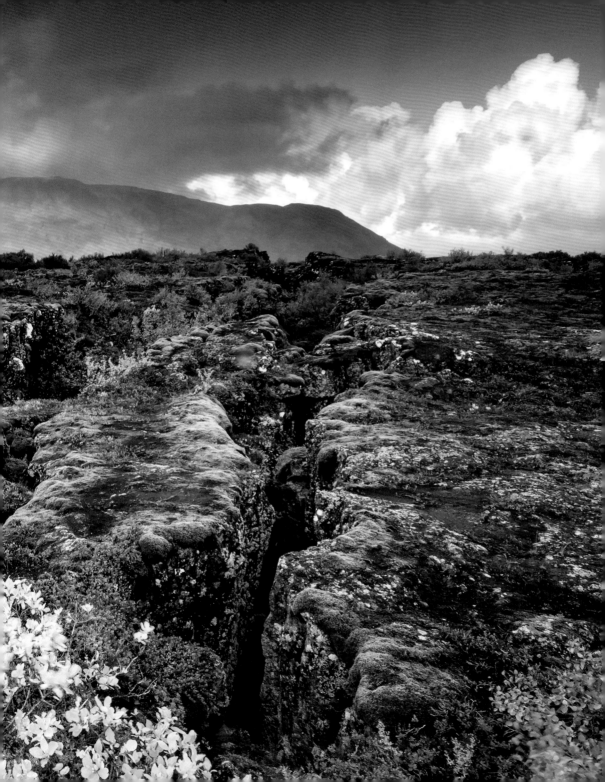

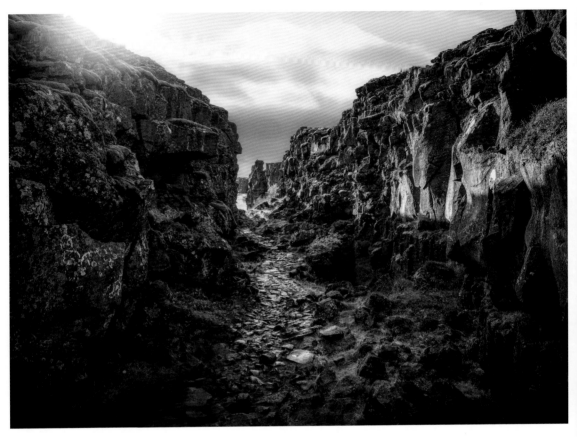

þingvellir National Park

South-West Iceland

The southwest of Iceland, which lies on the drift zone of two continental plates, is a geologically turbulent area. Powerful and unstoppable forces of nature are at work here to slowly divide the island in two. Some of Iceland's most visited sights are to be found not far from the capital on the "Golden Circle": geysers, mighty waterfalls such as Gullfoss, and Þingvellir National Park, a place of pilgrimage for historically conscious Icelanders to commemorate the founding of their nation.

Sud-ouest de l'Islande

Le sud-ouest de l'Islande est une région géologiquement agitée, puisqu'elle se trouve au-dessus de la zone de dérive de deux plaques continentales. Ici, d'énormes forces de la nature sont à l'œuvre, qui divisent lentement mais irrémédiablement l'île. Certains des sites les plus visités d'Islande ne sont pas loin de la capitale, sur l'axe surnommé le « Cercle d'or » : des geysers, de puissantes cascades comme la chute de Gullfoss ou le parc national de Þingvellir, lieu de pèlerinage pour les Islandais intéressés par l'histoire de leur nation.

Südwestisland

Eine geologisch unruhige Gegend ist der Südwesten Islands, der über der Driftzone zweier Kontinentalplatten liegt. Hier sind ungeheure Naturkräfte am Werk, die die Insel langsam, aber unaufhaltsam spalten. Einige der meistbesuchten Sehenswürdigkeiten Islands liegen unweit der Hauptstadt am „Goldenen Kreis": Geysire, mächtige Wasserfälle wie der Gullfoss und der Nationalpark Þingvellir, der für geschichtsbewusste Isländer als Ort der Nationwerdung geradezu eine Pilgerstätte ist.

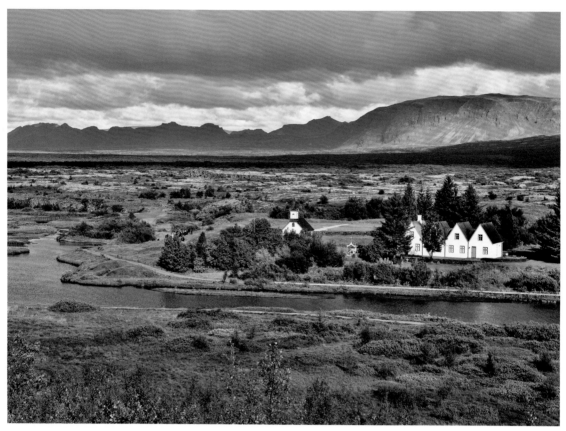

þingvellir National Park

Suroeste de Islandia

El suroeste de Islandia es una zona geológicamente turbulenta que se encuentra por encima de la zona de deriva de dos placas continentales. Aquí operan enormes fuerzas de la naturaleza, que lenta pero imparablemente dividen la isla. Algunos de los lugares más visitados de Islandia están cerca de la capital, en el "Círculo de Oro": géiseres, poderosas cascadas como la de Gullfoss y el parque nacional de Þingvellir, que es un lugar de peregrinación para los islandeses con conciencia histórica como lugar de nación.

Sud-Ovest dell'Islanda

Un'area geologicamente turbolenta è il sud-ovest dell'Islanda, sopra la zona di deriva di due placche continentali. Qui sono all'opera enormi forze della natura, che lentamente ma inarrestabilmente dividono l'isola. Alcune delle attrazioni più visitate d'Islanda non sono lontane dalla capitale, sul "Cerchio d'Oro": geyser, imponenti cascate come Gullfoss e il Parco nazionale di Þingvellir, luogo di pellegrinaggio per gli islandesi che amano la questo luogo che rappresenta storicamente senso di appartenenza della nazione.

Zuidwest-IJsland

Het gebied in het zuidwesten van IJsland is geologisch turbulent, omdat het boven de driftzone van twee continentale platen ligt. Hier zijn enorme natuurkrachten aan het werk, die het eiland langzaam maar zeker splijten. Enkele van de meest bezochte bezienswaardigheden van IJsland liggen niet ver van de hoofdstad op de 'Gouden Cirkel': geisers, machtige watervallen zoals de Gullfoss en het nationale park Þingvellir, dat als de plaats van natiewording een bedevaartsoord is voor historisch bewuste IJslanders.

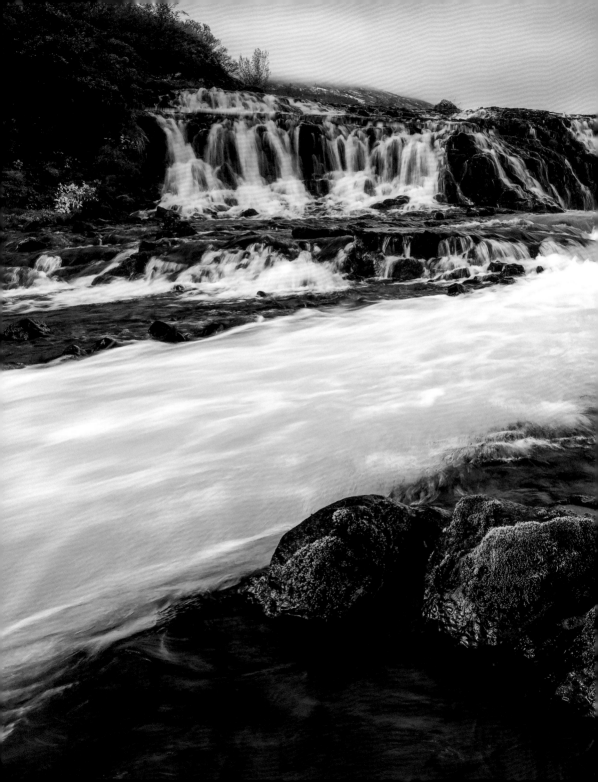

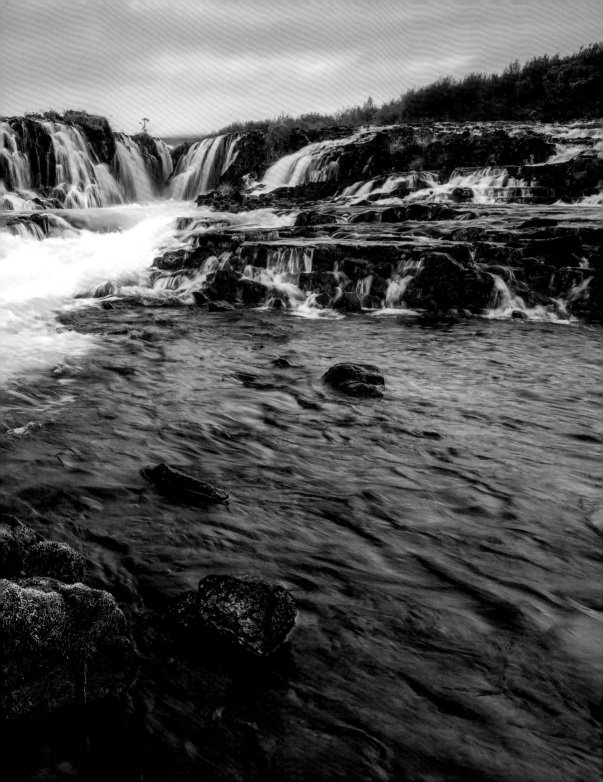

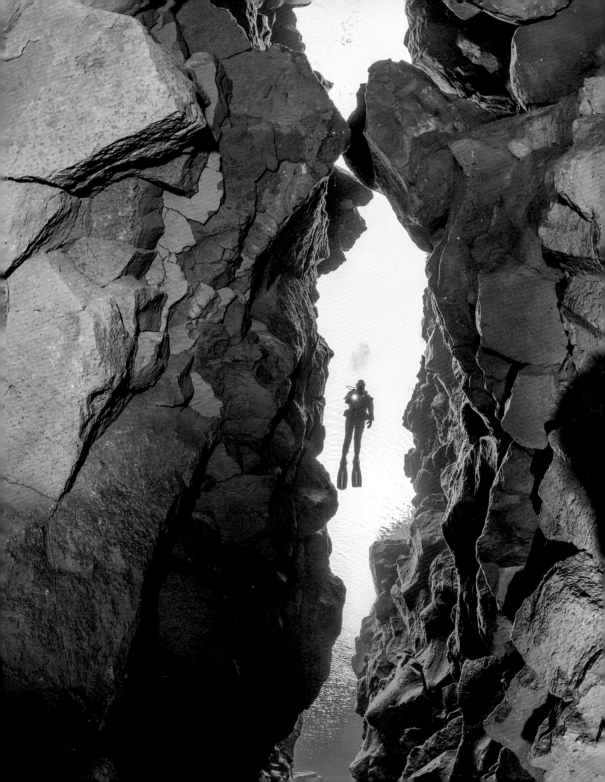

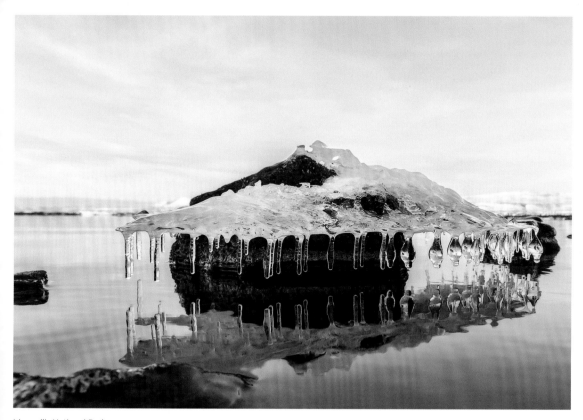
Þingvellir National Park

Þingvellir National Park
In Þingvellir National Park, you can experience the geological drift of the North American and Eurasian continental plates. Divers and snorkellers can commute between the continents in the crystal-clear waters of the Silfra fissure. The gap widens continuously, albeit by just under one centimetre per year.

Parc national de Þingvellir
Dans le parc national de Þingvellir, il est possible d'expérimenter le phénomène géologique de la dérive des plaques continentales nord-américaine et eurasienne. Dans les eaux cristallines de la crevasse de Silfra, les plongeurs et les snorkellers peuvent faire la navette entre les continents. L'écart se creuse continuellement, mais d'un peu moins d'un centimètre par an.

Þingvellir-Nationalpark
Im Þingvellir-Nationalpark lässt sich das geologische Phänomen des Auseinanderdriftens der nordamerikanischen und der eurasischen Kontinentalplatte erleben. Im glasklaren Wasser der Silfra-Spalte können Taucher und Schnorchler zwischen den Kontinenten pendeln. Der Spalt verbreitert sich kontinuierlich, wenn auch nur um knapp einen Zentimeter pro Jahr.

Parque nacional de Þingvellir
En el Parque Nacional de Þingvellir se puede experimentar el fenómeno geológico de la deriva de las placas continentales de Norteamérica y Eurasia. Los buzos y amantes del esnórquel pueden desplazarse entre los continentes por las aguas cristalinas de la grieta de Silfra. La brecha se ensancha algo menos de un centímetro por año, pero de manera constante.

Parco nazionale di Þingvellir
Nel Parco Nazionale di Þingvellir si può rivivere il fenomeno geologico della deriva delle placche continentali nordamericana ed eurasiatica. I subacquei e gli amanti dello snorkeling possono spostarsi tra i continenti nelle acque cristalline della Fessura di Silfra. Il divario aumenta continuamente, anche se di poco meno di un centimetro all'anno.

Nationaal park Þingvellir
In het nationale park Þingvellir is het geologische fenomeen van het uit elkaar drijven van de Noord-Amerikaanse en Euraziatische continentale platen te ervaren. Duikers en snorkelaars kunnen in het kristalheldere water van de Silfraspleten heen en weer zwemmen tussen de continenten. De kloof wordt steeds groter, zij het met maar iets minder dan 1 cm per jaar.

Seljalandsfoss
One of Iceland's most spectacular waterfalls is
Seljalandsfoss, which can be easily reached from the
Ring Road between Hvolsvöllur and Skógar. Fed by
the Eyjafjallajökull glacier, Seljalandsfoss plunges
60 metres down over a shelf of eroded coastline.
What makes this waterfall special is that you can
safely walk behind it, which makes for wonderful
photographs, especially in the evening sun.

Seljalandsfoss
L'une des chutes d'eau les plus spectaculaires
d'Islande est la cascade de Seljalandsfoss, facilement
accessible depuis la Route 1 entre Hvolsvöllur
et Skógar. Elle est alimentée par le glacier
Eyjafjallajökull, et plonge d'une bonne soixantaine de
mètres dans les profondeurs. Ce qui la rend spéciale,
c'est qu'il est possible de marcher derrière l'eau en
toute sécurité, un point de vue particulièrement
magnifique, surtout au soleil du soir.

Seljalandsfoss
Einer der spektakulärsten Wasserfälle Islands ist der
Seljalandsfoss, der gut von der Ringstraße zwischen
Hvolsvöllur und Skógar erreicht werden kann.
Gespeist wird er vom Gletscher Eyjafjallajökull. Gut
60 m stürzt er über den früheren Küstenabbruch in
die Tiefe. Besonders macht ihn, dass man gefahrlos
hinter ihm durchgehen kann, was vor allem bei
Abendsonne für wunderbare Bilder sorgt.

Seljalandsfoss
Una de las cascadas más espectaculares de Islandia
es Seljalandsfoss, a la que se puede acceder
fácilmente desde la carretera de circunvalación entre
Hvolsvöllur y Skógar. Está alimentada por el glaciar
Eyjafjallajökull. Tiene una caída de unos 60 m desde
la antigua línea costera. Lo que la hace especial es
que se puede caminar con seguridad por detrás de
la cascada, lo que da pie a imágenes maravillosas,
especialmente cuando se pone el sol.

Seljalandsfoss
Una delle cascate più spettacolari d'Islanda è
Seljalandsfoss, facilmente raggiungibile dalla
circonvallazione tra Hvolsvöllur e Skógar. È
alimentata dal ghiacciaio Eyjafjallajökull. Si immerge
ben 60 m nelle profondità dell'antica erosione
costiera. Ciò che la rende speciale è che si può
camminare in sicurezza dietro di essa, con immagini
spettacolari soprattutto al tramonto.

Seljalandsfoss
Een van de spectaculairste watervallen van IJsland
is de Seljalandsfoss, die gemakkelijk bereikbaar is
vanaf de ringweg tussen Hvolsvöllur en Skógar. Hij
krijgt zijn water van de gletsjer Eyjafjallajökull. Het
stort over de afgebroken kust ruim 60 meter de
diepte in. Wat hem bijzonder maakt, is dat je er veilig
achterlangs kunt lopen, hetgeen prachtige foto's
oplevert, vooral in de avondzon.

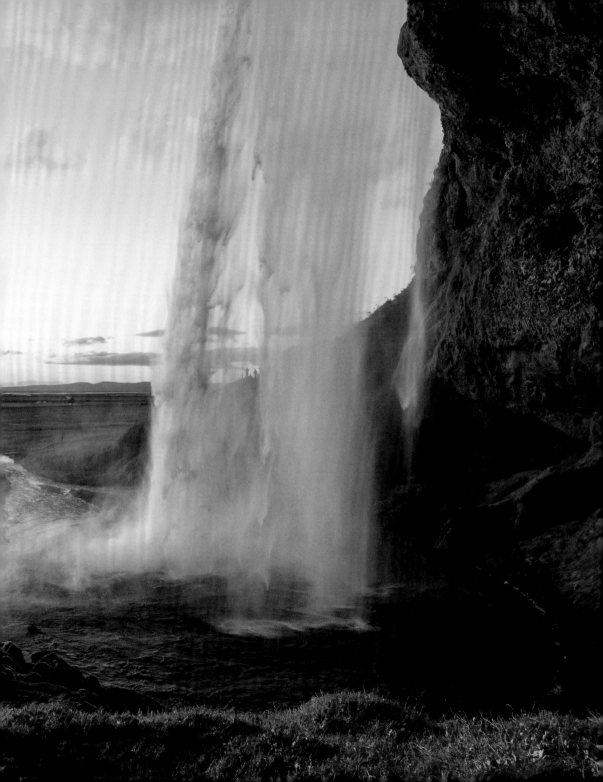

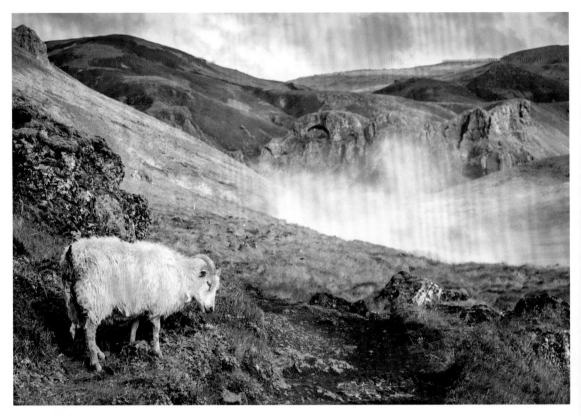

Hveragerði hot spring river trail

Hveragerði

The southern Icelandic municipality of Hveragerði is situated in an area with a great wealth of hot springs. Hiking trails lead through the geothermal regions, where white steam rises from the ground and pools bubble at every turn. The area has harnessed this energy, and is home to most of Iceland's greenhouses.

Hveragerði

La municipalité de Hveragerði, dans le sud de l'Islande, est située dans une région riche en sources d'eau chaude. Partout dans les environs, la vapeur blanche monte et l'eau bouillonne. Des sentiers de randonnée pédestre traversent la zone géothermique. La région a su exploiter l'énergie des profondeurs, puisqu'on trouve ici la plupart des serres islandaises.

Hveragerði

Die südisländische Gemeinde Hveragerði liegt in einem Gebiet mit einem großen Reichtum an heißen Quellen. Überall in der Umgebung steigt weißer Dampf auf, es brodelt auf Schritt und Tritt. Wanderwege führen durch das geothermische Gebiet. Der Ort hat sich die Energie aus der Tiefe nutzbar gemacht, hier stehen die meisten Gewächshäuser Islands.

Hveragerði

El municipio de Hveragerði, al sur de Islandia, está situado en una zona con una gran riqueza de aguas termales. En todas partes en el área circundante, el vapor blanco se eleva y burbujea a cada paso. Hay senderos que cruzan la zona geotérmica. El lugar ha aprovechado la energía de las profundidades, donde se encuentran la mayoría de los invernaderos de Islandia.

Hveragerði

Il comune di Hveragerði, nell'Islanda meridionale, è situato in una zona ricca di sorgenti termali. Ovunque nell'area circostante si erge il vapore bianco e gorgoglia ad ogni curva. I sentieri escursionistici attraversano l'area geotermica. Il luogo ha sfruttato l'energia dalle profondità della terra, qui si trovano la maggior parte delle serre islandesi.

Hveragerði

De Zuid-IJslandse gemeente Hveragerði ligt in een gebied met een grote rijkdom aan warmwaterbronnen. Overal in de omgeving stijgt witte damp op en bij elke stap borrelt het. Er lopen wandelpaden door het geothermische gebied. De plaats maakt gebruik van de energie uit de diepte – hier bevinden zich de meeste kassen van IJsland.

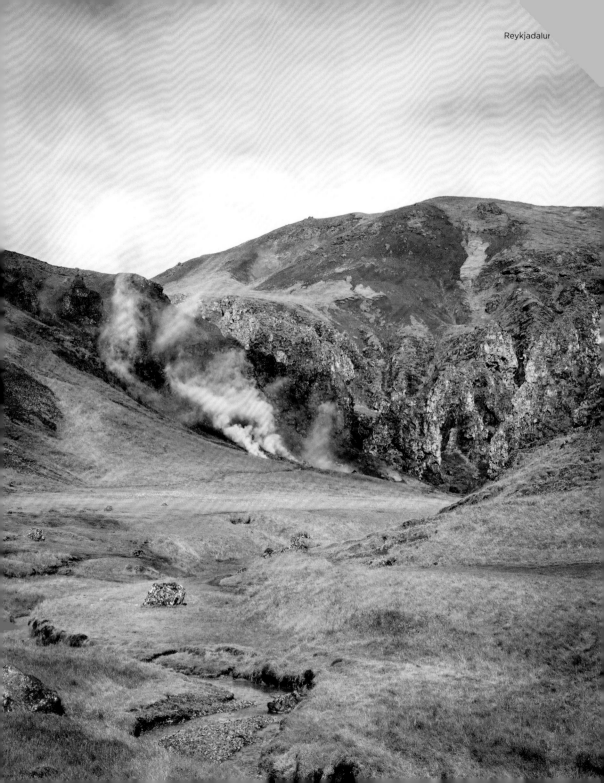

After the last ice age, Iceland rose up from under the ice. Its former coastline is now high above sea level. Over one of these old sea cliffs falls the 25-metre-wide Skógafoss, plunging 60 metres down into the Skógá River. According to legend, a Viking once hid a treasure chest in a cave behind the falls. A boy who found the chest managed to remove only its handle—which today can be seen in the Skógar Museum.

Skógafoss

Après la dernière période glaciaire, la terre s'est élevée, et l'ancienne côte est maintenant bien au-dessus du niveau de la mer. Sur l'un de ces anciens littoraux, Skógafoss, large de près de 25 m, plonge sur plus de 60 m. Selon la légende, un Viking cacha un jour un coffre au trésor dans une grotte derrière la chute. Un garçon l'aurait trouvé, mais n'aurait pu emporter que la poignée – aujourd'hui, elle est exposée au Musée de Skógar.

Skógafoss

Nach der letzten Eiszeit hob sich das Land, die ehemalige Küstenlinie liegt nun hoch über dem Meeresspiegel. An einer dieser Abbruchkanten stürzt der Skógafoss auf 25 m Breite 60 m in die Tiefe. Laut einer Sage versteckte einst ein Wikinger in einer Höhle hinter dem Fall eine Schatztruhe. Ein Junge, der die Truhe fand, bekam nur den Griff zu fassen – der ist heute im Museum Skógar zu sehen.

Skógafoss

Después de la última Edad de Hielo, el país se elevó, la antigua costa está ahora a gran altura sobre el nivel del mar. En uno de estos bordes, la cascada Skógafoss cae 60 m con una anchurada 25 m. Según una leyenda, un vikingo escondió una vez un cofre del tesoro en una cueva detrás de la cascada. Un niño que encontró el cofre solo llegó a empuñar las asas. Estas pueden apreciarse en la actualidad en el Museo de Skógar.

Skógafoss

Dopo l'ultima era glaciale, il paese si è innalzato, la vecchia costa è ora sopra il livello del mare. Su uno di questi spigoli costieri, Skógafoss discende a 60 m di profondità per una larghezza di 25 m. Secondo una leggenda, un vichingo un tempo volta nascose uno scrigno in una grotta dietro la cascata. Un giovane trovò poi lo scrigno ma ha potuto solo afferrare il manico – oggi conservato nel Museo di Skógar.

Skógafoss

Na de laatste ijstijd steeg het land, waardoor de voormalige kustlijn nu hoog boven de zeespiegel ligt. Aan een van de afgronden stort de Skógafoss over een breedte van 25 meter 60 meter de diepte in. Volgens een legende verstopte een Viking ooit een schatkist in een grot achter de waterval. Een jongen die de kist vond, kreeg alleen het handvat te pakken, dat nu te zien is in het Skógarmuseum.

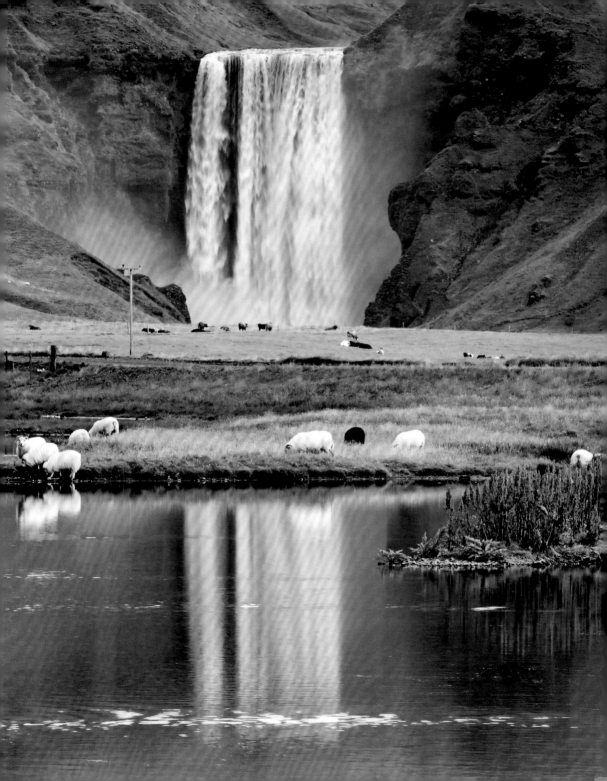

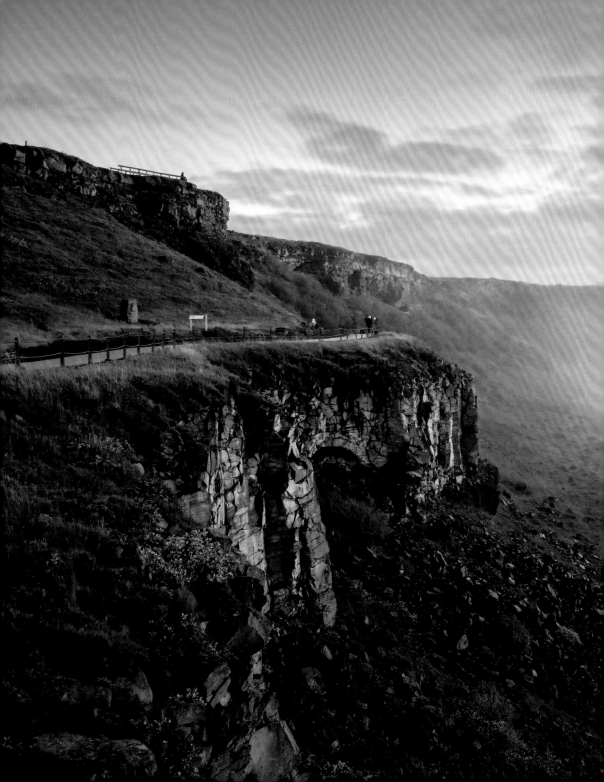

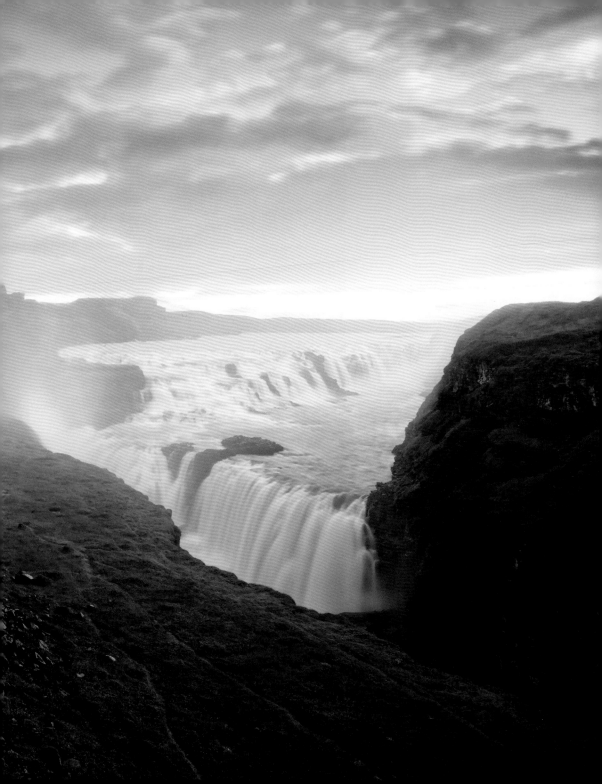

Gullfoss

One of Iceland's most famous sights is Gullfoss, the
"Golden Waterfall", located on the "Golden Circle".
Fed by the glacial river Hvítá, its waters flow in
two steps into a deep crevice. Two attempts have
already been made to dam the Gullfoss and build a
hydroelectric power station. The waterfall was saved
by the efforts of a farmer's daughter and is now
under environmental protection.

Gullfoss

L'un des sites les plus célèbres d'Islande est la
cascade Gullfoss, la «Chute d'or», située sur le
Cercle d'or. Alimentées par la rivière glaciaire Hvítá,
ses masses d'eau s'écoulent en deux étapes dans
une crevasse profonde. Par deux fois, le Gullfoss a
failli être exploité par une centrale hydroélectrique.
Il a été sauvé par l'engagement d'une fille
d'agriculteur et reste maintenant sous protection de
la nature.

Gullfoss

Zu den bekanntesten Sehenswürdigkeiten Islands
gehört der Gullfoss, der „Goldene Wasserfall",
der am „Goldenen Ring" liegt. Vom Gletscherfluss
Hvítá gespeist, ergießen sich seine Wassermassen
in zwei Stufen in eine tiefe Spalte. Zweimal bereits
sollte der Gullfoss durch ein Wasserkraftwerk
gezähmt werden. Durch das Engagement einer
Bauerntochter wurde er gerettet und steht heute
unter Naturschutz.

Gullfoss

Uno de los lugares más famosos de Islandia es
Gullfoss, la "Cascada Dorada", situada en el "Anillo
de Oro". Alimentada por el río glaciar Hvítá, sus
masas de agua fluyen en dos niveles hacia una
profunda grieta. Por segunda vez ya, una central
hidroeléctrica debería haber domesticado esta
cascada pero, gracias al compromiso de la hija de
un agricultor, la cascada se salvó y ahora es zona
protegida de la naturaleza.

Gullfoss

Una delle attrazioni più famose d'Islanda è Gullfoss,
la "cascata d'oro", che si trova sul "Cerchio d'Oro".
Alimentato dal fiume glaciale Hvítá, le sue masse
d'acqua scorrono in due livelli in una profonda
fessura. Già due volte il Gullfoss avrebbe dovuto
essere tenuta a freno da una centrale idroelettrica.
Salvata dall'impegno della figlia di un contadino, è
ora sotto protezione della natura.

Gullfoss

Een van IJslands beroemdste bezienswaardigheden
is de Gullfoss, de 'gouden waterval', gelegen aan
de 'Gouden Cirkel'. Gevoed door de gletsjerrivier
Hvítá vallen de watermassa's in twee stappen in een
diepe kloof. Twee keer zou de Gullfoss al getemd
worden door een waterkrachtcentrale. Door de inzet
van een boerendochter werd hij gered en hij valt nu
onder natuurbehoud.

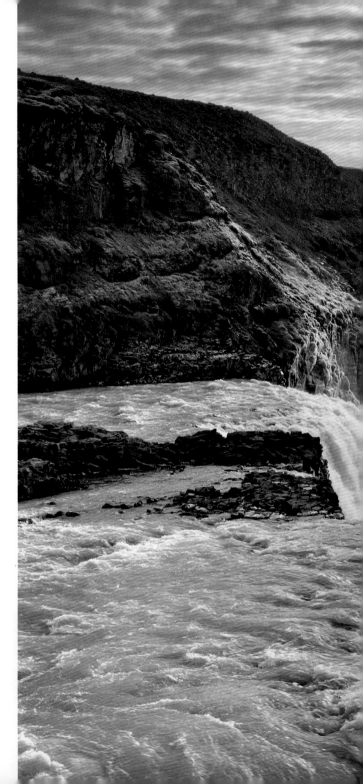

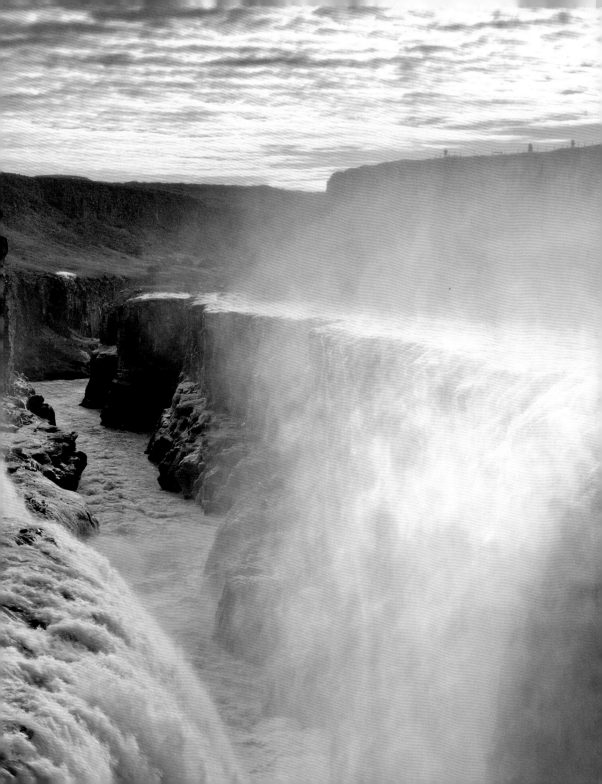

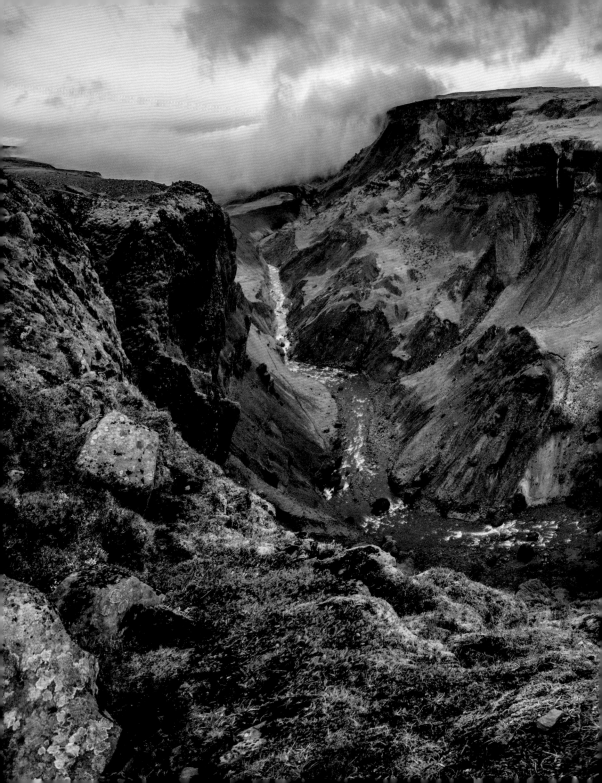

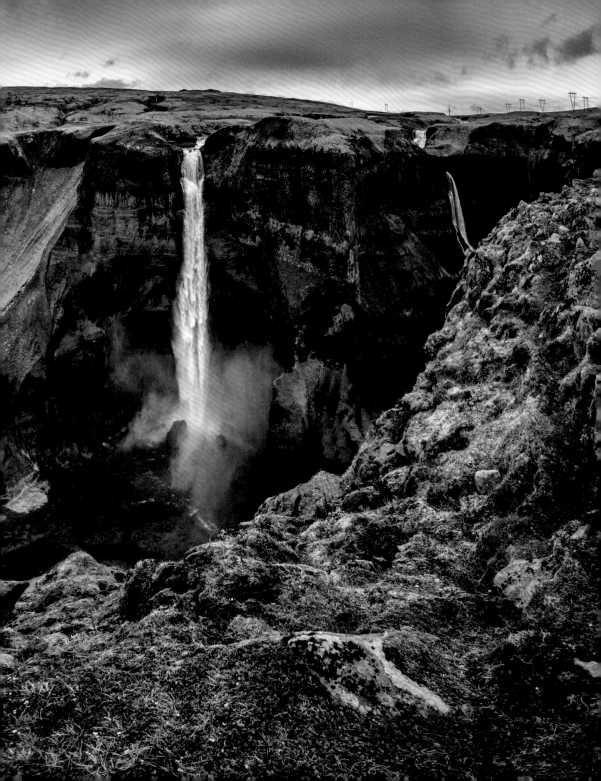

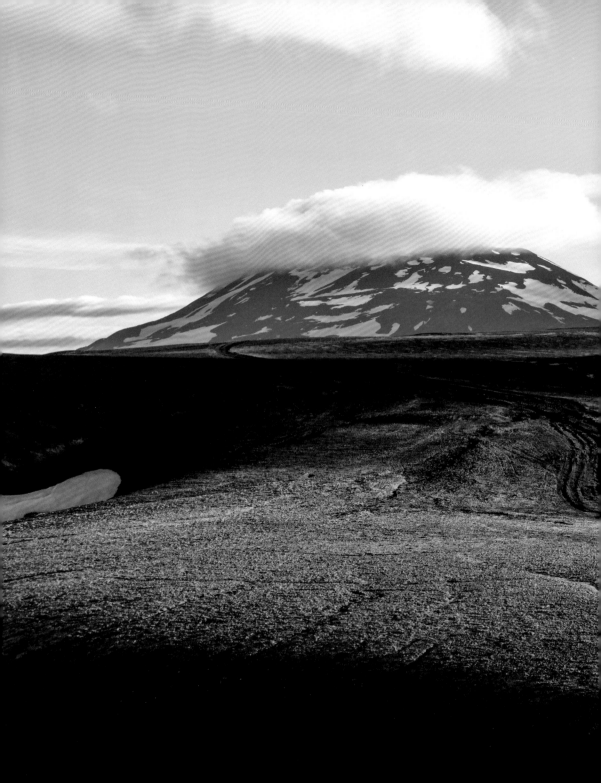

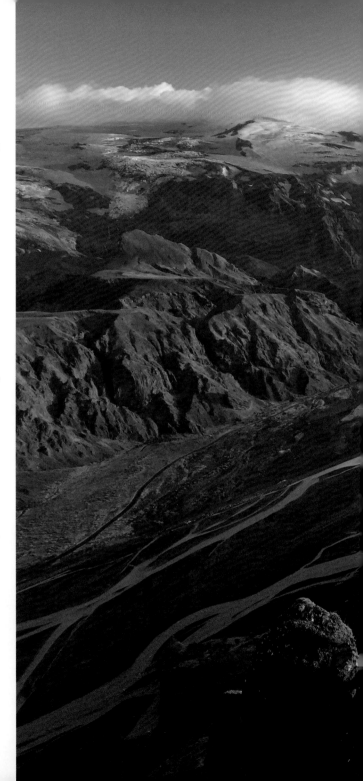

View from Valahnúkur mountain
towards Eyjafjallajökull volcano

Eyjafjallajökull

It may look calm and harmless, but Eyjafjallajökull
is an active volcano. Four outbreaks have occurred
over the last thousand years: the most recent one,
in 2010, made headlines worldwide when the ash
clouds paralysed air traffic in Northern and Central
Europe. A hundred thousand flights were cancelled
and ten million passengers were affected.

Eyjafjallajökull

Il semble calme et inoffensif, mais l'Eyjafjallajökull
fait partie des volcans actifs d'Islande.
Quatre foyers s'y sont déclarés au cours des
1000 dernières années. La dernière, en 2010, a fait
la une des journaux du monde entier parce que
les nuages de cendres produits par le volcan ont
paralysé le trafic aérien en Europe du Nord et en
Europe centrale. 100 000 vols ont été annulés et
dix millions de passagers ont été touchés.

Eyjafjallajökull

Scheinbar ruhig und harmlos liegt er da, aber der
übergletscherte Eyjafjallajökull gehört zu den
aktiven Vulkanen Islands. In den letzten tausend
Jahren ereigneten sich vier Ausbrüche. Der letzte
im Jahr 2010 sorgte weltweit für Schlagzeilen, weil
durch die Aschewolken der Flugverkehr in Nord-
und Mitteleuropa lahmgelegt wurde. 100 000 Flüge
wurden gestrichen, zehn Millionen Passagiere
waren betroffen.

Eyjafjallajökull

Parece tranquilo e inofensivo, pero el
Eyjafjallajökull es uno de los volcanes activos de
Islandia. En los últimos mil años se han producido
cuatro erupciones. La última, en 2010, fue noticia
en todo el mundo porque las nubes de ceniza
paralizaron el tráfico aéreo en el norte y centro de
Europa. Se cancelaron 100 000 vuelos y se vieron
afectados diez millones de pasajeros.

Eyjafjallajökull

All'apparenza tranquillo e innocuo, Eyjafjallajökull è
uno dei vulcani attivi dell'Islanda. Negli ultimi mille
anni si sono manifestati quattro eruzioni. L'ultima,
del 2010, ha fatto notizia in tutto il mondo perché
le nubi di cenere hanno paralizzato il traffico aereo
nell'Europa settentrionale e centrale. 100 000 voli
sono stati cancellati e 10 milioni di passeggeri sono
rimasti a terra.

Eyjafjallajökull

Hij ziet er rustig en onschuldig uit, maar de
Eyjafjallajökull is een van de actieve vulkanen
van IJsland. In de afgelopen duizend jaar waren
er vier uitbarstingen. De laatste in 2010 haalde
wereldwijd de krantenkoppen omdat de
aswolken het luchtverkeer in Noord- en Midden-
Europa stillegden. Er werden 100 000 vluchten
geannuleerd en tien miljoen passagiers
werden getroffen.

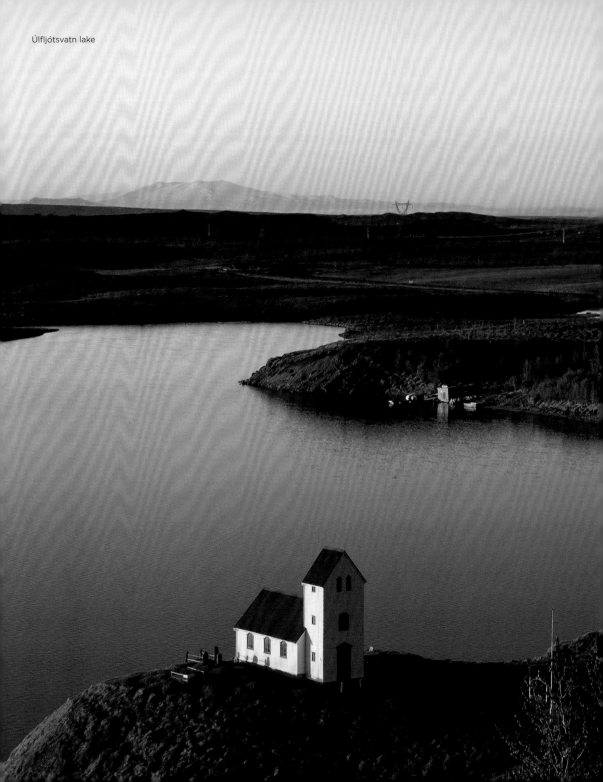

Úlfljótsvatn lake

Þingvallavatn lake

Þingvallavatn

Þingvallavatn plays a special role in the history of the island: on its northern shore in Þingvellir lies the Almannagjá gorge, where the Althing, one of the first parliaments in Europe, met for the first time in 930. The geologically unstable area is surrounded by volcanic systems. Since 2004, Þingvellir has been on the Unesco World Heritage List.

Þingvallavatn

Le lac Þingvallavatn tient un rôle particulier dans l'histoire de l'île : sur sa rive nord, à Þingvellir, se trouve l'Almannagjá, où l'Althing, l'un des premiers parlements d'Europe, s'est réuni pour la première fois en 930. La zone, géologiquement instable, est entourée de systèmes volcaniques. Depuis 2004, Þingvellir est inscrit sur la liste du patrimoine mondial de l'Unesco.

Þingvallavatn

Der Þingvallavatn spielt in der Geschichte der Insel eine besondere Rolle: An seinem Nordufer in Þingvellir liegt die Allmännerschlucht, wo im Jahr 930 erstmals das Althing tagte, eines der ersten Parlamente Europas. Die geologisch unruhige Gegend ist von Vulkansystemen umgeben. Seit 2004 steht Þingvellir auf der Unesco-Liste des Weltkulturerbes.

Þingvallavatn

El Þingvallavatn desempeña un papel especial en la historia de la isla: en su costa norte, en Þingvellir, se encuentra la falla Almannagjá, donde el Althing, uno de los primeros parlamentos de Europa, se reunió por primera vez en 930. El área geológicamente inestable está rodeada por sistemas volcánicos. Desde 2004, Þingvellir está inscrito en la Lista del Patrimonio Mundial de la Unesco.

Þingvallavatn

Il Þingvallavatn gioca un ruolo particolare nella storia dell'isola: sulla sua sponda settentrionale si trova l'Almannagjá, dove l'Althing, uno dei primi parlamenti d'Europa, si riunì per la prima volta nell'anno 930. L'area geologicamente instabile è circondata da sistemi vulcanici. Dal 2004 il Þingvellir è iscritto nella Lista del Patrimonio Mondiale dell'Unesco.

Þingvallavatn

Het meer Þingvallavatn speelt een bijzondere rol in de geschiedenis van het eiland: aan zijn noordelijke oever in Þingvellir ligt de Almannagjá, de 'allemensenkloof', waar het Althing, een van de oudste parlementen van Europa, in 930 voor het eerst bijeenkwam. Het geologisch labiele gebied is omgeven door vulkanen. Sinds 2004 staat Þingvellir op de werelderfgoedlijst van de Unesco.

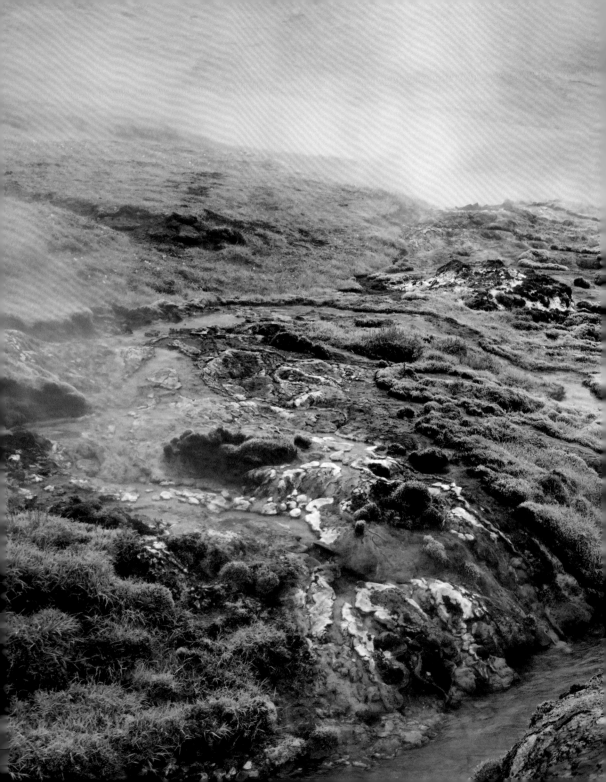

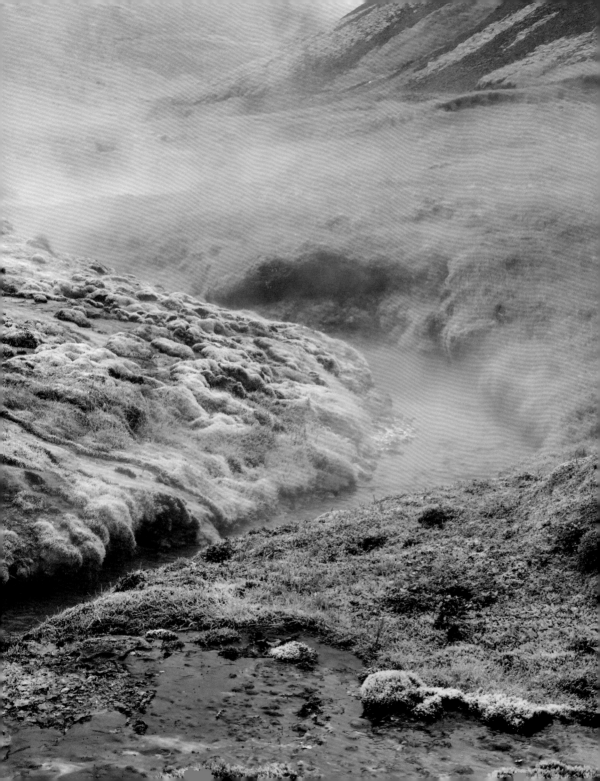

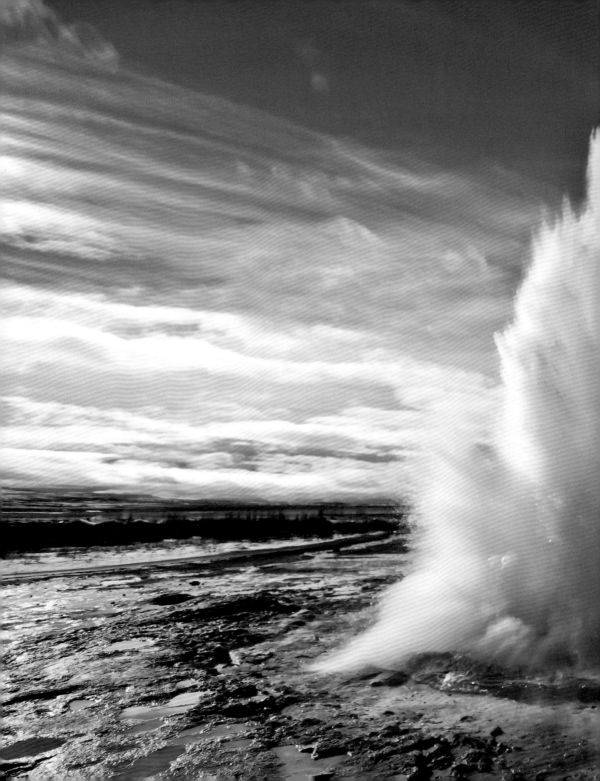

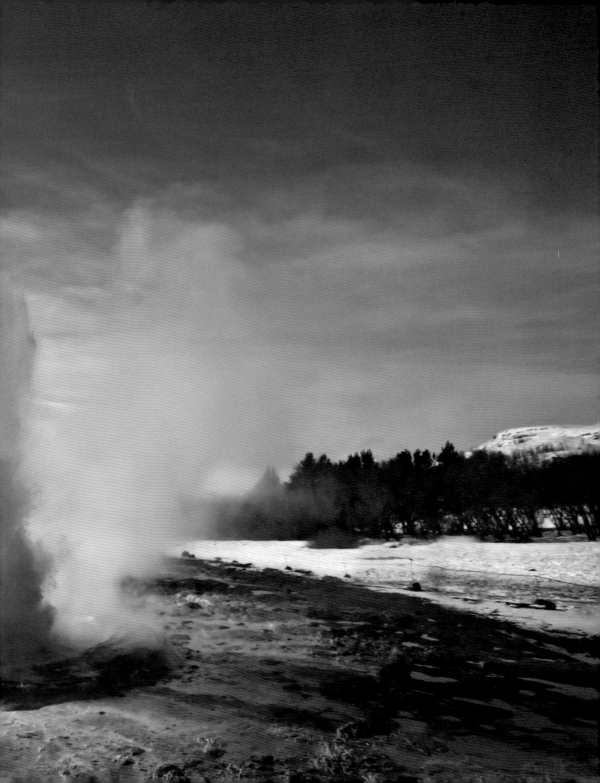

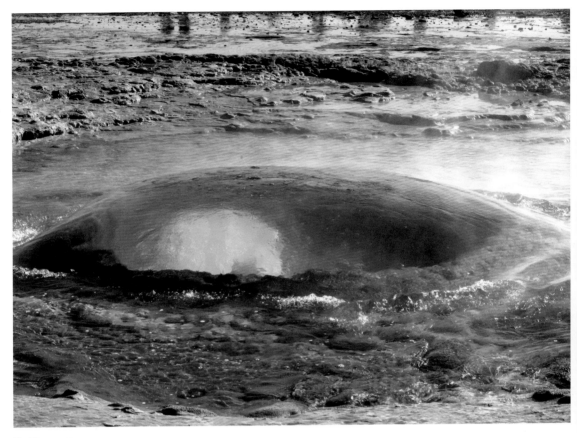

Strokkur geyser

Geysers

One of Iceland's best-known natural phenomena is its geysers and hot springs. Strokkur in Haukadalur is one of the most active: a boiling hot column of water and steam shoots up to 35 metres into the sky about every 10 minutes. The impending eruption can be recognised by the rising surface of the water in the centre of the pool.

Geysers

L'un des phénomènes naturels les plus connus d'Islande est celui du geyser – un type de sources chaudes qui jaillit de terre. Strokkur, à Haukadalur, est l'un des plus actifs. Une colonne de vapeur et d'eau bouillante se projette jusqu'à 35 m dans le ciel toutes les dix minutes environ. L'éruption imminente peut être anticipée en observant la surface de l'eau qui monte à l'extrémité supérieure du chenal.

Geysire

Zu den bekanntesten Naturphänomenen Islands zählen die Geysire, heiße Springquellen. Der Strokkur im Haukadalur ist einer der aktivsten. Regelmäßig etwa alle zehn Minuten schießt eine kochend heiße Wasser- und Dampfsäule bis zu 35 m in den Himmel. Die bevorstehende Eruption erkennt man an der sich emporwölbenden Wasseroberfläche am oberen Ende des Kanals.

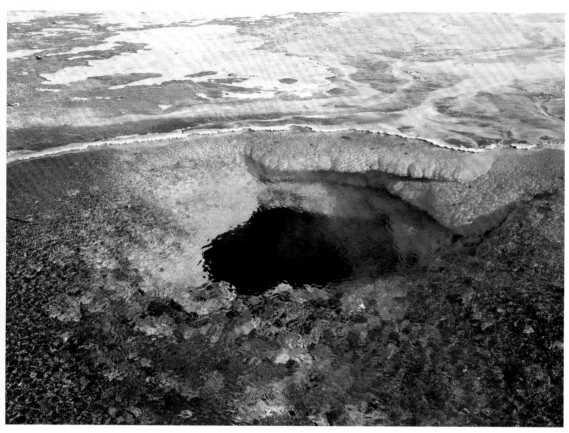

Blesi, thermal spring

Géiseres

Uno de los fenómenos naturales más conocidos de Islandia son los géiseres, fontanas de aguas caliente. El géiser Strokkur, en Haukadalur, es uno de los más activos. Una columna de agua caliente hirviendo y de vapor sale disparada del suelo hasta 35 m hacia el cielo aproximadamente cada diez minutos. La inminente erupción se puede reconocer por el aumento de la superficie acuática en el extremo superior del canal.

Geyser

Uno dei fenomeni naturali più noti in Islanda è il geyser, una sorgente termale. Strokkur nella valle di Haukadalur è uno dei più attivi. Una colonna d'acqua calda e bollente e il vapore si diffondono nel cielo fino a 35 m circa ogni dieci minuti. L'imminente eruzione viene anticipata dalla superficie dell'acqua che sale all'estremità superiore del canale.

Geisers

Tot de bekendste natuurverschijnselen van IJsland behoren de geisers, de warmwaterbronnen. Strokkur in het dal Haukadalur is een van de actiefste. Een kokendhete zuil van water en stoom schiet ongeveer om de tien minuten 35 meter de lucht in. De ophanden zijnde uitbarsting is te herkennen aan het opbollende wateroppervlak aan de bovenloop van het kaneel.

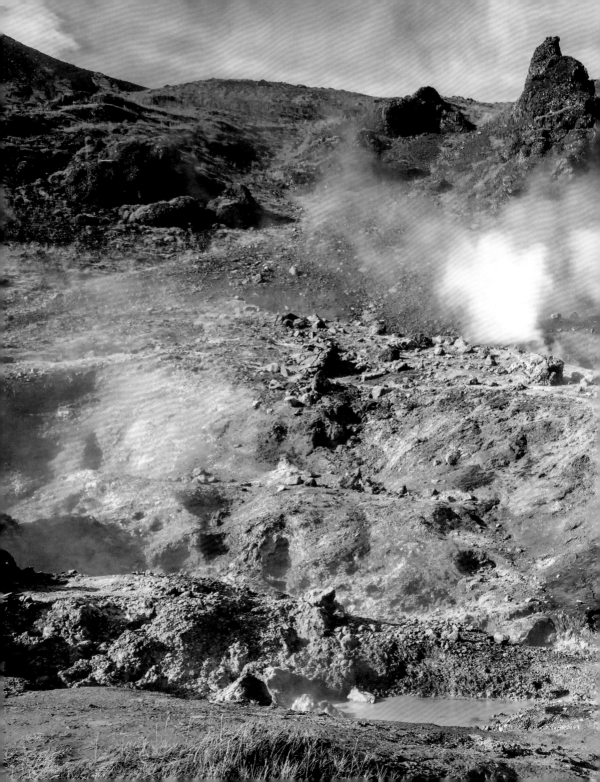

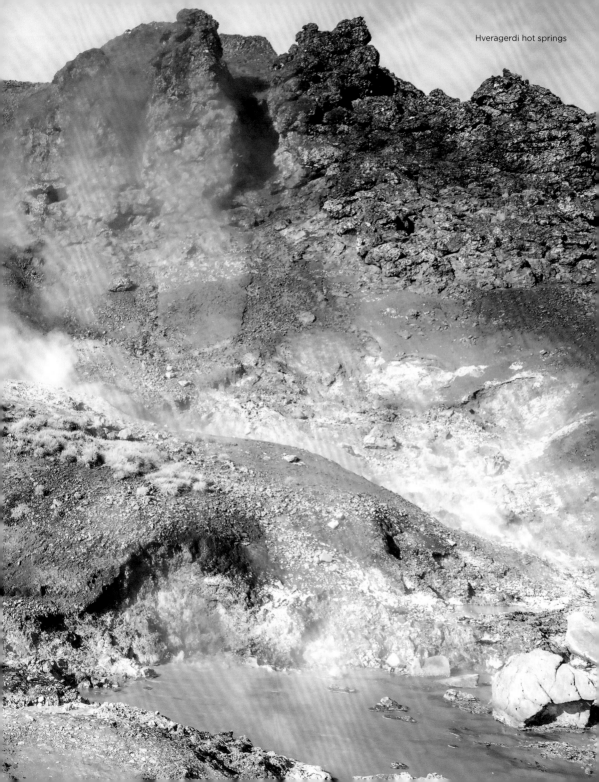

Hveragerdi hot springs

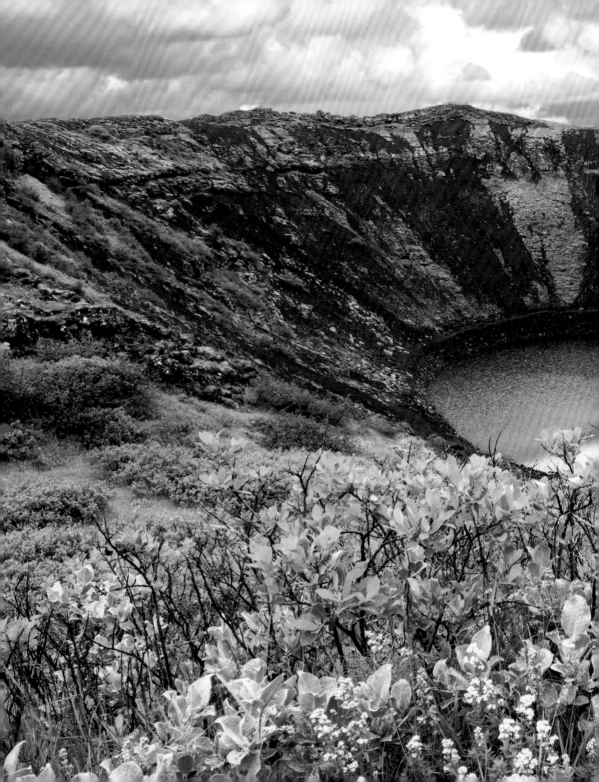

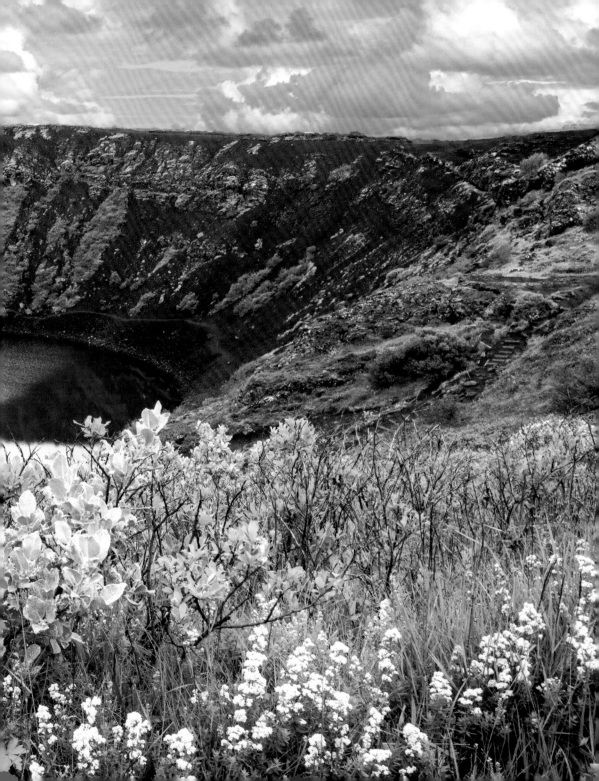

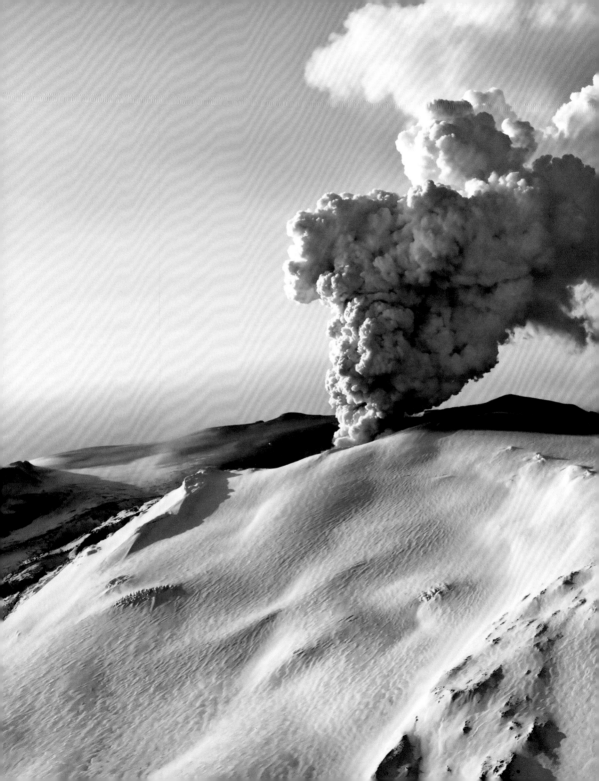

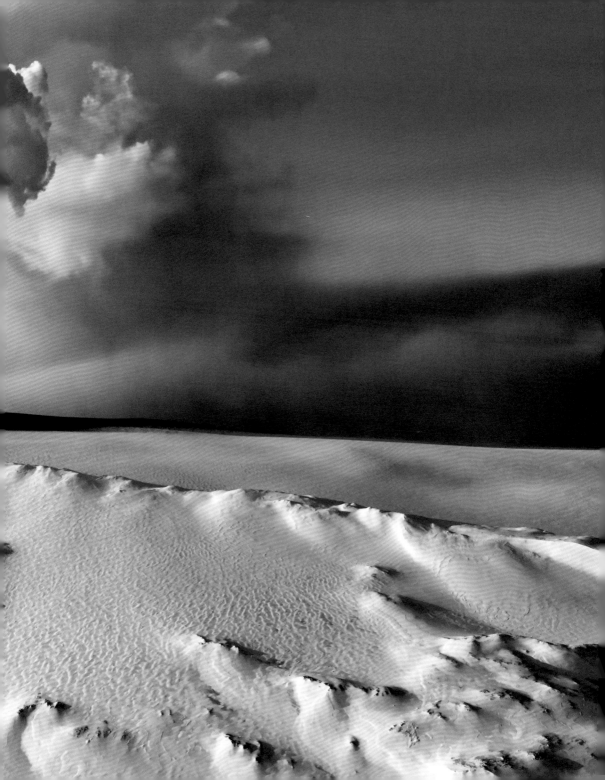

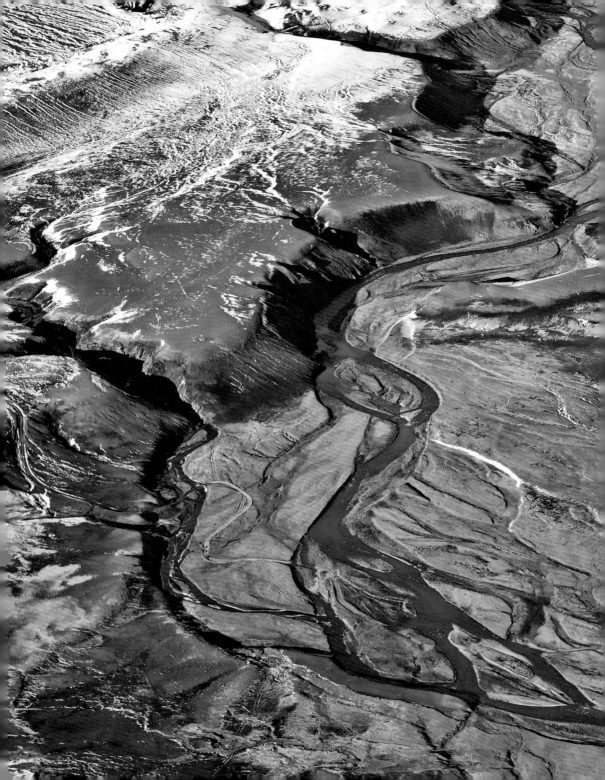

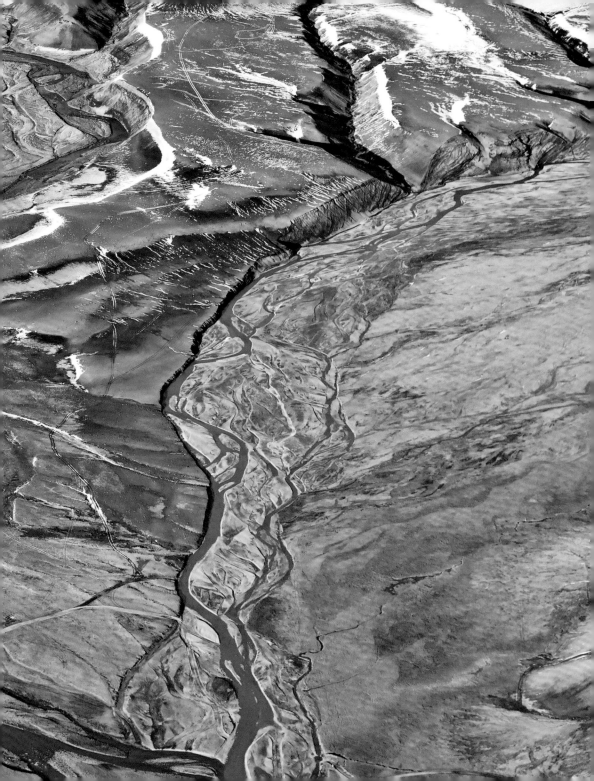

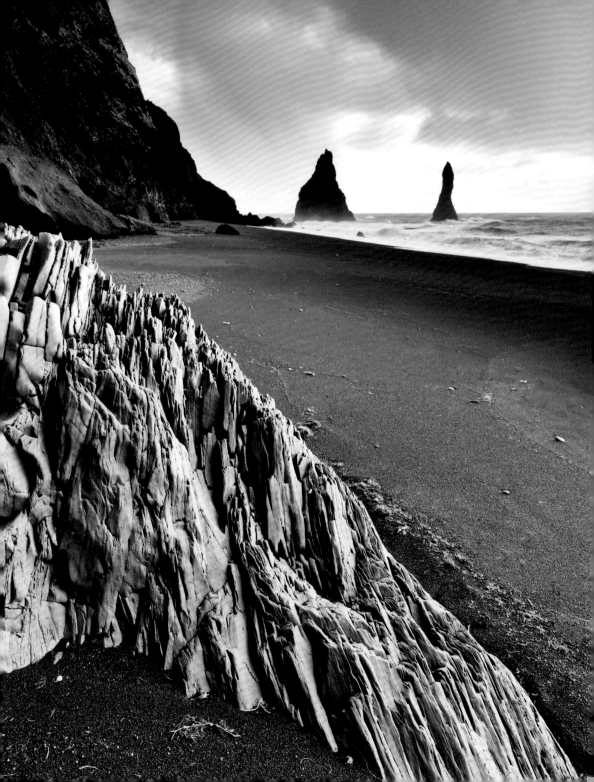

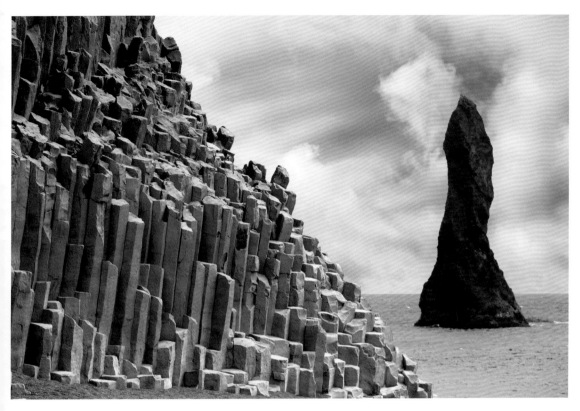

Basalt sea stacks, Reynisdrangar, Vík í Mýrdal

Reynisdrangar

Vík í Mýrdal, Iceland's southernmost town, has a kilometre-long black sand beach. Just off the beach are several eroded pillars of rock jutting dramatically out of the water. According to Icelandic folklore, the Reynisdrangar were created when two trolls tried one night to pull a three-masted ship to shore, but were surprised by the sunrise and turned to stone.

Reynisdrangar

Vík í Mýrdal, la ville la plus au sud de l'Islande, possède une plage de sable noir d'un kilomètre de long. De là, on peut apercevoir plusieurs aiguilles de roche érodées qui sortent de l'eau. Selon la croyance populaire, les Reynisdrangar sont en fait un trois-mâts et deux trolls, qui ont essayé de ramener le navire à terre mais, surpris par le lever du soleil, se sont solidifiés en pierre.

Reynisdrangar

Vík í Mýrdal, der südlichste Ort Islands, hat einen kilometerlangen schwarzen Sandstrand. Von hier sieht man mehrere erodierte Felsnadeln aus dem Wasser ragen. Der Volksglaube hält die Reynisdrangar für einen Dreimaster und zwei Trolle, die versucht haben, das Schiff an Land zu bringen, jedoch vom Sonnenaufgang überrascht wurden und zu Stein erstarrt sind.

Reynisdrangar

Vík í Mýrdal, la ciudad más meridional de Islandia, tiene una playa de arena negra de un kilómetro de longitud. Desde aquí se pueden ver varias agujas de roca erosionadas que sobresalen del agua. La creencia popular considera que los Reynisdrangar son un buque de tres mástiles y dos troles, que intentaron llevar el barco a tierra, pero fueron sorprendidos por el amanecer y se solidificaron en piedra.

Reynisdrangar

Vík í Mýrdal, la zona più meridionale dell'Islanda, ha una spiaggia di sabbia nera lunga chilometri. Da qui si possono ammirare diverse formazioni rocciose erosa che si stagliano dall'acqua. La credenza popolare vuole che i Reynisdrangar rappresentino un trialbero e due troll, che hanno cercato di portare la nave a riva, ma sorpresi dall'alba, sono diventati pietra.

Reynisdrangar

Vík í Mýrdal, de zuidelijkste plaats van IJsland, heeft een kilometerslang zwart zandstrand. Vanaf hier zijn diverse geërodeerde rotsnaalden te zien die uit het water steken. Volgens het volksgeloof zijn de Reynisdrangar een driemaster met twee trollen die het schip aan land probeerden te brengen, maar verrast werden door de zonsopgang en versteenden.

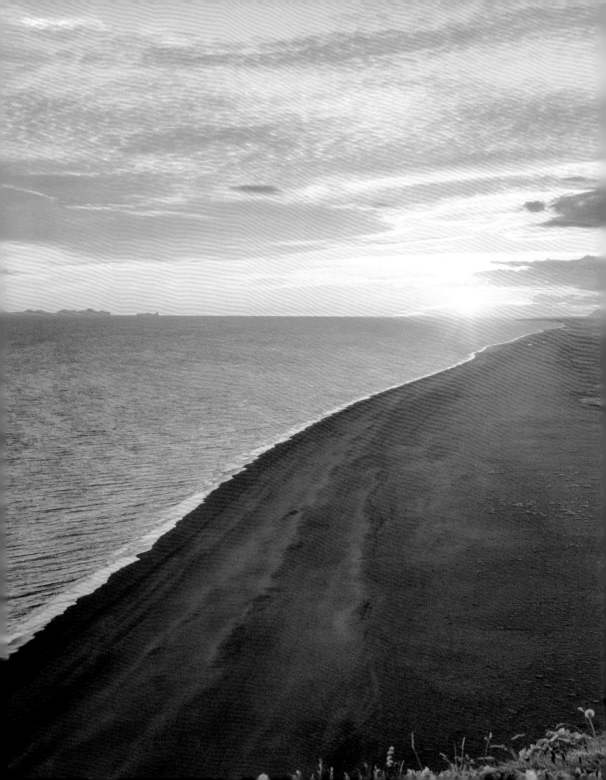

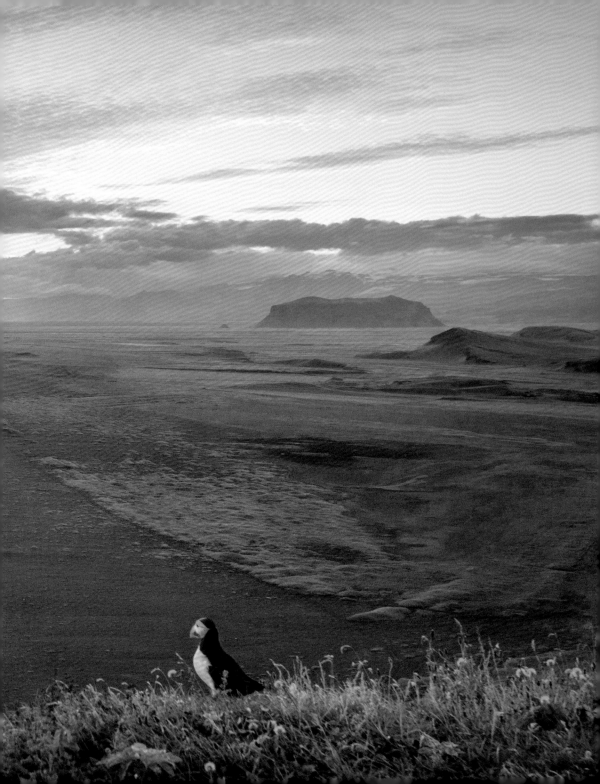

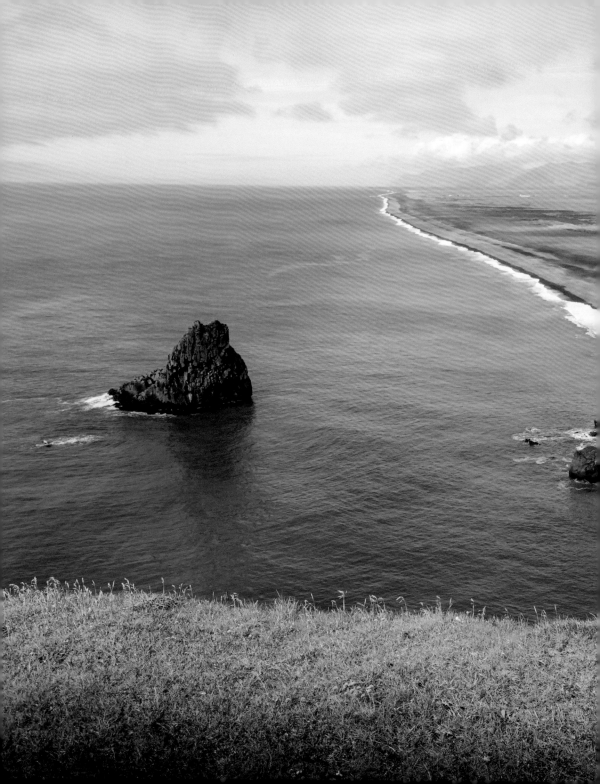

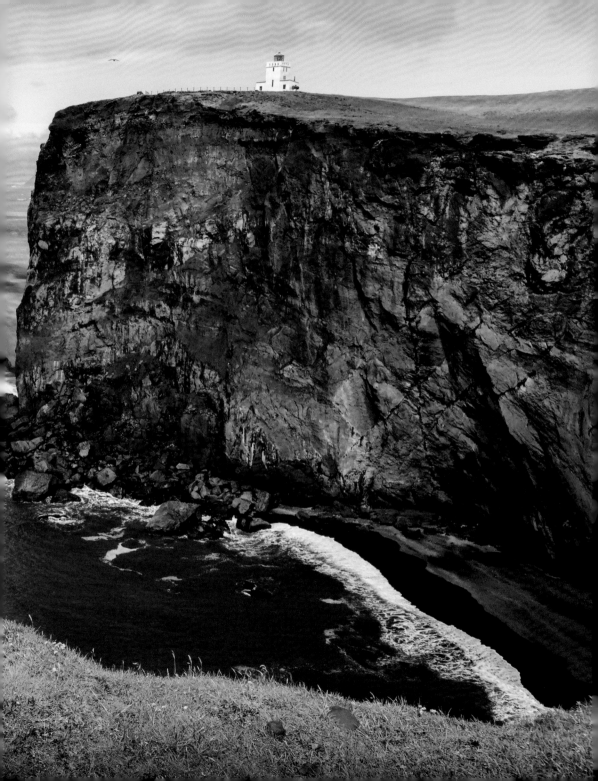

Dyrhólaey

The over 100-metre-high cliffs at Dyrhólaey break off vertically; on the highest point sits a lighthouse. Puffins build their breeding burrows in the cliff faces. To the west, you can see a beautiful, empty, kilometre-long black sand beach; to the east is the Reynisdrangar rock formation near Vík í Mýrdal.

Dyrhólaey

Les falaises de plus de 100 m du cap Dyrhólaey sont particulièrement abruptes; sur le point le plus haut, un phare a été construit. Les macareux se reproduisent dans des grottes creusées dans leurs parois. À l'ouest, on peut voir une sublime plage de sable noir, déserte et longue d'un kilomètre; à l'est, la formation rocheuse de Reynisdrangar près de Vík í Mýrdal.

Dyrhólaey

Senkrecht brechen die über 100 m hohen Klippen am Kap Dyrhólaey ab, auf dem höchsten Punkt thront ein Leuchtturm. An der Abbruchkante haben Papageitaucher ihre Bruthöhlen. In Richtung Westen blickt man auf einen kilometerlangen schwarzen, menschenleeren Traumstand, im Osten ist die Felsformation der Reynisdrangar bei Vík í Mýrdal zu sehen.

Dyrhólaey

Los acantilados de más de 100 m de altura en el cabo Dyrhólaey se sesgan en vertical. Un faro encumbra el punto más alto. En el acantilado, los frailecillos tienen sus cuevas de cría. Al oeste se puede ver un rodal de un kilómetro de largo, negro y desértico, al este se puede ver la formación rocosa de Reynisdrangar, cerca de Vík í Mýrdal.

Dirhólaey

Le scogliere di Dyrhólaey si innalzano verticalmente di oltre 100 m, sul punto più alto troneggia un faro. Ai margini, le pulcinelle hanno le loro grotte per la riproduzione. A ovest si può vedere una spiaggia da sogno, nera, deserta e lunga un chilometro, a est si può vedere la formazione rocciosa di Reynisdrangar vicino a Vík í Mýrdal.

Dyrhólaey

De meer dan 100 meter hoge klippen op de kaap Dyrhólaey breken verticaal af en op het hoogste punt staat een vuurtoren. Langs de rand hebben papegaaiduikers hun broedgrotten. Naar het westen toe zie je een kilometerslang zwart, verlaten droomstrand, in het oosten zie je de Reynisdrangar-formatie in de buurt van Vík í Mýrdal.

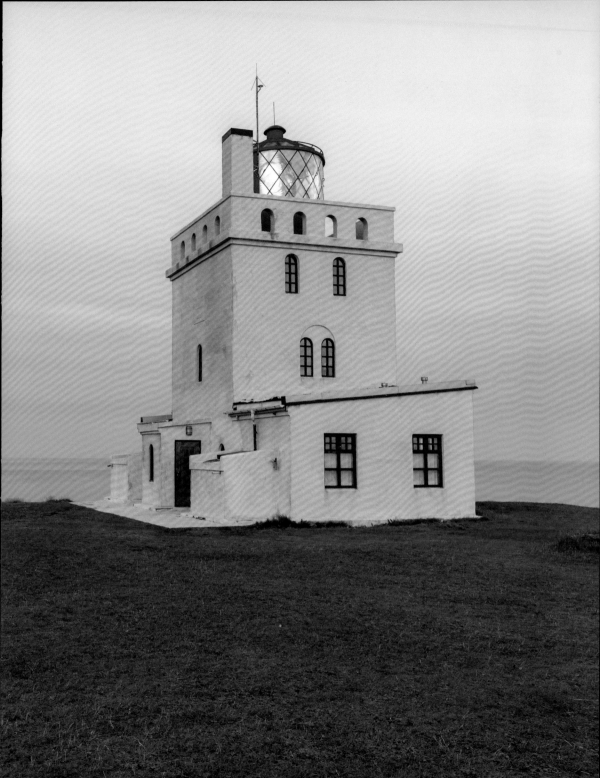

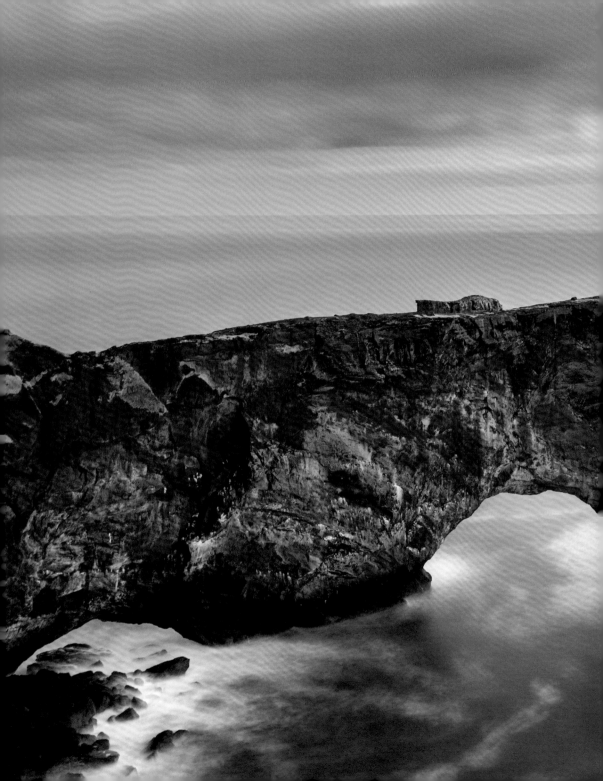

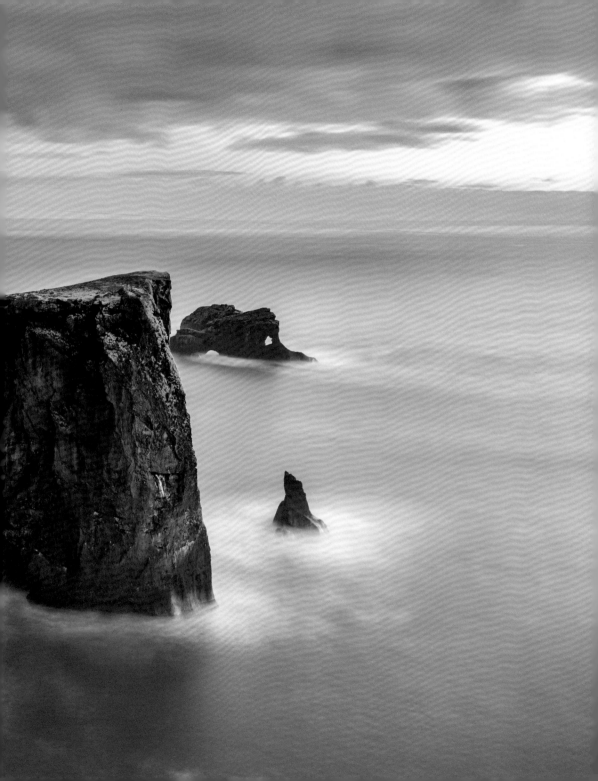

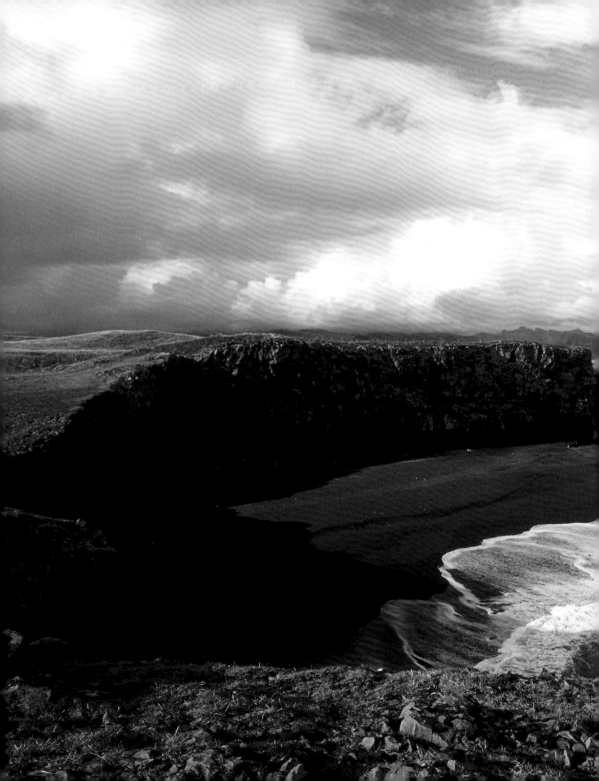

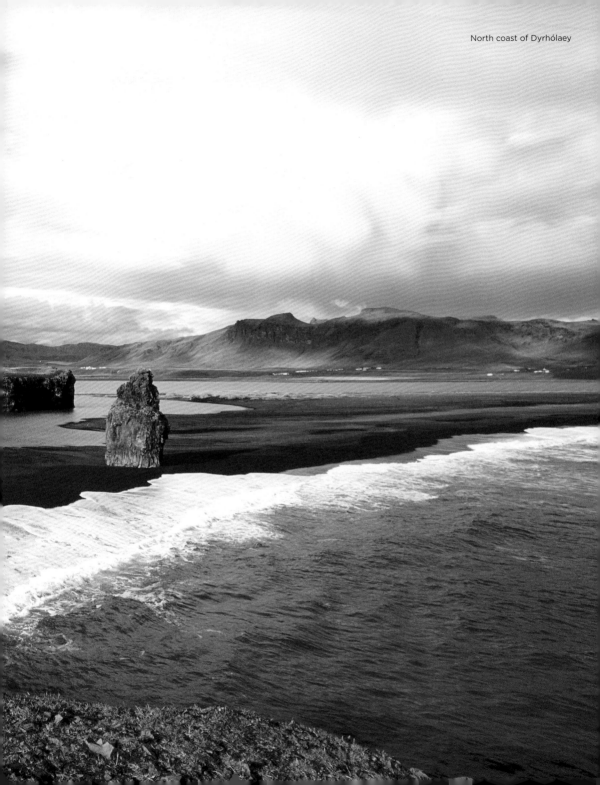

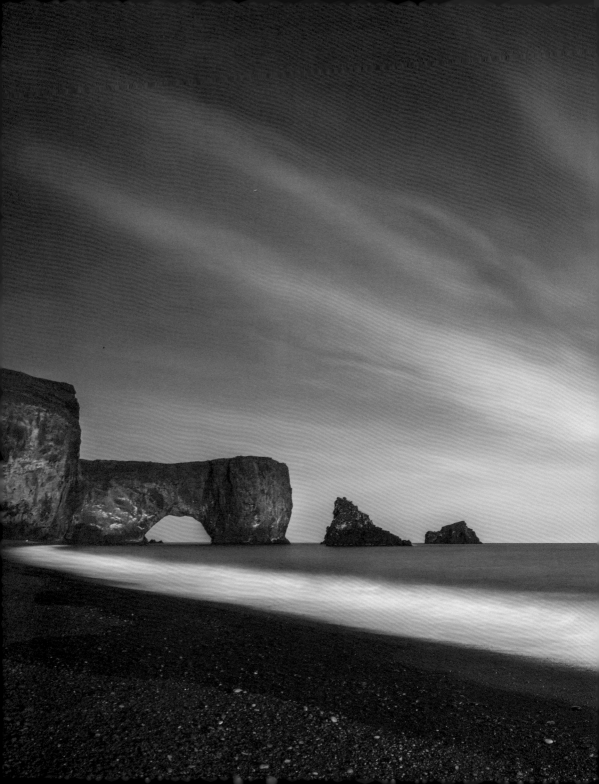

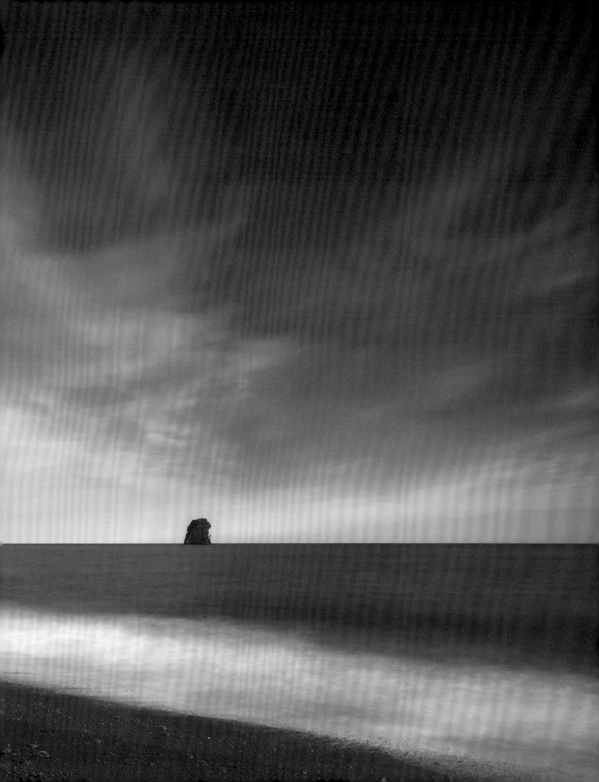

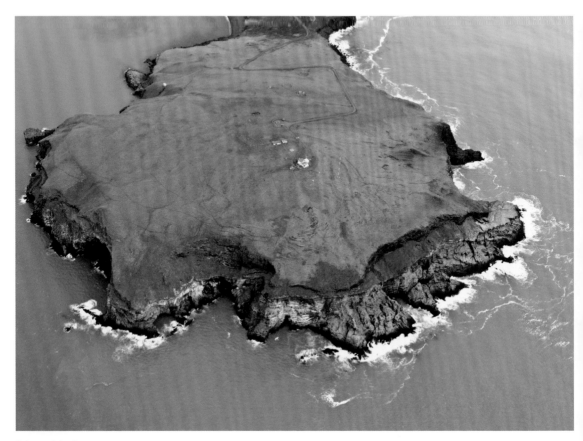

Heimaey island

Heimaey

A few kilometres from the southern
coast of Iceland lies the Vestmannaeyjar
archipelago. Only its largest island,
Heimaey, is inhabited; the other islands
and rocks belong to the seabirds. On
23 January 1973, a volcanic eruption buried
large parts of Heimaey under lava and ash.
The population was evacuated and could
only return to the island some months later.

Heimaey

À quelques kilomètres de la côte sud de
l'Islande se trouvent les îles Vestmann.
Seule la plus grande, Heimaey, est habitée,
les autres îles et rochers ne sont peuplés
que d'oiseaux marins. Le 23 janvier 1973,
une éruption volcanique a enseveli de
grandes parties de Heimaey sous la
lave et les cendres. La population a été
évacuée et n'a pu rejoindre l'île qu'après
plusieurs mois.

Heimaey

Wenige Kilometer vor der Südküste
Islands liegen die Westmännerinseln. Nur
die größte Insel Heimaey ist bewohnt,
die anderen Eilande und Felsen werden
nur von Seevögeln bevölkert. Am 23.
Januar 1973 hat ein Vulkanausbruch
große Teile von Heimaey unter Lava und
Asche begraben. Die Bevölkerung wurde
evakuiert und konnte erst nach Monaten
wieder zurück auf die Insel.

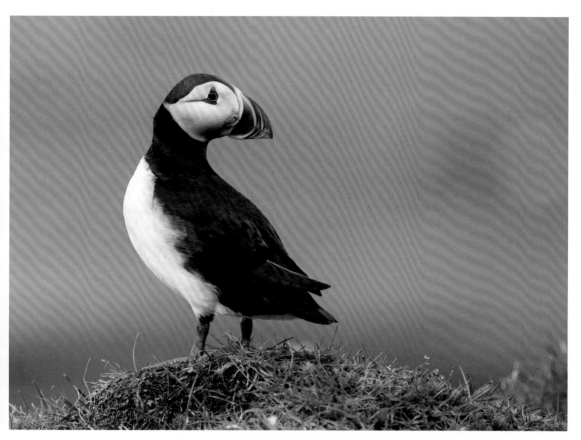

Puffin, Heimaey island

Heimaey

A pocos kilómetros de la costa sur de Islandia se encuentran las Islas Vestman. Solo la isla más grande, Heimaey, está habitada, las otras islas y rocas solo están pobladas solopor aves marinas. El 23 de enero de 1973, una erupción volcánica enterró gran parte de Heimaey bajo lava y ceniza. La población fue evacuada y solo pudo regresar a la isla después de meses.

Heimaey

A pochi chilometri dalla costa meridionale dell'Islanda si trova l'arcipelago delle Isole Vestmann. Solo l'isola più grande Heimaey è abitata, le altre isole e le rocce sono popolate solo da uccelli marini. Il 23 gennaio 1973, un'eruzione vulcanica seppelli gran parte di Heimaey sotto la lava e la cenere. La popolazione fu evacuata e poté tornare sull'isola solo dopo mesi.

Heimaey

Op enkele kilometers voor de zuidkust van IJsland bevinden zich de Westmaneilanden. Alleen het grootste eiland Heimaey wordt bewoond, de andere eilanden en rotsen worden slechts bevolkt door zeevogels. Op 23 januari 1973 raakten grote delen van Heimaey door een vulkaanuitbarsting bedolven onder het lava en de as. De bevolking werd geëvacueerd en kon pas na maanden terug naar het eiland.

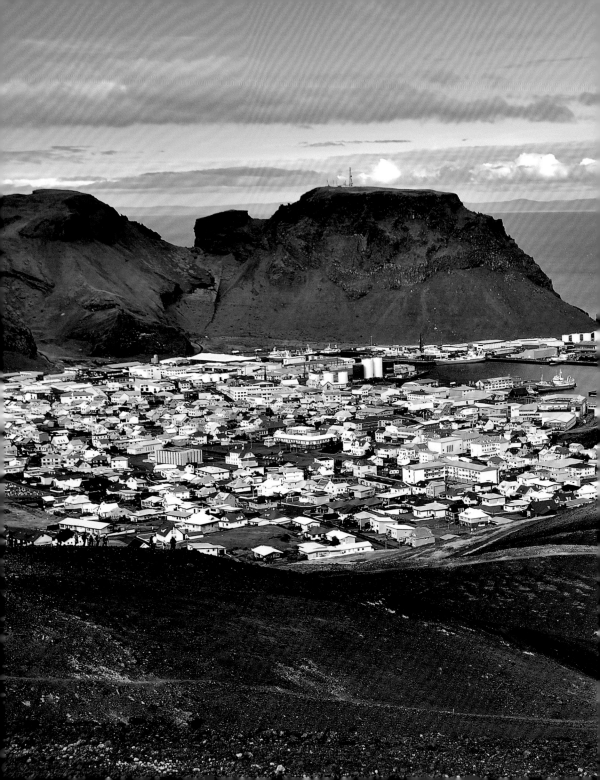

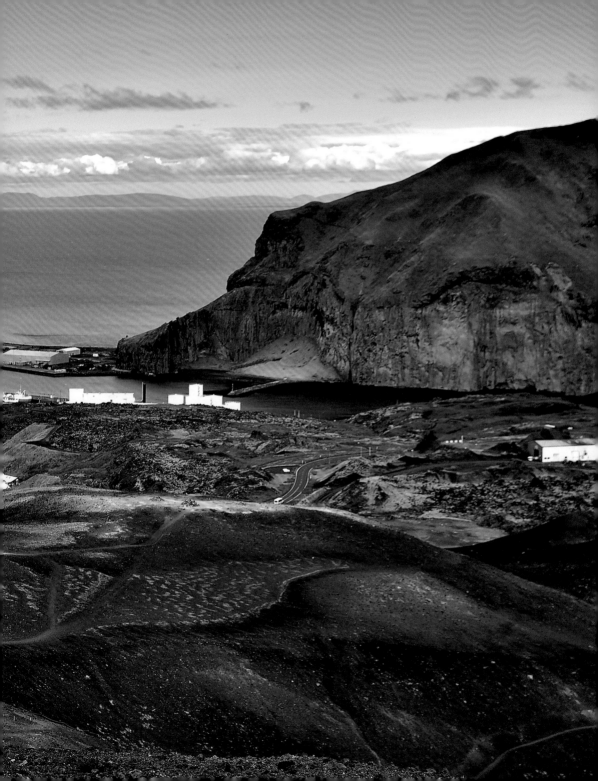

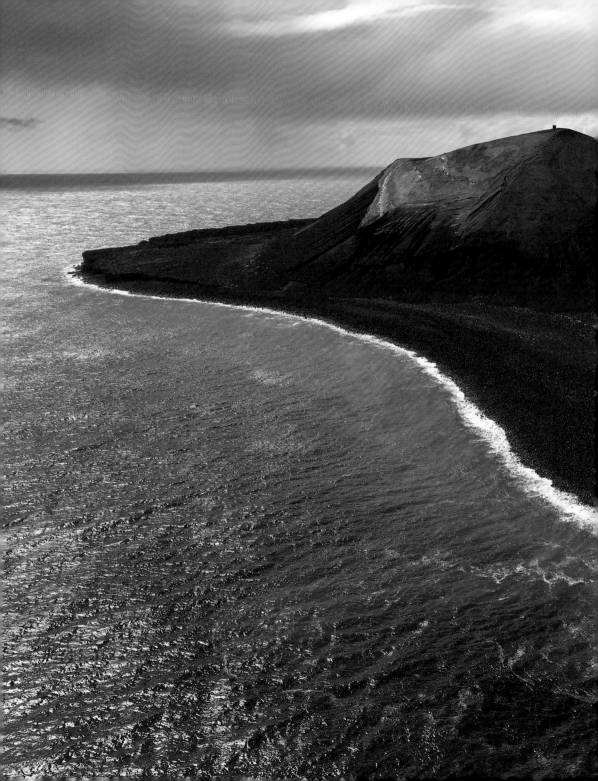

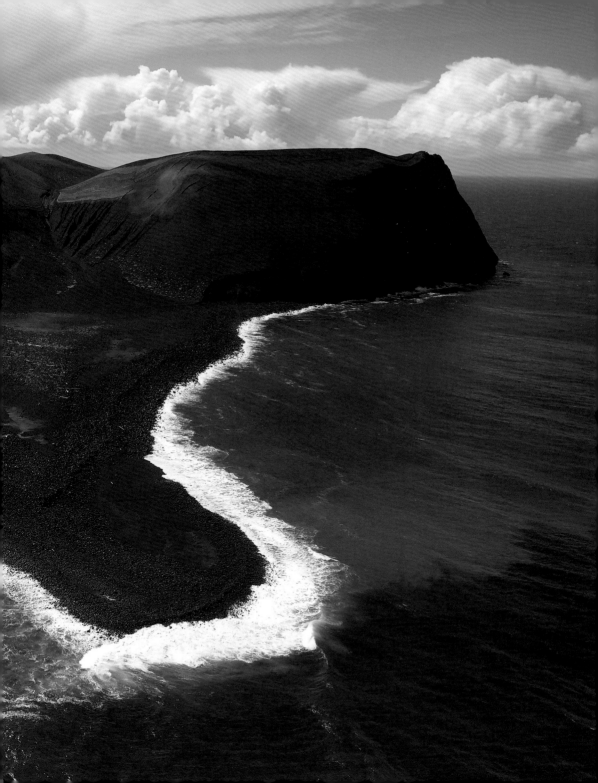

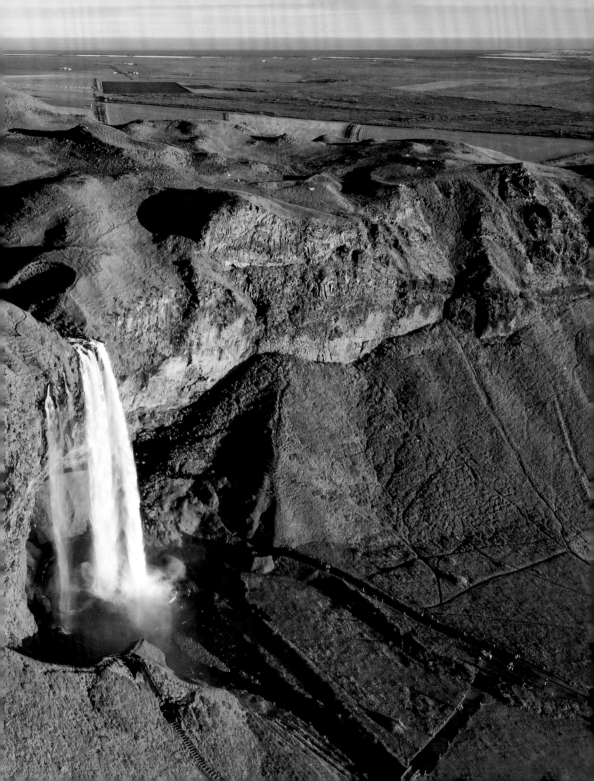

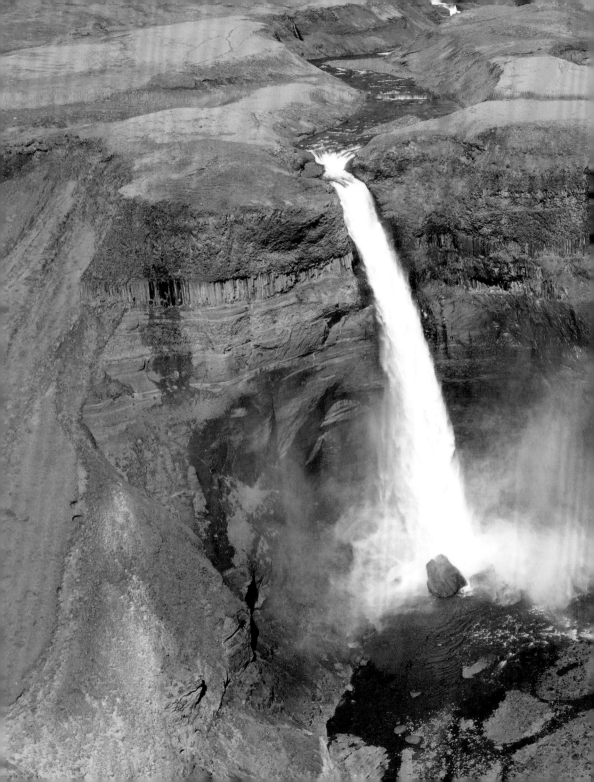

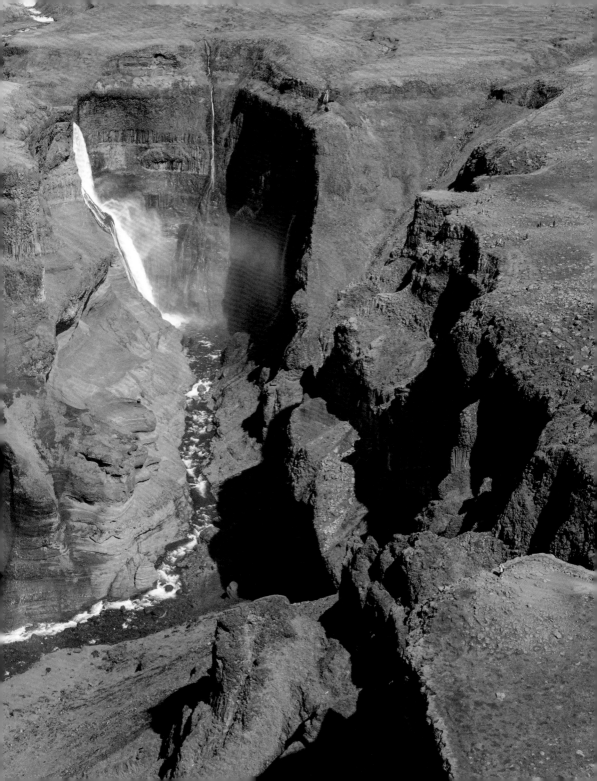

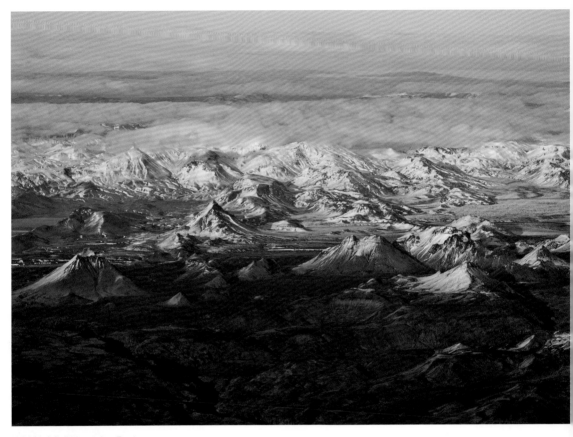

Kaldaklofsfjoll Mountains, Emstrur area,
Torfajökull glacier

Urriðafoss

Although the Urriðafoss is located just
south of the Ring Road near Selfoss, it is
rarely visited. Its drop height is only a few
metres, but the wide waters of Þjórsá—
Iceland's longest river—rush over its edge.
Especially in winter, when ice sheets a
metre thick form, the view is spectacular.

Urriðafoss

L'Urriðafoss est situé juste au sud de la
Route 1, près de Selfoss, et est encore
rarement visité. Sa hauteur de chute n'est
que de quelques mètres, mais les masses
d'eau de Þjórsá – la plus longue rivière
d'Islande – s'engouffrent largement sur le
littoral. En hiver, lorsque la glace se forme,
la vue est spectaculaire.

Urriðafoss

Der Urriðafoss liegt unmittelbar südlich
der Ringstraße in der Nähe von Selfoss
und wird trotzdem nur selten besucht.
Seine Fallhöhe beträgt nur wenige Meter,
doch die Wassermassen der Þjórsá – des
längsten Flusses Islands – rauschen breit
gefächert über die Kante. Besonders im
Winter, wenn sich meterdickes Eis bildet,
ist der Anblick spektakulär.

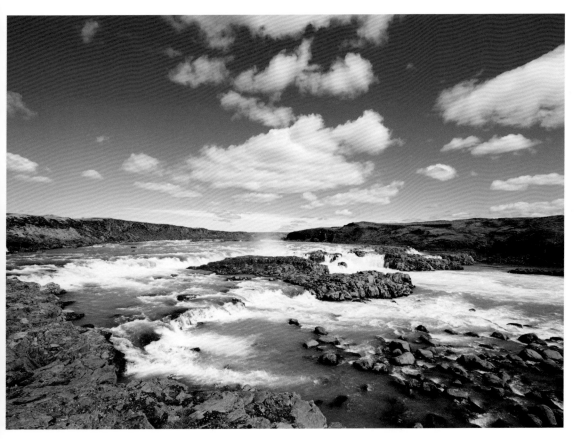

Urriðafoss, Þjórsá river

Urriðafoss

La cascada Urriðafoss está situada justo al sur de la carretera de circunvalación cerca de Selfoss, no obstante, sigue recibiendo alguna visita esporádica. Su caída es de solo unos pocos metros, pero las masas de agua de Þjórsá –el río más largo de Islandia– se precipitan por encima de la orilla. La vista es espectacular especialmente en invierno, cuando se forma hielo de un metro de espesor.

Urriðafoss

L'Urriðafoss si trova a sud della circonvallazione, vicino a Selfoss, ed è ancora poco visitato. Il dislivello è di pochi metri, ma le masse d'acqua di Þjórsá – il fiume più lungo d'Islanda – si riversano abbondantemente oltre il fianco. La vista è spettacolare soprattutto in inverno, quando si forma ghiaccio spesso un metro.

Urriðafoss

De Urriðafoss ligt net ten zuiden van de ringweg bij Selfoss en wordt toch zelden bezocht. De valhoogte is slechts een paar meter, maar de watermassa's van de Þjórsá – de langste rivier van IJsland – razen breed uitgewaaierd over de rand. Vooral in de winter, wanneer een metersdikke ijslaag wordt gevormd, is de aanblik spectaculair.

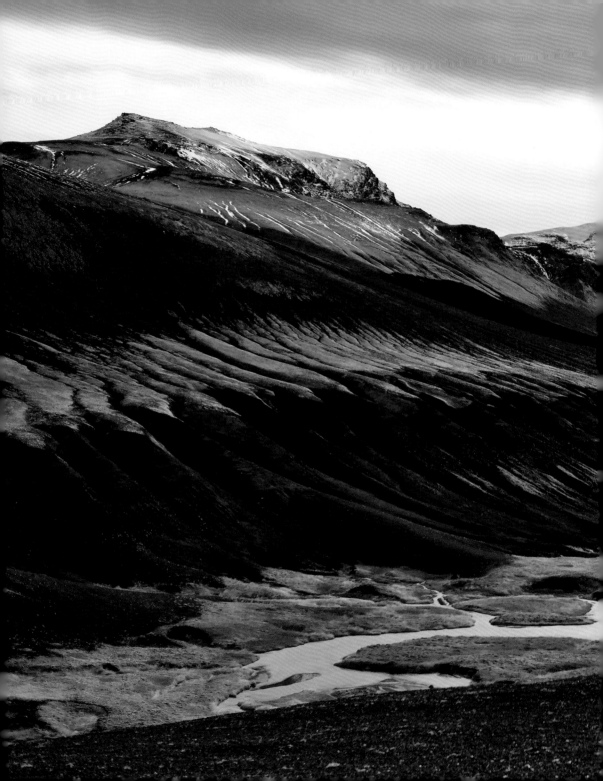

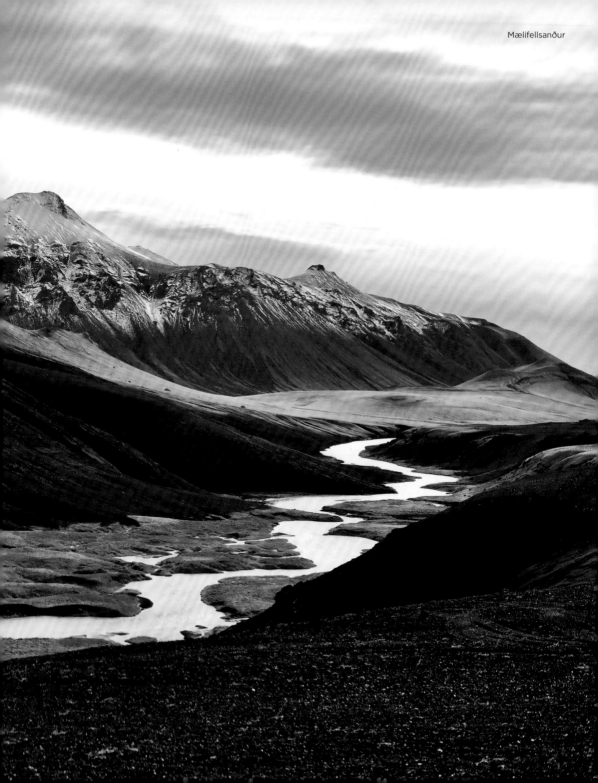

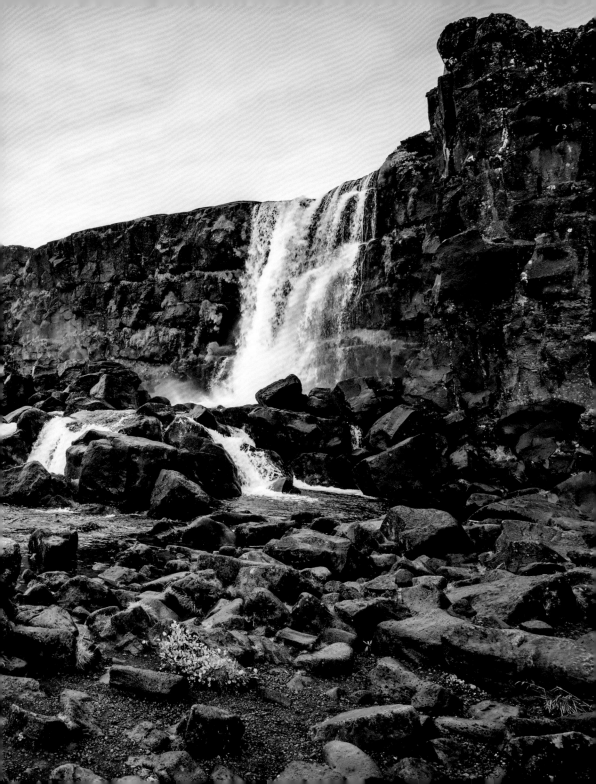

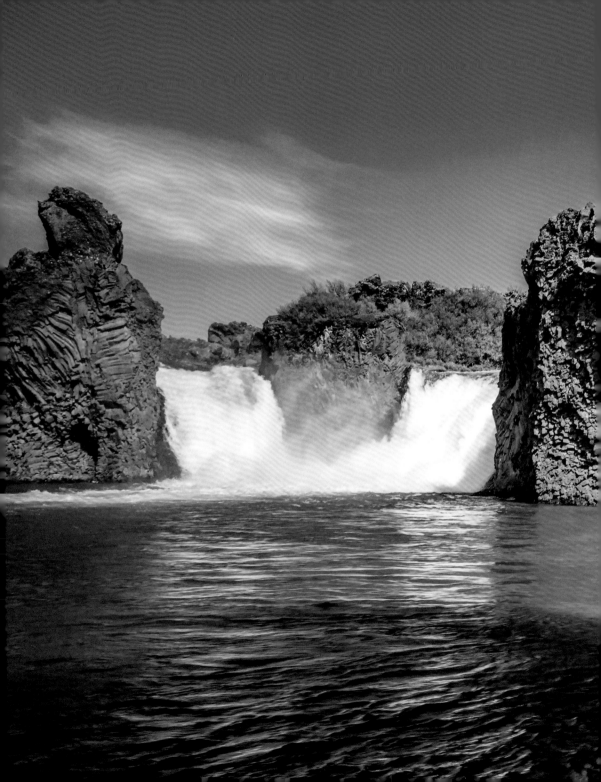

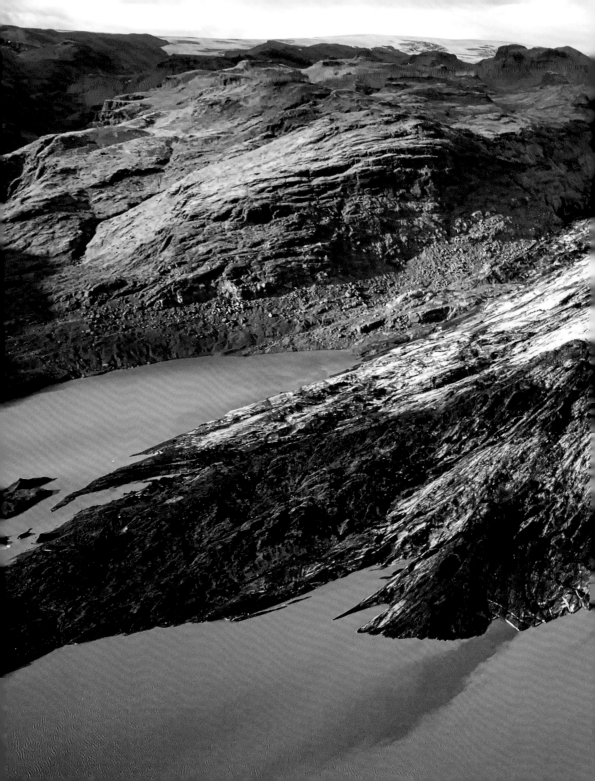

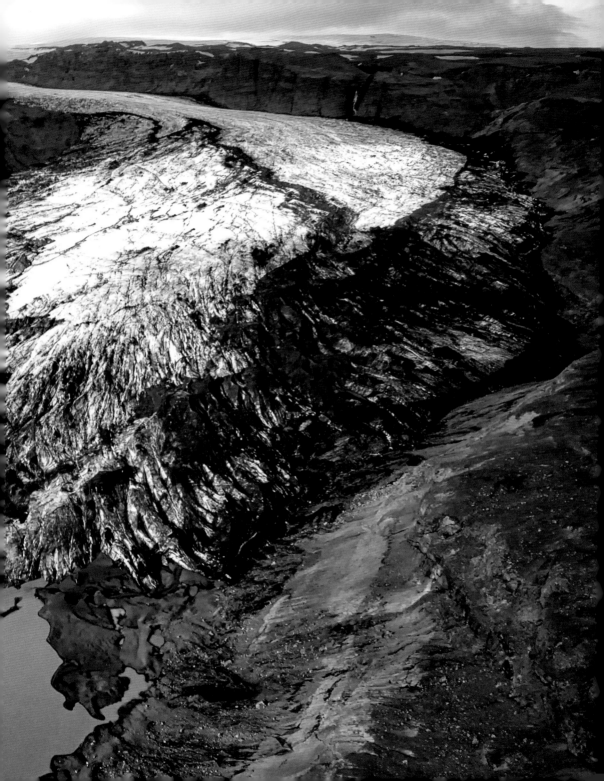

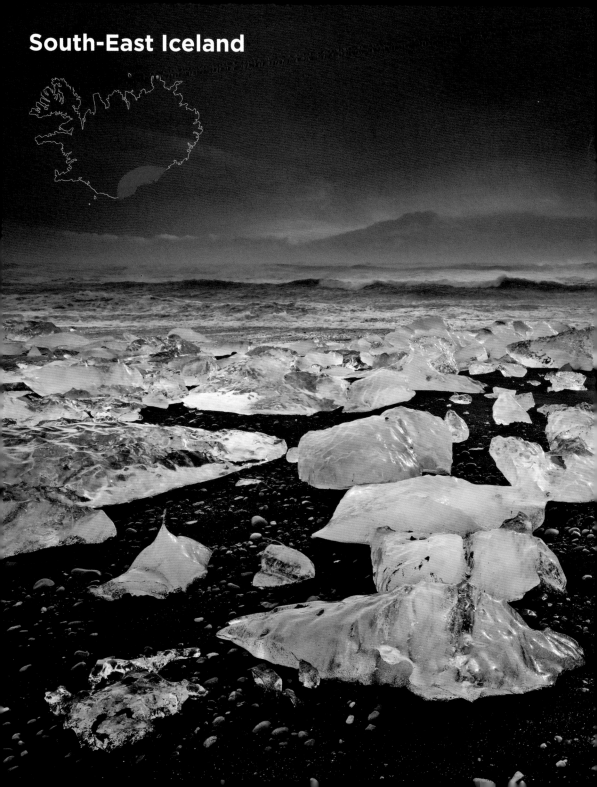

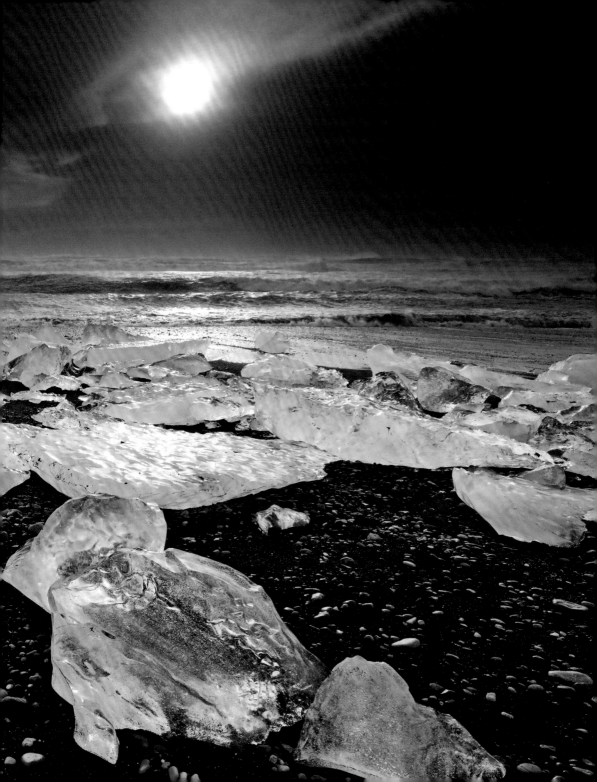

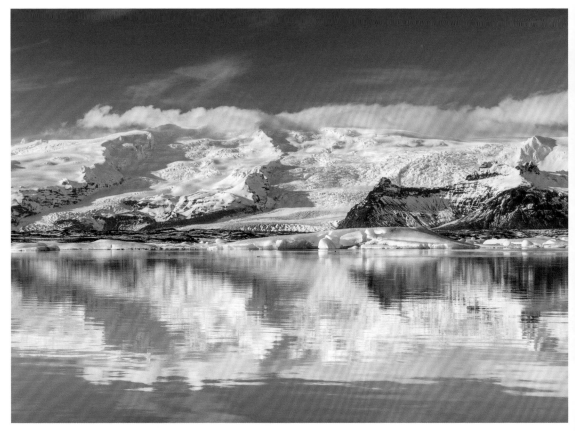

Jökulsárlón glacial lake, Vatnajökull glacier

South-East Iceland

The south-east of Iceland is dominated by Vatnajökull (the Water Glacier), the largest ice cap in the country. Over 3000 square kilometres of ice reach almost to the coast, leaving only a narrow strip of fertile land. Wide alluvial plains are fed by meandering glacial rivers that constantly change their course. The largest of these inhospitable plains is Skeiðarársandur, at about 1000 square kilometres. Until the construction of the Ring Road, crossing these outwash plains was a laborious and dangerous undertaking.

Sud-est de l'Islande

Le sud-est de l'Islande est largement occupé par le glacier Vatnajökull. Sur de nombreux kilomètres, ses masses de glace atteignent presque la côte, et ne laissent la place qu'à une étroite bande de terre fertile. De larges plaines alluviales sont alimentées par des rivières glaciaires sinueuses qui changent constamment de cours. La plus grande de ces plaines inhospitalières est le Skeiðarársandur, dont la superficie est d'environ 1000 km². Jusqu'à la construction de la Route 1, le franchissement de ces zones était une entreprise laborieuse et dangereuse.

Südostisland

Der Südosten Islands liegt unter dem Einfluss des Vatnajökull. Über viele Kilometer reichen seine Eismassen bis fast an die Küste heran und lassen nur einen schmalen Streifen fruchtbaren Landes. Weite Schwemmlandebenen werden von mäandernden Gletscherflüssen gespeist, die fortwährend ihren Lauf verändern. Die größte dieser unwirtlichen Ebenen ist mit rund 1000 km² der Skeiðarársandur. Bis zum Bau der Ringstraße war das Durchqueren dieser Sander ein mühseliges und gefährliches Unterfangen.

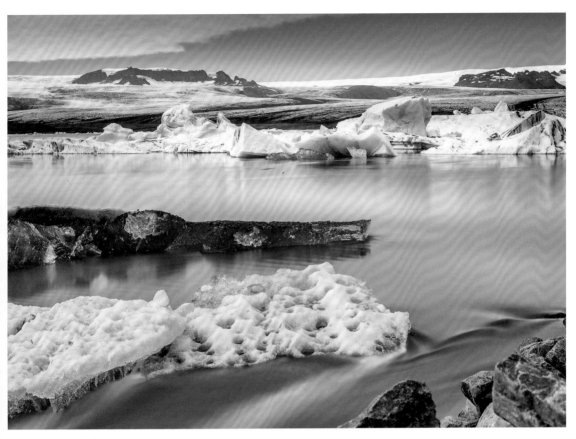

Jökulsárlón glacial lake

Sureste de Islandia

El sureste de Islandia está bajo la influencia del glaciar Vatnajökull. A lo largo de muchos kilómetros, sus masas de hielo llegan casi hasta la costa y dejan solo una estrecha franja de tierra fértil. Ríos glaciares serpenteantes alimentan amplias llanuras aluviales que cambian constantemente su curso. La mayor de estas inhóspitas llanuras es la de Skeiðarársandur con unos 1000 km². Hasta la construcción de la carretera de circunvalación, cruzar estes sandar era una tarea laboriosa y peligrosa.

Sud-Est dell'Islanda

Il sud-est dell'Islanda è sotto l'influsso del Vatnajökull. Per molti chilometri le sue masse di ghiaccio raggiungono quasi la costa e lasciano solo una stretta striscia di terra fertile. Ampie pianure alluvionali sono alimentate da fiumi glaciali serpeggianti che cambiano continuamente il loro corso. La più grande di queste pianure inospitali è Skeiðarársandur con circa 1000 km². Fino alla costruzione della circonvallazione, l'attraversamento di queste zone era un'impresa laboriosa e pericolosa.

Zuidoost-IJsland

Het zuidoosten van IJsland wordt beïnvloed door de Vatnajökull. Zijn ijsmassa's reiken over vele kilometers tot bijna aan de kust en laten slechts een smalle strook vruchtbaar land over. Brede alluviale vlakten worden gevoed door kronkelende gletsjerrivieren die hun loop voortdurend veranderen. De grootste van deze onherbergzame vlakten is de Skeiðarársandur van zo'n 1000 km². Tot aan de aanleg van de ringweg was het oversteken van deze sandrs een moeizame en gevaarlijke onderneming.

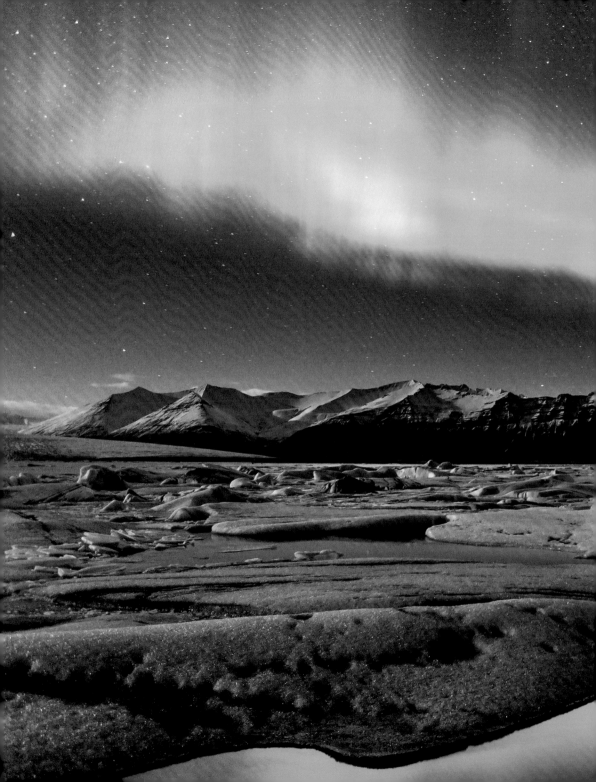

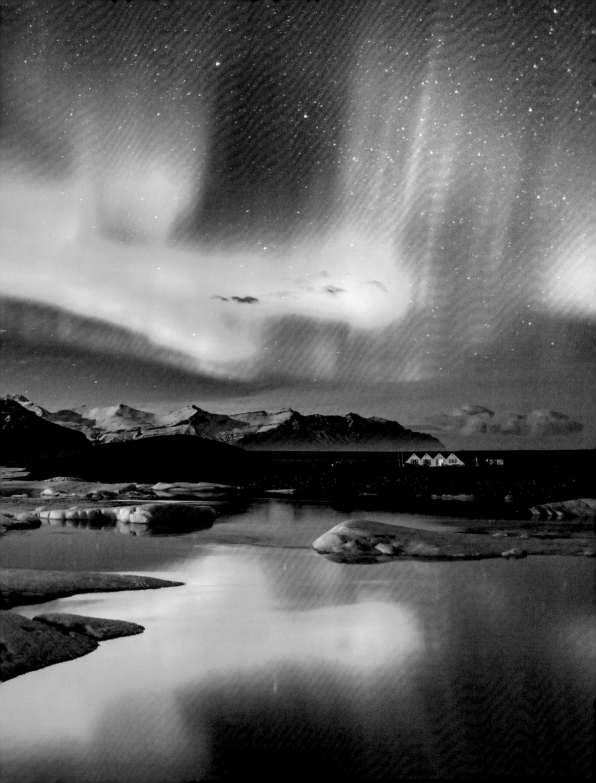

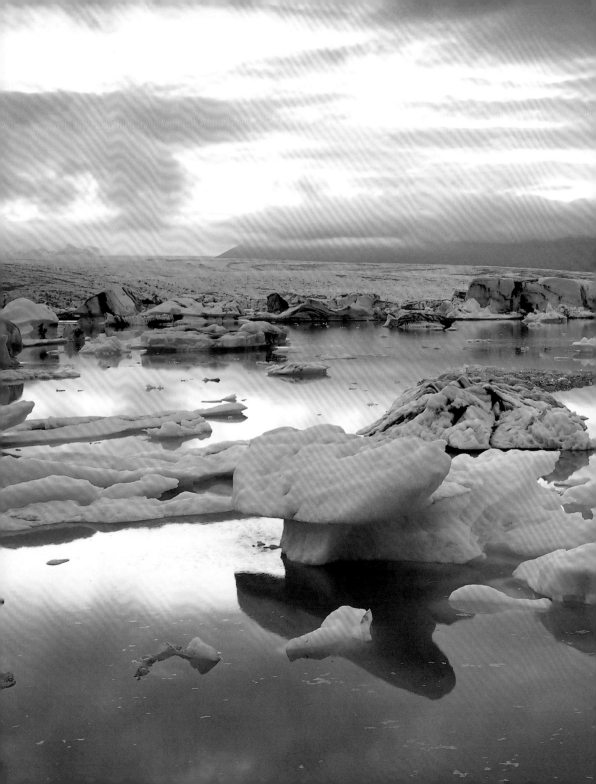

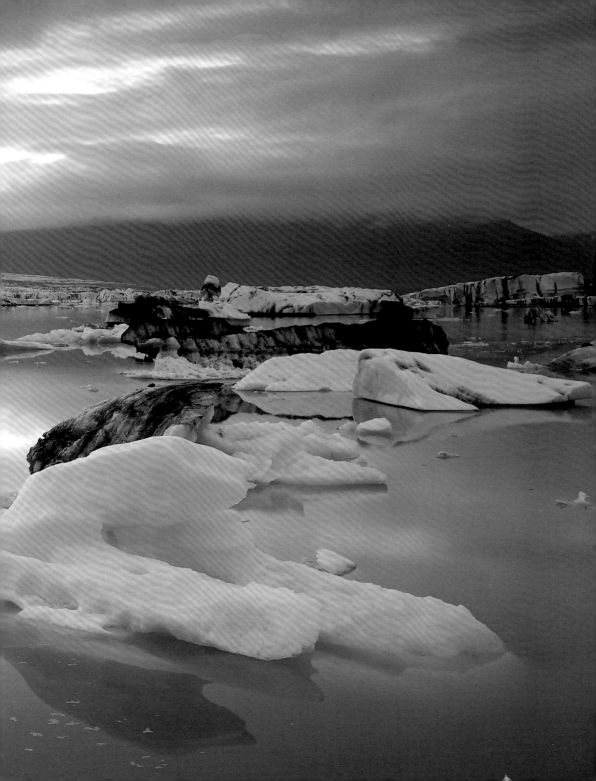

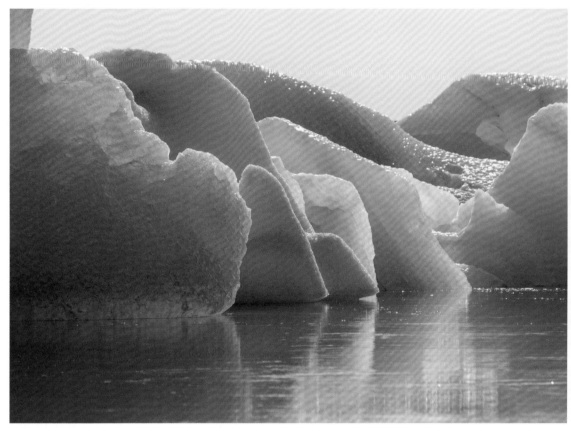

Jökulsárlón glacial lake

Jökulsárlón

Jökulsárlón is a star among Iceland's glacial lagoons. Icebergs drift on the surface of the 18-square-kilometre, 250-metre-deep lagoon, lending it an enchanting, almost unreal atmosphere. Jökulsárlón has played a leading role in several Hollywood productions, including two James Bond films and *Batman Begins*.

Jökulsárlón

Jökulsárlón est un joyau parmi les lacs glaciaires d'Islande. D'une superficie de 18 km² et d'une profondeur de 250 m, parsemé d'icebergs, il enchante avec son atmosphère presque irréelle. Cela explique pourquoi il a joué un rôle de premier plan dans plusieurs productions cinématographiques, dont deux films de la saga James Bond et le blockbuster *Batman Begins*.

Jökulsárlón

Ein Star unter den Gletscherseen Islands ist der Jökulsárlón. So verzaubert der 18 km² große und 250 m tiefe See, auf dem Eisberge treiben, mit einer geradezu unwirklichen Atmosphäre. Und gerade deshalb spielte er auch in mehreren Filmproduktionen eine Hauptrolle, unter anderem in zwei James-Bond-Filmen sowie in *Batman Begins*.

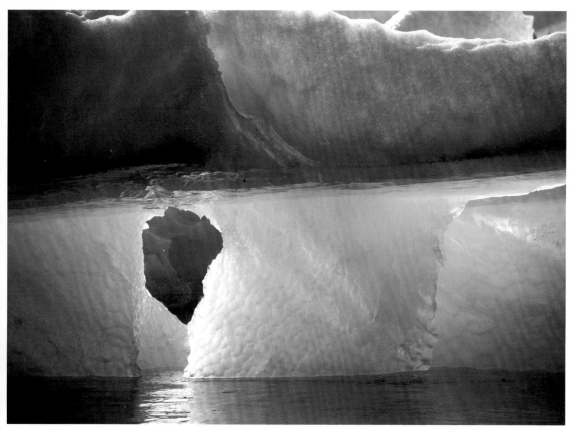

Jökulsárlón glacial lake

Jökulsárlón

El glaciar Jökulsárlón es la estrella entre los lagos glaciares de Islandia. Cuenta con 18 km² de superficie y 250 m de profundidad, a la deriva sobre icebergs, su atmósfera es casi irreal. Por eso ha sido protagonista en varias producciones cinematográficas, incluyendo dos películas de James Bond y *Batman Begins*.

Jökulsárlón

Jökulsárlón è la star dei laghi glaciali islandesi. Il lago, 18 km² di superficie e 250 m di profondità, alla deriva sugli iceberg, incanta con un'atmosfera quasi irreale. Ecco perché ha avuto un ruolo di primo piano in diverse produzioni cinematografiche, tra cui due film di James Bond e *Batman Begins*.

Jökulsárlón

Jökulsárlón is onder de gletsjermeren van IJsland een ster. Het 18 km² grote en 250 meter diepe meer waarop ijsbergen drijven, betovert met een bijna onwerkelijke sfeer. Daarom speelde hij in diverse filmproducties een hoofdrol, waaronder twee Bondfilms en *Batman Begins*.

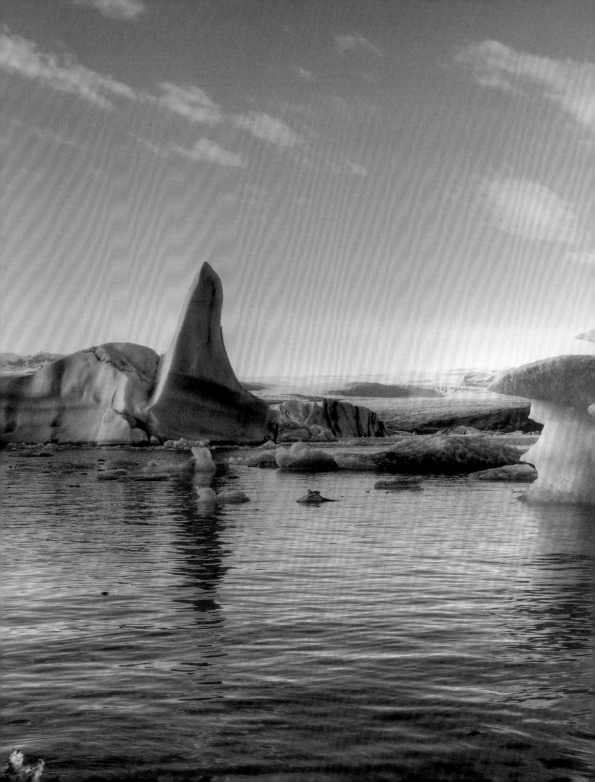

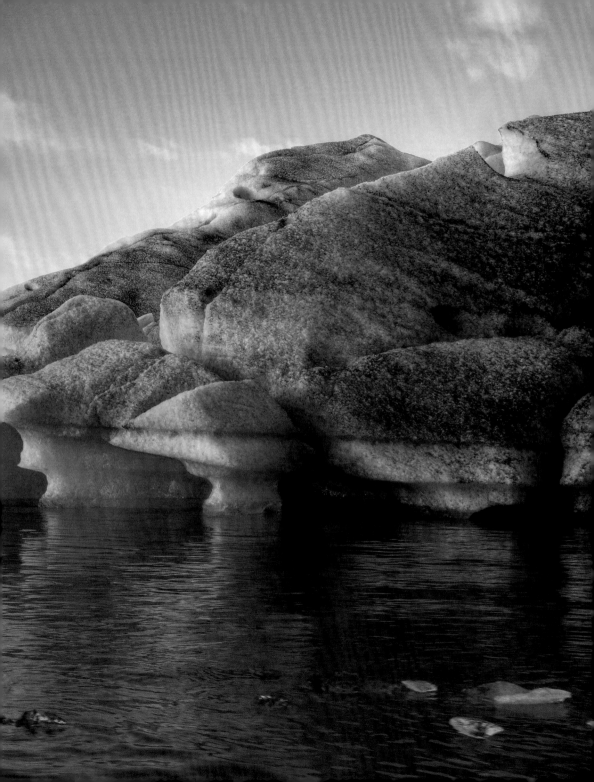

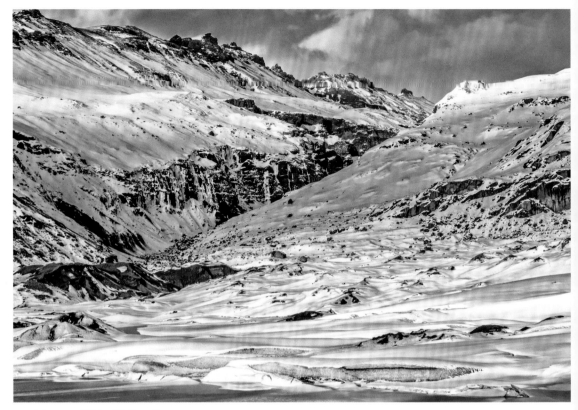

Mountains near Sólheimajökull glacier

Sólheimarjökull

The 10-kilometre-long Sólheimarjökull glacier is part of the Mýrdalsjökull glacier, the fourth-largest in Iceland. Below it lies Katla, one of the island's most active volcanoes. In the summer, several hikes a day are offered on Sólheimarjökull, during which you can see crevasses, ice sculptures, and meltwater basins.

Sólheimarjökull

Die rund 10 km lange Gletscherzunge Sólheimarjökull gehört zum Mýrdalsjökull, dem viertgrößten Gletscher Islands. Unter ihm schlummert die Katla, einer der aktivsten Vulkane der Insel. Auf dem Sólheimarjökull werden im Sommer mehrmals täglich Wanderungen angeboten, während derer man Spalten, Eisskulpturen und Schmelzwasserkessel zu sehen bekommt.

Sólheimarjökull

Il Sólheimarjökull, la lingua del ghiacciaio lunga 10 km, appartiene al Mýrdalsjökull, il quarto ghiacciaio più grande d'Islanda. Sotto di esso si trova il Katla, uno dei vulcani più attivi dell'isola. Sólheimarjökull offre in estate diverse escursioni al giorno, durante le quali si possono vedere crepacci, sculture di ghiaccio e grotte di ghiaccio.

Sólheimarjökull

La langue glaciaire Sólheimarjökull, longue de 10 km, appartient à Mýrdalsjökull, le quatrième plus grand glacier d'Islande. Sous ce dernier se trouve le Katla, l'un des volcans les plus actifs de l'île. Sólheimarjökull offre plusieurs possibilités de randonnées par jour en été, pendant lesquelles vous pourrez observer des crevasses, des sculptures de glace et des bassins d'eau de fonte.

Sólheimarjökull

La lengua del glaciar Sólheimarjökull, de 10 km de largo, pertenece al Mýrdalsjökull, el cuarto glaciar más grande de Islandia. Debajo de él se encuentra el Katla, uno de los volcanes más activos de la isla. Sólheimarjökull ofrece varias caminatas al día en verano, durante las cuales se pueden ver grietas, esculturas de hielo y calderas de agua derretida.

Sólheimarjökull

De 10 km lange gletsjertong Sólheimarjökull is een uitloper van de Mýrdalsjökull, de op drie na grootste gletsjer van IJsland. Eronder sluimert de Katla, een van de actiefste vulkanen van het eiland. Op de Sólheimarjökull worden 's zomers meerdere wandelingen per dag aangeboden, waarbij u spleten, ijssculpturen en smeltwaterketels kunt zien.

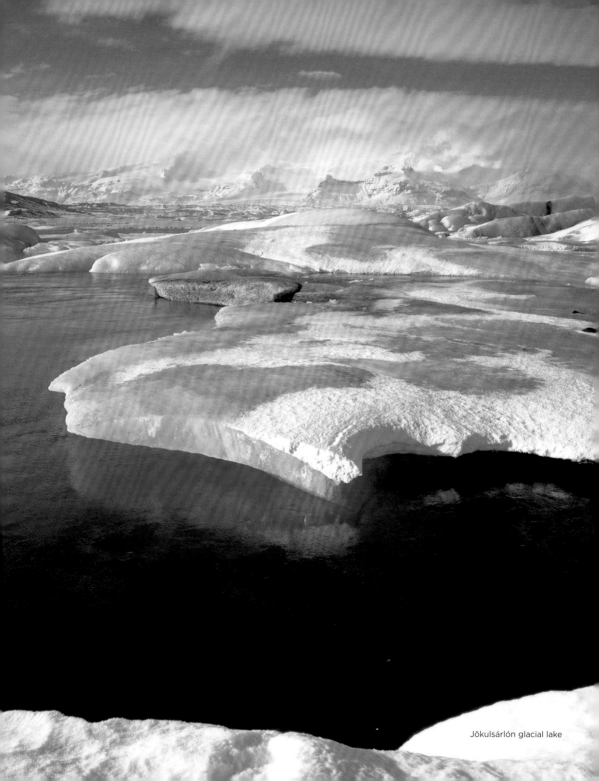

Jökulsárlón glacial lake

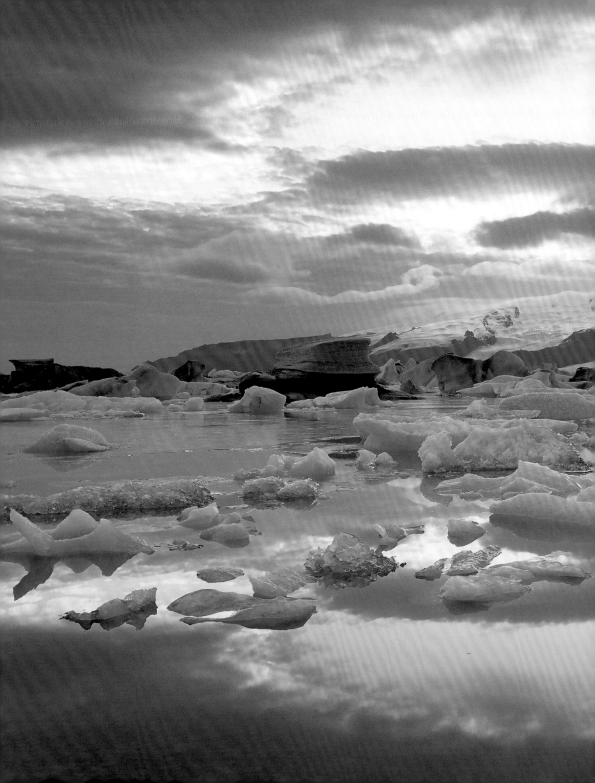

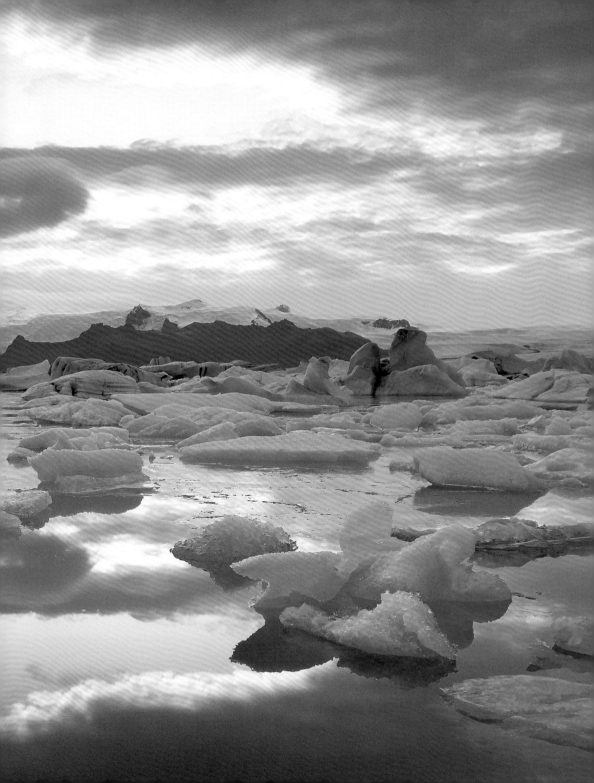

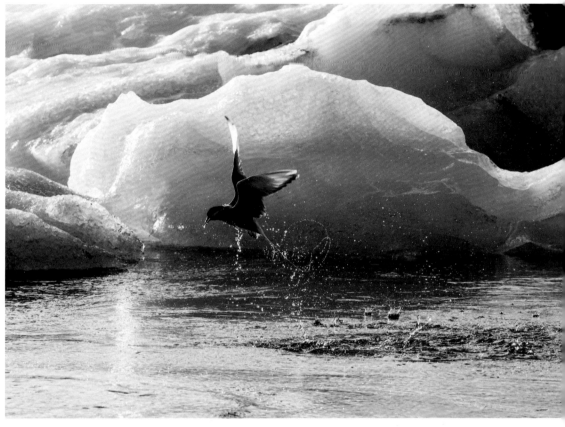

Artic Tern, Jökulsárlón glacial lake

Arctic Terns

These small birds, which weigh only 100 grams, breed in the Arctic and hibernate in the southern polar regions, covering at least 30,000 kilometres per year. In summer, they breed on meadows inland from the beach and aggressively defend their nests with acrobatic pseudo-attacks.

Sternes arctiques

Ces oiseaux, qui ne pèsent que 100 grammes, se reproduisent dans les régions arctiques et hibernent dans les régions polaires méridionales. En un an, ils couvrent au moins 30 000 km. En été, ils couvent dans les prairies qui se trouvent derrière la plage et défendent agressivement leurs nids en attaquant tout intrus de manière acrobatique.

Küstenseeschwalben

Die nur 100 Gramm schweren Vögel brüten in den Nordpolargebieten und überwintern in den Südpolargebieten. In einem Jahr legen sie so mindestens 30 000 km zurück. Im Sommer brüten sie auf Wiesen hinter dem Strand und verteidigen ihre Nester aggressiv mit akrobatischen Scheinangriffen gegen jeden Eindringling.

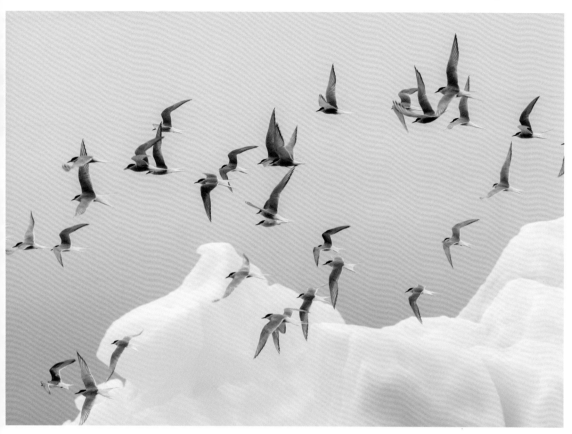

Birds over Jökulsárlón glacial lake

Charranes árticos

Estas aves, que pesan solo 100 gramos, se reproducen en las regiones árticas e hibernan en las regiones polares meridionales. En un año cubren un mínimo de 30 000 km. En verano se reproducen en los prados detrás de la playa y defienden sus nidos con agresividad realizando pseudo-ataques acrobáticos contra cualquier intruso.

Sterne artiche

Questi uccelli, che pesano solo 100 grammi, si riproducono nelle regioni artiche e svernano nelle regioni polari meridionali. In un anno percorrono almeno 30 000 km. In estate si riproducono sui prati dietro la spiaggia e difendono i loro nidi in modo aggressivo con pseudo-attacchi acrobatici contro ogni intruso.

Noordse sterns

De slechts 100 gram wegende vogels broeden in het Noordpoolgebied en overwinteren in het Zuidpoolgebied. In één jaar tijd leggen ze minstens 30 000 km af. In de zomer broeden ze op weiden achter het strand en verdedigen agressief hun nesten met acrobatische schijnaanvallen tegen elke indringer.

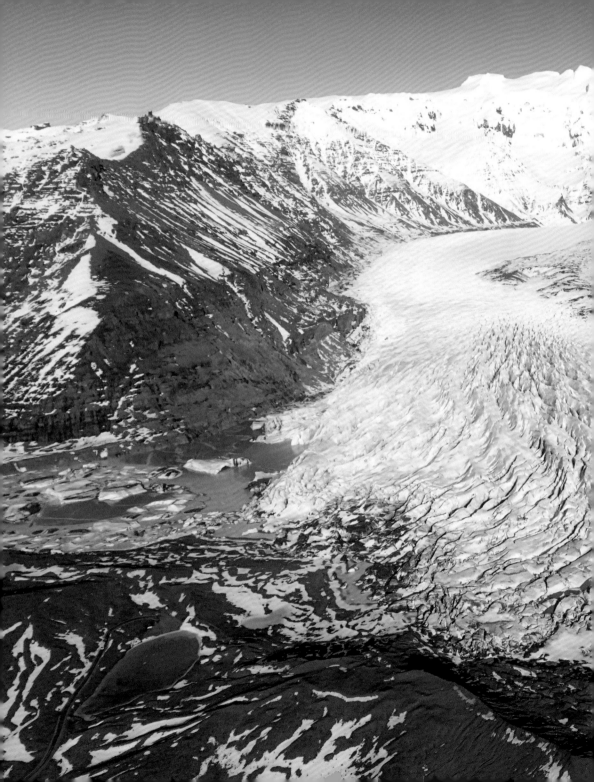

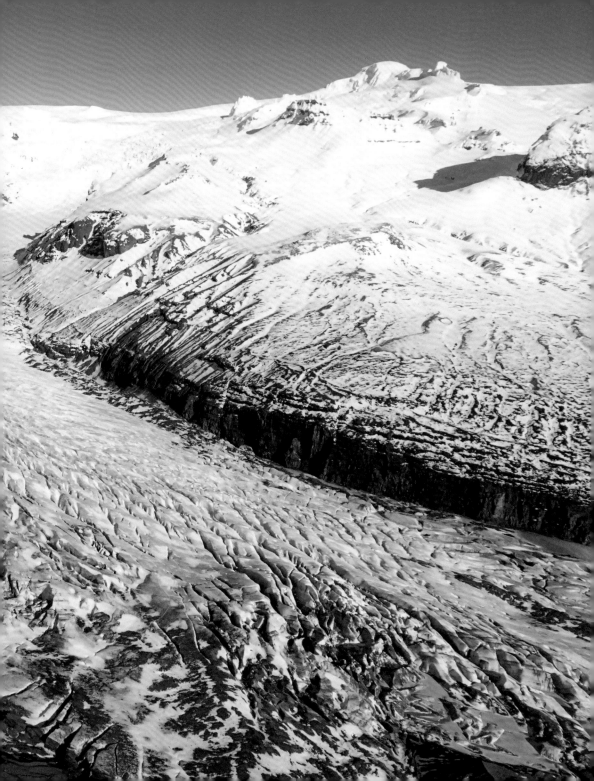

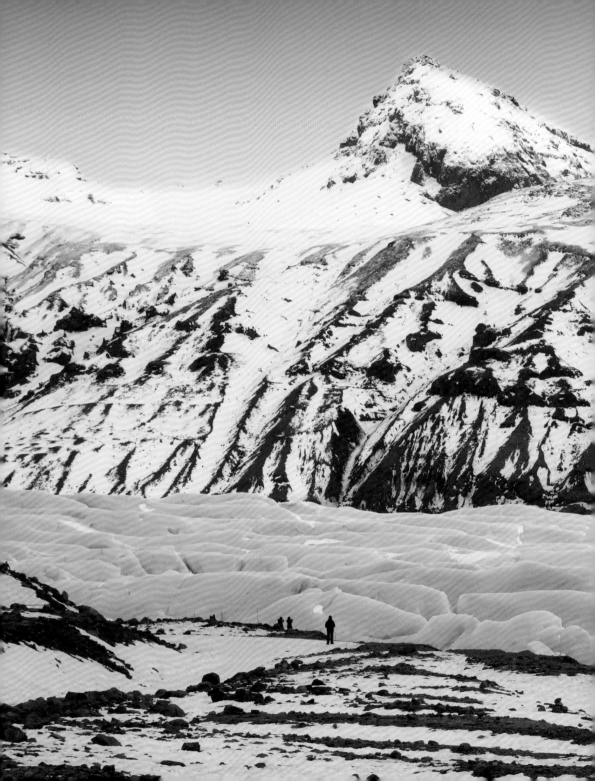

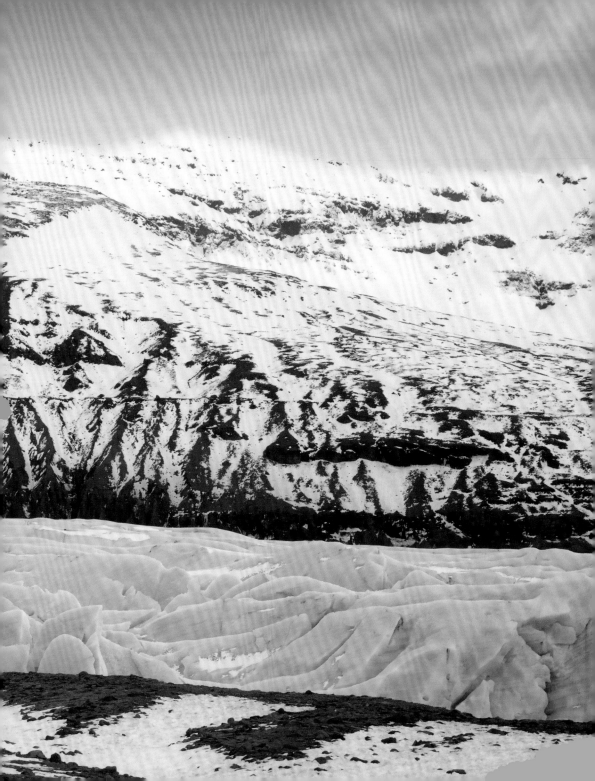

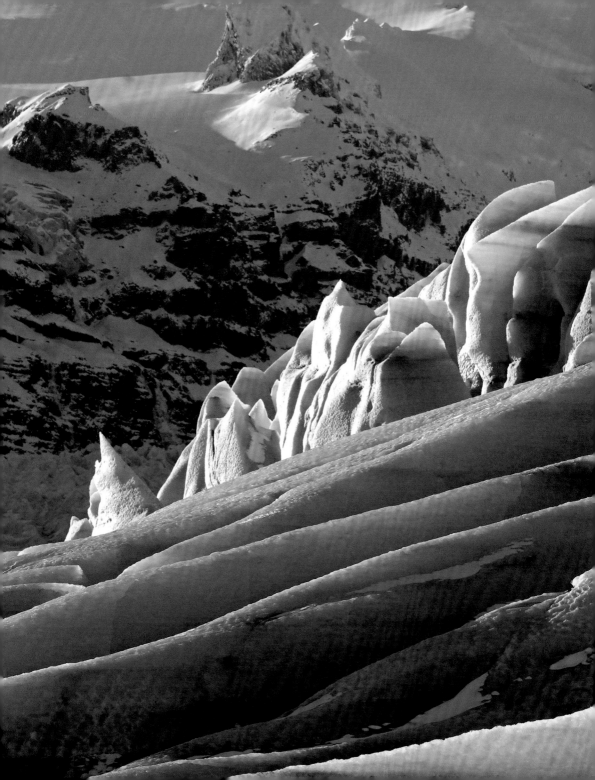

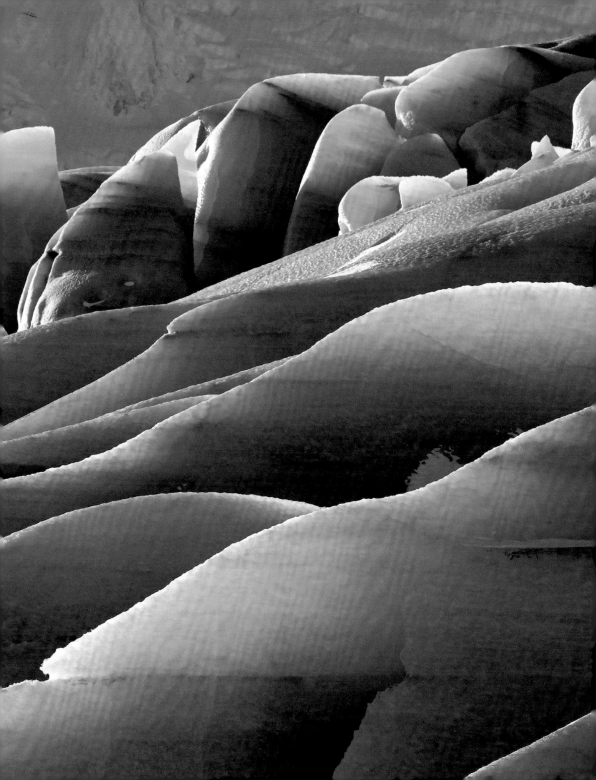

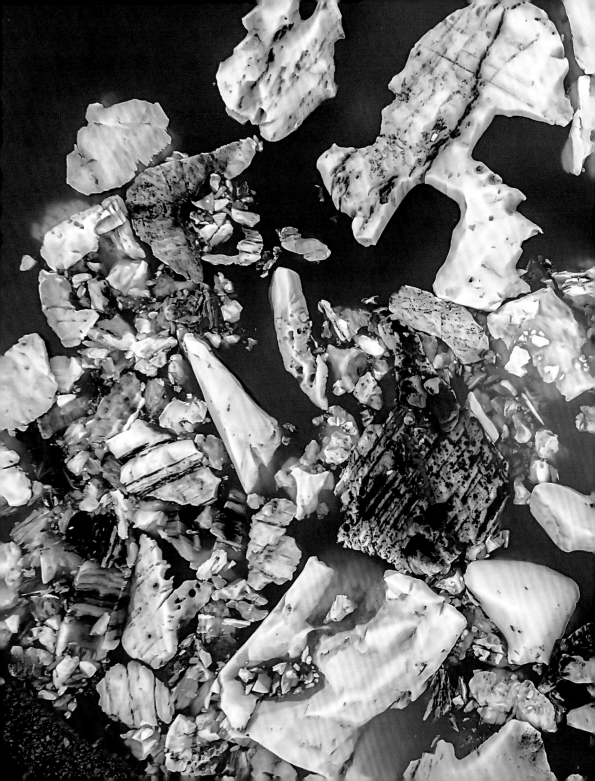

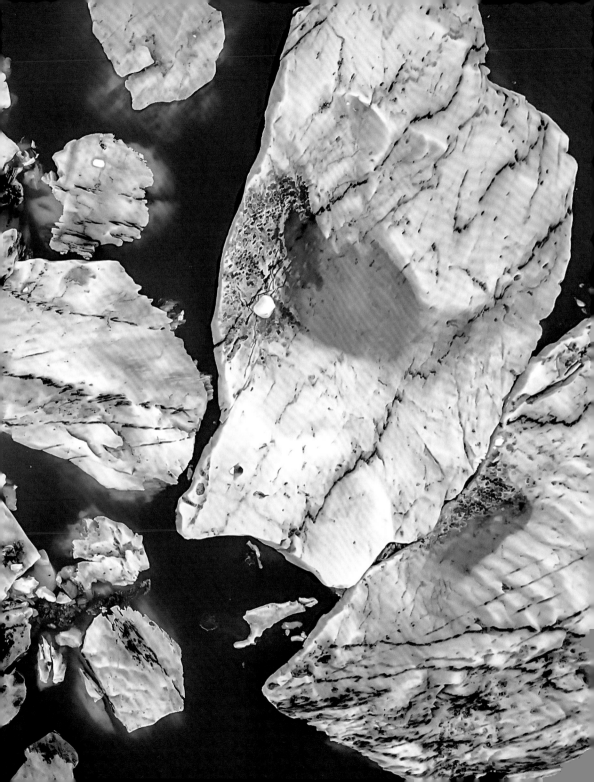

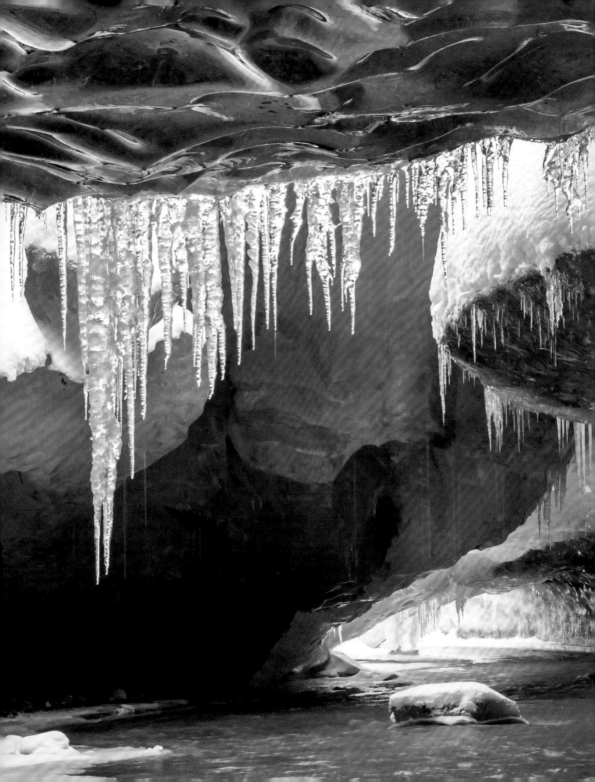

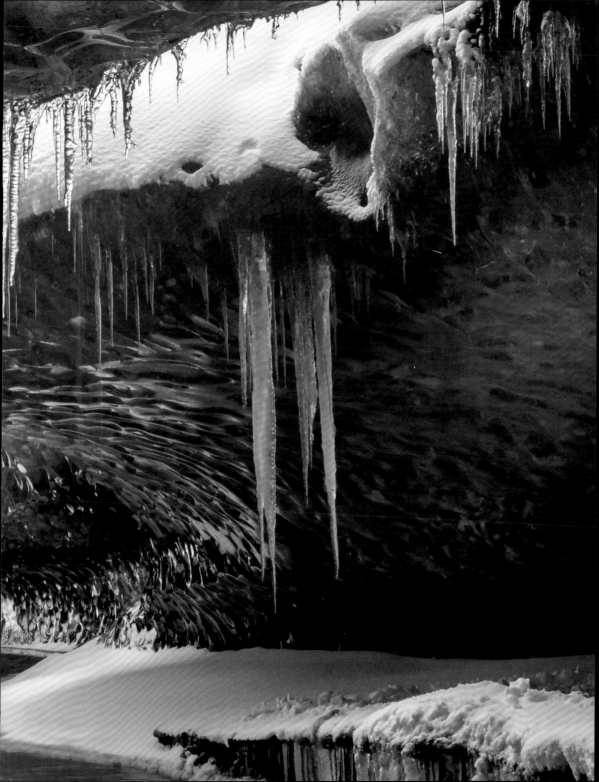

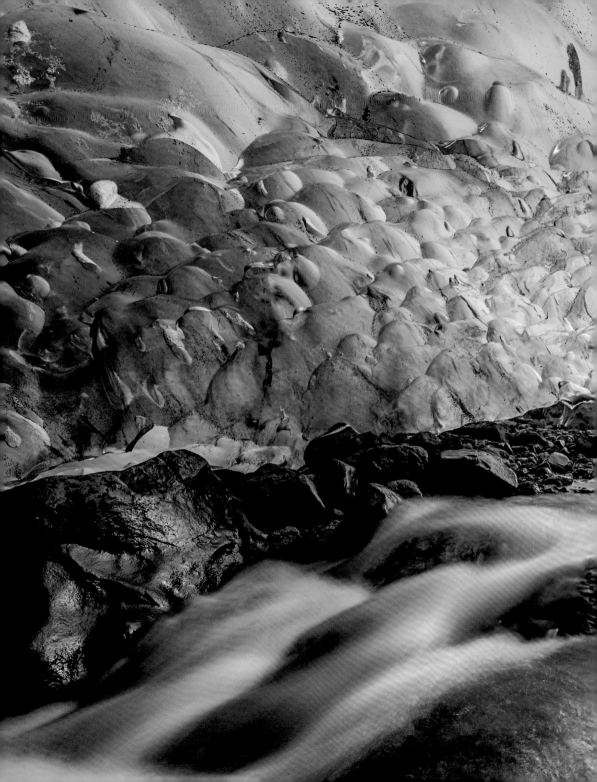

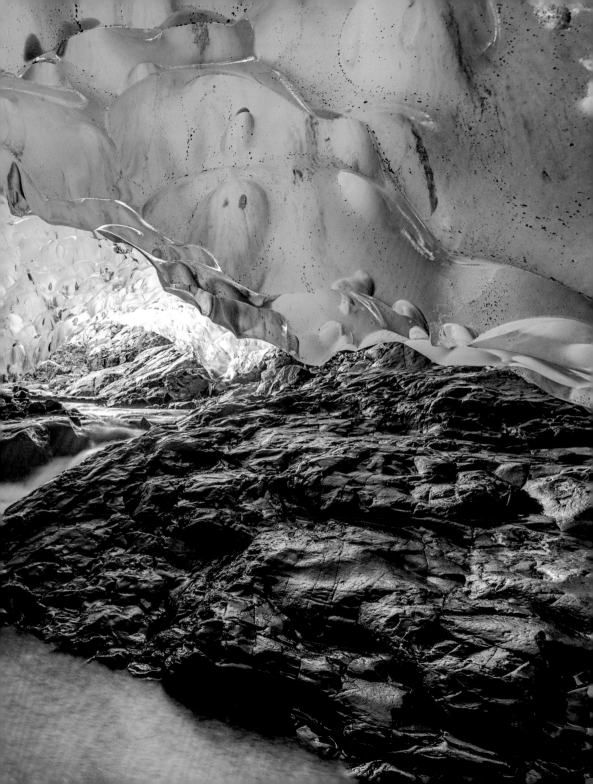

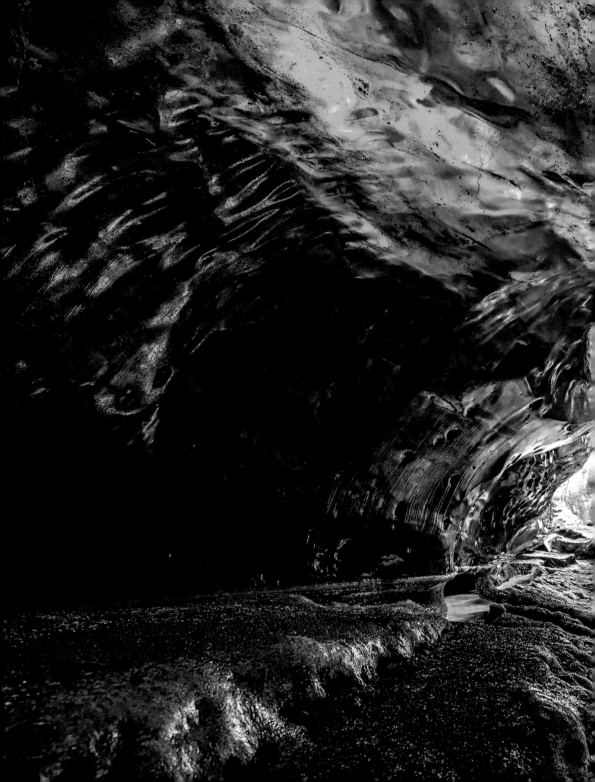

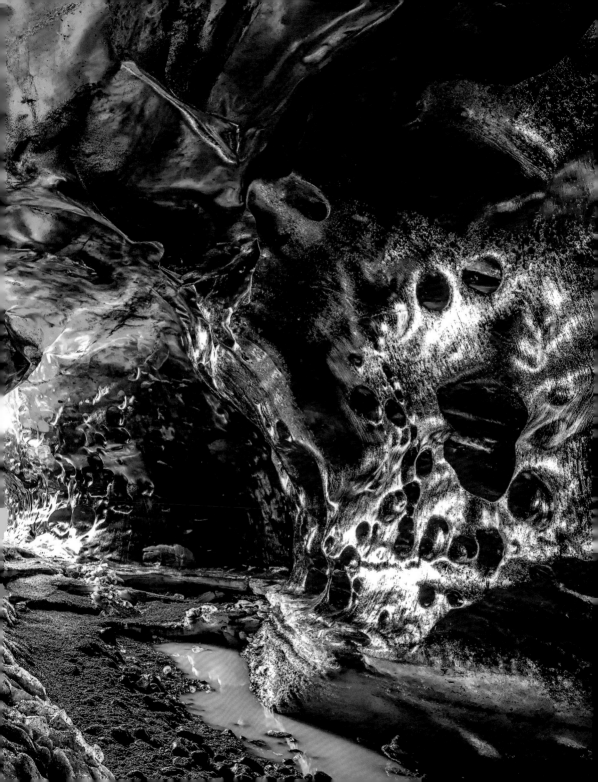

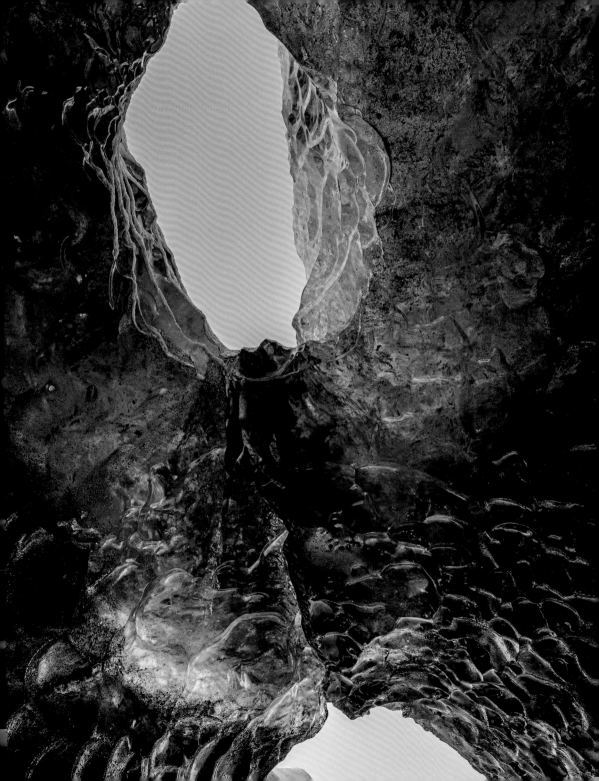

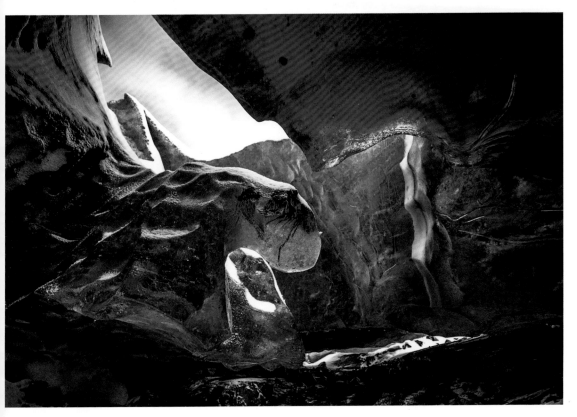

Ice cave, Vatnajökull

Ice Caves in Vatnajökull

Underneath Vatnajökull, volcanoes feed the hot springs. The springs form hot-water rivers, which carve their way through the glacier ice, forming caves as they go. The walls of such caves are particularly fascinating because the warm water thaws the surface of the ice. When it freezes again, extraordinary glittering patterns form on the walls.

Grottes de glace dans le Vatnajökull

Sous les volcans du Vatnajökull se trouvent des sources d'eau chaude ; elles forment des rivières qui creusent leurs chemins sous les glaciers et forment ainsi des grottes. Les murs de ces renfoncements sont particulièrement fascinants car la glace fond au contact de l'eau chaude, puis, lorsqu'elle gèle à nouveau, crée des paillettes irréelles sur les surfaces.

Eishöhlen im Vatnajökull

Unter dem Vatnajökull speisen Vulkane heiße Quellen. Diese bilden Heißwasserflüsse, die sich unter dem Gletschereis ihren Weg suchen und dabei Höhlen bilden. Besonders faszinierend sind die Wände solcher Höhlen, denn das warme Wasser taut die Eisoberfläche an. Wenn es dann wieder gefriert, bilden sich unwirklich glitzernde Muster an den Wänden.

Cuevas de hielo en el Vatnajökull

Bajo el glaciar Vatnajökull, los volcanes se alimentan de fuentes termales. Estas forman ríos de agua caliente que se abren paso bajo el hielo de los glaciares y forman cuevas. Las paredes de estas cuevas son particularmente fascinantes porque el agua caliente descongela la superficie de hielo. Cuando se congela de nuevo, se forman figuras irreales en las paredes.

Grotte di ghiaccio nel Vatnajökull

Sotto Vatnajökull i vulcani alimentano le sorgenti termali. Questi formano fiumi di acqua calda, che cercano la loro strada sotto il ghiaccio del ghiacciaio fino a formare grotte. Le pareti di queste grotte sono particolarmente affascinanti perché l'acqua calda scongela la superficie ghiacciata. Quando si congela di nuovo, sulle pareti si formano dei veri e propri disegni luminosi.

IJsgrotten in de Vatnajökull

Onder de Vatnajökull voeden vulkanen hete bronnen. Deze vormen warmwaterrivieren die hun weg zoeken onder het gletsjerijs en daarbij grotten vormen. De wanden van dergelijke grotten zijn uiterst fascinerend omdat het warme water het ijsoppervlak laat smelten. Als het daarna weer vriest, vormen zich onwerkelijk glinsterende patronen op de wanden.

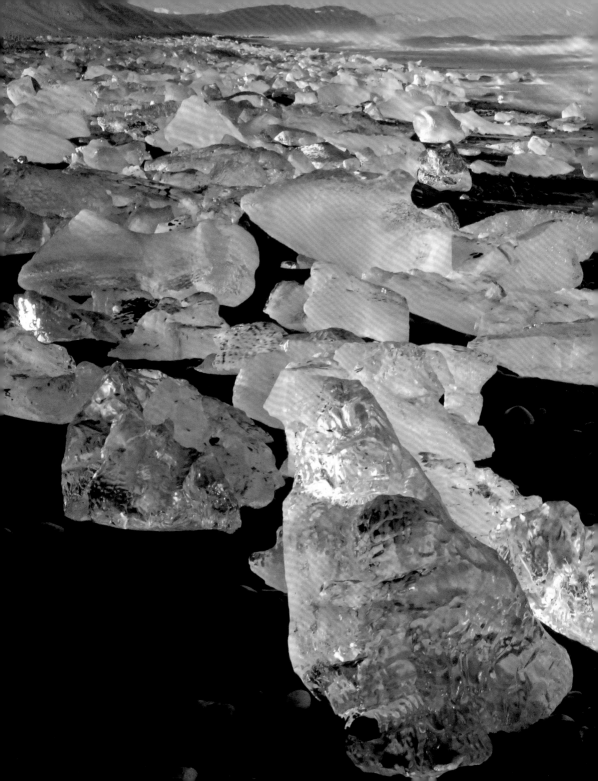

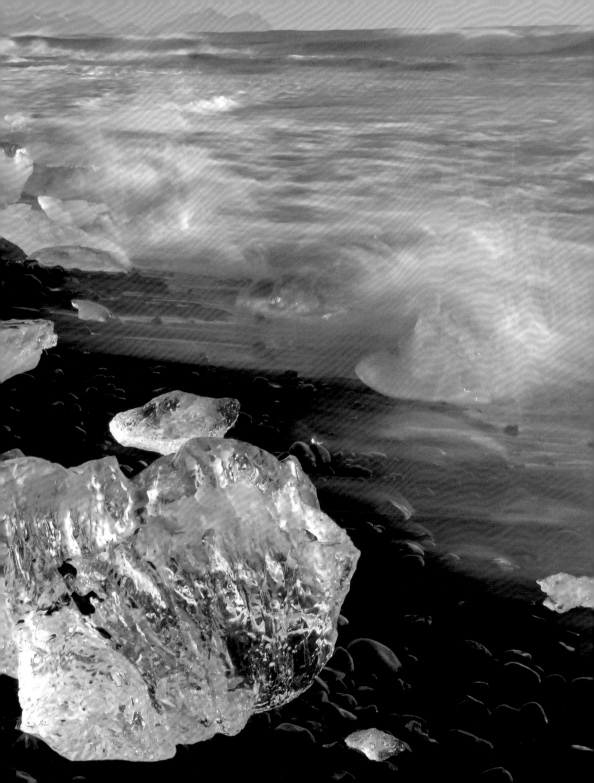

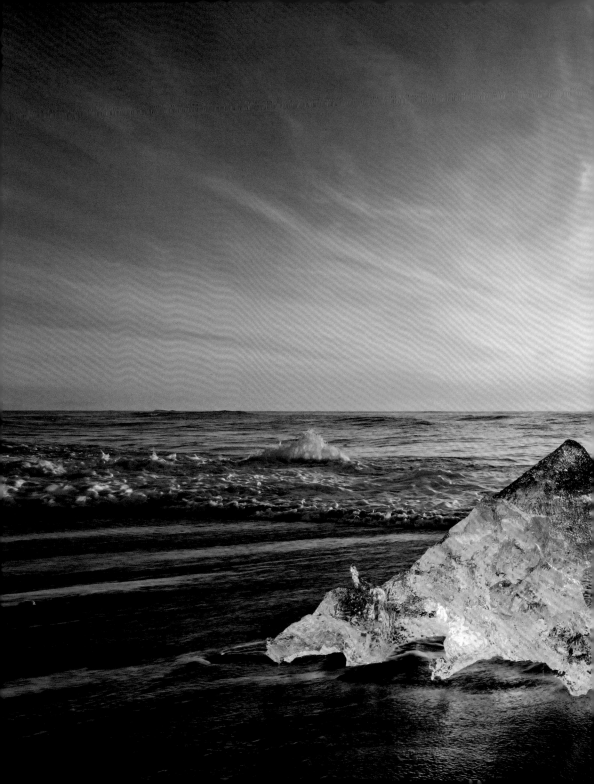

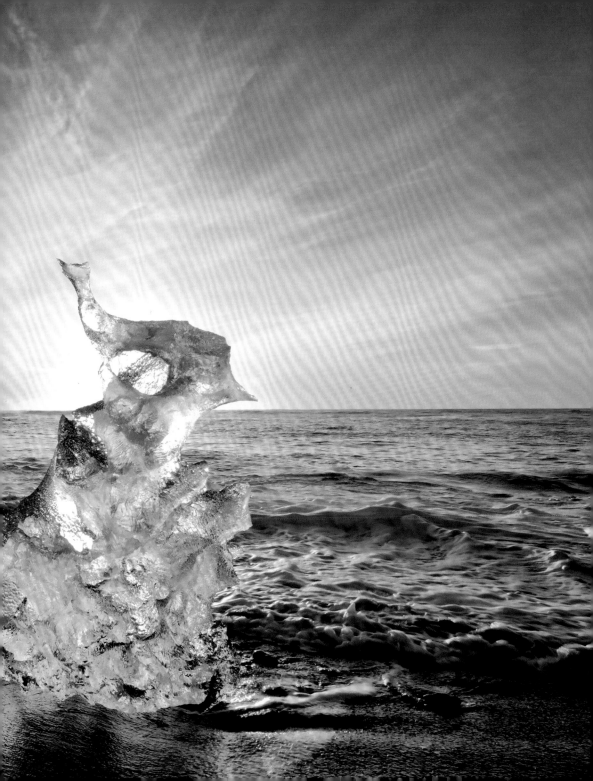

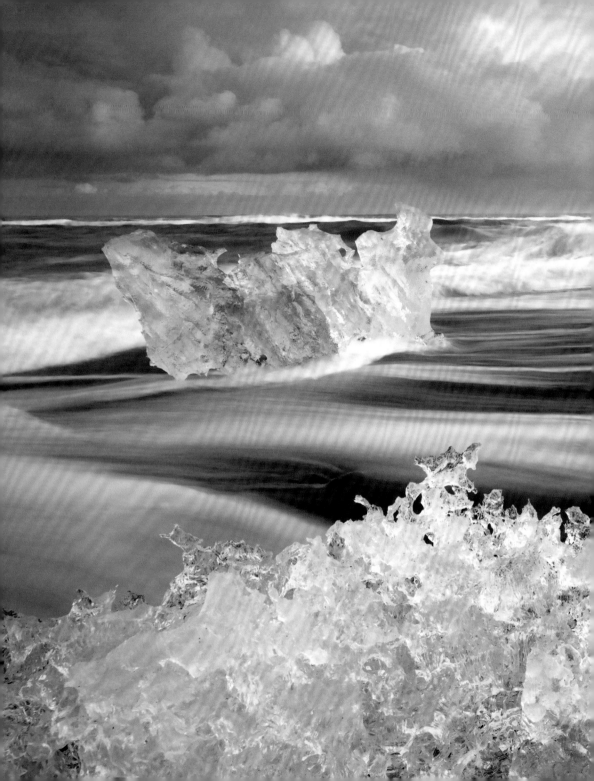

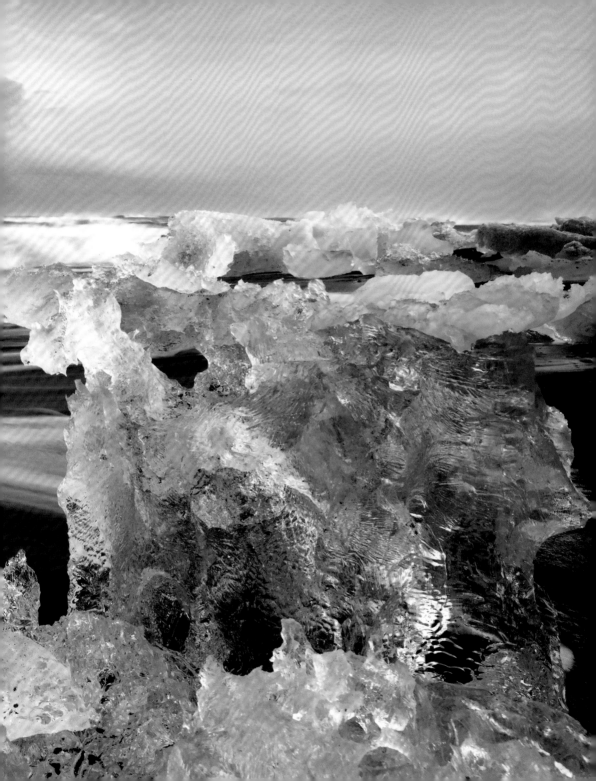

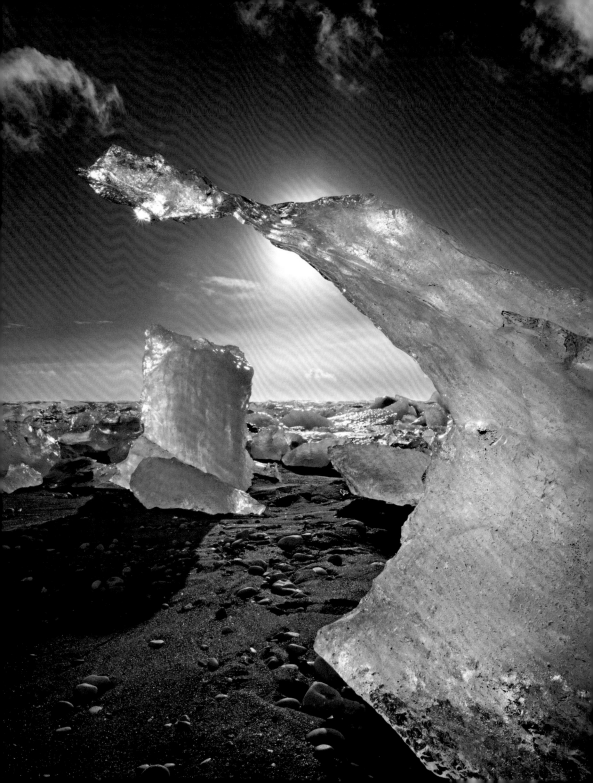

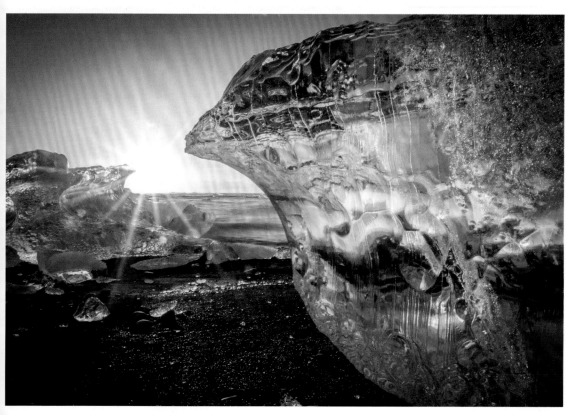

Jökulsárlón beach

Jökulsárlón Beach

The Breiðamerkurjökull glacier supplies Jökulsárlón with new icebergs, which can grow up to 15 metres in height. The different colours of the ice are due to crystals and their reflective surfaces, as well as to black volcanic ash. Nevertheless, you'd be hard-pressed to find purer ice to cool your drink.

Plage de Jökulsárlón

Le glacier Breiðamerkurjökull alimente le Jökulsárlón en nouveaux icebergs, qui peuvent atteindre 15 m de haut. Les différentes couleurs de la glace sont dues d'une part aux cristaux et à leurs reflets, et d'autre part aux cendres volcaniques noires. Pour autant, il est difficile d'obtenir une glace plus pure pour refroidir votre boisson.

Jökulsárlón-Strand

Der Gletscher Breiðamerkurjökull versorgt den Jökulsárlón mit immer wieder neuen Eisbergen, die bis zu 15 m hoch werden können. Die unterschiedlichen Färbungen des Eises rühren zum einen von Kristallen und ihren Reflektionen her, zum anderen von schwarzer Vulkanasche. Dennoch kann man wohl kaum reineres Eis bekommen, um seinen Drink zu kühlen.

Playa de Jökulsárlón

El glaciar Breiðamerkurjökull abastece al Jökulsárlón de nuevos icebergs que pueden llegar hasta los 15 m de altura. Los diferentes colores del hielo se deben, por un lado, a los cristales y sus reflejos y, por otro, a la ceniza volcánica negra. Sin embargo, es difícil conseguir hielo más puro para enfriar su bebida.

Spiaggia di Jökulsárlón

Il ghiacciaio Breiðamerkurjökull rifornisce il lago Jökulsárlón di nuovi iceberg, che possono raggiungere i 15 m di altezza. I diversi colori del ghiaccio sono dovuti da un lato ai cristalli e ai loro riflessi e dall'altro alla cenere vulcanica nera. È difficile procurarsi il ghiaccio per un raffreddare un drink.

Jökulsárlón-strand

De Breiðamerkurjökull-gletsjer voorziet het Jökulsárlón-meer steeds van nieuwe ijsbergen, die wel 15 meter hoog kunnen worden. De verschillende kleuren dankt het ijs enerzijds aan kristallen en hun reflecties, anderzijds aan de zwarte vulkanische as. Toch is het moeilijk om zuiverder ijs te vinden om uw drankje te koelen.

Skeiðarársandur

Iceland's largest alluvial plain covers an area of
1000 square kilometres on the southern coast.
Several rivers, all fed by Vatnajökull, meander
through the wide plain, constantly changing their
course. Crossing Skeiðarársandur was a dangerous
prospect until 1974, when Ring Road was closed by
a nearly one-kilometre-long bridge.

Skeiðarársandur

La plus grande plaine alluviale d'Islande couvre
une superficie de 1000 km² sur la côte sud et
plusieurs rivières, toutes alimentées par le glacier
de Vatnajökull, serpentent à travers la vaste plaine,
changeant constamment de cours. La traversée de
Skeiðarársandur était une entreprise dangereuse
jusqu'en 1974, date à laquelle ce dernier tronçon de
la Route 1, un pont de près d'un kilomètre de long,
a été installé.

Skeiðarársandur

Die größte Schwemmlandebene Islands bedeckt
an der Südküste eine Fläche von 1000 km².
Mehrere Flüsse, die alle vom Vatnajökull gespeist
werden, mäandern durch die weite Ebene und
ändern fortwährend ihren Lauf. Bis zum letzten
Lückenschluss der Ringstraße 1974 durch
eine fast einen Kilometer lange Brücke war
die Durchquerung des Skeiðarársandur ein
gefährliches Unterfangen.

Skeiðarársandur

Se trata de la llanura aluvial más grande de Islandia
cubre un área de 1000 km² en la costa sur y
varios ríos, todos alimentados por el Vatnajökull,
serpentean a través de la amplia llanura,
cambiando constantemente su curso. Atravesar
el sandur Skeiðarársandur fue una empresa
peligrosa hasta el último tramo de la carretera de
circunvalación de 1974, que discurre por un puente
de casi un kilómetro de longitud.

Skeiðarársandur

La più grande pianura alluvionale dell'Islanda copre
una superficie di 1000 km² sulla costa meridionale
e diversi fiumi, tutti alimentati dal Vatnajökull,
si insinuano nell'ampia pianura, cambiando
continuamente il loro corso. L'attraversamento di
Skeiðarársandur è stato un'impresa pericolosa fino
all'ultima chiusura della circonvallazione, nel 1974,
con un ponte lungo quasi un chilometro.

Skeiðarársandur

De grootste alluviale vlakte van IJsland beslaat
aan de zuidkust een gebied van 1000 km².
Verschillende rivieren, allemaal gevoed door de
Vatnajökull, slingeren door de weidse vlakte en
veranderen voortdurend hun loop. De oversteek
van de Skeiðarársandur was een gevaarlijke
onderneming tot de laatste afsluiting van de
ringweg in 1974 door een bijna een kilometer
lange brug.

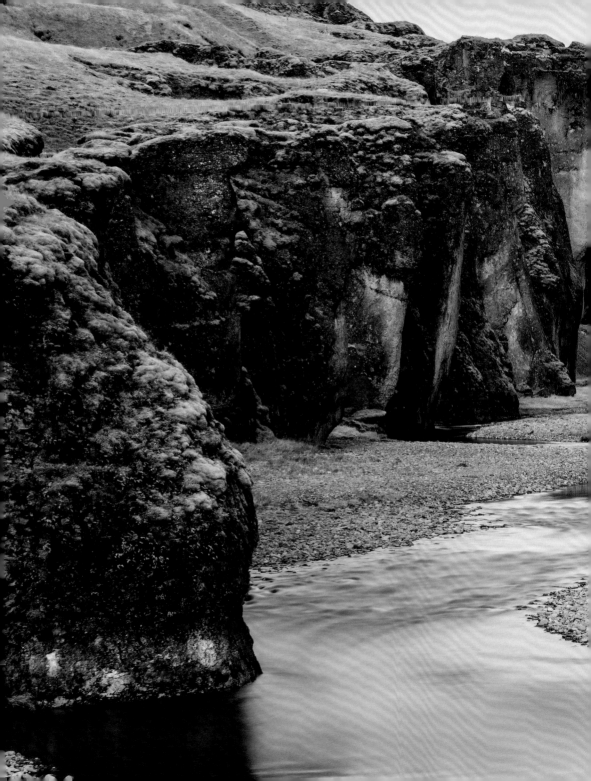

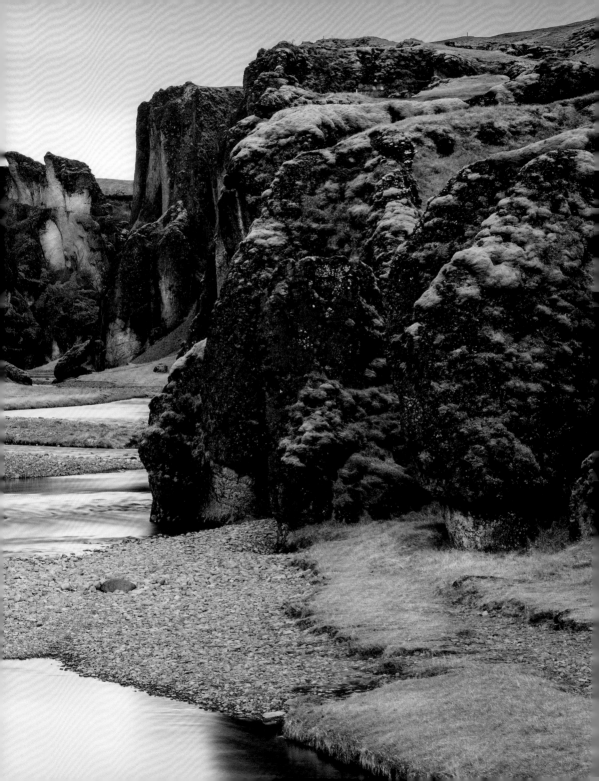

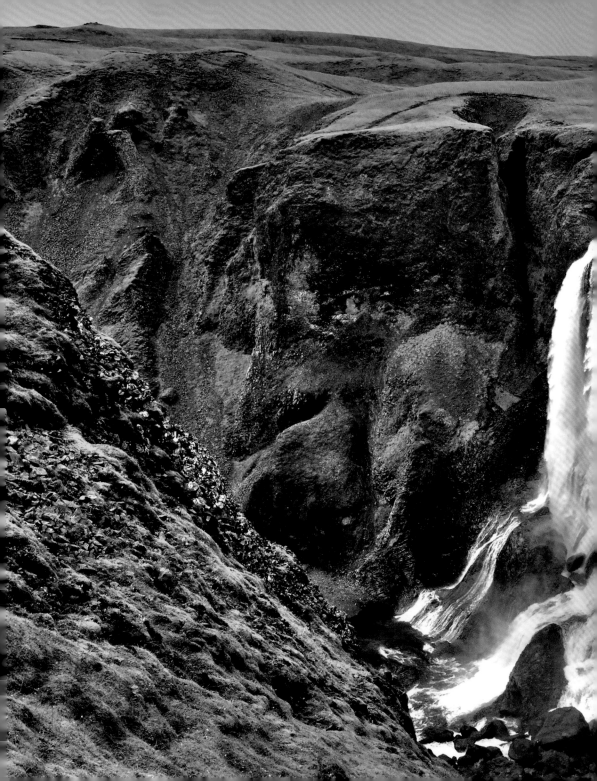

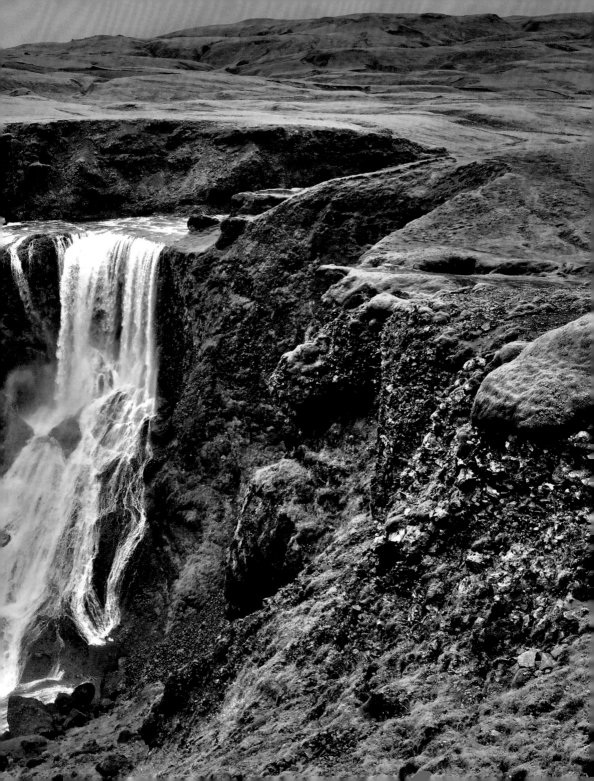

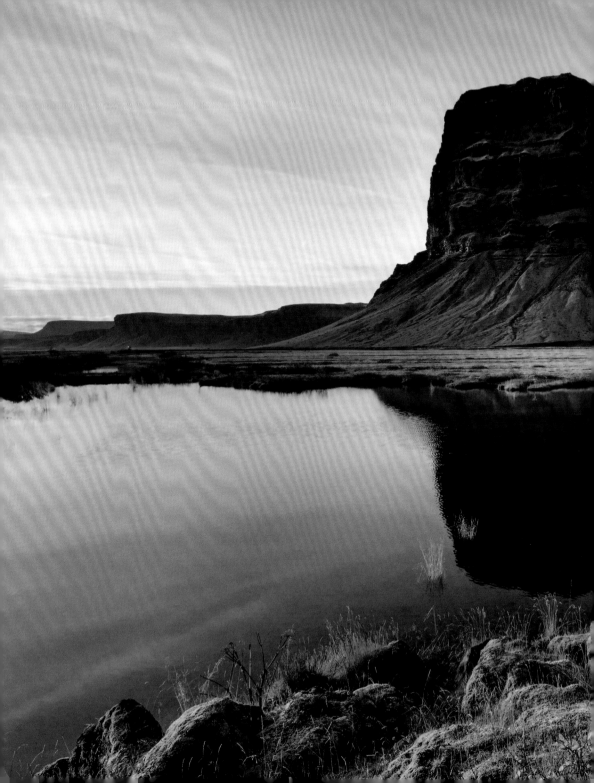

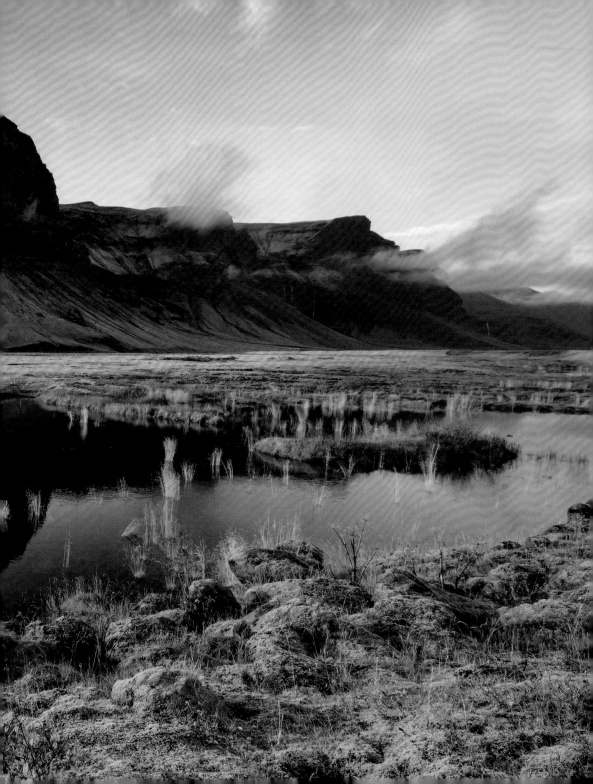

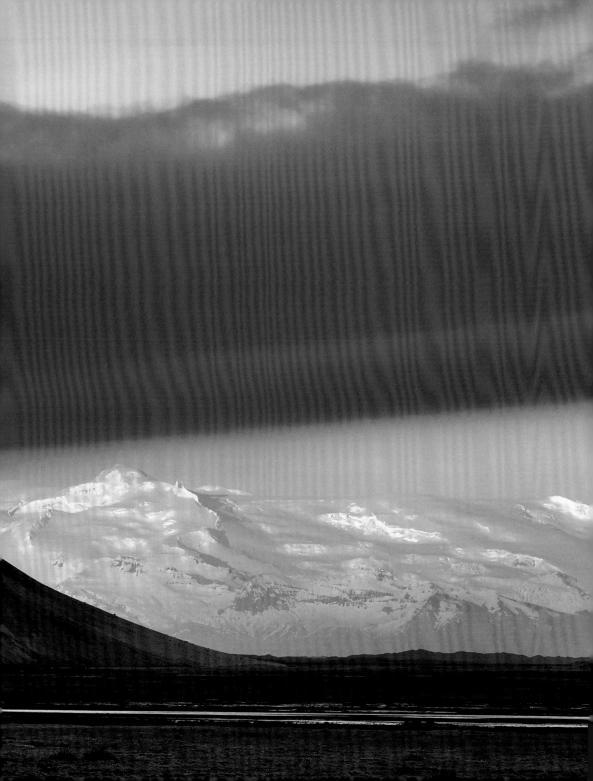

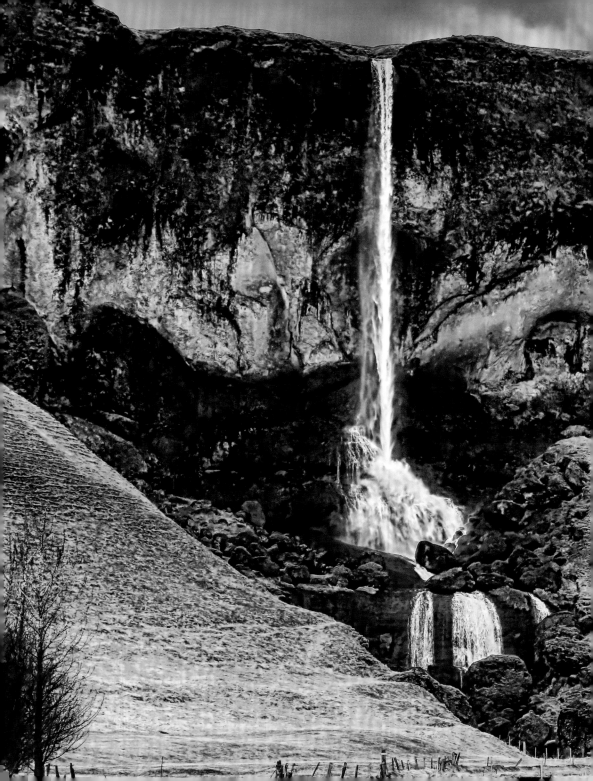

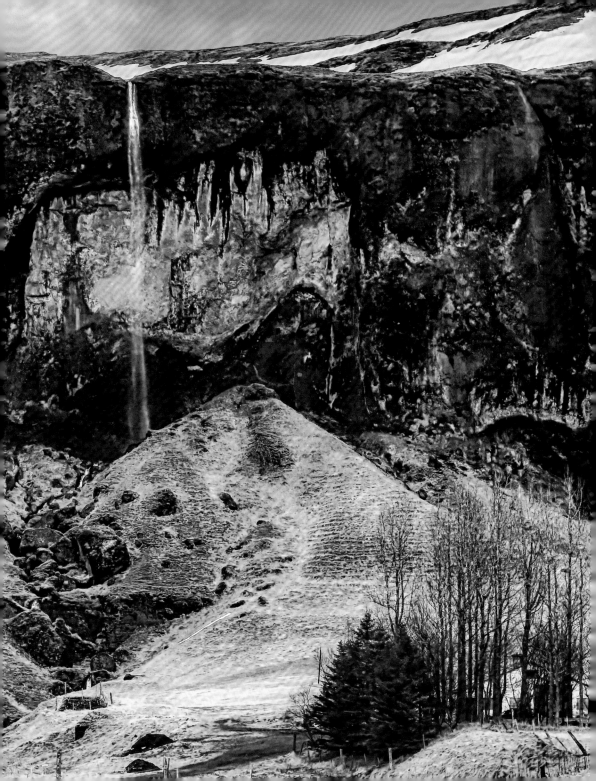

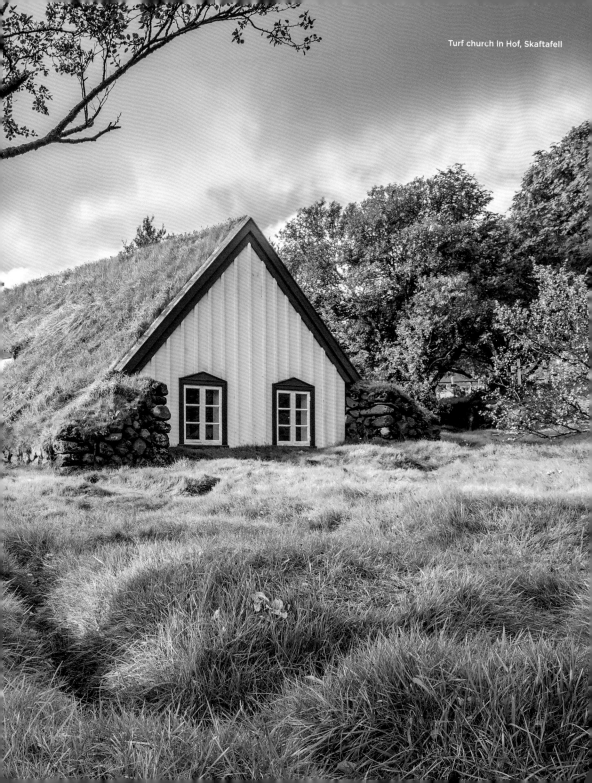

Turf church In Hof, Skaftafell

Kirkjugólf (The Church Floor), Kirkjubæjarklaustur

Kirkjugólf

Kirkjubæjarklaustur has only 150 inhabitants, and yet it is far and away the largest settlement in the area. In a meadow outside the village, there is a stone area of a few square metres that resembles the paved floor of a church, and is therefore called Kirkjugólf. In fact, the surface is not the remains of a church, but rather the ends of a few dozen basalt columns, polished smooth by water and ice.

Kirkjugólf

Seulement 150 personnes vivent à Kirkjubæjarklaustur, et pourtant c'est la plus grande agglomération de la région. À l'extérieur du village, sur quelques mètres carrés, le sol semble pavé comme dans une église ; le lieu est ainsi surnommé Kirkjugólf (« le sol de l'église »). Ce ne sont pourtant pas des ruines, mais les extrémités de quelques dizaines de colonnes de basalte polies par l'eau et la glace.

Kirkjugólf

Kirkjubæjarklaustur hat nur 150 Einwohner und doch ist es weit und breit die größte Ansiedlung. Außerhalb des Ortes kommt man auf einer Wiese zu einigen Quadratmetern, die Ähnlichkeit mit dem gepflasterten Fußboden einer Kirche haben und deshalb Kirkjugólf genannt werden. Es sind aber nicht die Reste eines Gotteshauses, sondern die von Wasser und Eis glatt polierten Enden von einigen Dutzend Basaltsäulen.

Kirkjugólf

Kirkjubæjarklaustur tiene solo 150 habitantes y, sin embargo, es el mayor asentamientocon diferencia. Fuera del pueblo, en una pradera, hay unos pocos metros cuadrados que se asemejan al suelo pavimentado de una iglesia, de ahí su nombre en islandés, Kirkjugólf. Pero no son los restos de una iglesia, sino los extremos de unas docenas de columnas de basalto pulidas por el agua y el hielo.

Kirkjugólf

Kirkjubæjarklaustur ha solo 150 abitanti eppure è il più grande insediamento in lungo e in largo. All'esterno del villaggio, su un prato, ci sono alcuni metri quadrati che assomigliano al pavimento lastricato di una chiesa e sono quindi chiamati Kirkjugólf. Non sono i resti di una chiesa, ma le estremità di alcune decine di colonne di basalto levigate dall'acqua e dal ghiaccio.

Kirkjugólf

Kirkjubæjarklaustur heeft slechts 150 inwoners en is toch wijd en zijd de grootste nederzetting. Net buiten het dorp kom je op een weiland bij een paar vierkante meter die op de verharde vloer van een kerk lijken en daarom Kirkjugólf genoemd worden. Maar het zijn niet de overblijfselen van een kerk, maar de door water en ijs gladgepolijste uiteinden van enkele tientallen basaltzuilen.

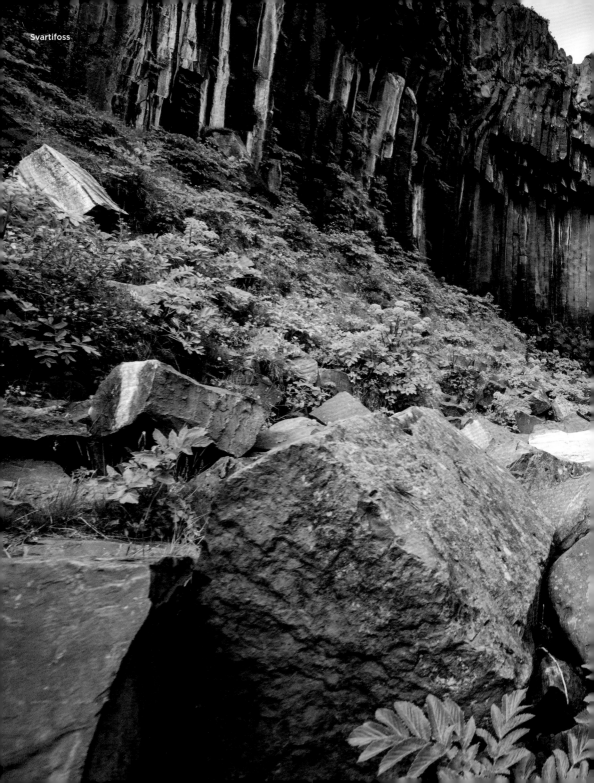
Svartifoss

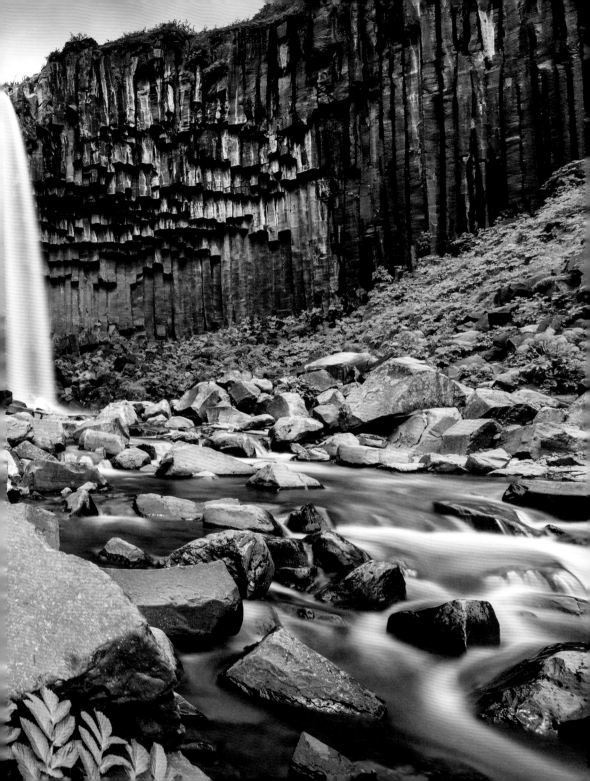

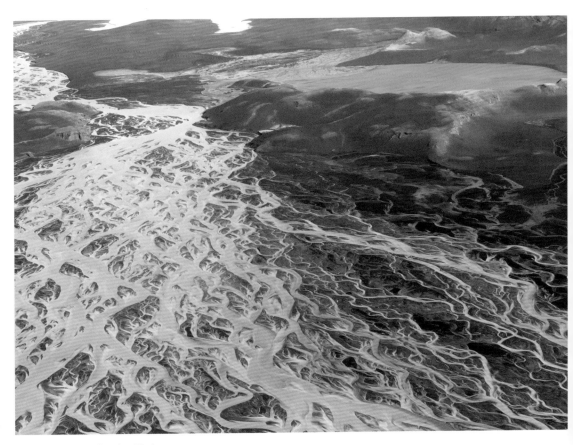

Skaftafell, Vatnajökull National Park

Skaftafell

This region was named after the extinct volcano Skaftafell, which is surrounded by the three glaciers Skaftafellsjökull, Skeiðarárjökull, and Öræfajökull. In summer, guided glacier hikes are offered by the visitor centre. A short walk takes you to Svartifoss, a waterfall that drops into a basin framed by basalt columns.

Skaftafell

La région porte le nom du volcan éteint Skaftafell, entouré par les trois langues glaciaires Skaftafellsjökull, Skeiðarárjökull et Öræfajökull. En été, il est possible de faire des randonnées guidées à partir du centre d'accueil. Une courte promenade mène à Svartifoss, une chute d'eau qui se jette dans un bassin encadré par des colonnes de basalte.

Skaftafell

Die Region wurde nach dem erloschenen Vulkan Skaftafell benannt, der von den drei Gletscherzungen Skaftafellsjökull, Skeiðarárjökull und Öræfajökull umgeben ist. Vom Besucherzentrum kann man im Sommer geführte Gletscherwanderungen unternehmen. Ein kurzer Spaziergang führt zum Svartifoss, einem Wasserfall, der in ein von Basaltsäulen umrahmtes Becken stürzt.

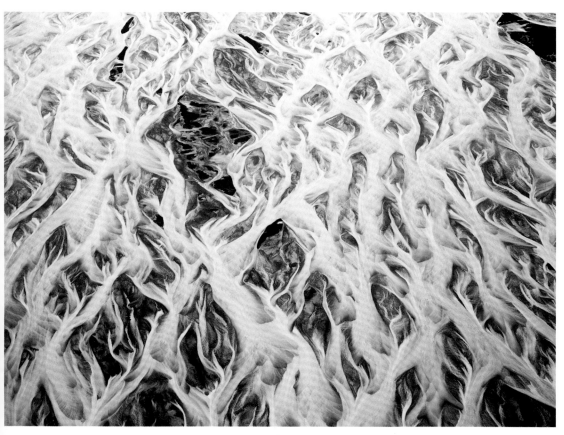

Skaftafell, Vatnajökull National Park

Skaftafell

La región lleva el nombre del extinto volcán Skaftafell, que está rodeado por las tres lenguas glaciares Skaftafellsjökull, Skeiðarárjökull y Öræfajökull. En verano, se pueden realizar excursiones guiadas a los glaciares desde el centro de visitantes. Un corto paseo conduce a Svartifoss, una cascada que cae en una cuenca enmarcada por columnas de basalto.

Skaftafell

La regione prende il nome dal vulcano spento Skaftafell, circondato dalle tre lingue dei ghiacciai Skaftafellsjökull, Skeiðarárjökull e Öræfajökull. In estate è possibile effettuare escursioni guidate sul ghiacciaio dal centro di accoglienza turistica. Una breve passeggiata conduce a Svartifoss, una cascata che cade in una conca incorniciata da colonne di basalto.

Skaftafell

De regio is vernoemd naar de uitgedoofde vulkaan Skaftafell, die omgeven is door de drie gletsjertongen Skaftafellsjökull, Skeiðarárjökull en Öræfajökull. In de zomer kunnen vanaf het bezoekerscentrum gletsjerwandelingen met een gids worden gemaakt. Een korte wandeling leidt naar de Svartifoss, een waterval die in een door basaltzuilen omgeven waterbekken uitkomt.

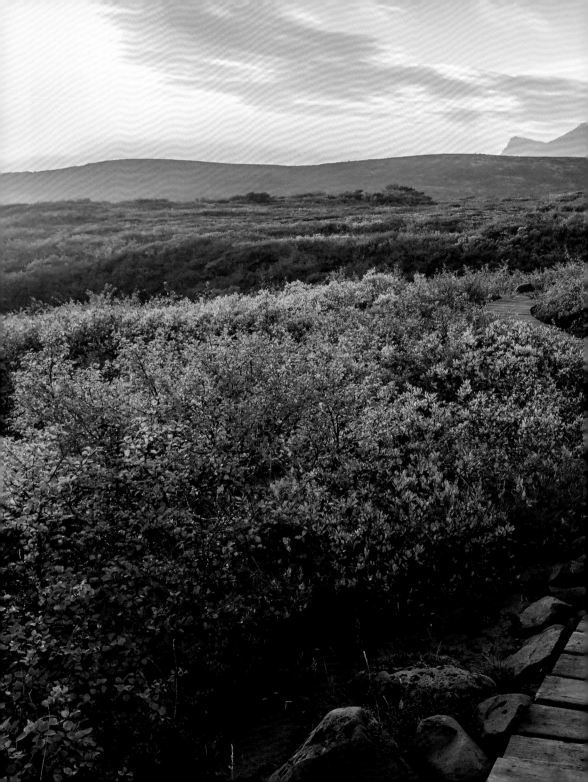

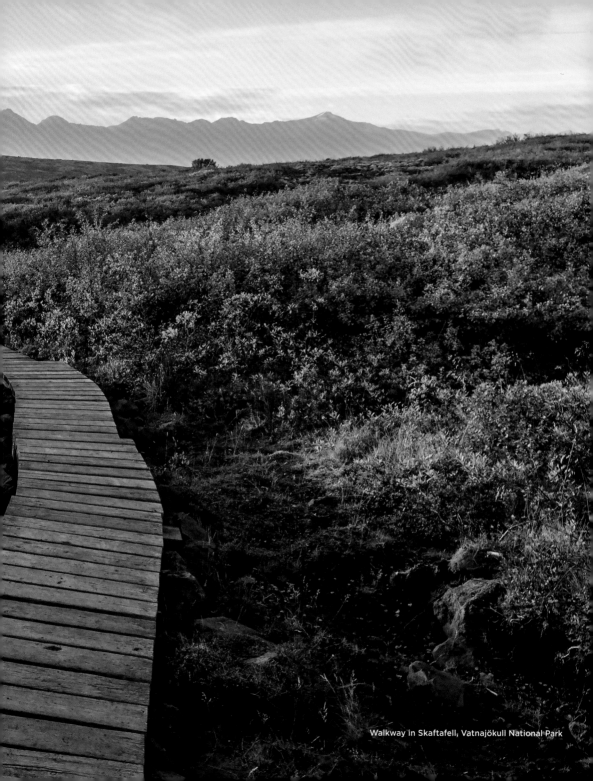

Walkway in Skaftafell, Vatnajökull National Park

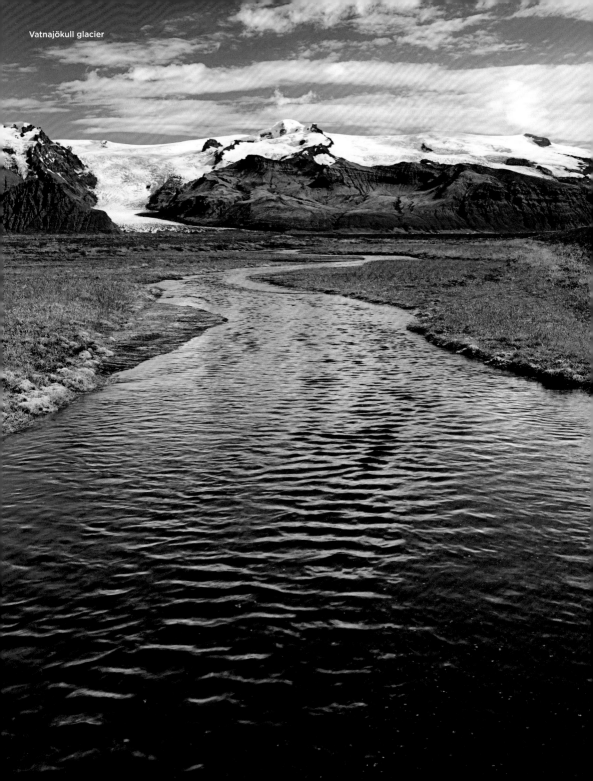

Vatnajökull glacier

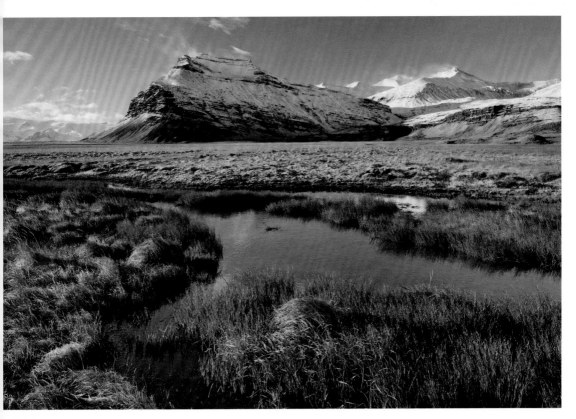

Fellsfjall

Fellsfjall

Following the Ring Road from the Jökulsárlón lagoon a few kilometres to the east, you come to 665-metre-high Fellsfjall. In contrast to the lagoon, which receives a steady stream of visitors all year round, you almost never run into anyone at Fellsfjall, and can therefore enjoy the impressive mountain scenery on the edge of Vatnajökull in complete silence.

Fellsfjall

Sur la Route 1 qui longe le glacier de Jökulsárlón, à quelques kilomètres à l'est, se trouve la montagne Fellsfjall, qui culmine à 665 mètres. Contrairement à la lagune glaciaire, très fréquentée toute l'année, on ne rencontre presque jamais personne ici et on peut profiter en silence de l'impressionnant paysage de montagne au bord du Vatnajökull.

Fellsfjall

Folgt man der Ringstraße von der Gletscherlagune Jökulsárlón einige Kilometer in Richtung Osten, kommt man zum 665 m hohen Berg Fellsfjall. Im Gegensatz zur ganzjährig stark besuchten Gletscherlagune trifft man hier fast nie einen Menschen und kann in aller Stille die eindrucksvolle Bergkulisse am Rande des Vatnajökull genießen.

Fellsfjall

Siguiendo la carretera de circunvalación desde la laguna del glaciar Jökulsárlón unos kilómetros al este, se llega a Fellsfjall, a 665 metros de altura. A diferencia de la laguna glaciar, que es muy visitada durante todo el año, esta localidad apenas tiene visitantes y se puede disfrutar del impresionante paisaje montañoso al borde del glaciar Vatnajökull en completo silencio.

Fellsfjall

Seguendo la circonvallazione dalla laguna glaciale di Jökulsárlón, a pochi chilometri a est, si arriva a Fellsfjall, alta 665 metri. A differenza della laguna glaciale, molto visitata tutto l'anno, qui non si incontra quasi mai nessuno e si può godere lo straordinario paesaggio montano ai margini di Vatnajökull nel silenzio più assoluto.

Fellsfjall

Als u de ringweg van de Jökulsárlón-gletsjerlagune een paar kilometer naar het oosten volgt, komt u bij de 665 meter hoge Fellsfjall. In tegenstelling tot de gletsjerlagune, die het hele jaar door druk bezocht wordt, zult u hier bijna nooit iemand tegenkomen en kunt u in alle stilte genieten van het indrukwekkende berglandschap aan de rand van Vatnajökull.

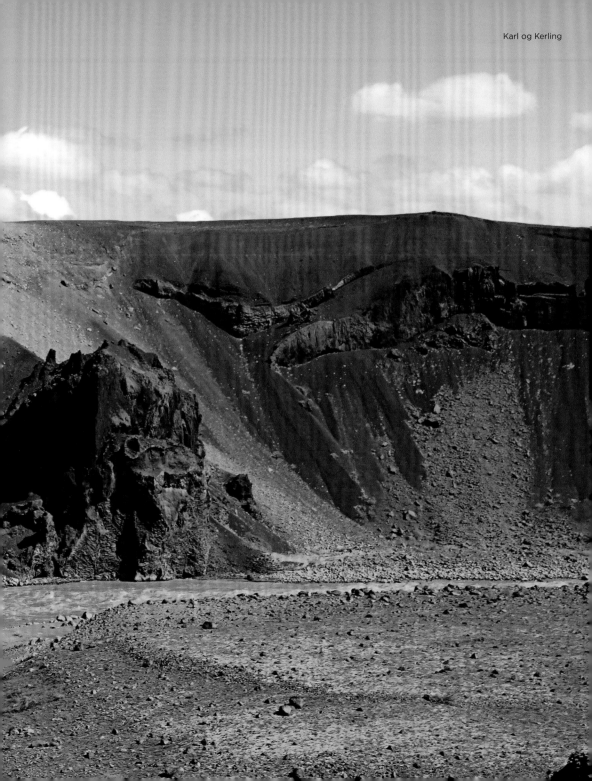

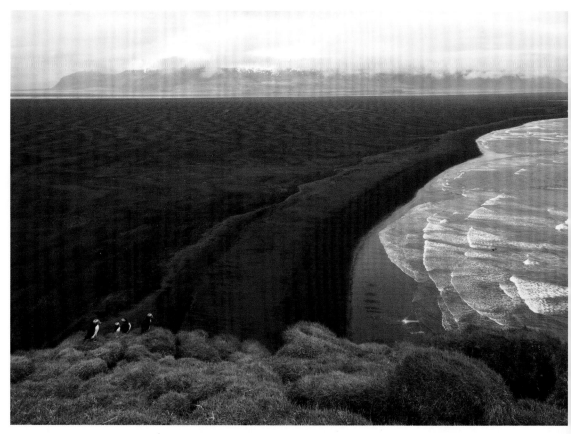

Ingólfshöfði

Ingólfshöfði

Ingólfshöfði is a headland rising from the black sands that are washed over at high tide. This is where the first settler of Iceland, Ingólfur Arnarson, is said to have landed. The plateau offers nesting grounds for thousands of birds.

Ingólfshöfði

Ingólfshöfði est un cap rocheux s'élevant des sables noirs, recouverts à marée haute. C'est là que le premier colon d'Islande, Ingólfur Arnarson, aurait débarqué. Le plateau est un lieu de nidification pour des milliers d'oiseaux.

Ingólfshöfði

Ingólfshöfði ist ein Vogelfelsen, der sich aus schwarzen, bei Flut überspülten Sanderflächen erhebt. Hier soll der erste Siedler Islands, Ingólfur Arnarson, gelandet sein. Das Plateau bietet tausenden Vögeln Nistplätze.

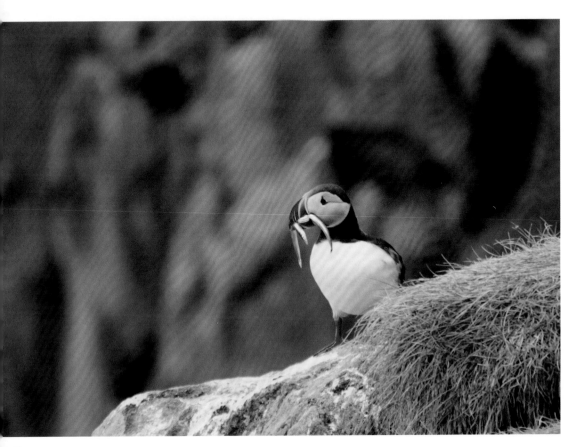

Puffin

Ingólfshöfði

Ingólfshöfði es un acantiladode pájaros formado por arenas negras arrastradas por la marea alta. Aquí es donde se dice que desembarcó el primer colono de Islandia, Ingólfur Arnarson.. La meseta ofrece lugares de anidación para miles de aves.

Ingólfshöfði

Ingólfshöfði è una scogliera per uccelli che nasce dalle sabbie nere bagnate durante l'alta marea. Qui sarebbe attraccato il primo colono d'Islanda, Ingólfur Arnarson. L'altopiano offre zone di nidificazione per migliaia di uccelli.

Ingólfshöfði

Ingólfshöfði is een vogelrots die oprijst uit een zwarte, bij vloed overspoelde spoelzandvlakte. Hier zou de eerste kolonist van IJsland, Ingólfur Arnarson, aan land zijn gekomen. Het plateau biedt nestplaatsen aan duizenden vogels.

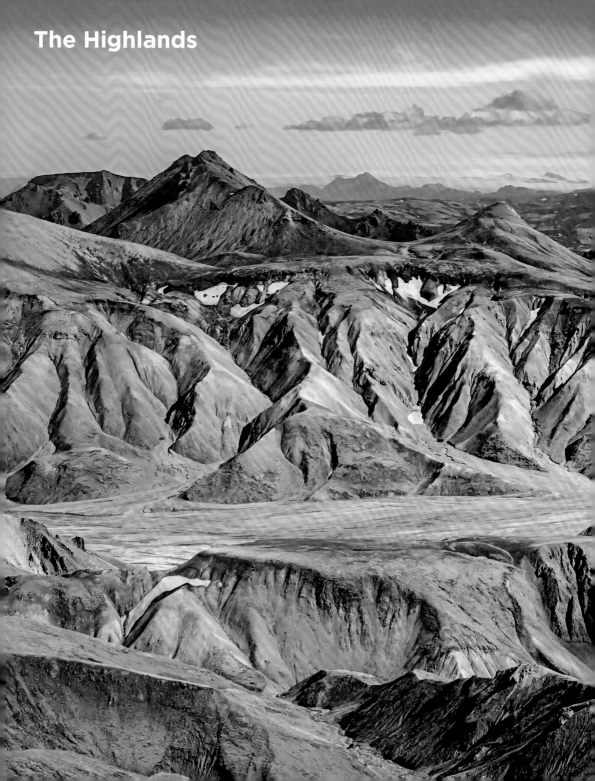

The Highlands

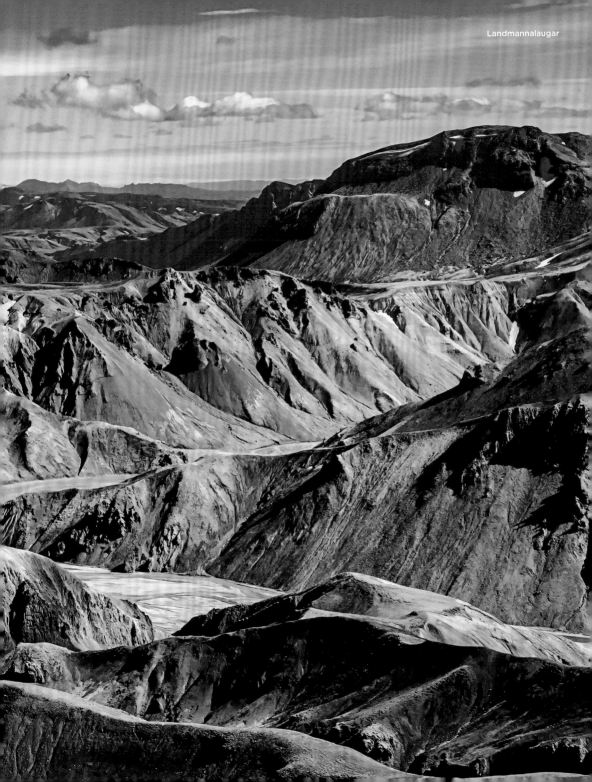

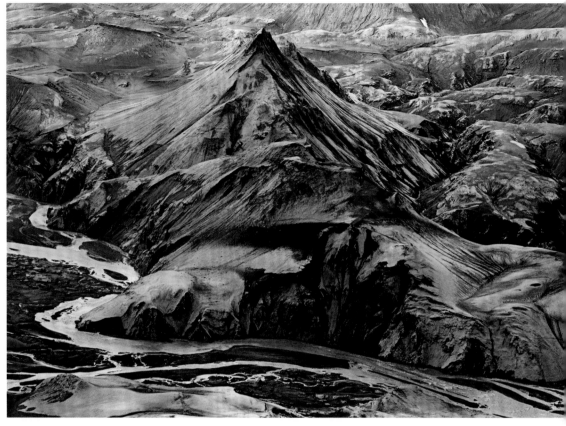

Lakagígar, craters of Laki

The Highlands

Except for a narrow coastal strip, the rest of the island belongs to the highlands. The interior of the island is hostile to life and therefore almost uninhabited, but its colourful rhyolite mountains, rugged, eroded peaks, hot springs, deep gorges, and dramatic volcanic activities exert a powerful fascination. Only a few roads, most of which can only be taken by four-wheel-drive vehicles, lead into the highlands. The most demanding tour a visitor can undertake—and every Icelander's dream—is to cross the island along the Sprengisandur route.

Les Hautes Terres

À l'exception d'une étroite bande côtière, la majorité de l'Islande fait partie de la région montagneuse des Hautes Terres. L'intérieur de l'île est hostile à la vie et donc presque inhabité, mais fascine par ses montagnes colorées de rhyolite, ses pics rugueux et érodés, ses sources chaudes, ses profondes gorges et son activité volcanique spectaculaire. Seules quelques pistes, qui ne peuvent généralement être empruntées uniquement par des véhicules à quatre roues motrices, mènent aux hauts plateaux. Le chemin le plus exigeant – et le rêve de chaque Islandais – est la traversée de l'île sur la route de Sprengisandur.

Das Hochland

Bis auf einen schmalen Küstenstreifen zählt der große Rest der Insel zum Hochland. Das Inselinnere ist lebensfeindlich und deshalb fast unbesiedelt, es fasziniert aber mit farbigen Rhyolithbergen, schroffen, erodierten Gipfeln, heißen Quellen, tiefen Schluchten und dramatischen vulkanischen Aktivitäten. Nur wenige, meist nur mit Allradfahrzeugen zu bewältigende Pisten führen ins Hochland. Die anspruchsvollste Tour und Traum jedes Islandfahrers ist die Durchquerung der Insel auf der Sprengisandur-Route.

Goats in Landmannalaugar

Las Tierras Altas

Excepto por una estrecha franja costera, el resto de la isla forma parte de las tierras altas. El interior de la isla es hostil a la vida y, por lo tanto casi deshabitado, pero fascina con coloridas montañas de riolita, picos escarpados y erosionados, aguas termales, profundas gargantas y una actividad volcánica extrema. Solo unas pocas pistas, que por lo general solo pueden ser dominadas por vehículos 4×4, conducen a las tierras altas. El viaje más exigente y soñado de todo islandés es la travesía de la isla por la ruta Sprengisandur.

Gli Altipiani

Ad eccezione di una stretta fascia costiera, il resto dell'isola appartiene agli Altipiani. L'interno dell'isola è ostile alla vita e quindi quasi disabitato, ma affascina con le sue colorate montagne di riolite, le sue cime aspre ed erose, le sue sorgenti termali, le sue gole profonde e le sue drammatiche attività vulcaniche. Solo poche piste, di solito percorribili solo con fuoristrada, conducono sull'Altopiano. Il tour più impegnativo e il sogno di ogni Islandese è di attraversare l'isola sulla rotta Sprengisandur.

De hooglanden

Behalve een smalle kuststrook behoort de rest van het eiland tot de hooglanden. Het binnenland biedt geen levenskansen en is daarom bijna onbewoond, maar het fascineert wel, met kleurige ryolietbergen, ruige, geërodeerde toppen, warmwaterbronnen, diepe kloven en dramatische vulkanische activiteit. Slechts enkele pistes, die meestal alleen begaanbaar zijn met voertuigen met vierwielaandrijving, leiden naar het hoogland. De meest veeleisende tocht en droom van iedere IJslander is het eiland via de Sprengisandur-route te doorkruisen.

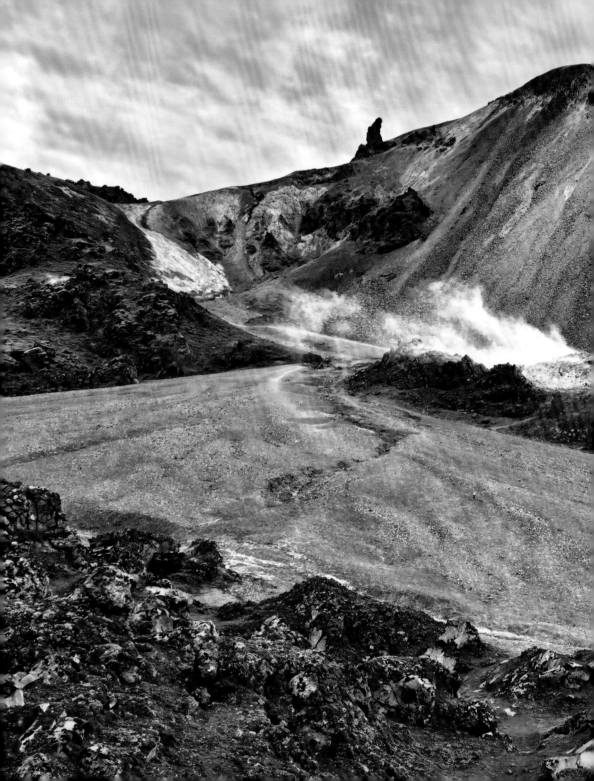

Brennisteinsalda

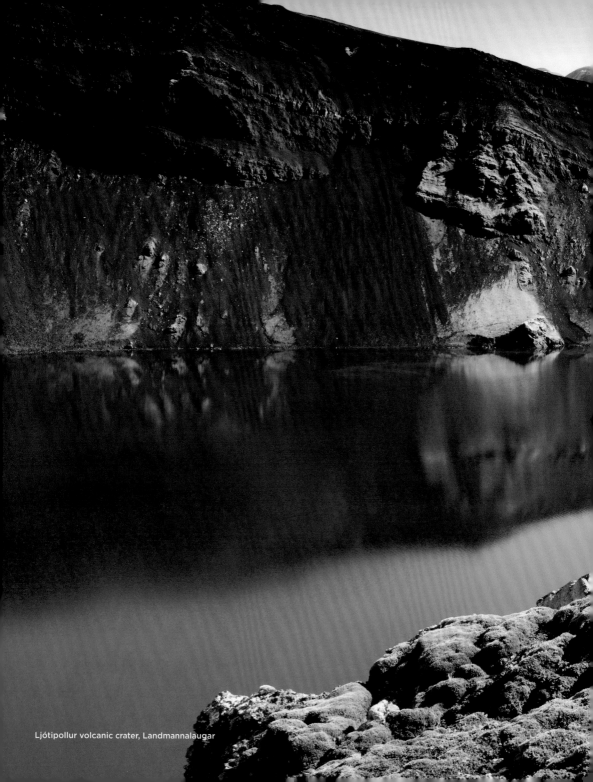

Ljótipollur volcanic crater, Landmannalaugar

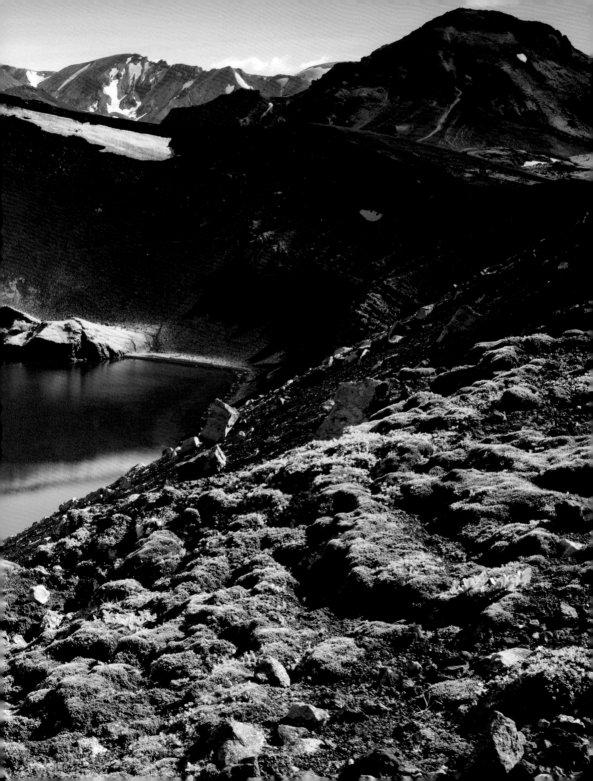

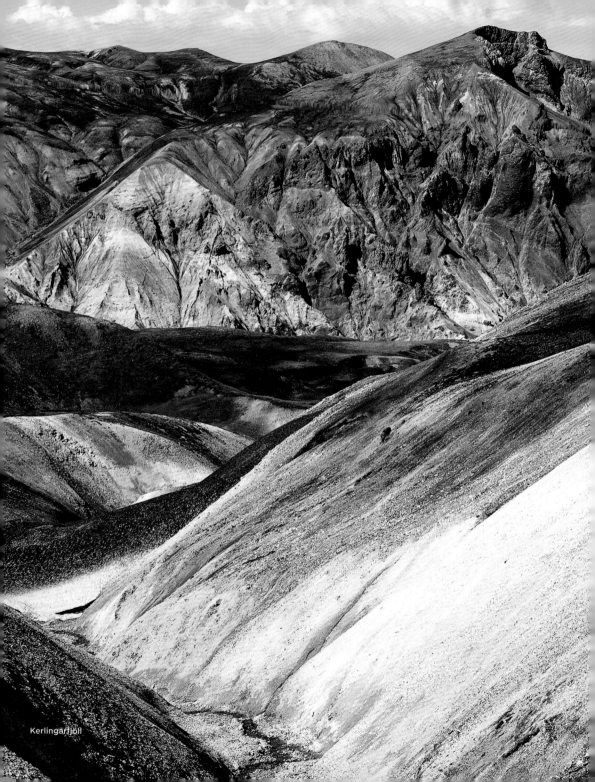

Kerlingarfjöll

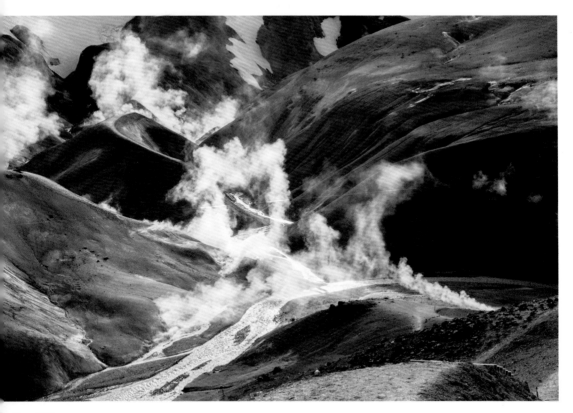

Kerlingarfjöll

Kerlingarfjöll

The Kerlingarfjöll volcanic mountain range lies just a short way off the Kjölur route in the highlands. Its ochre and sulphur-yellow hills contrast with the green moss and snowy white caps of the peaks. The typical rotten-egg smell of volcanic activity permeates the warm region of Hveradalir.

Kerlingarfjöll

Wer auf der Kjölur-Route im Hochland unterwegs ist, erreicht den vulkanischen Gebirgszug Kerlingarfjöll auf einem kurzen Abstecher. Seine schwefelgelben und ockerfarbenen Hügel stehen im Kontrast zu den grünen Moosflächen und den weißen Schneekappen der Gipfel. Über dem Hochtemperaturgebiet Hveradalir liegt der typische Geruch des Vulkanismus nach faulen Eiern.

Kerlingarfjöll

Chi è sulla pista Kjölur negli Altopiani, raggiunge la catena montuosa vulcanica Kerlingarfjöll in un breve viaggio. Le sue colline giallo zolfo e color ocra contrastano con il muschio verde e le candide cime innevate. Al di sopra della zona ad alta temperatura di Hveradalir si sente il tipico odore dell'attività vulcanica delle uova marce.

Kerlingarfjöll

Depuis la route de Kjölur, dans les Hautes Terres, il est possible d'atteindre la chaîne de montagnes volcaniques Kerlingarfjöll par un court détour. Ses collines jaune soufre et ocres contrastent avec la mousse verte et les chapeaux de neige blanche des sommets. Au-dessus de la zone géothermique de Hveradalir, on retrouve l'odeur typique des volcans, proche de celle des œufs pourris.

Kerlingarfjöll

Quien conduzca por la ruta de Kjölur, en las tierras altas, llegará a la cordillera volcánica Kerlingarfjöll en un trajecto corto. Sus colinas de color amarillo azufre y ocre contrastan con los verdes musgos y los blancos casquetes nevados de los picos. Por encima de la zona de alta temperatura de Hveradalir, se encuentra el olor a huevos podridos, propio de la actividad volcánica.

Kerlingarfjöll

Wie de Kjölur-route in het hoogland bereist, bereikt na een korte omweg de vulkanische bergketen Kerlingarfjöll. De zwavelgele en okerkleurige heuvels contrasteren schril met de groene mosvlakten en de witte sneeuw op de toppen. Boven het geothermische gebied van Hveradalir hangt de voor vulkaanactiviteit kenmerkende geur van rotte eieren.

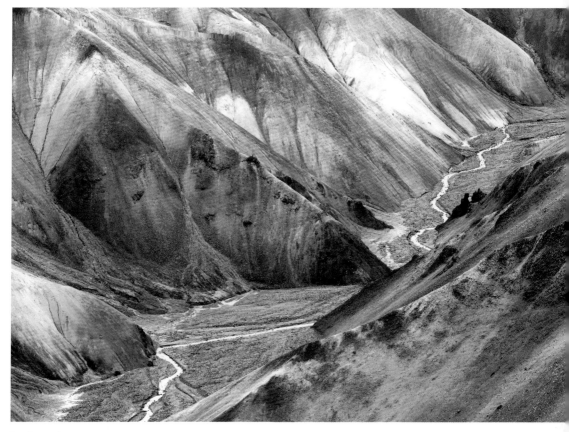

Landmannalaugar

Landmannalaugar

The entire region north of Mýrdalsjökull is an orgy of colour. Rhyolite turns the mountain slopes yellow, orange, and brown, in rare cases even turquoise. Deep black obsidian streaks and green meadows offer a stunning contrast. Warm springs invite you to swim, and the Laugavegur trail to a four-day hike through a fairy-tale landscape to Þórsmörk.

Landmannalaugar

Toute la région au nord du glacier de Mýrdalsjökull est une explosion de couleur. La rhyolite teinte les pentes de montagne en jaune, orange et brun, voire dans de rares cas turquoise, contrastées par les ruisseaux d'obsidienne noirs profonds et les prairies vertes. Il est possible de s'y baigner dans les sources chaudes ou de réaliser une randonnée de quatre jours sur le Laugavegur («route des sources chaudes»), à travers un paysage féerique qui s'étend jusqu'à Þórsmörk.

Landmannalaugar

Die gesamte Region nördlich des Mýrdalsjökull ist eine einzige Farborgie. Rhyolith färbt die Berghänge gelb, orange und braun, in seltenen Fällen sogar türkis. Den Kontrast bilden tiefschwarze Obsidianströme und grüne Wiesen. Warme Quellen laden zum Baden ein und der Laugavegur zu einer viertägigen Wanderung durch eine Märchenlandschaft nach Þórsmörk.

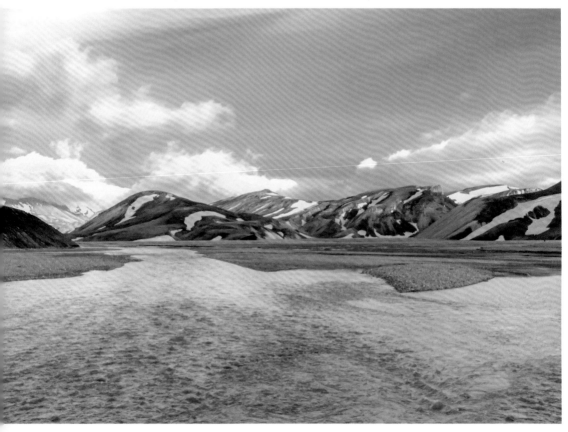

Landmannalaugar, Fjallabak Nature Reserve

Landmannalaugar
Toda la región al norte de Mýrdalsjökull
es un festival monocromático. La riolita
tiñe las laderas de la montaña de amarillo,
naranja y marrón, en raras ocasiones
incluso turquesa. El contraste está formado
por profundos arroyos de obsidiana negra
y verdes praderas. Los cálidos manantiales
invitan a nadar y, el camino Laugavegur,
a una caminata de cuatro días a través de
un paisaje de cuento de hadas que llega
hasta Þórsmörk.

Landmannalaugar
L'intera regione a nord di Mýrdalsjökull è
caratterizzata da un tripudio di colori. La
riolite colora le pendici della montagna
di giallo, arancione e marrone, in rari casi
anche turchese. Il contrasto è formato
dai ruscelli di ossidiana di colore nero
profondo e dai prati verdi. Le sorgenti
calde invitano a nuotare e il Laugavegur a
un'escursione di quattro giorni attraverso
un paesaggio fiabesco fino a Þórsmörk.

Landmannalaugar
De hele regio ten noorden van de
Mýrdalsjökull is een orgie van kleur. Ryoliet
kleurt de berghellingen geel, oranje en
bruin, in zeldzame gevallen zelfs turkoois.
Het contrast wordt gevormd door
diepzwarte obsidiaanstromen en groene
weiden. Warmwaterbronnen nodigen
uit om te baden en de Laugavegur voor
een vierdaagse wandeling door een
sprookjesachtig landschap naar Þórsmörk.

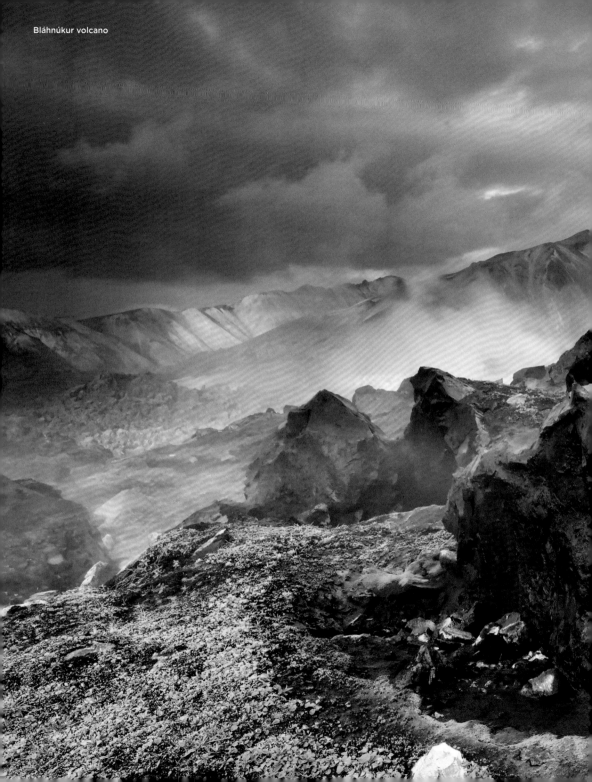
Bláhnúkur volcano

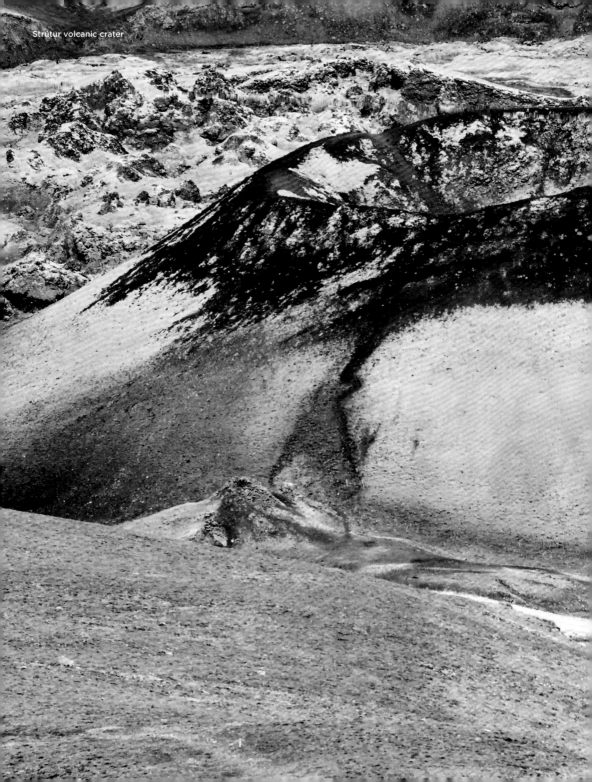
Strútur volcanic crater

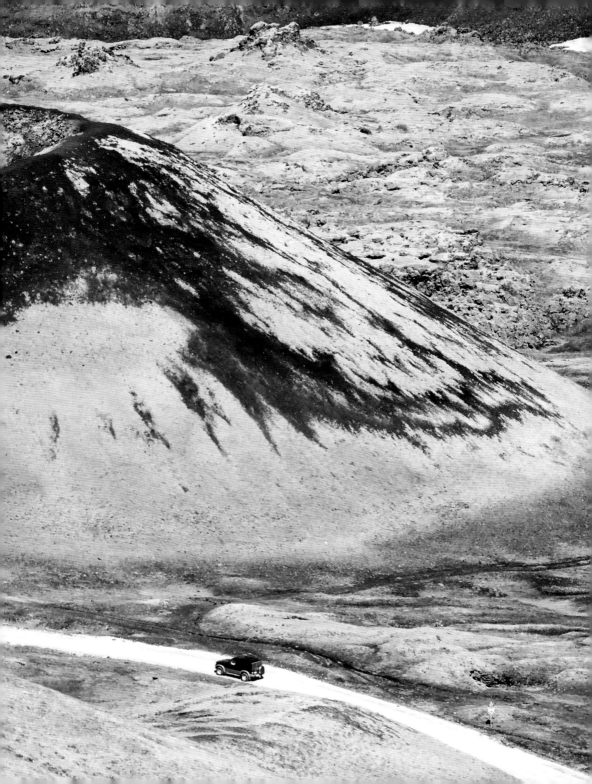

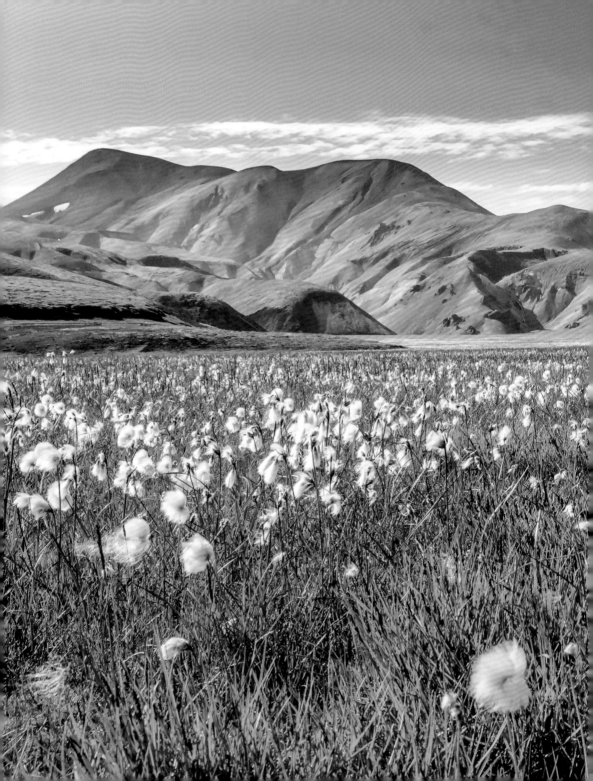

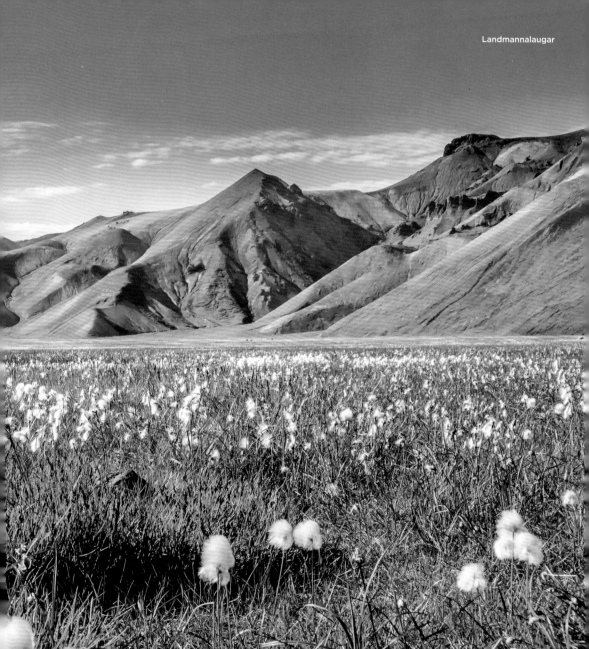

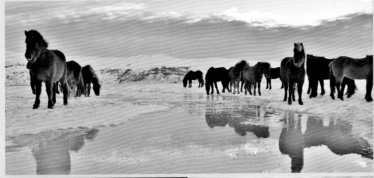
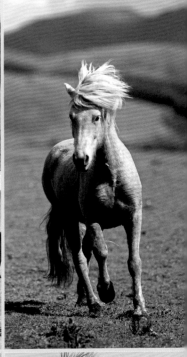
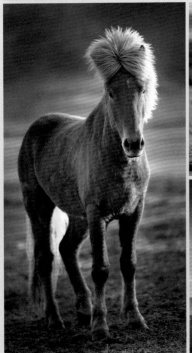
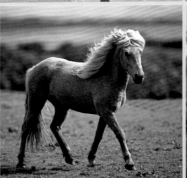
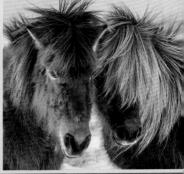
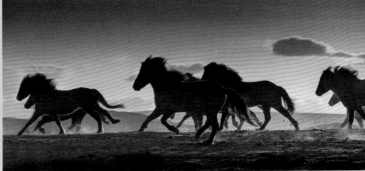

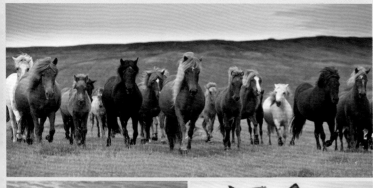

Icelandic Horses

Small, robust, hearty and hale: these much-loved creatures are typical of the island. They are very good-natured and thus excellent even for beginning riders. The little horses also proved almost indispensable in the settlement of the island. One of their special talents is the tölt, a fourth gait, which is almost vibration-free for the rider.

Chevaux islandais

Petits, robustes, résistants : les chevaux islandais, très appréciés, sont typiques de l'île. Ils peuvent aussi être montés par des débutants car ils sont considérés comme étant de très bonne nature. Ils ont été presque indispensables à la colonisation de l'Islande. L'une de leurs particularités est la maîtrise du tölt, une quatrième allure presque sans vibrations pour les cavaliers.

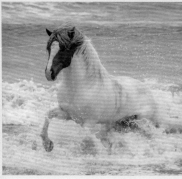
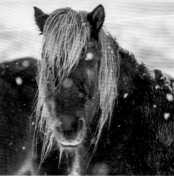

Islandpferde

Klein, robust, ausdauernd: Die vielgeliebten Vierbeiner sind typisch für die Insel. Auch Anfänger können sie reiten, sie gelten als sehr gutmütig. Für die Besiedlung Islands waren sie nahezu unentbehrlich. Eine Besonderheit ist der Tölt, eine vierte Gangart, die für die Reiter fast erschütterungsfrei ist.

Caballos islandeses

Pequeños, robustos, duraderos: estos queridos animales son típicos de la isla. También pueden montar principiantes, se les considera muy bondadosos. Eran casi indispensables para el asentamiento de Islandia. Una característica especial es el Tölt, otra tipo de caballo, que apenas implica vibraciones para los jinetes.

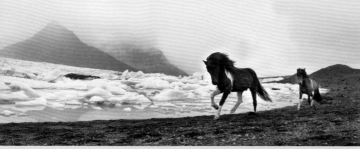

Cavalli islandesi

Piccolo, robusto, resistente: gli amatissimi amici a quattro zampe sono tipici di quest'isola. Anche i principianti li possono cavalcare i principianti, sono considerati di carattere mite. Sono stati quasi indispensabili per l'insediamento dell'Islanda. Una caratteristica speciale è il tölt, una quarta andatura, che è quasi privo di sbalzi per i cavalieri.

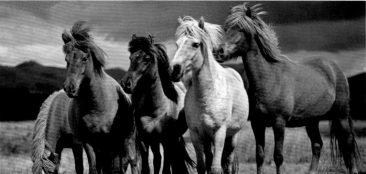

IJslandse paarden

Klein, robuust en onvermoeibaar: de geliefde viervoeters zijn karakteristiek voor het eiland. Ook beginners kunnen ze berijden, want ze worden als zeer goedhartig beschouwd. Ze waren bijna onmisbaar voor het bewoonbaar maken van IJsland. Bijzonder is de tölt, een vierde gang, die voor de berijders bijna schokvrij is.

Landmannalaugar

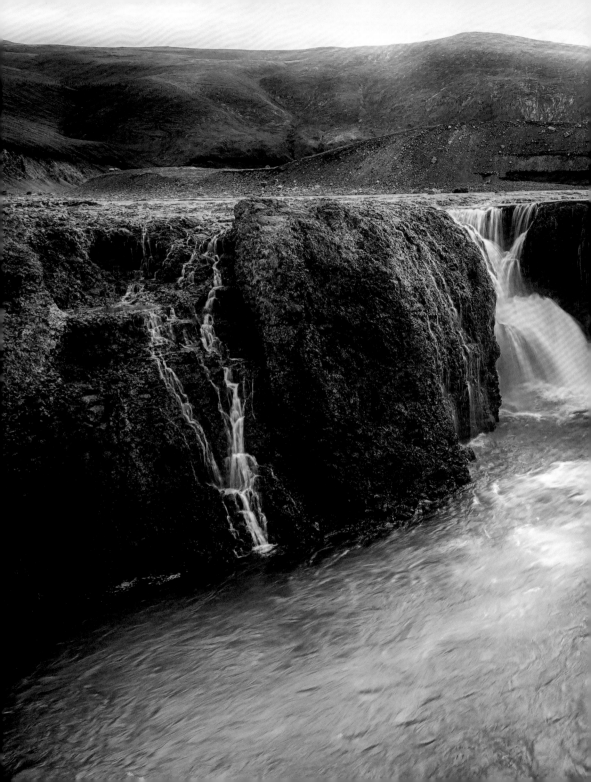

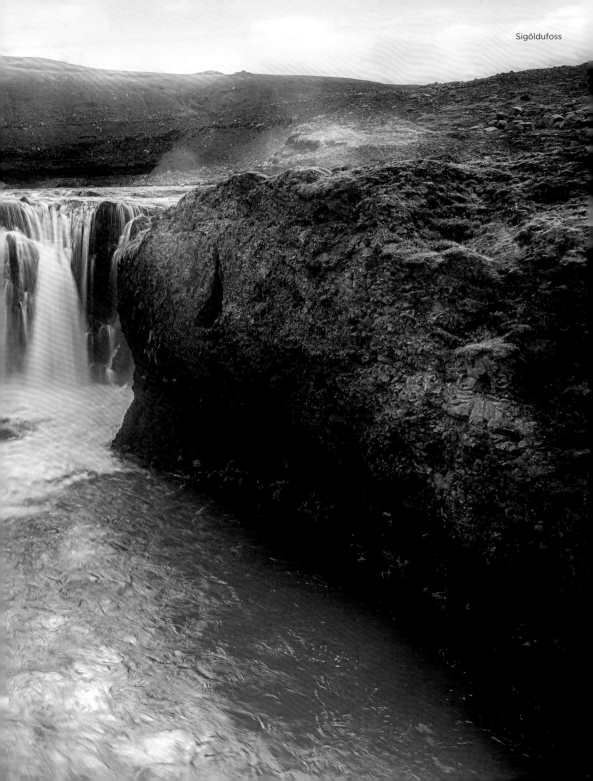

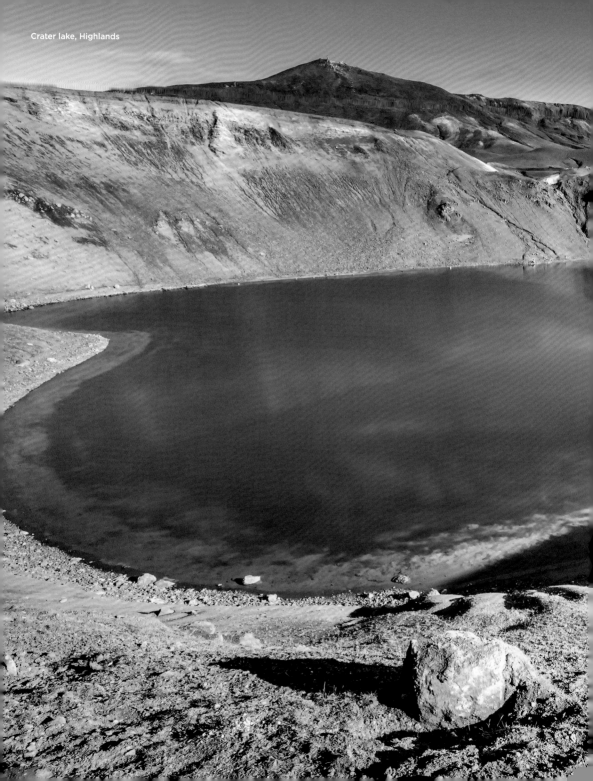
Crater lake, Highlands

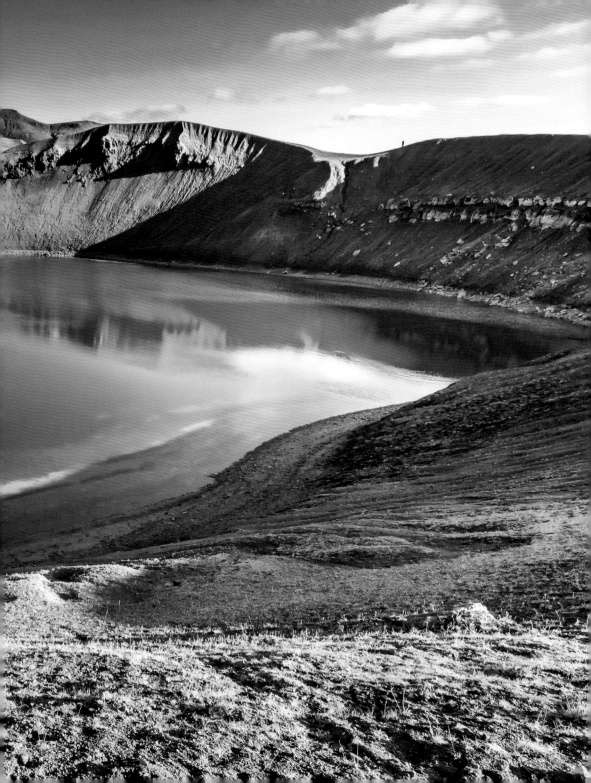

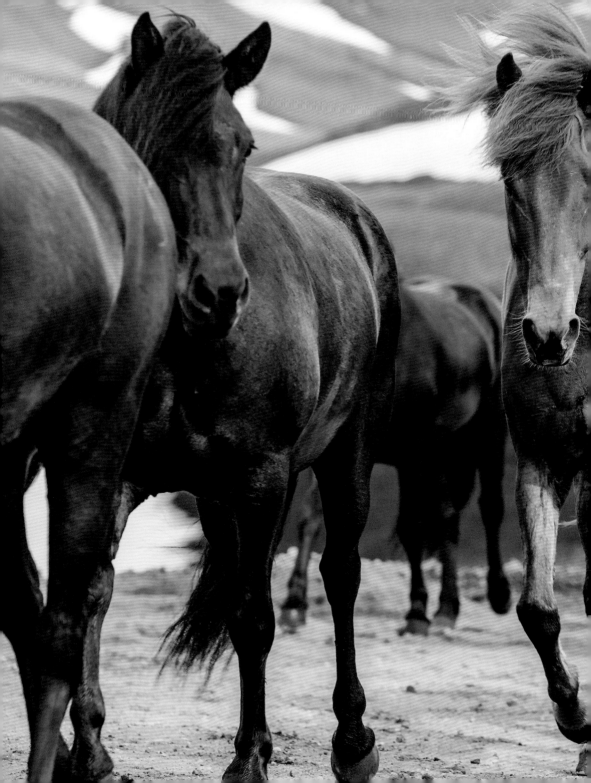

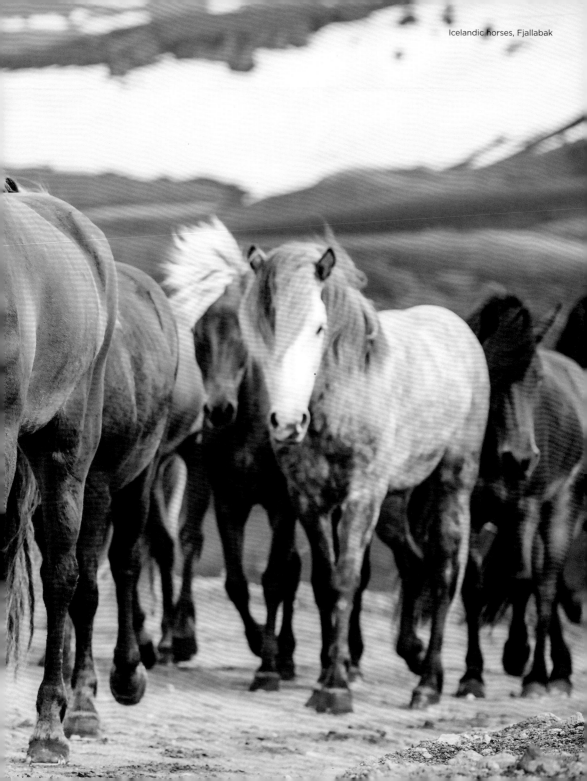

Icelandic horses, Fjallabak

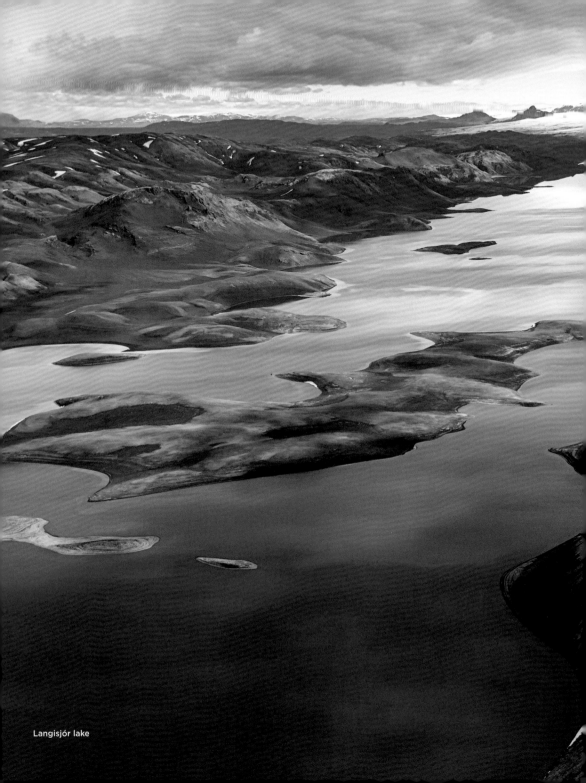

Langisjór lake

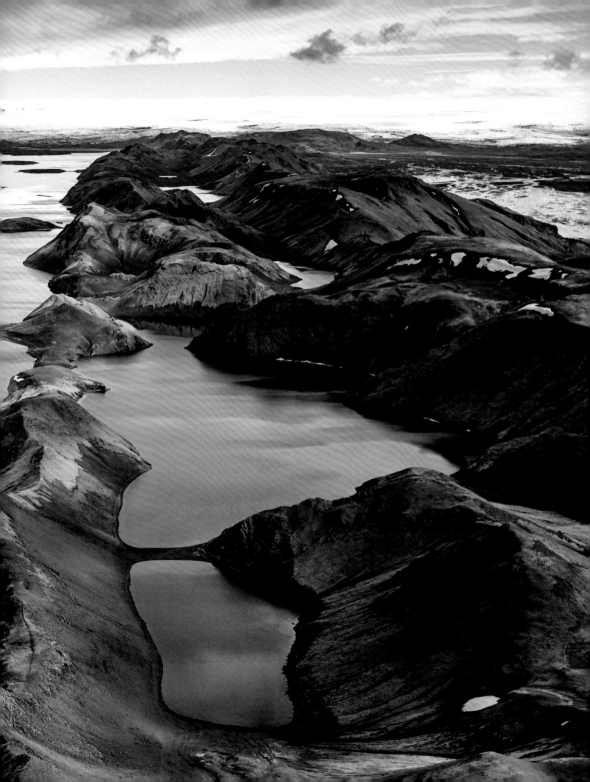

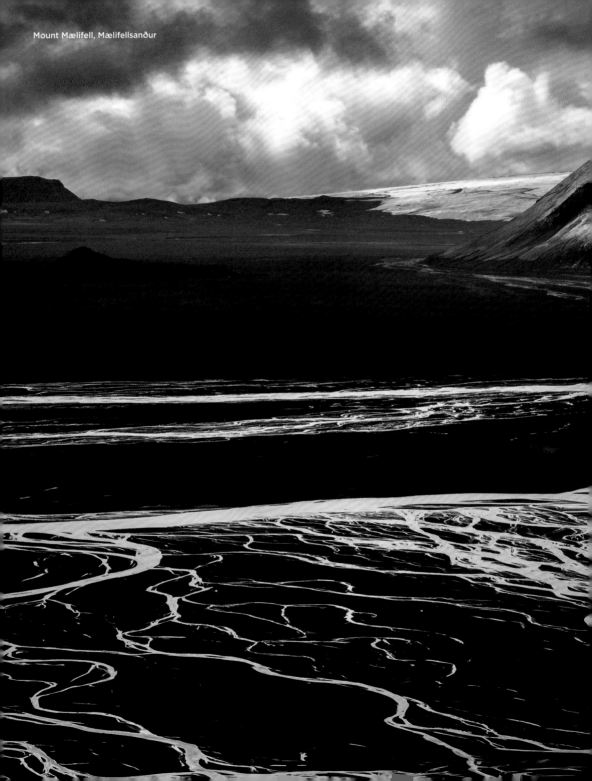

Mount Mælifell, Mælifellsanður

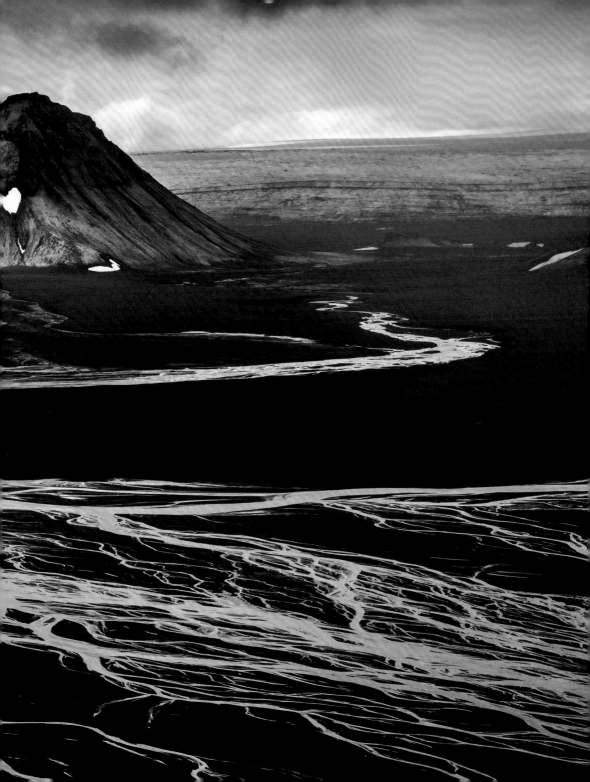

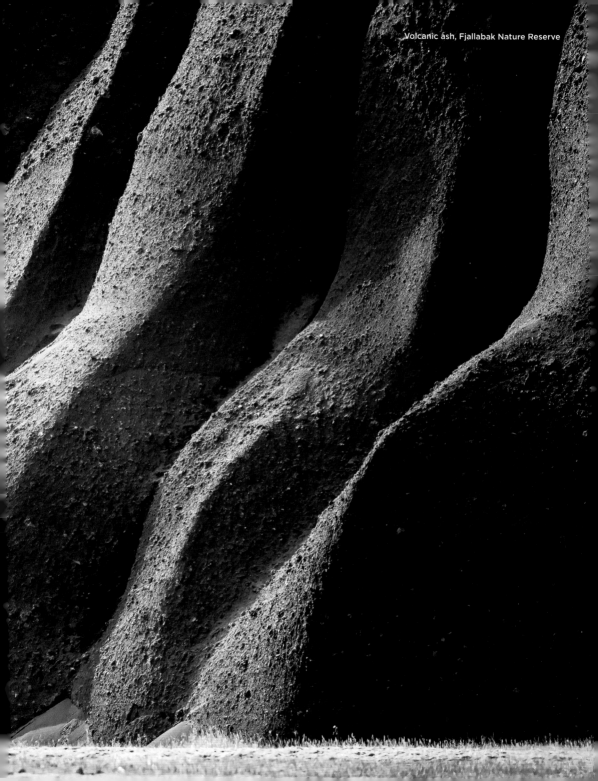
Volcanic ash, Fjallabak Nature Reserve

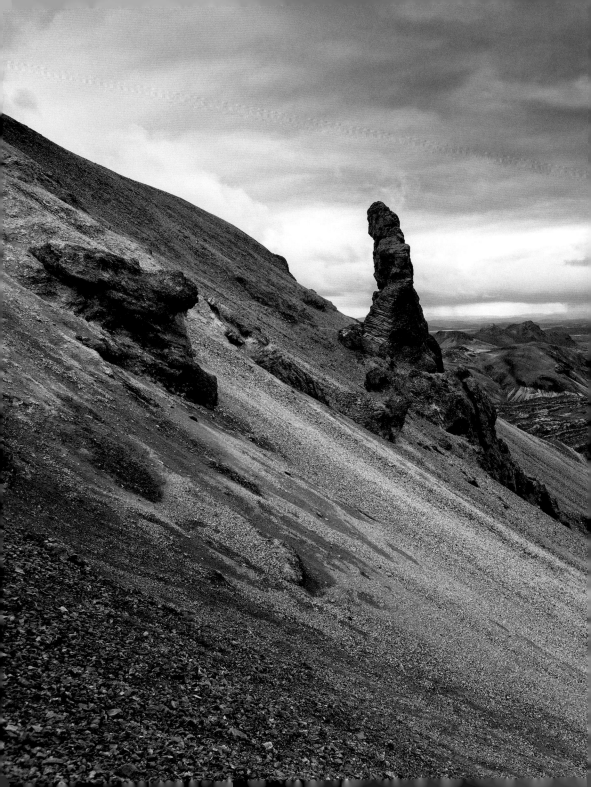

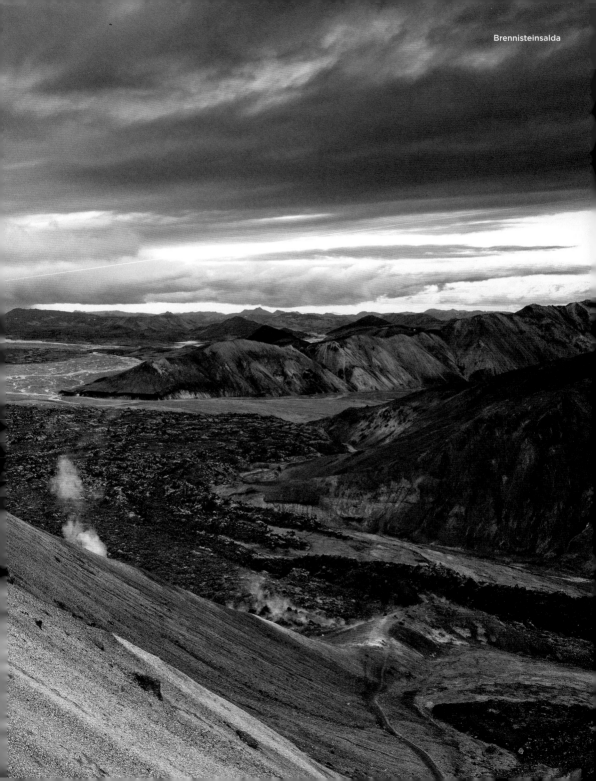

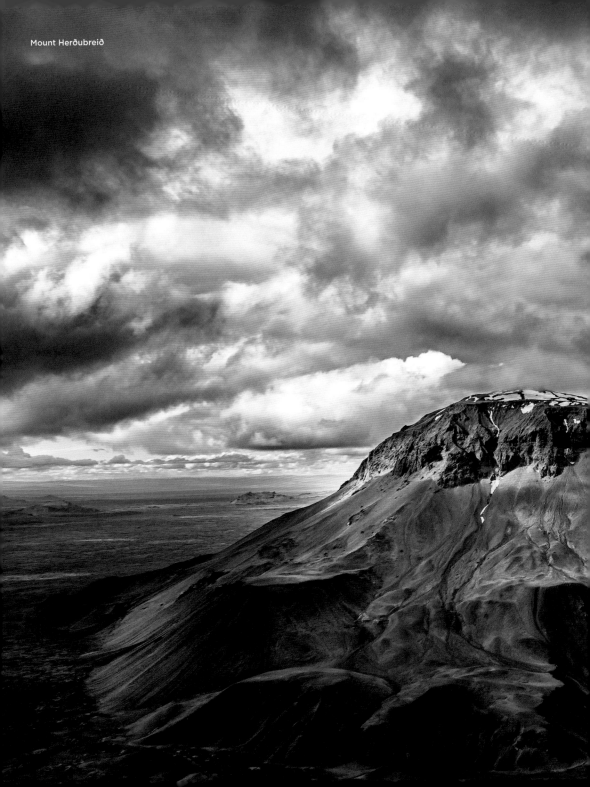

Mount Herðubreið

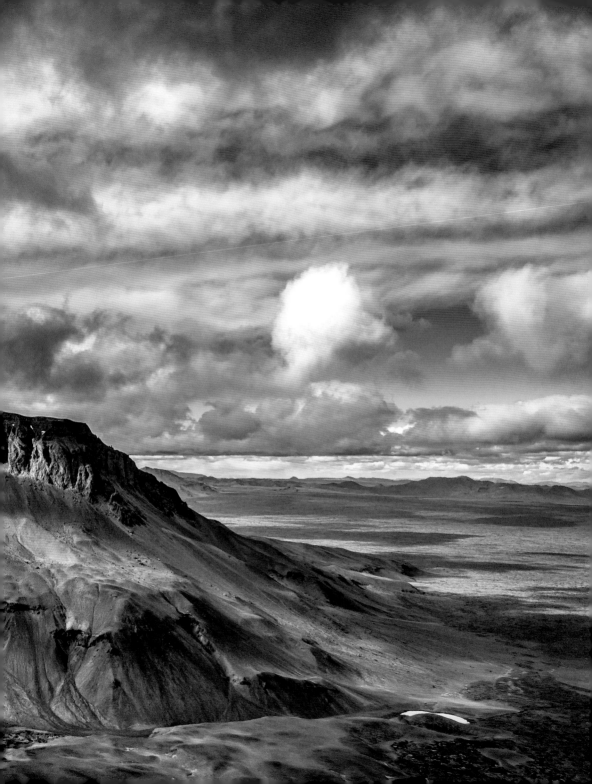

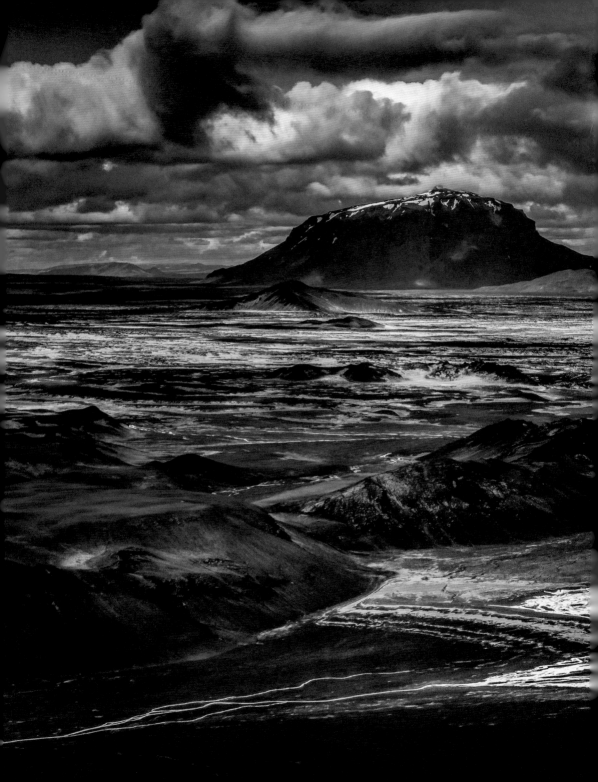

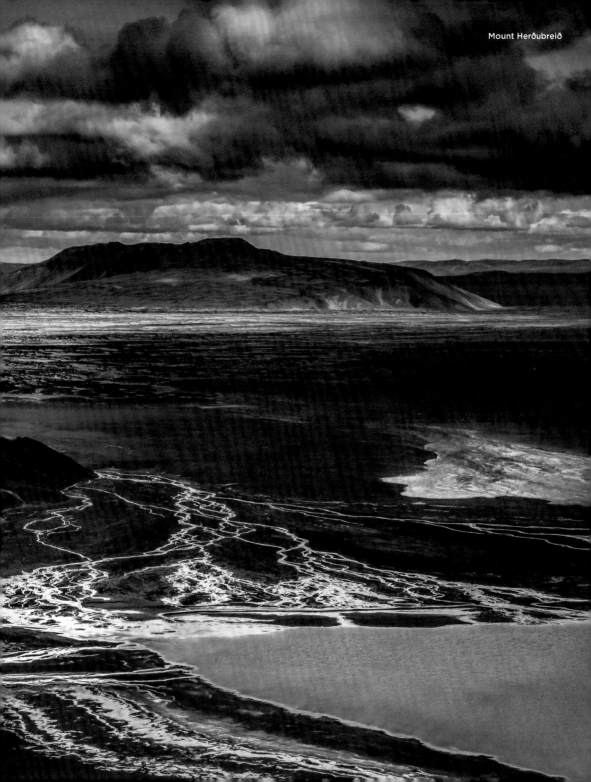

Mount Herðubreið

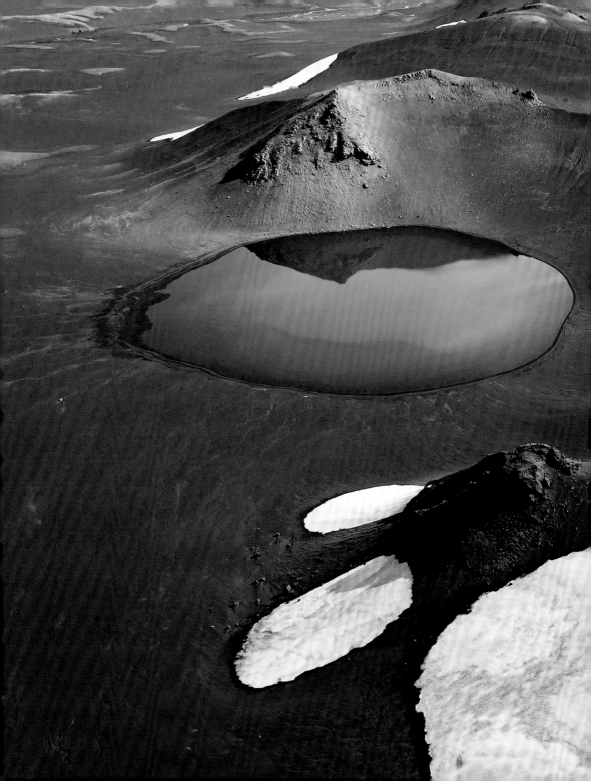

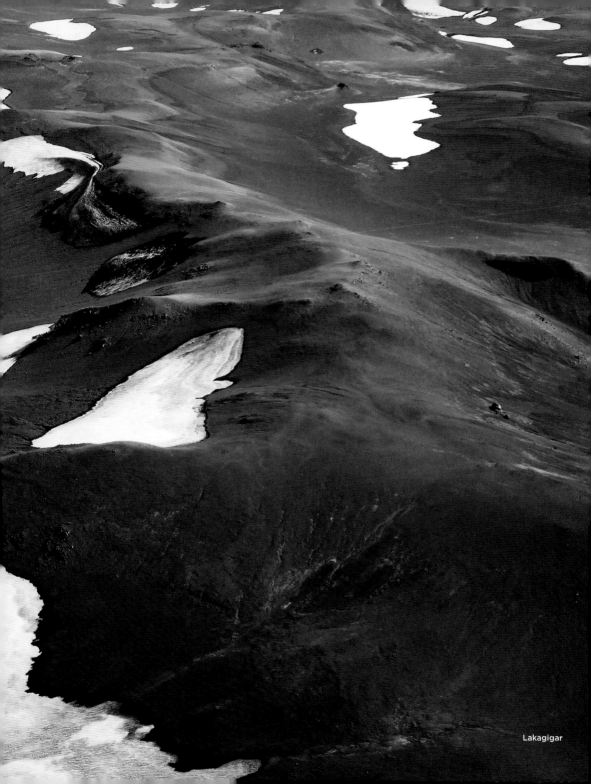
Lakagigar

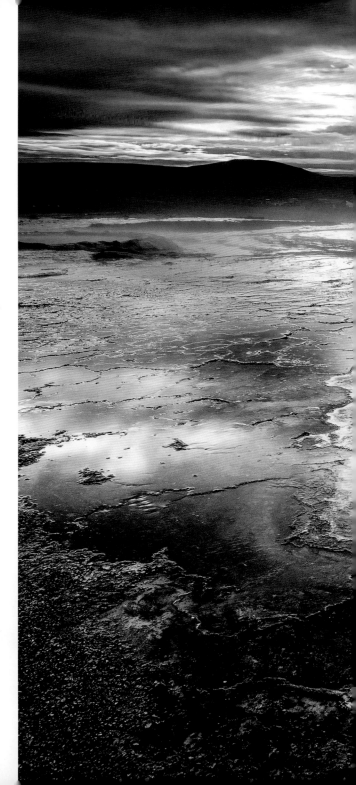

Geothermal pool, Hveravellir

Hveravellir
This geothermal area, under environmental protection since 1960, is located in the highlands almost exactly between Reykjavík and Akureyri. It can also be reached from the south on the Kjölur route without a four-wheel-drive vehicle. Here you can bathe in a hot spring, stay overnight in a hiking club hut, and walk to fumaroles and solfataras.

Hveravellir
La zone géothermique, protégée depuis 1960, est située dans les Hautes Terres, presque exactement entre Reykjavík et Akureyri. On peut également y accéder par le sud via la route de Kjölur sans véhicule à quatre roues motrices. Ici, vous pourrez vous baigner dans une source chaude, passer la nuit dans une cabane du club de randonnée et vous promener dans les fumerolles et les solfatares.

Hveravellir
Das seit 1960 geschützte Geothermalgebiet befindet sich im Hochland ziemlich genau in der Mitte zwischen Reykjavík und Akureyri. Von Süden ist es auf der Kjölur-Route auch ohne Allradfahrzeug zu erreichen. Hier kann man in einer heißen Quelle baden, in einer Hütte des Wandervereins übernachten und einen Spaziergang zu Fumarolen und Solfataren unternehmen.

Hveravellir
La zona geotérmica, que está protegida desde 1960, está situada en las tierras altas casi equidistante entre Reikiavik y Akureyri. También se puede llegar desde el sur por la ruta de Kjölur sin un vehículo 4×4. Aquí es posible bañarse en un manantial termal, pasar la noche en una cabaña del club de senderismo y dar un paseo a fumarolas y solfataras.

Hveravellir
L'area geotermica, protetta dal 1960, si trova negli Altopiani quasi esattamente a metà strada tra Reykjavík e Akureyri. È raggiungibile anche da sud sulla pista Kjölur senza bisogno di fuoristrada. Qui è possibile fare il bagno in una sorgente termale, pernottare in una capanna del club escursionistico e fare una passeggiata tra le fumarole e le solfatare.

Hveravellir
Het sinds 1960 beschermde geothermische gebied ligt in het hoogland bijna precies tussen Reykjavik en Akureyri in. Het kan vanuit het zuiden ook via de Kjölur-route worden bereikt zonder voertuig met vierwielaandrijving. Hier kunt u baden in een heetwaterbron, overnachten in een hut van de wandelvereniging en wandelen naar fumarolen en solfataren.

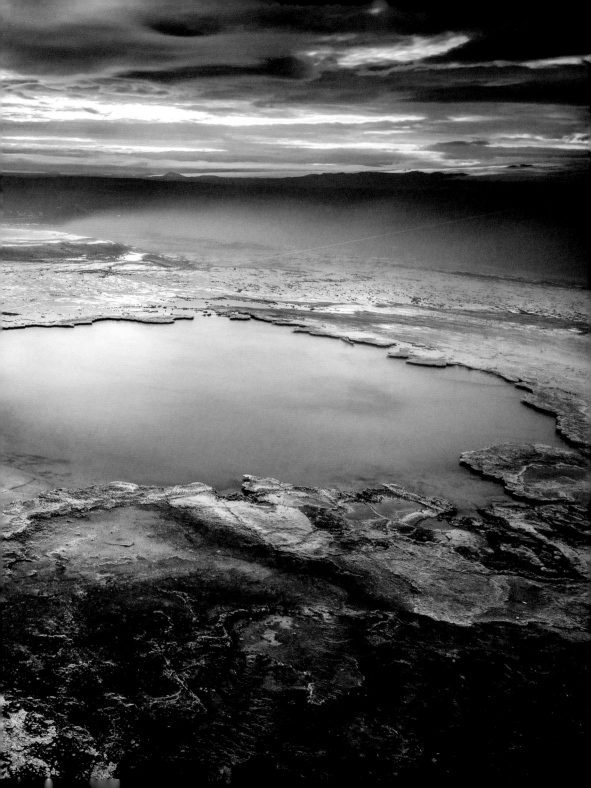

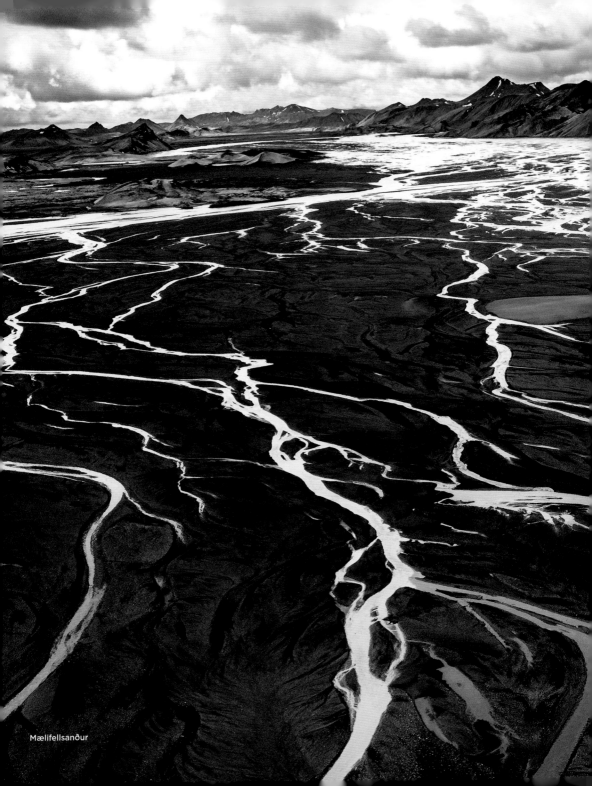

Mælifellsanður

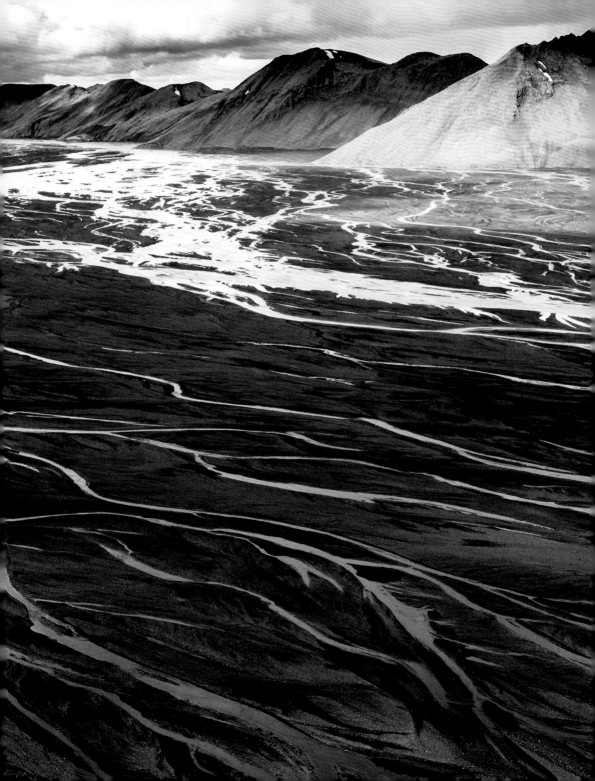

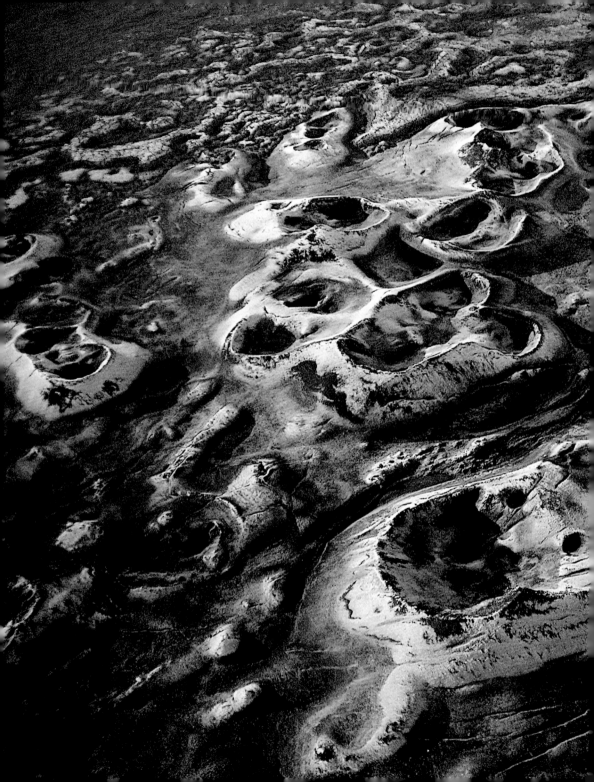

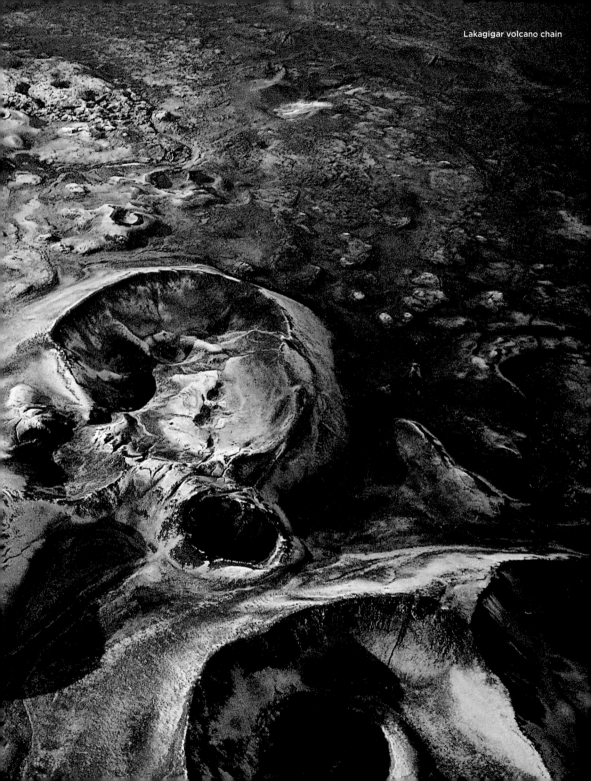
Lakagígar volcano chain

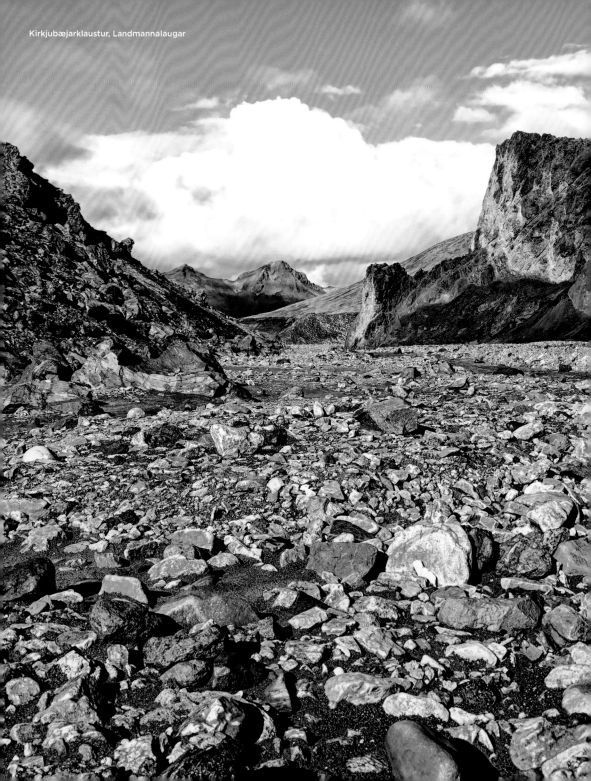

Gjáin

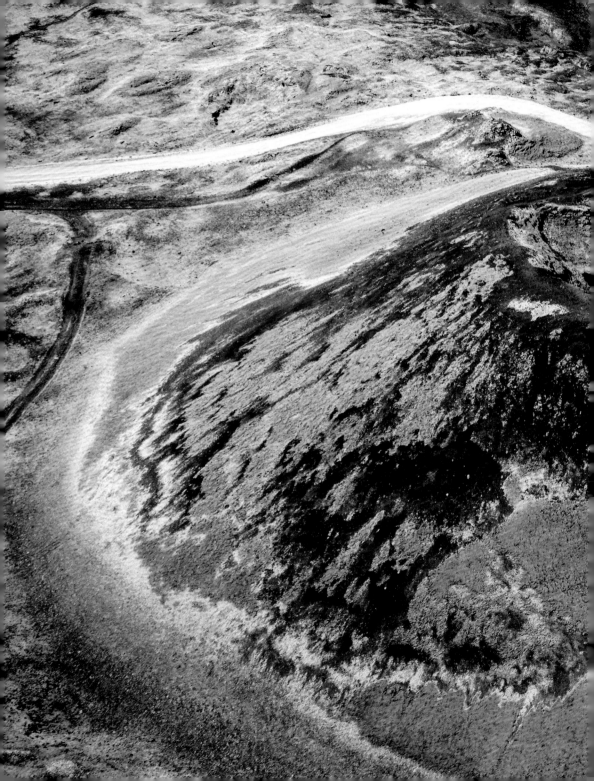

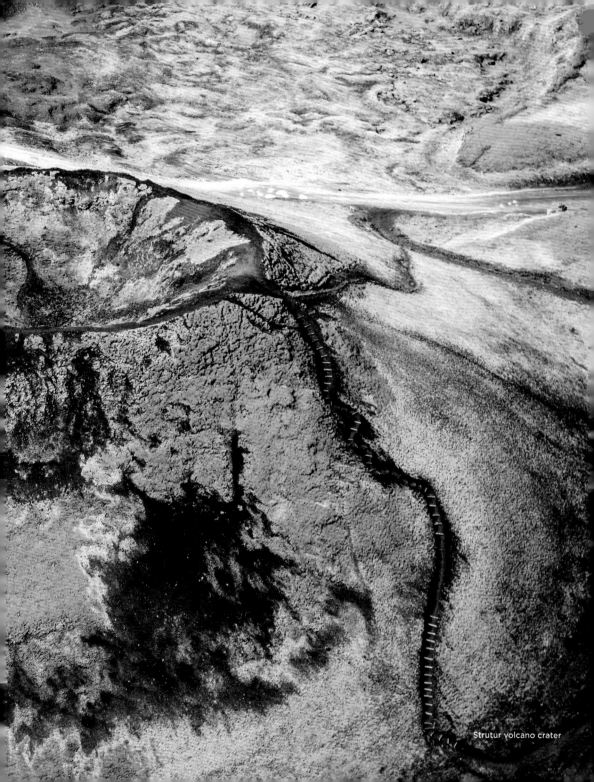

Strutur volcano crater

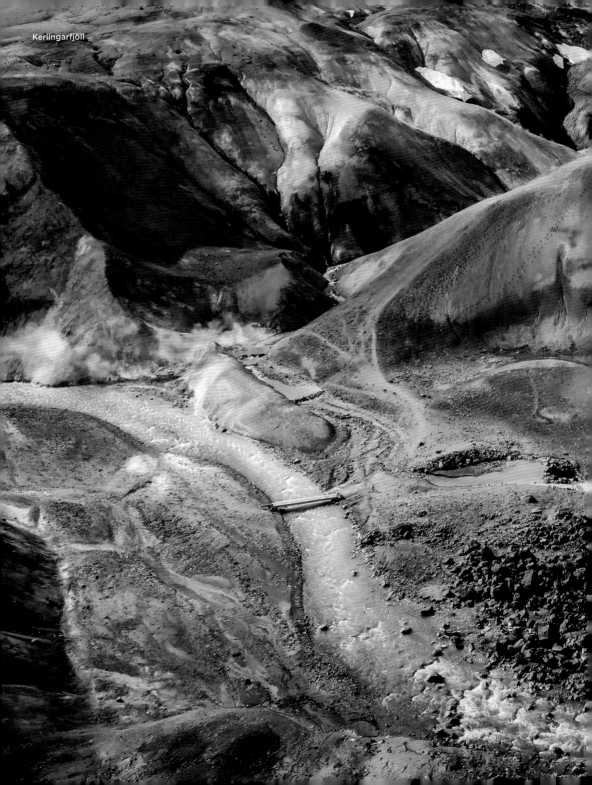

Kerlingarfjöll

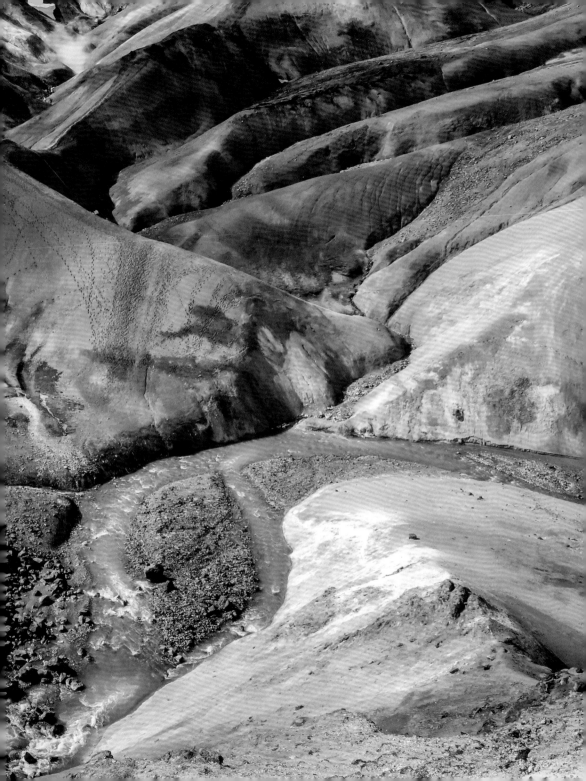

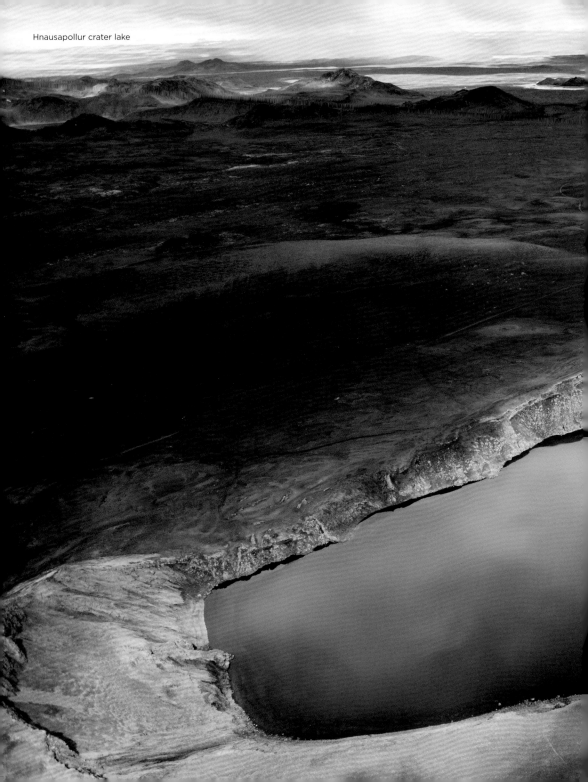

Hnausapollur crater lake

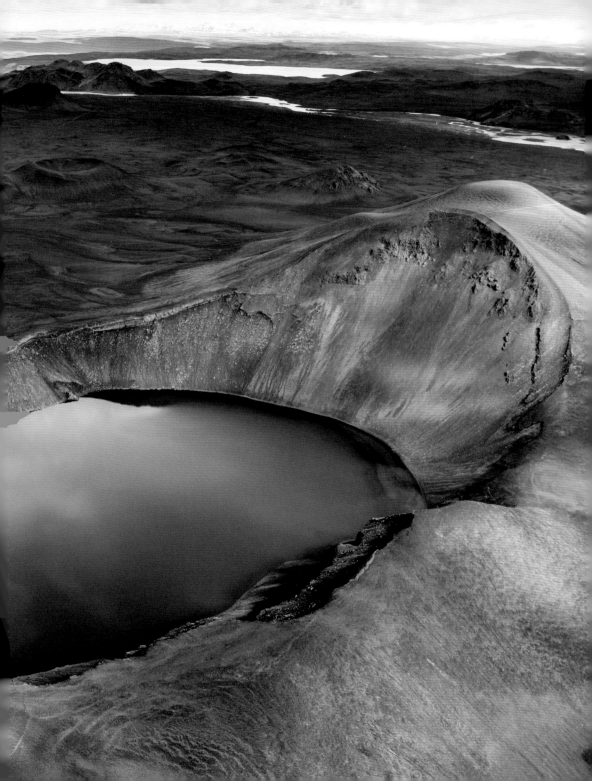

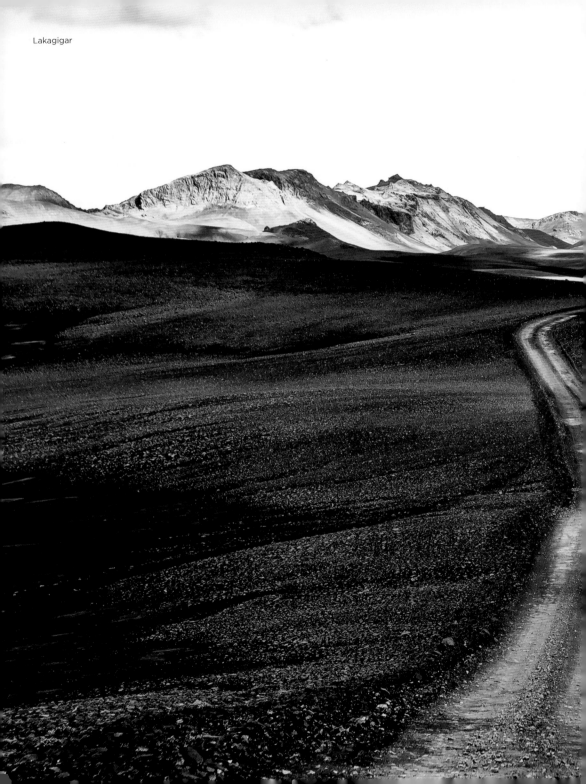

Lakagigar

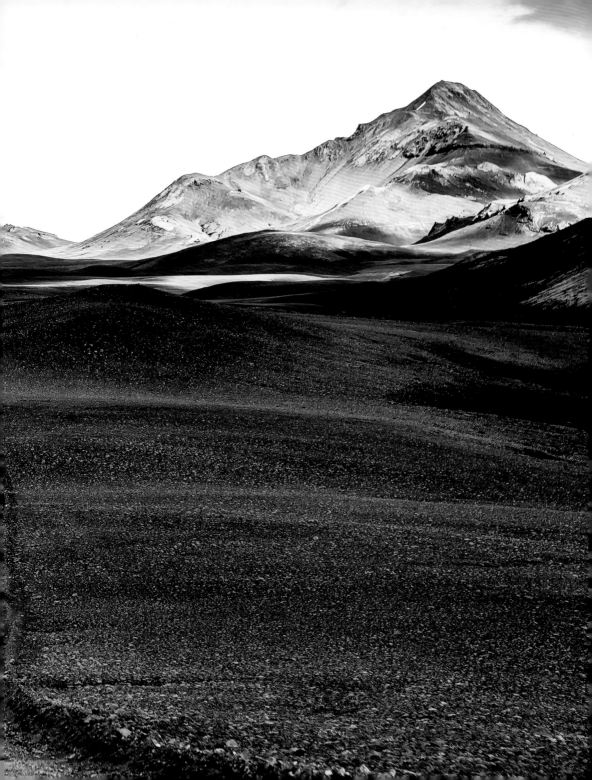

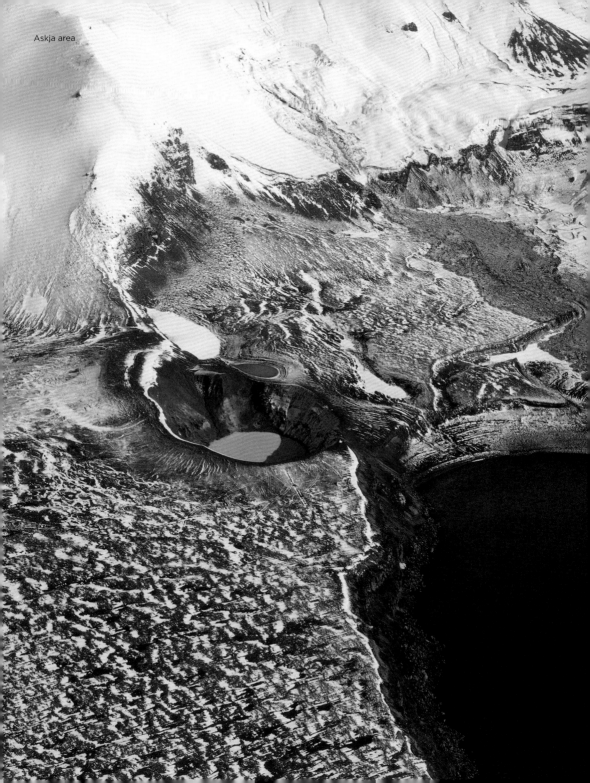
Askja area

View towards Vatnajökull glacier

Vatnajökull

At 8100 square kilometres, Vatnajökull is Iceland's largest glacier. Its ice conceals active volcanoes and the country's highest mountain, Hvannadalshnúkur. The Vatnajökull National Park was founded in 2008, incorporating the former national parks Skaftafell and Jökulsárgljúfur to cover more than 12,000 square kilometres.

Vatnajökull

Avec ses 8100 km², le Vatnajökull est le plus grand glacier d'Islande. Sous la glace se trouvent des volcans actifs mais aussi la plus haute montagne de l'île, le Hvannadalshnúkur. En 2008, le parc national de Vatnajökull, grand de plus de 12000 km², a vu le jour ; il englobe aujourd'hui les anciens parcs nationaux de Skaftafell et Jökulsárgljúfur.

Vatnajökull

Mit 8100 km² ist der Vatnajökull der größte Gletscher Islands. Unter seinem Eis liegen aktive Vulkane sowie der höchste Berg Islands, der Hvannadalshnúkur. 2008 wurde der mehr als 12000 km² umfassende Vatnajökull-Nationalpark gegründet. Die früheren Nationalparks Skaftafell und Jökulsárgljúfur gehören seitdem zum Vatnajökull.

Vatnajökull

Con 8100 km², Vatnajökull es el glaciar más grande de Islandia. Bajo su hielo se encuentran volcanes activos y la montaña más alta de Islandia, el Hvannadalshnúkur. En 2008 se fundó el Parque Nacional de Vatnajökull, de más de 12000 km². Desde entonces, los antiguos parques nacionales Skaftafell y Jökulsárgljúfur pertenecen a Vatnajökull.

Vatnajökull

Con i suoi 8100 km², Vatnajökull è il più grande ghiacciaio d'Islanda. Sotto il suo ghiaccio sono attivi vulcani e la montagna più alta d'Islanda, il Hvannadalshnúkur. Nel 2008 è stato fondato il Parco nazionale di Vatnajökull, che si estende su una superficie di oltre 12000 km². I vecchi parchi nazionali Skaftafell e Jökulsárgljúfur appartengono da allora a Vatnajökull.

Vatnajökull

Met 8100 km² is de Vatnajökull de grootste gletsjer van IJsland. Onder het ijs bevinden zich actieve vulkanen en de hoogste berg van IJsland, de Hvannadalshnúkur. In 2008 werd het meer dan 12000 km² grote nationale park Vatnajökull opgericht. De vroegere nationale parken Skaftafell en Jökulsárgljúfur maken er sindsdien deel van uit.

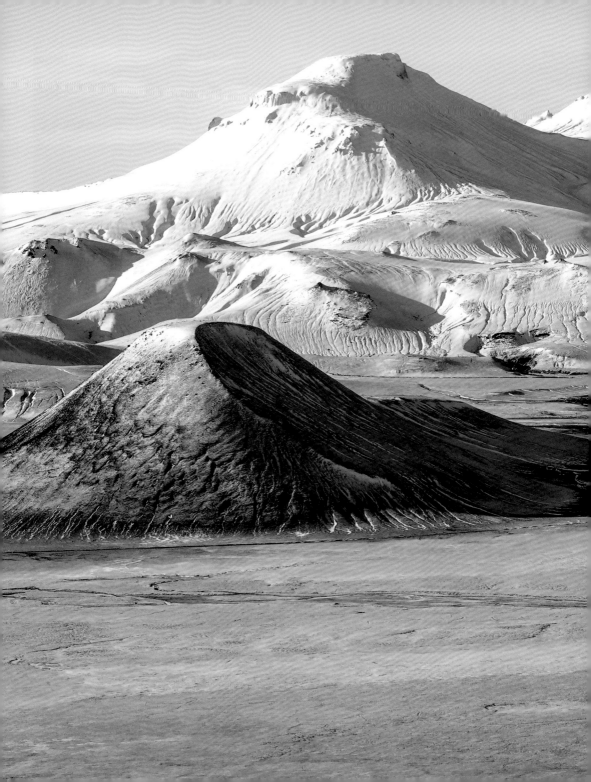

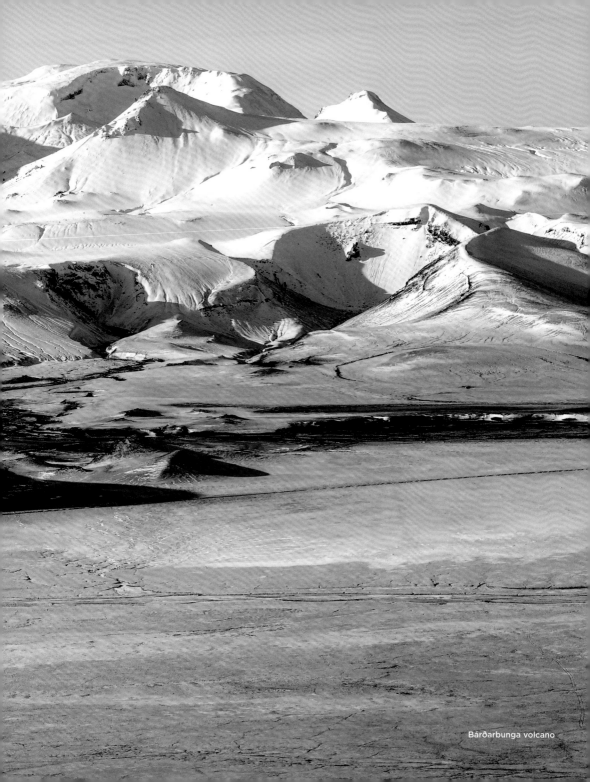

Bárðarbunga volcano

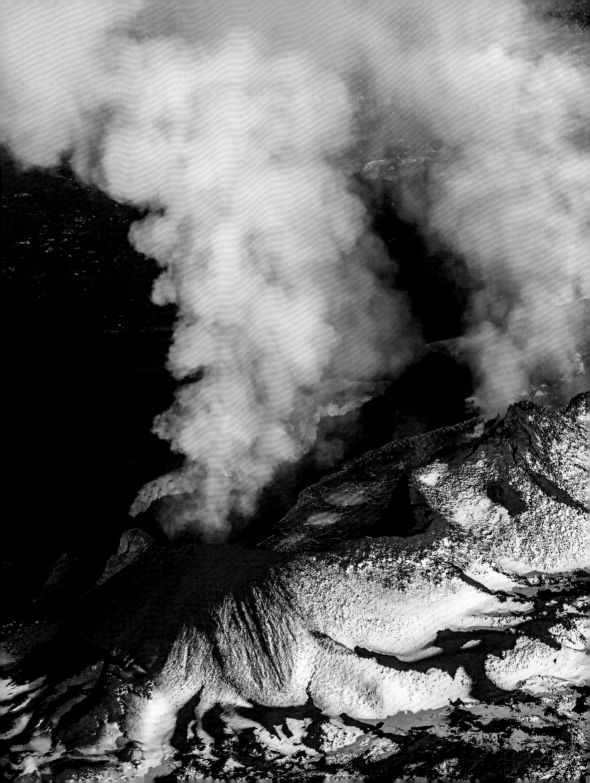

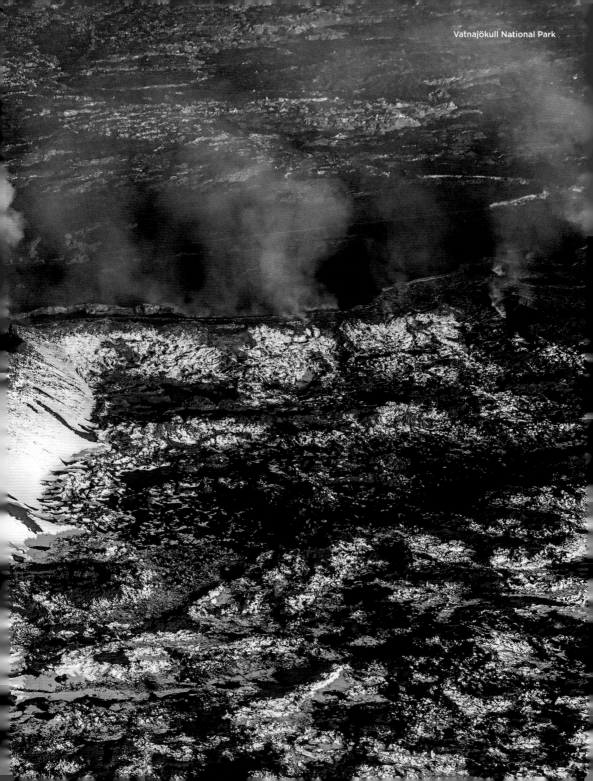

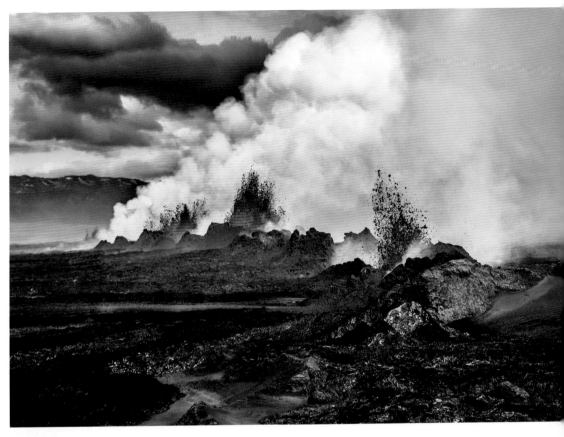

Vatnajökull National Park

Bárðarbunga

Bárðarbunga is a subglacial volcano with adjacent fissure networks. The last eruption in Holuhraun, one of its lava fields, lasted from August 2014 to February 2015 and produced around 1.3 cubic kilometres of lava that spread over an area of 85 square kilometres. The lava flow, which attracted barely any attention outside of Iceland, was about ten times more massive than that of Eyjafjallajökull.

Bárðarbunga

Bárðarbunga est un volcan sous-glaciaire duquel s'étire un ensemble de fissures volcaniques. La dernière éruption à Holuhraun, l'un de ses champs de lave, a duré d'août 2014 à février 2015 et a produit environ 1,3 km³ de lave, qui s'est étendue sur 85 km². La coulée, à peine remarquée en dehors des frontières de l'Islande, était pourtant près de dix fois plus massive que celle d'Eyjafjajfallajökull.

Bárðarbunga

Die Bárðarbunga ist ein subglazialer Vulkan mit angrenzenden Spaltensystemen. Die bisher letzte Eruption im Holuhraun, einem ihrer Lavafelder, dauerte von August 2014 bis Februar 2015 und förderte rund 1,3 km³ Lava, die sich auf 85 km² ausbreitete. Der außerhalb Islands kaum beachtete Lavastrom war rund zehn Mal massereicher als der des Eyjafjallajökull.

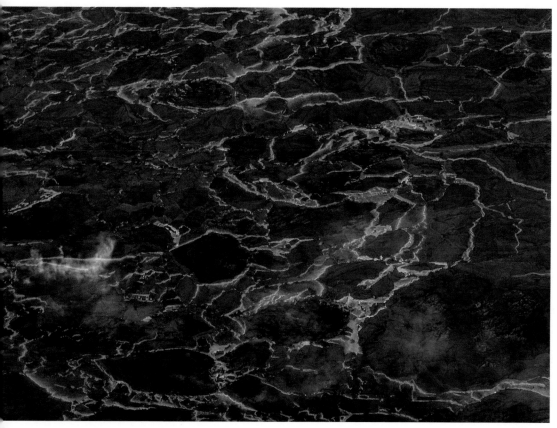

Holuhraun, near Bardarbunga volcano

Bárðarbunga

Bárðarbunga es un volcán subglacial con sistemas de fisuras adyacentes. La última erupción hasta el momento, en Holuhraun, uno de sus campos de lava, duró de agosto de 2014 a febrero de 2015 y produjo alrededor de 1,3 km³ de lava, que se extendió por 85 km². El flujo de lava, que apenas se tuvo en cuenta fuera de Islandia, tenía una masaunas diez veces mayor que el de Eyjafjallajökull.

Bárðarbunga

Bárðarbunga è un vulcano subglaciale con sistemi a colonna adiacenti. L'ultima eruzione a Holuhraun, uno dei suoi campi di lava, è durata dall'agosto 2014 al febbraio 2015 e ha prodotto circa 1,3 km³ di lava, che si è estesa fino a 85 km². La colata di lava al di fuori dell'Islanda era circa dieci volte più massiccia di quella dello Eyjafjallajökull.

Bárðarbunga

Bárðarbunga is een subglaciale vulkaan met een aangrenzend klovenstelsel. De tot nog toe laatste uitbarsting in Holuhraun, een van de lavavelden, duurde van augustus 2014 tot februari 2015 en produceerde zo'n 1,3 km³ lava, dat zich over 85 km² uitspreidde. De buiten IJsland nauwelijks opgemerkte lavastroom was ongeveer tien keer zo omvangrijk als die van de Eyjafjallajökull.

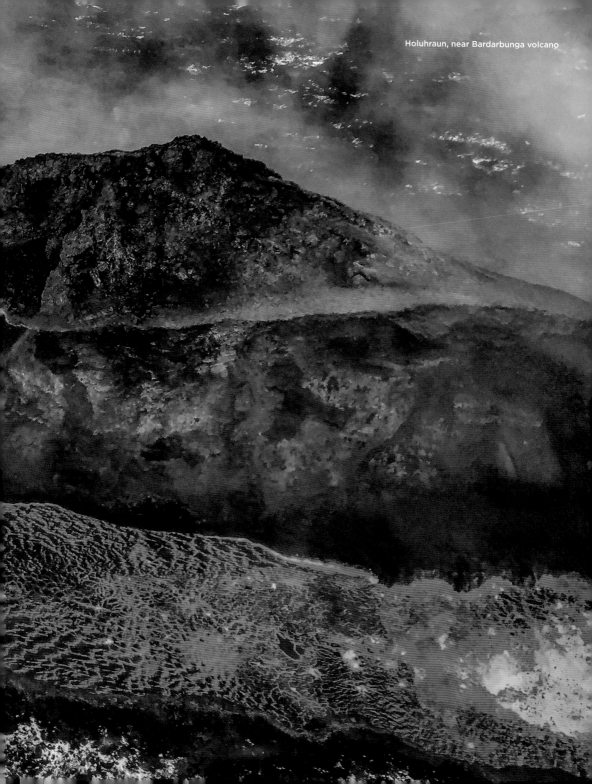

Holuhraun, near Bardarbunga volcano

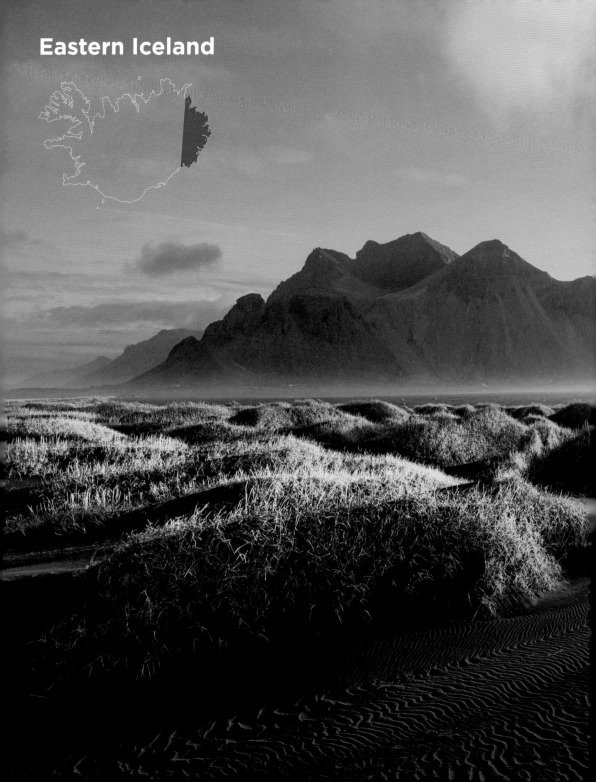

Eastern Iceland

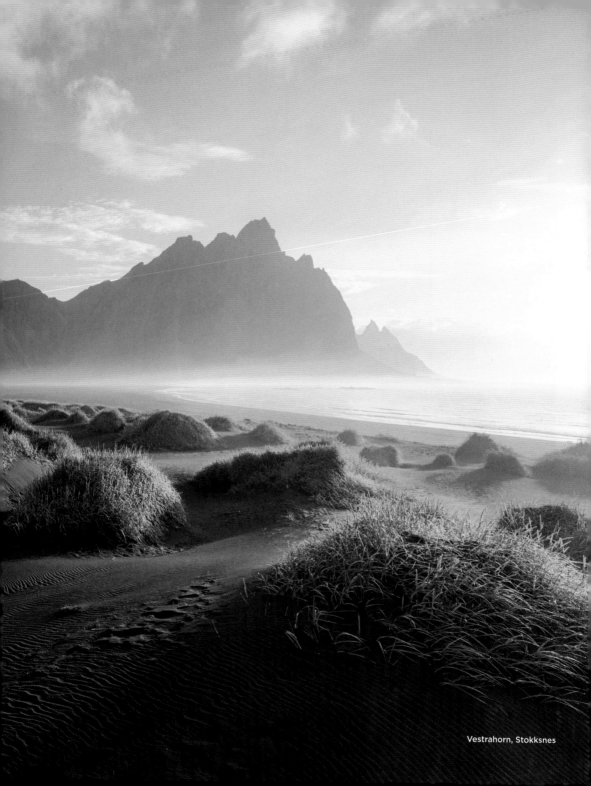

Vestrahorn, Stokksnes

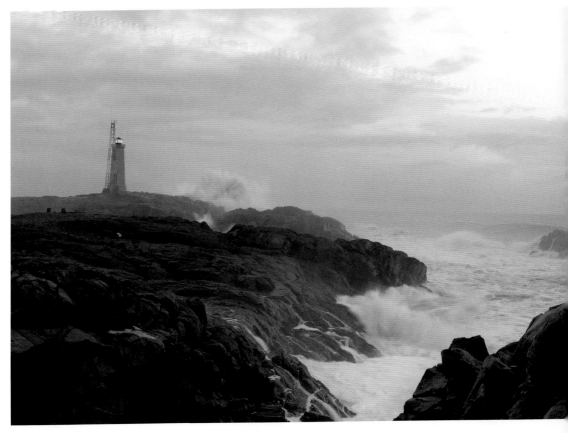

Stokksnes

Eastern Iceland

The coast of eastern Iceland is broken up by numerous fjords. Steep mountains often rise up behind them, making for tight spaces, but also good natural harbours for fishing. The region is geologically relatively old, so there are no active volcanoes, and the landscape is predominantly that of the Ice Age. Since the roads almost always lead along the shores of the fjords, travel is slow. In the interior, on the eastern shore of Lake Lagarfljót, lies Iceland's largest forest area.

Islande orientale

La côte est de l'Islande est fortement découpée par de nombreux fjords, derrière lesquels s'élèvent des montagnes souvent abruptes, qui ne laissent guère de place pour les lieux d'habitation, mais offrent de bons ports naturels de pêche. D'un point de vue géologique, la région est relativement ancienne, il n'y a donc plus de volcanisme actif et le paysage est principalement marqué par l'âge glaciaire. Comme les routes longent presque toujours les rives des fjords, les déplacements y sont lents. À l'intérieur des terres, sur la rive est du lac Lagarfljót, se trouve la plus grande zone forestière d'Islande.

Ostisland

Die Küste Ostislands ist durch zahlreiche Fjorde stark gegliedert, dahinter ragen oft steile Berge auf, die den Orten kaum Platz lassen, aber durch gute Naturhäfen Fischfang ermöglichen. Die Region ist geologisch relativ alt, deshalb gibt es keinen aktiven Vulkanismus mehr und die Landschaft ist überwiegend eiszeitlich geprägt. Da die Straßen fast immer an den Ufern der Fjorde entlangführen, kommt man nur langsam vorwärts. Im Landesinnern, am Ostufer des Sees Lagarfljót, liegt Islands größtes Waldgebie

Eskifjörður village

Este de Islandia

La costa del este de Islandia está muy dividida por numerosos fiordos, detrás de los cuales, a menudo se elevan montañas escarpadas que apenas dejan sitio, pero que hacen posible la pesca gracias a los buenos puertos naturales. La región es relativamente antigua en términos geológicos, por lo que ya no hay volcanismo activo y el paisaje se caracteriza principalmente por la Edad de Hielo. Dado que los caminos casi siempre conducen a lo largo de las orillas de los fiordos, se avanza despacio. En el interior, en el margen oriental del lago Lagarfljót, se encuentra la mayor superficie forestal de Islandia.

Islanda Orientale

La costa dell'Islanda orientale è divisa da numerosi fiordi, alle loro spalle si ergono spesso ripide montagne, che lasciano poco spazio ai luoghi abitati, ma rendono possibile la pesca grazie a porti naturali. La regione è geologicamente antica, quindi non c'è più vulcanismo attivo e il paesaggio è caratterizzato principalmente dall'era glaciale. Poiché le strade si snodano quasi sempre lungo le rive dei fiordi, si procede molto lentamente. All'interno, sulla riva orientale del lago Lagarfljót, si trova la più grande area forestale dell'Islanda.

Oost-IJsland

De kust van Oost-IJsland is sterk verdeeld door de vele fjorden, waarachter vaak steile bergen oprijzen die nauwelijks ruimte overlaten voor de dorpen, maar door de goede natuurlijke havens wel visvangst mogelijk maken. De regio is in geologisch opzicht relatief oud, zodat er geen actief vulkanisme meer is en het landschap is vooral gevormd tijdens de ijstijd. Omdat de wegen bijna altijd langs de oevers van de fjorden lopen, kom je maar langzaam vooruit. In het binnenland, aan de oostoever van het Lagarfljót-meer, ligt IJslands grootste bosgebied.

Kirkjubær church

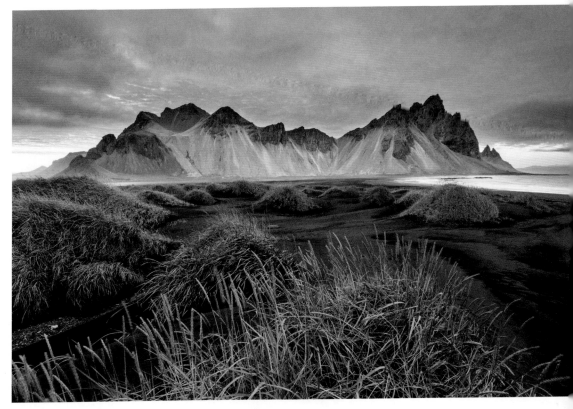

Vestrahorn, Stokksnes

Vestrahorn, Stokksnes

Above the breaking waves on a black sand beach looms the imposing mountain Vestrahorn. A detour from the Ring Road to the Stokksnes peninsula reveals this wild panorama, an impressive and popular subject among photographers. Despite its isolation, this was one of the first settlements on Iceland, as well as a base for the British army in the Second World War.

Vestrahorn, Stokksnes

L'étrange Vestrahorn s'élève au-dessus d'une plage de sable noir où les vagues viennent se briser. L'accès au panorama sauvage et particulièrement photogénique de la péninsule de Stokksnes se fait via un embranchement à partir de la Route 1. Malgré son isolement, ce fut l'une des premières colonies d'Islande ainsi qu'une base pour l'armée britannique pendant la seconde guerre mondiale.

Vestrahorn, Stokksnes

Über einem schwarzen Strand, an dem sich die Wellen brechen, erhebt sich das bizarre Vestrahorn. Ein Abstecher von der Ringstraße auf die Halbinsel Stokksnes eröffnet das wilde Panorama mit dem beeindruckenden Fotomotiv. Trotz der Weltabgeschiedenheit war hier eine der ersten Siedlungen Islands und im Zweiten Weltkrieg ein Stützpunkt der britischen Armee.

Vestrahorn, Stokksnes

El extraño pico Vestrahorn se eleva sobre una playa negra donde rompen las olas. Un desvío de la circunvalación a la península de Stokksnes abre el panorama salvaje con la impresionante fotografía. A pesar de su aislamiento, este fue uno de los primeros asentamientos de Islandia y una base para el ejército británico en la Segunda Guerra Mundial.

Vestrahorn, Stokksnes

La stravagante Vestrahorn si erge sopra una spiaggia nera dove si infrangono le onde. Una deviazione dalla Ringstrasse alla penisola di Stokksnes apre il panorama selvaggio ad uno straordinario soggetto fotografico. Nonostante l'isolamento, fu uno dei primi insediamenti in Islanda e una base per l'esercito britannico nella Seconda guerra mondiale.

Vestrahorn, Stokksnes

De bizarre Vestrahorn verheft zich boven een zwart strand waar de golven breken. Na een korte afdwaling van de ringweg naar het schiereiland Stokksnes openbaart zich een fotogeniek en indrukwekkend woest panorama. Ondanks de afzondering bevond zich hier een van de eerste nederzettingen van IJsland en in de Tweede Wereldoorlog had het Britse leger hier een uitvalsbasis.

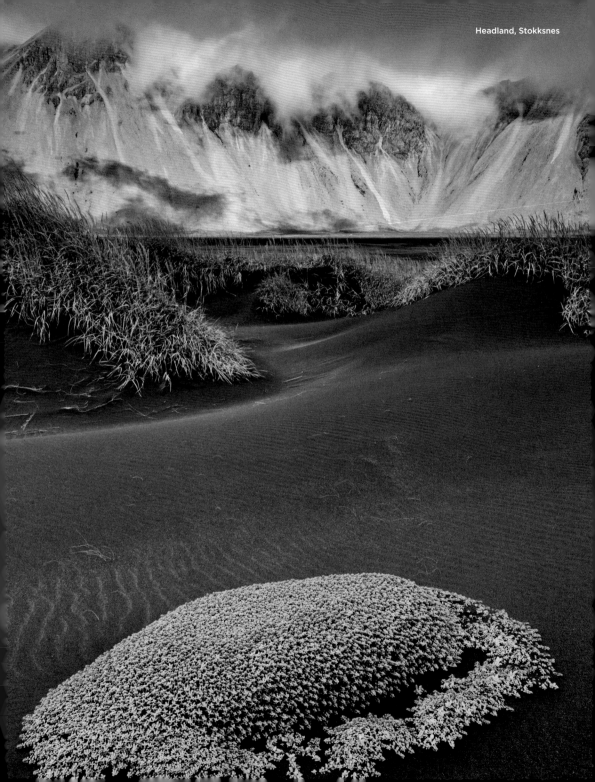

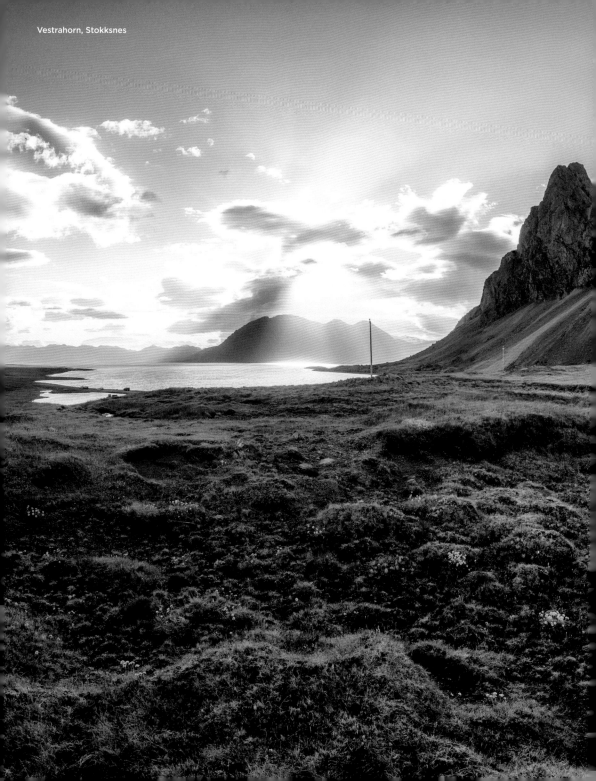
Vestrahorn, Stokksnes

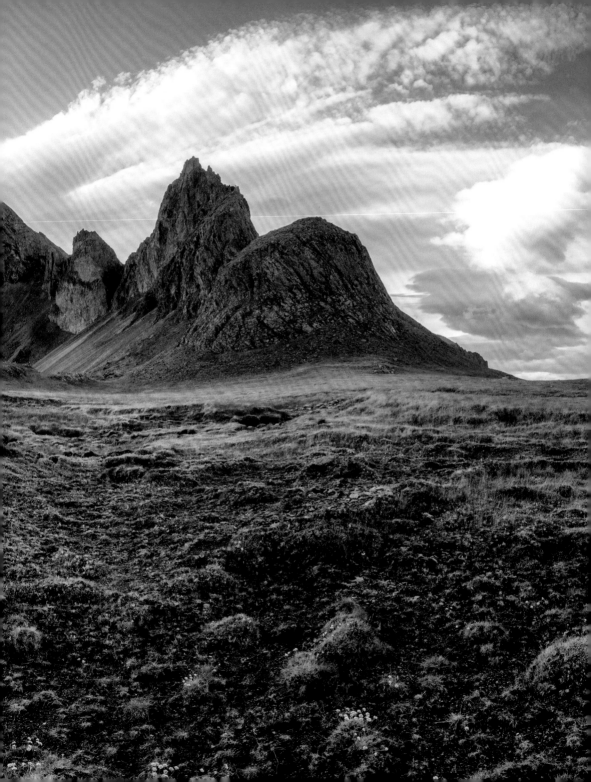

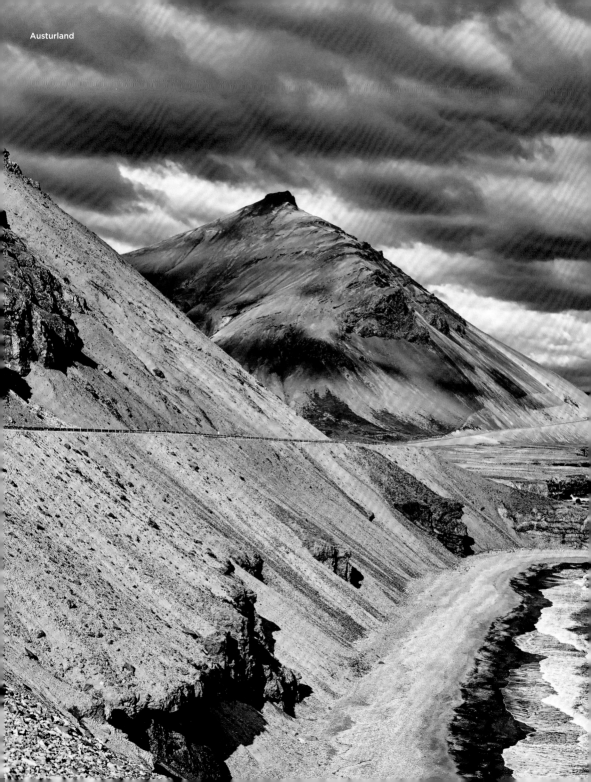

Djupivogur

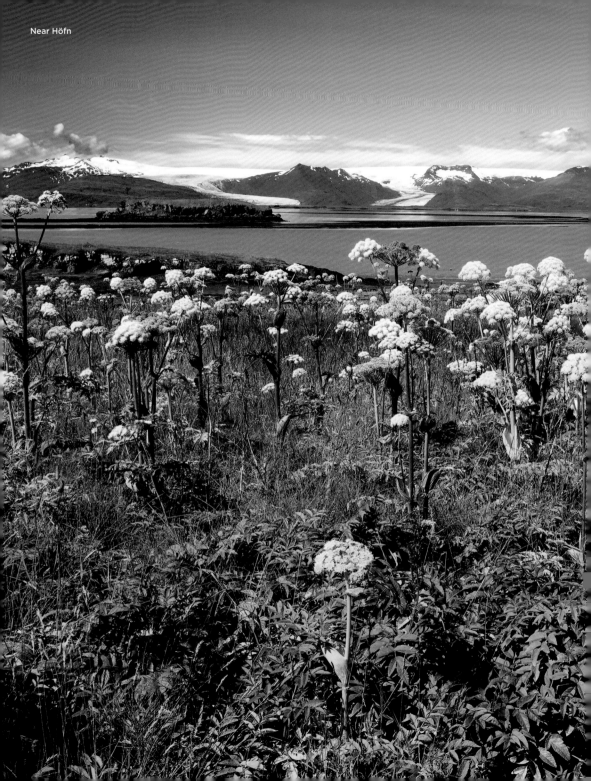

Near Höfn

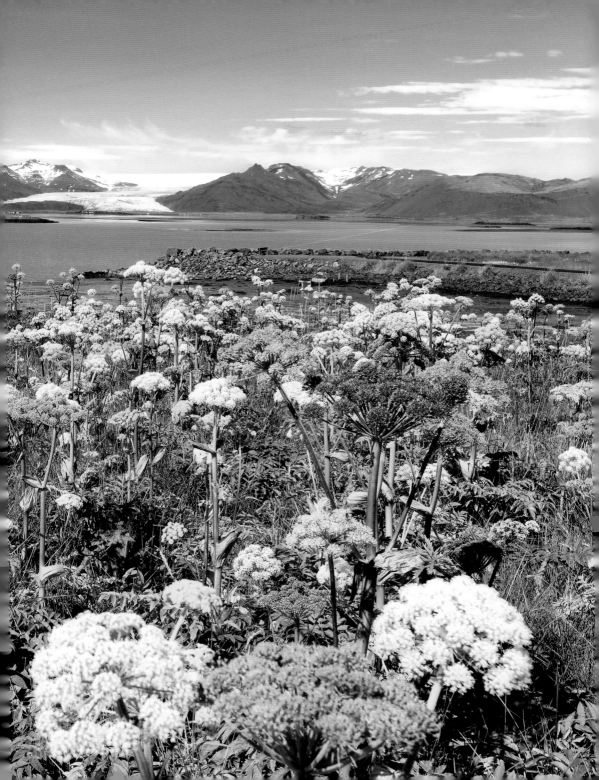

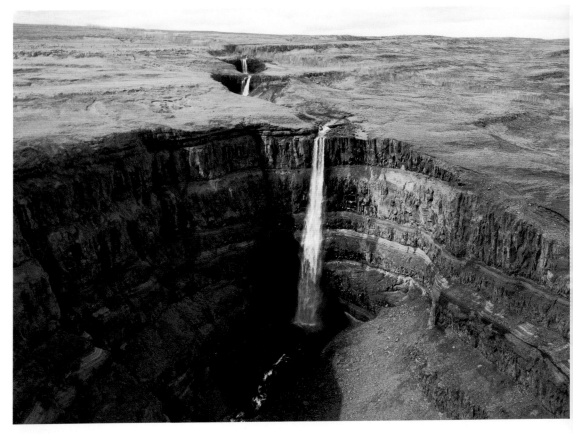

Hengifoss

Hengifoss

At 118 metres, Hengifoss, on the shore of Lake Lagarfljót, is Iceland's third-highest waterfall. After half an hour's uphill trek, you reach Litlanesfoss, surrounded by basalt columns; another half-hour brings you to Hengifoss, which falls into a horseshoe-shaped basin. Coloured sandstone bands shine below the waterfall's edge as a result of interstratified beds of iron oxide.

Hengifoss

Hengifoss, sur la rive du lac Lagarfljót, est, avec ses 118 m, la troisième plus haute chute d'eau d'Islande. Après une demi-heure de randonnée, vous arriverez à Litlanesfoss, entouré de colonnes de basalte ; après une heure, vous atteindrez Hengifoss, qui se jette dans un bassin en forme de fer à cheval. Sur ses parois brillent des bandes de grès – leur couleur rouge est due à la présence d'oxyde de fer.

Hengifoss

Der Hengifoss am Ufer des Sees Lagarfljót ist mit 118 m Islands dritthöchster Wasserfall. Nach einer halben Stunde bergauf erreicht man den von Säulenbasalt umgebenen Litlanesfoss, nach einer Stunde den Hengifoss, der in einen hufeisenförmigen Kessel stürzt. Unterhalb der Fallkante leuchten durch Eisenoxid-Einlagerungen farbige Sandsteinbänder.

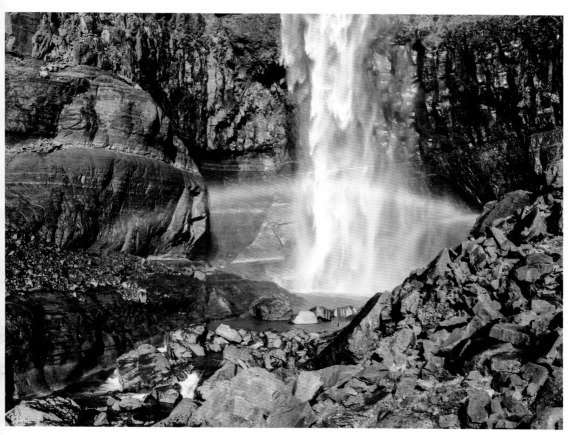

Hengifoss

Hengifoss

Hengifoss, a orillas del lago Lagarfljót, es la tercera cascada más alta de Islandia, con 118 metros de altura. Después de media hora de subida se llega a la cascada Litlanesfoss, rodeada de columnas de basalto, y una hora después se llega a Hengifoss, que cae en una cuenca en forma de herradura. Debajo del borde de caída, bandas de arenisca de colores se iluminan debido a las inclusiones de óxido de hierro.

Hengifoss

Hengifoss, sulle rive del lago Lagarfljót, è la terza cascata più alta d'Islanda, con i suoi 118 metri di altezza. Dopo mezz'ora di salita si raggiunge Litlanesfoss, circondata dal basalto colonnare, e dopo un'ora si raggiunge Hengifoss, che cade in una conca a ferro di cavallo. Sotto il punto di caduta, le fasce di arenaria colorata si illuminano grazie alle inclusioni di ossido di ferro.

Hengifoss

Hengifoss aan de oever van het Lagarfljót-meer is met 118 meter de op twee na hoogste waterval van IJsland. Na een half uur bergopwaarts bereikt u de door basaltzuilen omgeven Litlanesfoss en na een uur de Hengifoss, waarvan het water in een hoefijzervormig bekken klettert. In de rotswand erachter lichten door ijzeroxide gekleurde banen op.

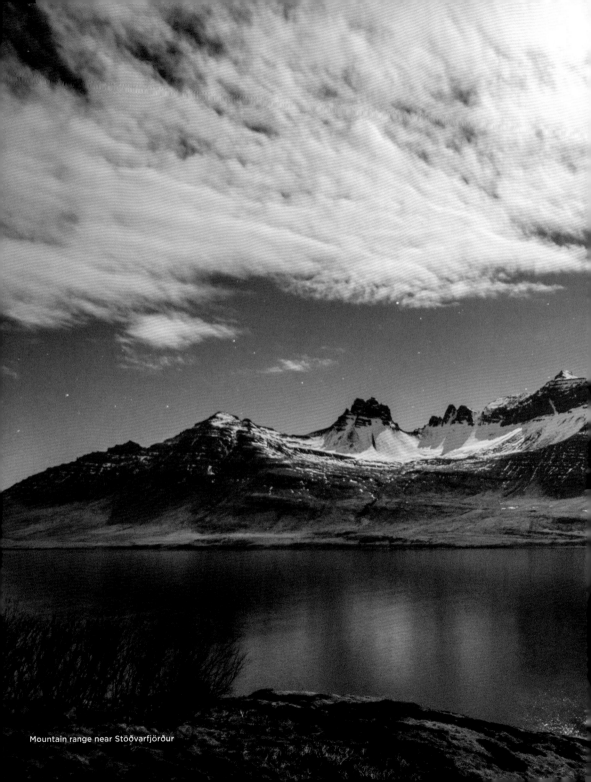

Mountain range near Stöðvarfjörður

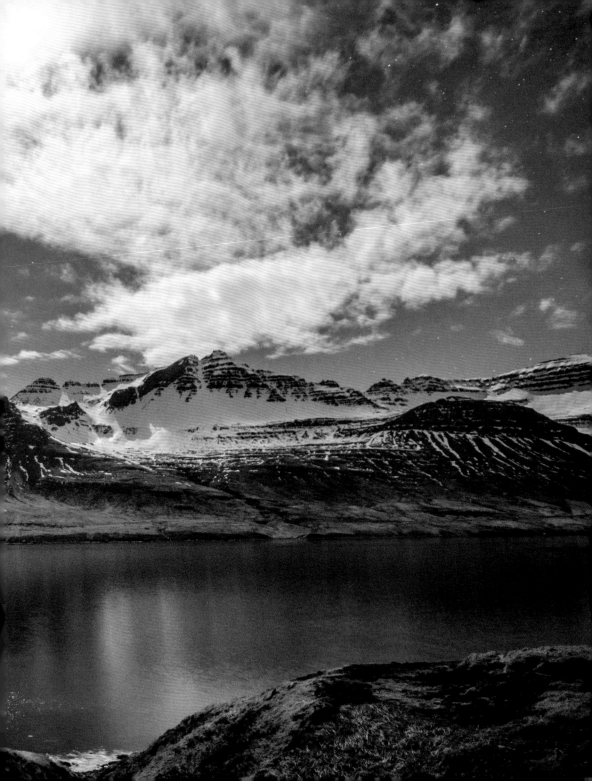

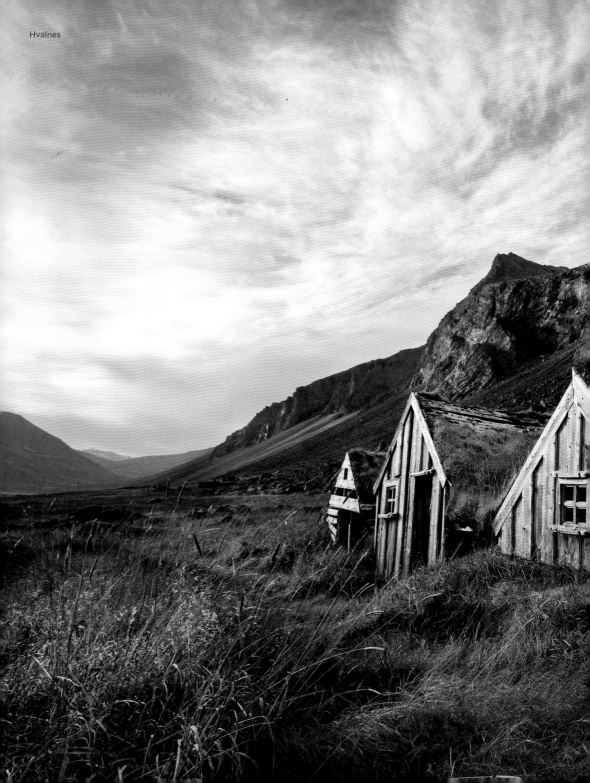

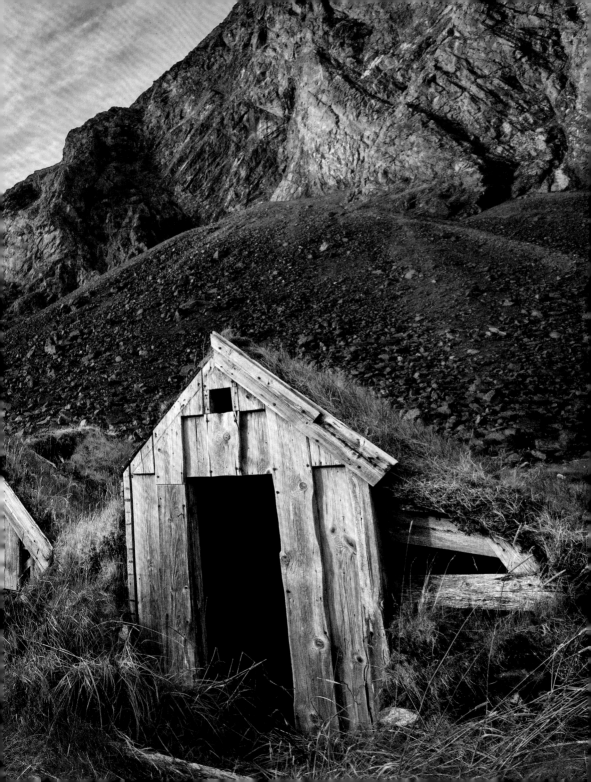

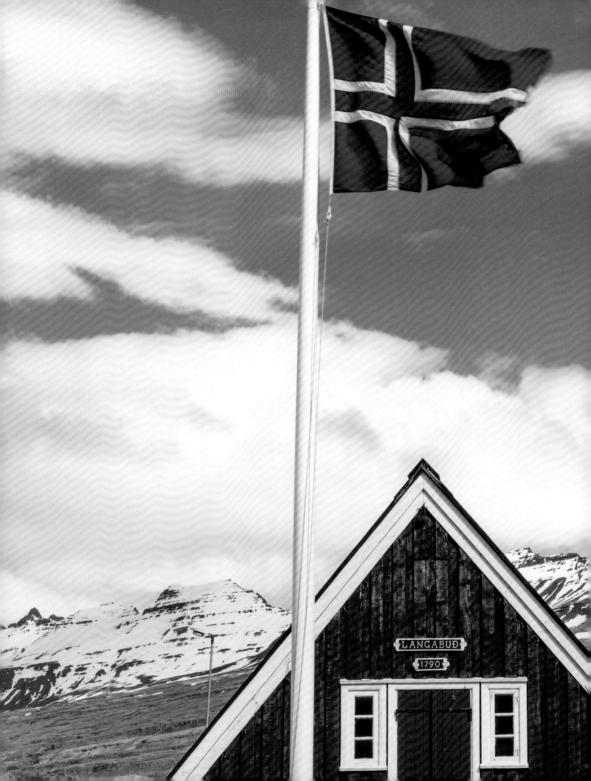

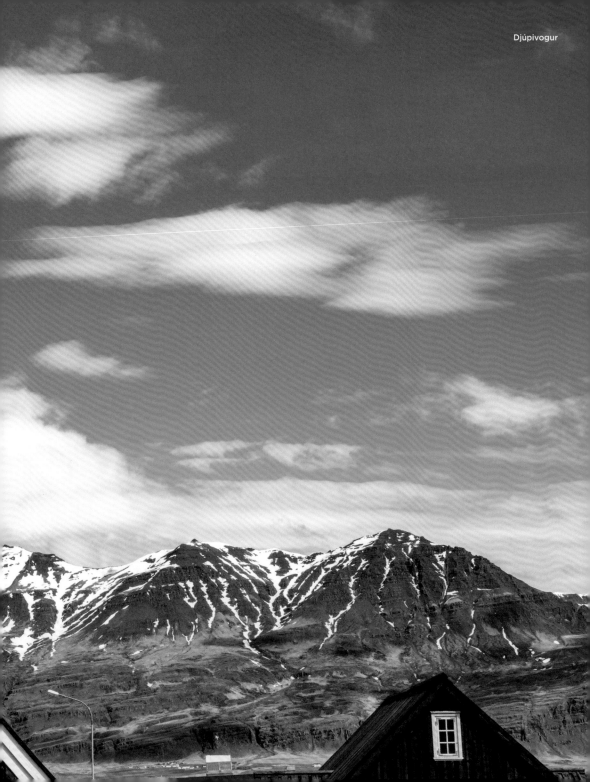

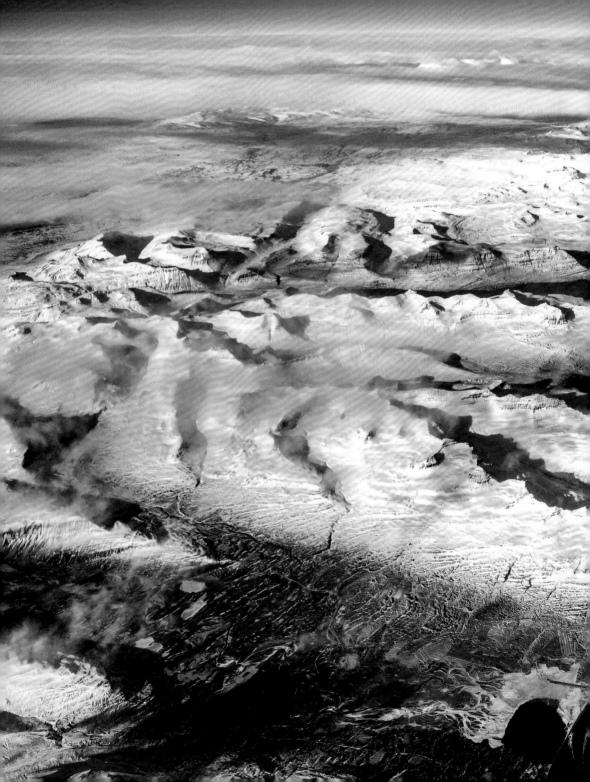

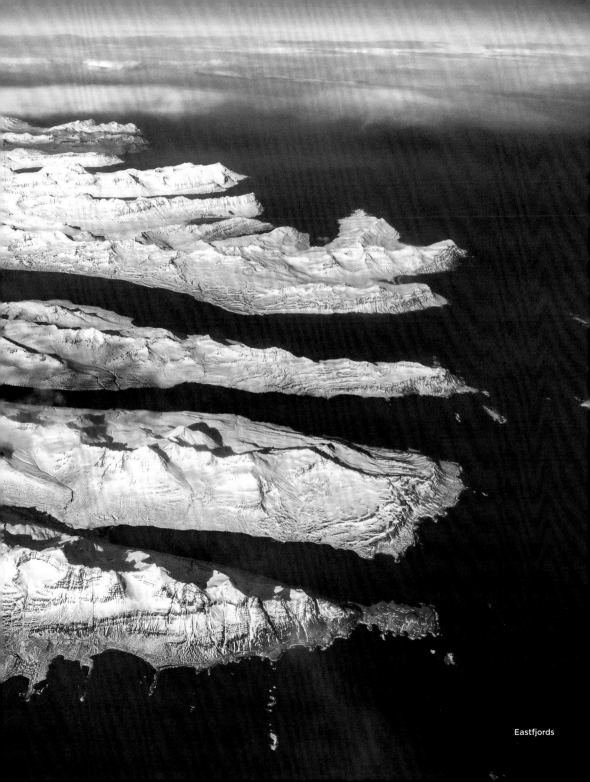

Eastfjords

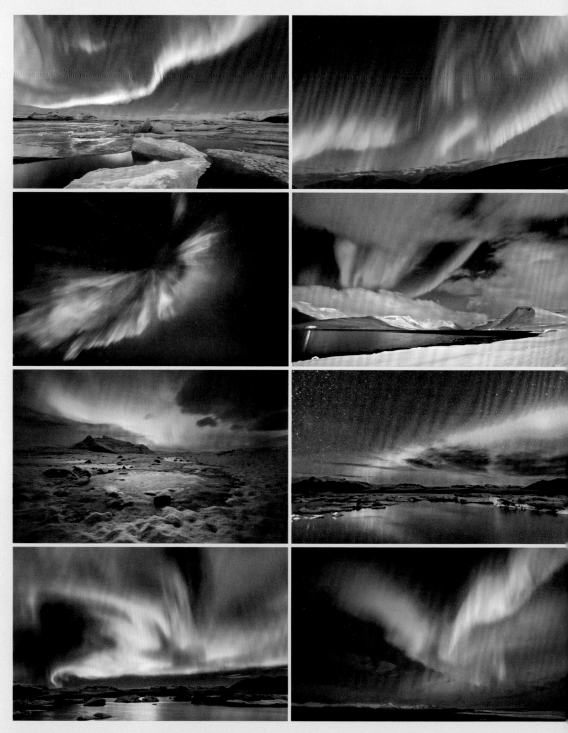

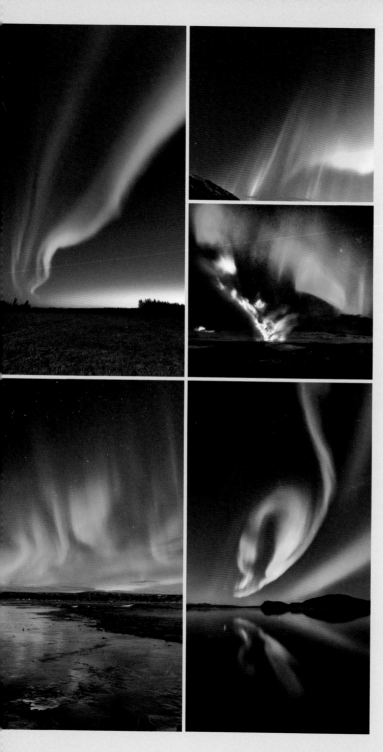

Northern Lights

The locals are as mesmerised as newcomers by this natural wonder. As if from nowhere, green, blue, or red veils emerge and waft across the sky. They hover in the air for a while, constantly changing shape, and then disappear just as suddenly and silently as they came.

Aurores boréales

Même les habitants sont encore fascinés par ce spectacle naturel. Comme venus de nulle part, des voiles verts, bleus ou rouges émergent et flottent dans le ciel. Pendant un certain temps, ils changent constamment de forme puis disparaissent aussi soudainement et silencieusement qu'ils sont apparus.

Polarlichter

Auch die Einheimischen sind immer wieder aufs Neue von diesem Naturschauspiel fasziniert. Wie aus dem Nichts entstehen grüne, blaue oder rote Schleier und wabern über den Himmel. Eine Zeitlang verändern sie ständig ihre Form und verschwinden dann genauso plötzlich und lautlos wie sie gekommen sind.

Aurora boreal

Los lugareños también están fascinados una y otra vez por este espectáculo natural. Como si de la nada surgieran velos verdes, azules o rojos que ondulan a través del cielo. Durante un tiempo cambian de forma constantemente y luego desaparecen tan repentina y silenciosamente como vinieron.

Aurora boreale

Anche la gente del posto è sempre affascinata da questo spettacolo naturale. Come dal nulla, emergono veli verdi, blu o rossi che si diffondono nel cielo. Per un po' cambiano continuamente forma e poi scompaiono all'improvviso e silenziosamente.

Noorderlicht

Ook de lokale bevolking is nog altijd gefascineerd door dit natuurspektakel. Als uit het niets komen groene, blauwe of rode sluiers tevoorschijn die aan de hemel wapperen. Een tijd lang veranderen ze steeds van vorm en dan verdwijnen ze weer even plotseling en geruisloos als ze gekomen zijn.

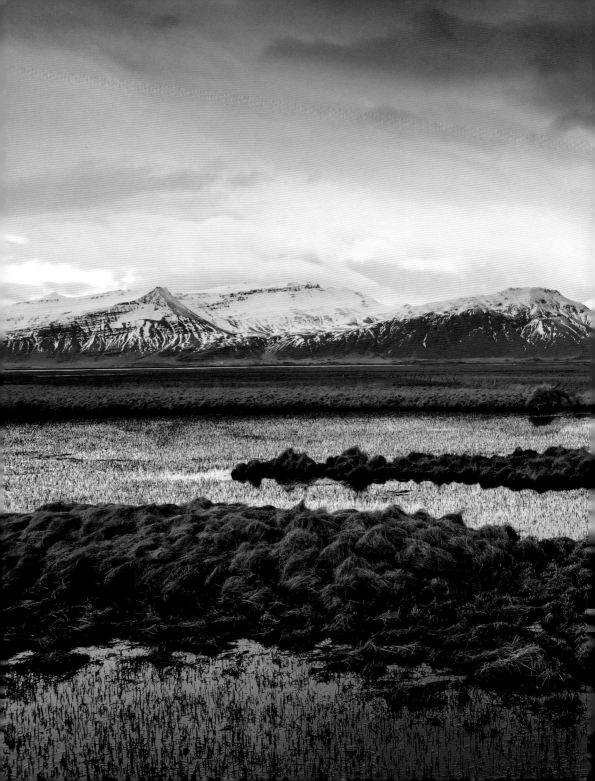

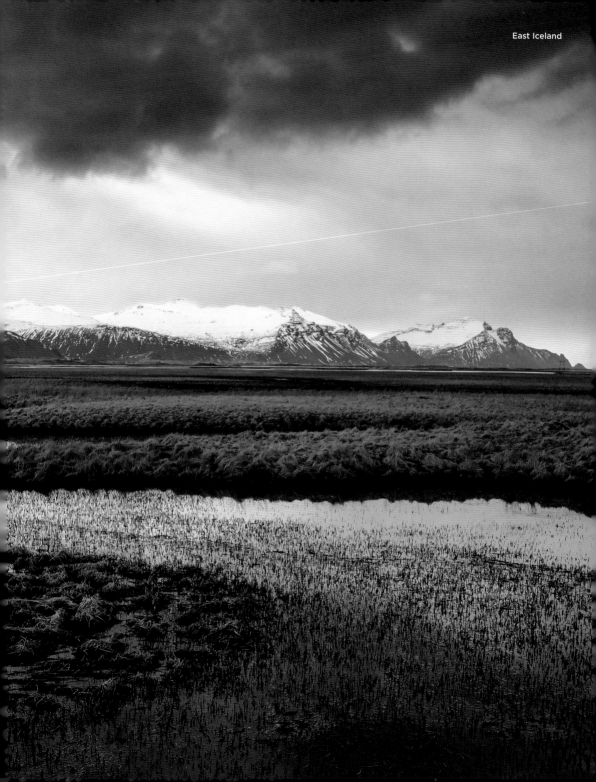

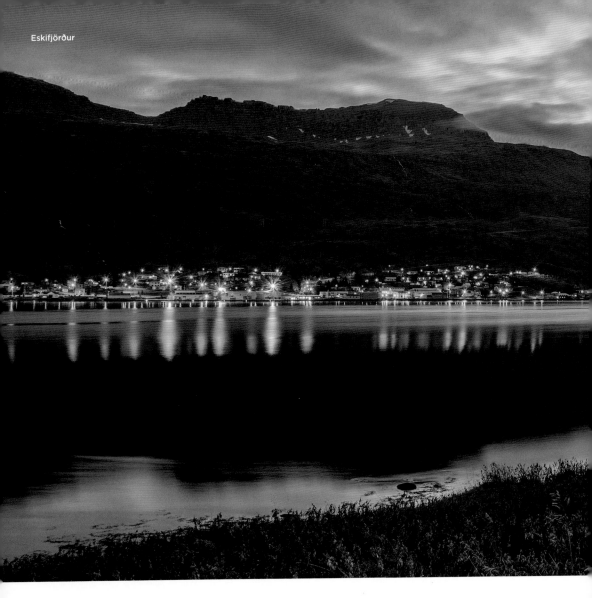

Eskifjörður

The colourful houses of the elongated village look tiny against the mighty mountain backdrop. In winter, the low sun does not make it over the mountain, leaving the village in total shade for weeks. The Fishery Museum of Eastern Iceland is located in Gamla búð, a trading house dating from 1816. On the other side of the fjord, the 985-metre-high Holmatindur is an impressive landmark.

Eskifjörðurður

Les maisons colorées de ce village allongé paraissent minuscules au regard de la montagne. En hiver, l'endroit reste à l'ombre pendant des semaines, parce que le soleil bas ne dépasse pas le sommet. Le musée de la Pêche de l'est de l'Islande est situé à Gamla búð, une maison de commerce datant de 1816. De l'autre côté du fjord, le mont Holmatindur, avec ses 985 m de haut, est une attraction impressionnante.

Eskifjörður

Die bunten Häuser des langgestreckten Ortes wirken vor der gewaltigen Bergkulisse winzig. Im Winter liegt der Ort wochenlang im Schatten, denn die tiefstehende Sonne schafft es nicht über den Berg. Das Fischereimuseum Ostislands ist in Gamla búð, einem Handelshaus aus dem Jahr 1816, untergebracht. Auf der anderen Fjordseite ragt die 985 m hohe Holmatindur als beeindruckende Landmarke auf.

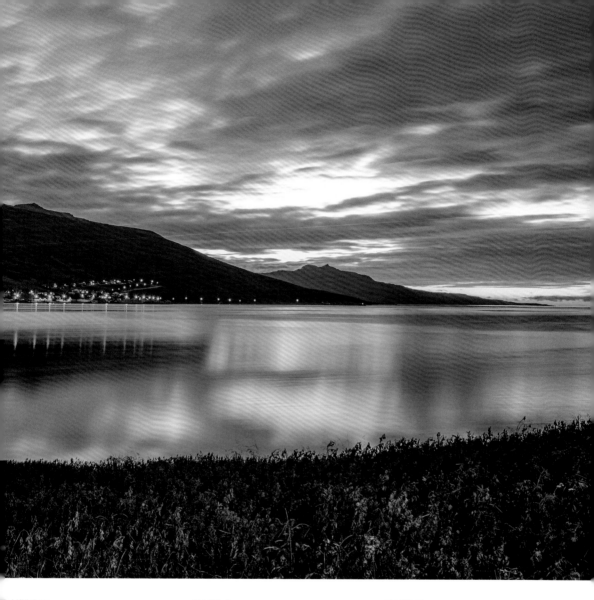

Eskifjörður

Las coloridas casas de la alargada aldea parecen minúsculas con el poderoso telón de fondo de la montaña. En invierno, el lugar permanece en sombra durante semanas porque el sol bajo no llega a la montaña. El Museo de la Pesca del Este de Islandia se encuentra en Gamla búð, una casa comercial que data de 1816. Al otro lado del fiordo, el Holmatindur de 985 m de altura destaca como un punto de referencia impresionante.

Eskifjörður

Le case colorate del lungo villaggio sembrano minuscole sullo sfondo della montagna. In inverno il luogo si trova all'ombra per settimane, perché il sole basso non arriva sopra la montagna. Il Museo della pesca dell'Islanda orientale si trova a Gamla búð, una casa commerciale risalente al 1816. Dall'altra parte del fiordo, Holmatindur, con i suoi 985 m di altezza, si distingue per la sua imponenza.

Eskifjörður

De kleurige huizen van het langgerekte dorp zien er piepklein uit tegen een achtergrond van machtige bergen. In de winter ligt het dorp weken in de schaduw, omdat de lage zon niet boven de berg uitkomt. Het Visserijmuseum van Oost-IJsland is gevestigd in Gamla búð, een handelshuis uit 1816. Aan de andere kant van de fjord valt de 985 meter hoge Holmatindur op als indrukwekkend landmerk

Near Fjord of Eskifjörður

Fellabær village

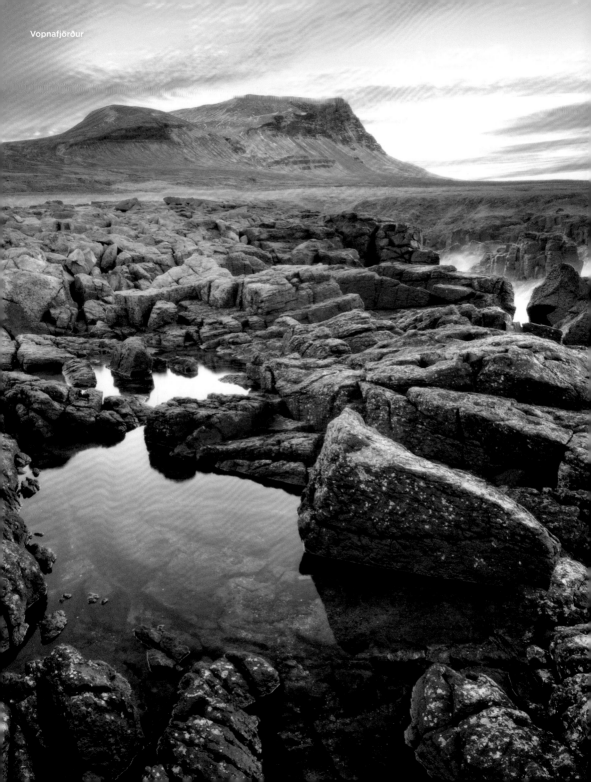

Vopnafjörður village

Vopnafjörður

The Hanseatic League had a trading centre at Vopnafjörður, but a permanent settlement has only existed since the end of the 19th century. Today, the village (on the fjord of the same name) has about 500 inhabitants. Many novels by the Nobel Prize-winning Icelandic writer Gunnar Gunnarsson are set in the region, and in 1989, on the occasion of his 100th birthday, a bust of the writer was unveiled in Vopnafjörður.

Vopnafjörður

Même si la Ligue hanséatique avait déjà établi un centre d'échanges à Vopnafjörður, le village n'existe que depuis la fin du XIX° siècle. Aujourd'hui, la localité, sur le fjord du même nom, compte environ 500 habitants. En 1989, à l'occasion du 100° anniversaire du poète Gunnar Gunnarsson, une statue y a été érigée, nous rappelant que beaucoup de ses romans se déroulent dans la région.

Vopnafjörður

Schon die Hanse unterhielt am Vopnafjörður einen Handelsplatz, doch eine Ansiedlung gibt es erst seit dem Ende des 19. Jahrhunderts. Heute hat der Ort am gleichnamigen Fjord rund 500 Einwohner. Anlässlich des 100. Geburtstages des Dichters Gunnar Gunnarsson wurde 1989 eine Büste enthüllt, sie erinnert daran, dass viele seiner Romane in der Region spielen.

Vopnafjörður

Vopnafjörður constituyó un lugar de comercio para la Liga Hanseática, pero el asentamiento solo existe desde finales del siglo XIX. Hoy en día, el pueblo en el fiordo del mismo nombre cuenta con unos 500 habitantes. Con motivo del centenario del nacimiento del poeta Gunnar Gunnarsson, en 1989 se descubrió un busto que nos recuerda que muchas de sus novelas están ambientadas en la región.

Vopnafjörður

La Lega anseatica aveva già un centro commerciale a Vopnafjörður, ma un insediamento esiste solo dalla fine del XIX secolo. Oggi il villaggio sull'omonimo fiordo conta circa 500 abitanti. In occasione del centenario del poeta Gunnar Gunnarsson, nel 1989 è stato presentato un busto che ci ricorda che molti dei suoi romanzi sono ambientati nella regione.

Vopnafjörður

De hanze had in de Vopnafjörður-fjord al een handelscentrum, maar een nederzetting is er pas sinds eind 19e eeuw. Tegenwoordig telt dit gelijknamige dorp zo'n 500 inwoners. Ter gelegenheid van de honderdste verjaardag van de dichter Gunnar Gunnarsson werd in 1989 een borstbeeld onthuld, dat mensen eraan herinnert dat veel van zijn romans zich in de regio afspelen.

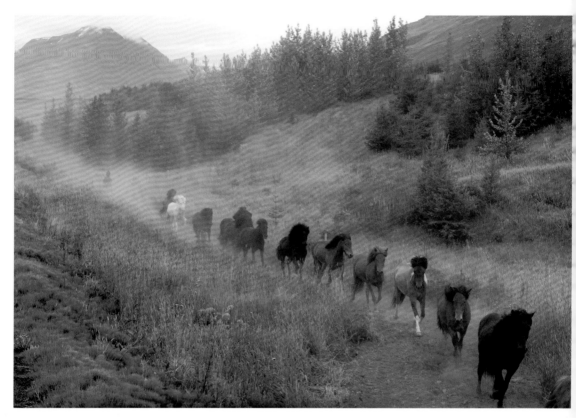

Horses at Eyjafjarðardalur

Stöðvarfjörður

The charming little church near Stöðvarfjörður has long since ceased to serve its original purpose, even if its pulpit and altar are still intact. The building, perched on a hill and visible from a distance, now serves as an unusual sort of inn. The choir gallery can accommodate up to ten sleeping bags, for travellers who prefer originality over comfort.

Stöðvarfjörður

La surprenante petite église près de Stöðvarfjörður, visible de loin sur une colline, est devenue aujourd'hui un logement plutôt inhabituel, même si sa chaire et son autel existent toujours. La galerie de la chorale peut ainsi accueillir jusqu'à dix voyageurs qui préfèrent l'originalité au confort et y dorment dans des sacs de couchage.

Stöðvarfjörður

Als Kirche hat sie schon lange ausgedient, auch wenn Kanzel und Altar noch vorhanden sind. Aber das auffällige und weithin sichtbar auf einem Hügel gelegene Kirchlein bei Stöðvarfjörður dient heute als ungewöhnliche Unterkunft. Bis zu zehn Reisende, denen Originalität vor Komfort geht, finden auf der Chorempore Platz, übernachtet wird in Schlafsäcken.

Stöðvarfjörður

Desde hace mucho tiempo ha cumplido su propósito como iglesia, aunque el púlpito y el altar todavía existen. Pero la pequeña y llamativa iglesia cerca de Stöðvarfjörður, que es visible desde lejos en una colina, ahora sirve como alojamiento esporádico. La galería del coro puede alojar hasta diez viajeros que prefieren la originalidad a la comodidad y dormir en sacos de dormir.

Stöðvarfjörður

Da tempo ha servito come chiesa, anche se il pulpito e l'altare esistono ancora. Ma la suggestiva chiesetta nei pressi di Stöðvarfjörður, visibile da lontano su una collina, oggi è un alloggio insolito. La galleria del coro può accogliere fino a dieci ospiti che preferiscono l'originalità al comfort, dormendo in sacchi a pelo.

Stöðvarfjörður

Als kerk doet het allang geen dienst meer, ook al staan de preekstoel en het altaar er nog. Maar het opvallende kerkje in de buurt van Stöðvarfjörður, dat al van verre op een heuvel zichtbaar is, dient nu als een ongebruikelijk onderkomen. De kooromgang biedt onderdak aan tien reizigers die originaliteit verkiezen boven comfort en in slaapzakken slapen.

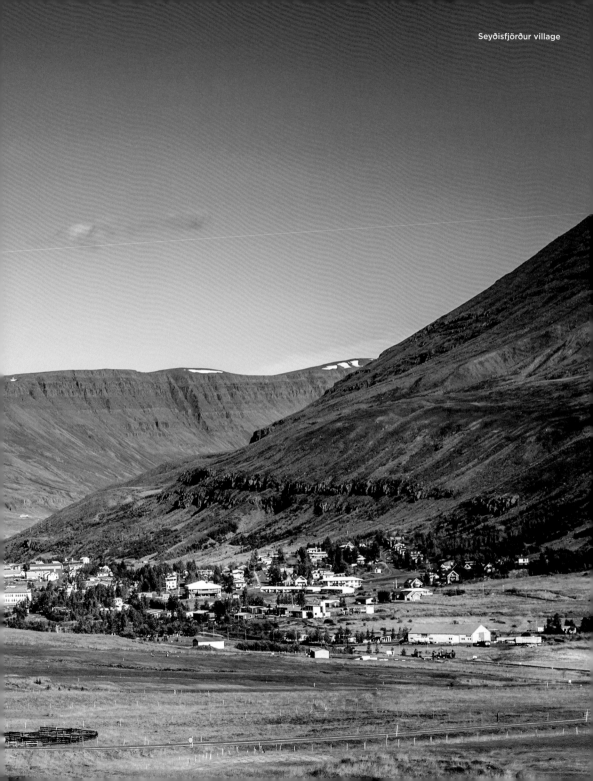

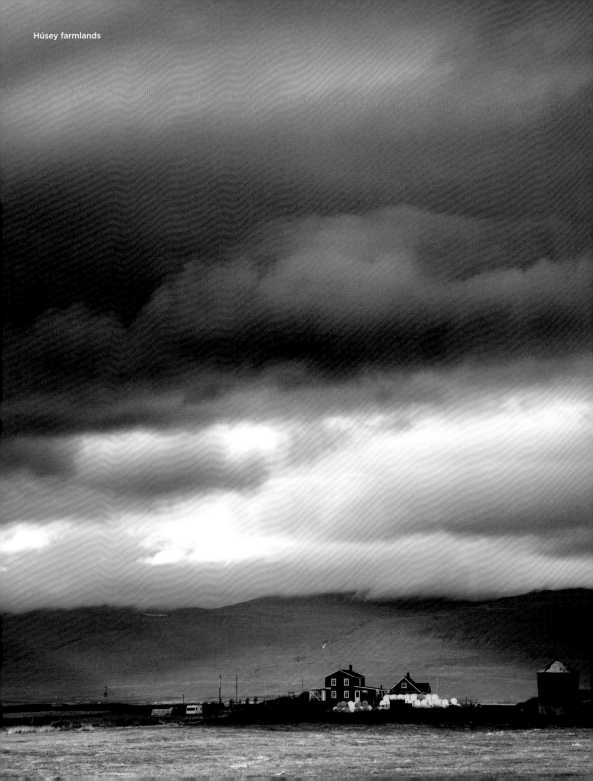

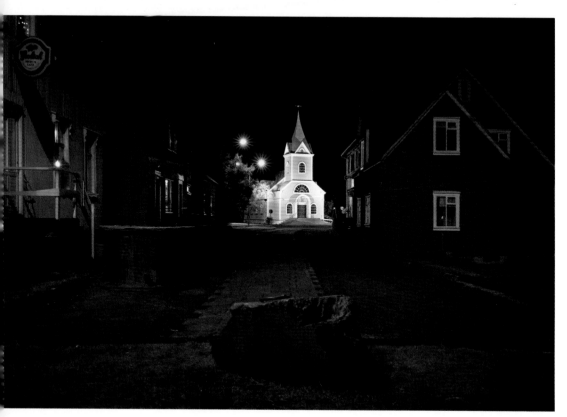

Church of Seyðisfjörður

Church of Seyðisfjörður
As you might expect based on its icy colour, this stately church is also known as the "Blue Church". Like many wooden houses in the city, the church originally arrived as a kit from Norway and has changed location several times. Today, it plays a leading role as Seyðisfjörður's cultural centre and offers an ambitious concert programme.

Église de Seyðisfjörður
On l'appelle aussi « l'église bleue » – un surnom dû évidemment à la couleur bleu glacier de l'église majestueuse. Comme beaucoup de maisons en bois dans la ville, le bâtiment est arrivé en kit depuis la Norvège et a changé d'emplacement plusieurs fois. Aujourd'hui, l'église joue un rôle de premier plan à Seyðisfjörður : devenue centre culturel, elle propose un programme de concerts ambitieux.

Kirche von Seyðisfjörður
Sie heißt auch die „Blaue Kirche" – naheliegend bei der eisblauen Farbe des stattlichen Gotteshauses. Die Kirche kam einst wie viele Holzhäuser der Stadt als Bausatz aus Norwegen und wechselte mehrmals ihren Standort. Heute spielt sie in der Mitte von Seyðisfjörður als Kulturzentrum mit einem ambitionierten Konzertprogramm eine Hauptrolle.

Iglesia de Seyðisfjörður
También llamada la "Iglesia Azul" –elección evidente por el color azul hielo de la iglesia señorial. Como muchas casas de madera en la ciudad, la iglesia llegó como un conjunto de módulos desde Noruega y cambió su ubicación varias veces. Hoy en día desempeña un papel destacado en el centro de Seyðisfjörður como centro cultural con un ambicioso programa de conciertos.

Chiesa di Seyðisfjörður
Si chiama anche la "Chiesa Blu" – la scelta ovvia per il colore blu ghiaccio della maestosa chiesa. Come molte case di legno della città, la chiesa proviene da un kit di prefabbricati dalla Norvegia e ha cambiato la sua posizione più volte. Oggi svolge un ruolo di primo piano nel centro di Seyðisfjörður come centro culturale con un interessante programma di concerti.

Kerk van Seyðisfjörður
Hij wordt ook wel de 'blauwe kerk' genoemd – dat ligt voor de hand, gezien de lichtblauwe kleur van het statige godshuis. Net als veel houten huizen in de stad kwam de kerk als bouwpakket uit Noorwegen en veranderde hij meermaals van standplaats. Tegenwoordig speelt hij als cultureel centrum met een ambitieus concertprogramma een hoofdrol in het centrum van Seyðisfjörður.

Farmhouse, Borgarfjörður Eystri

Lindarbakki

The small village of Bakkagerði is also known as Borgarfjörður eystri. The sod-roofed red wooden house Lindarbakki is over 100 years old and looks like an open-air museum, though it is still used as a summer house.

Lindarbakki

Le petit village de Bakkagerði est aussi connu sous le nom de Borgarfjörður eystri. La maison en bois rouge Lindarbakki, au toit en tourbe, a plus de 100 ans ; elle ressemble à un musée en plein air, mais elle est toujours utilisée comme maison d'été.

Lindarbakki

Der kleine Ort Bakkagerði ist auch unter dem Namen Borgarfjörður eystri bekannt. Das rote Holzhaus Lindarbakki mit dem Grassodendach ist über 100 Jahre alt und wirkt wie ein Freilichtmuseum, wird jedoch immer noch als Sommerhaus genutzt.

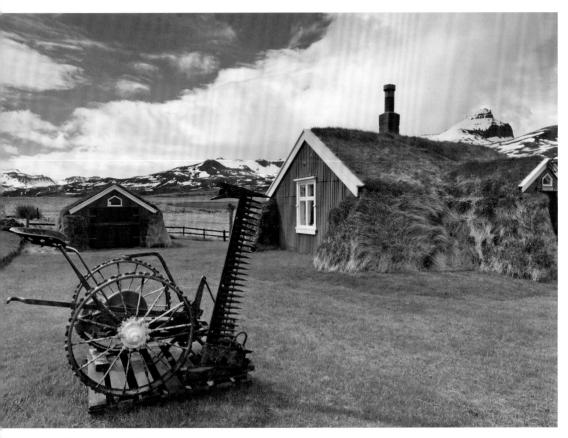

Lindarbakki Turf House, Bakkagerði village

Lindarbakki

El pequeño pueblo de Bakkagerði también es conocido como Borgarfjörður eystri. El Lindarbakki, casa de madera roja con techo de césped, tiene más de 100 años de antigüedad y parece un museo al aire libre, pero todavía se utiliza como casa de verano.

Lindarbakki

Il piccolo villaggio di Bakkagerði è anche conosciuto come Borgarfjörður eystri. La casa di legno rosso Lindarbakki con il tetto di zolle ha più di 100 anni e sembra un museo all'aperto, ma è ancora usato come una casa estiva.

Lindarbakki

Het kleine dorpje Bakkagerði is ook bekend onder de naam Borgarfjörður eystri. Het Lindarbakki-huis, een rood houten huis met een zadeldak, is meer dan honderd jaar oud en ziet eruit als een openluchtmuseum, maar wordt nog steeds gebruikt als zomerhuis.

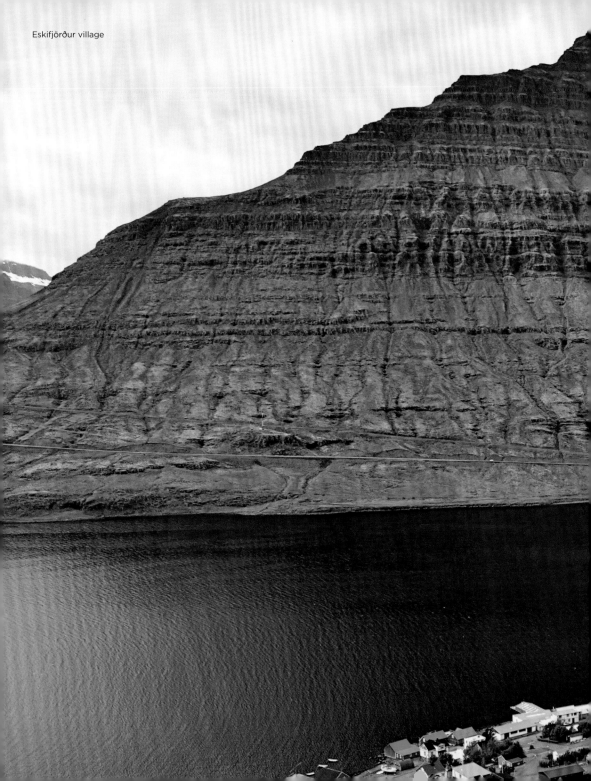

Eskifjörður village

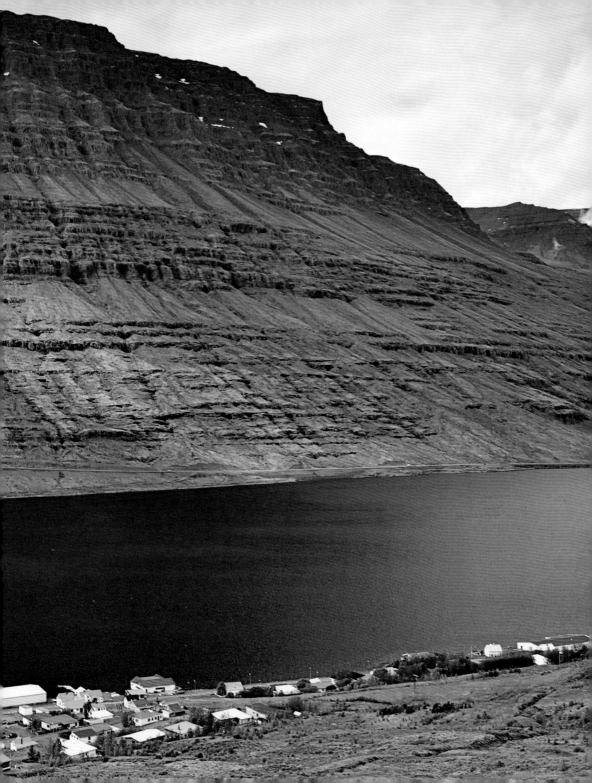

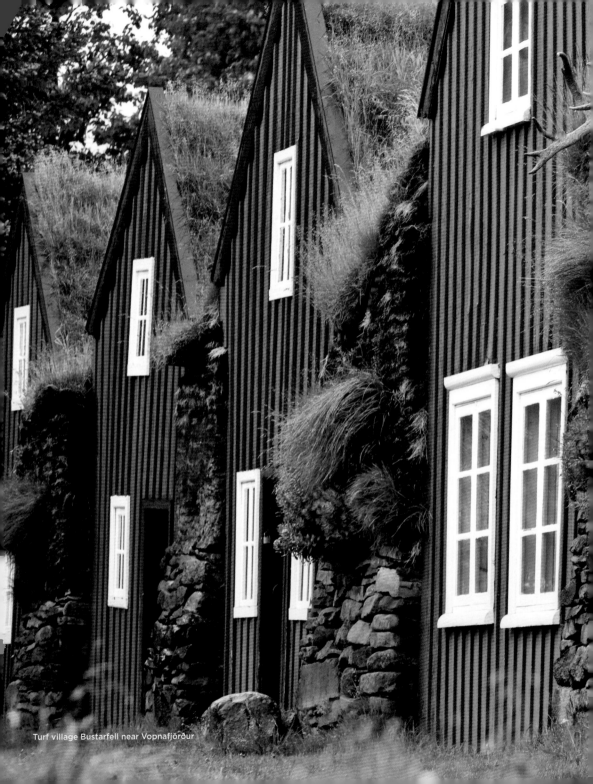
Turf village Bustarfell near Vopnafjörður

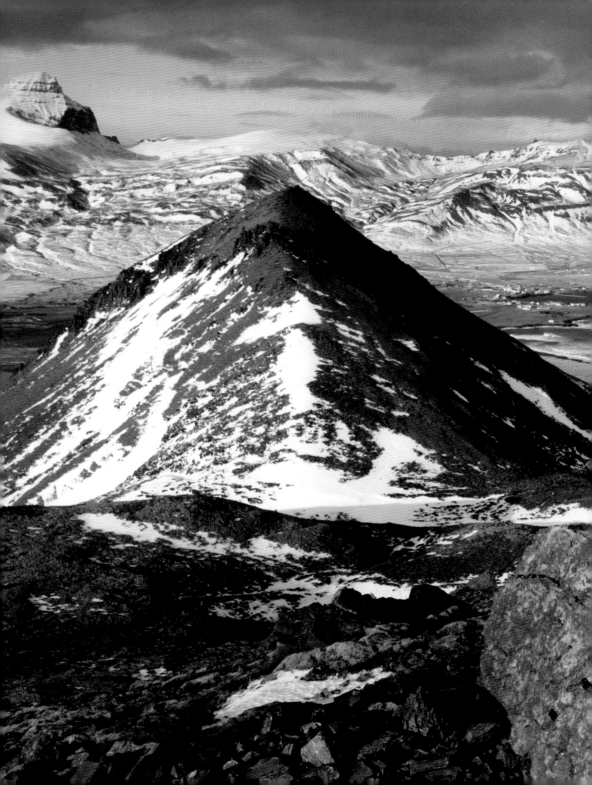

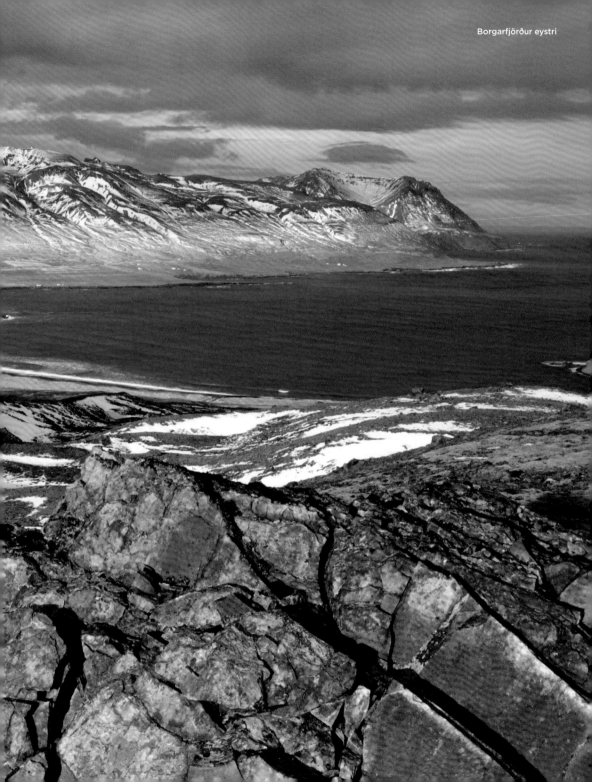

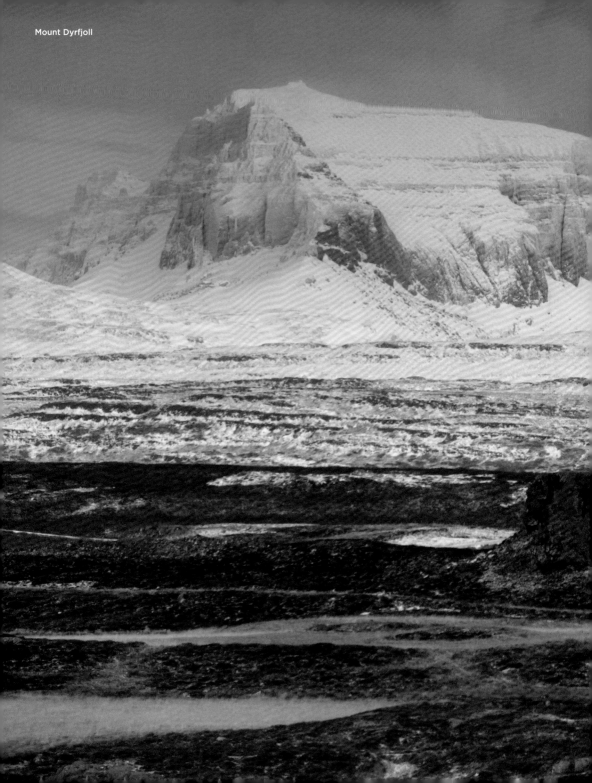

Mount Dyrfjoll

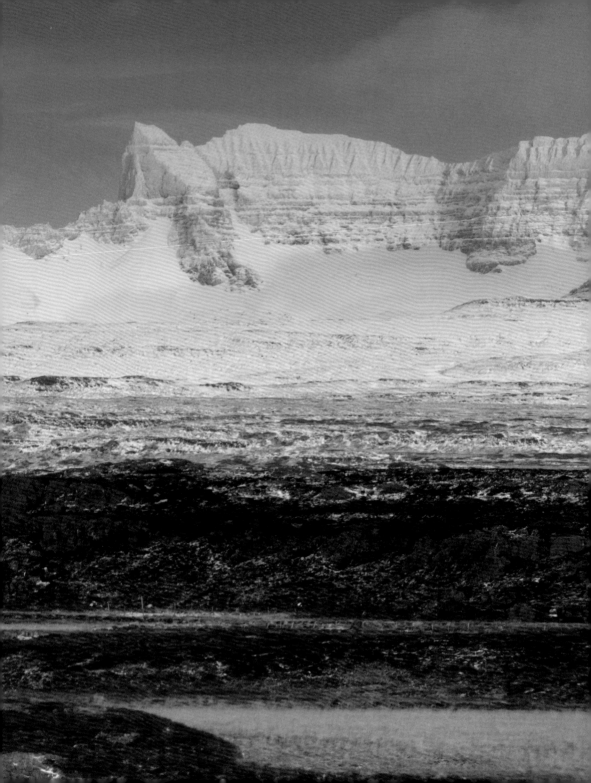

Reyðarfjörður

The construction of an aluminium plant in the early 2000s reversed the decline in this region's population. The raw material comes from ships from all over the world and is processed in Reyðarfjörður with cheap electricity produced by the Kárahnjúkar power plant in the highlands. The power plant's dam was the most controversial construction project in Iceland's history, due to its extensive environmental impact.

Reyðarfjörður

La construction de l'usine d'aluminium a permis d'enrayer le déclin de population dans la région. La matière première est acheminée par des navires du monde entier, et elle est traitée à Reyðarfjörður avec de l'électricité bon marché, produite par la centrale électrique de Kárahnjúkar, dans les Hautes Terres. Le barrage de la centrale a été le projet de construction le plus controversé d'Islande, en raison de son impact considérable sur la nature.

Reyðarfjörður

Der Bau des Aluminiumwerkes hat den Bevölkerungsrückgang der Region umgekehrt. Der Rohstoff kommt mit Schiffen aus aller Welt und wird in Reyðarfjörður mit billigem Strom verarbeitet. Diesen produziert das Kárahnjúkar-Kraftwerk im Hochland. Der Staudamm des Kraftwerks war wegen der umfangreichen Eingriffe in die Natur das umstrittenste Bauvorhaben Islands.

Reyðarfjörður

La construcción de la planta de aluminio ha invertido el declive de la población de la región. La materia prima proviene de barcos de todo el mundo y se procesa en Reyðarfjörður con electricidad de bajo coste. Esta procede de la central eléctrica de Kárahnjúkar, en las tierras altas. La presa de la central eléctrica fue el proyecto de construcción más controvertido de Islandia debido a su gran impacto en la naturaleza.

Reyðarfjörður

La costruzione della fabbrica di alluminio ha invertito la tendenza al declino della popolazione della regione. La materia prima proviene da navi di tutto il mondo e viene lavorata a Reyðarfjörður con energia elettrica a basso costo. Questo è prodotto dalla centrale elettrica di Kárahnjúkar negli Altipiani. La diga della centrale elettrica è stato il progetto di costruzione più controverso in Islanda a causa del suo ampio impatto sulla natura.

Reyðarfjörður

Met de bouw van de aluminiumfabriek is de bevolkingsafname in de regio omgebogen. De grondstof komt van schepen uit de hele wereld en wordt in Reyðarfjörður met goedkope elektriciteit verwerkt. Deze wordt in het hoogland opgewekt door de Kárahnjúkar-energiecentrale. De dam van de elektriciteitscentrale was het meest omstreden bouwproject van IJsland vanwege zijn grote impact op de natuur.

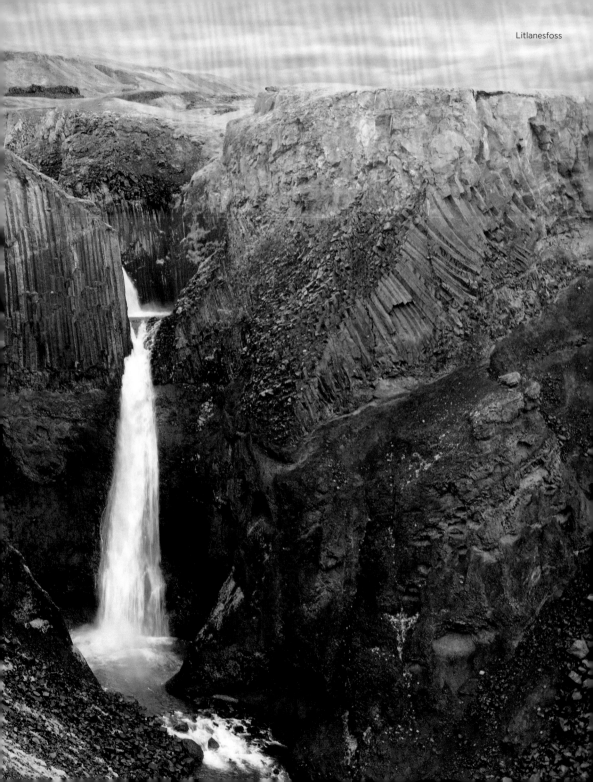

Seyðisfjörður

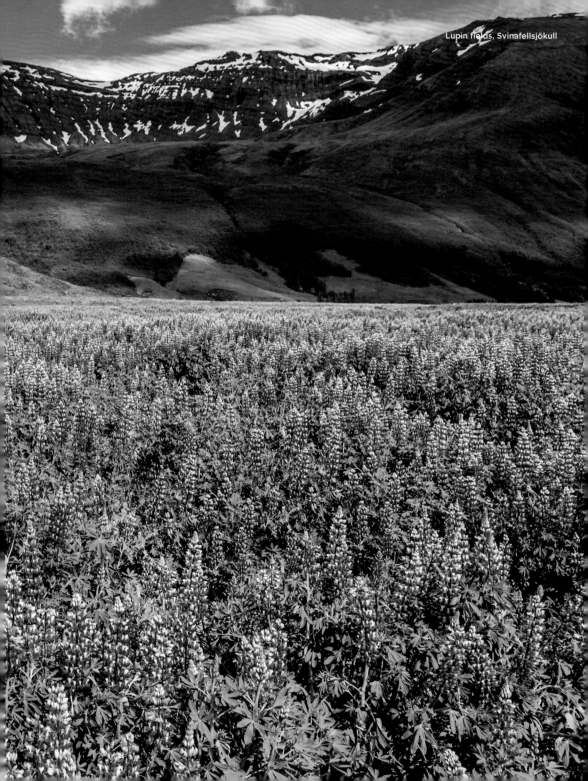
Lupin fields, Svinafellsjökull

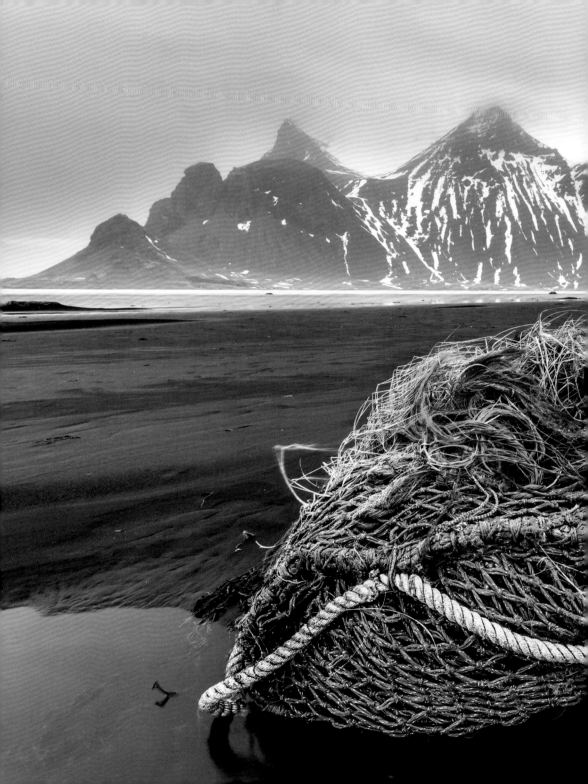

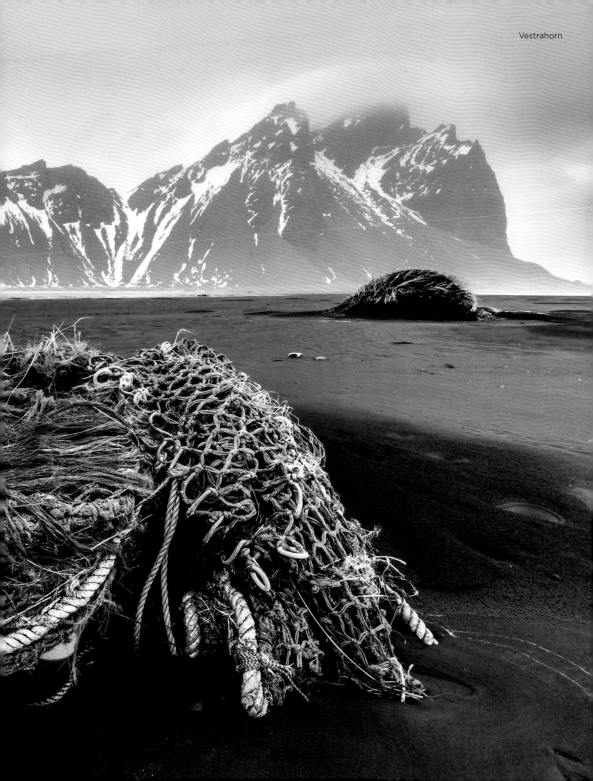

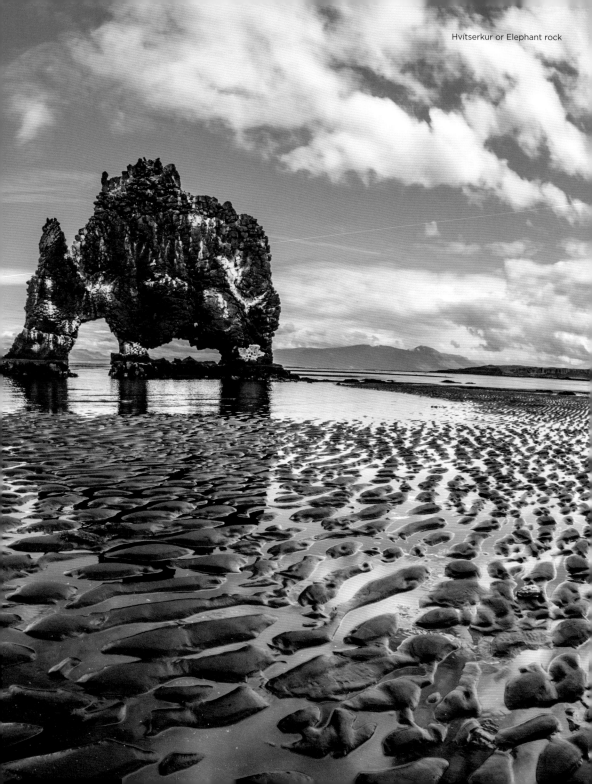
Hvítserkur or Elephant rock

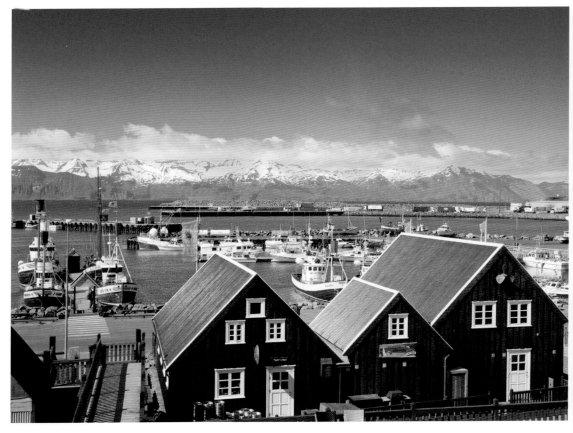

Harbour of Húsavík

Northern Iceland

Fjords and peninsulas shape the northern coast of Iceland. While there are no more active volcanoes in the west, in the east, many places still hiss and steam, and mud pools bubble with boiling sludge. Especially around Lake Mývatn, volcanic activity shows off its most spectacular side. Iceland's fourth largest city, Akureyri, has several museums and a relatively mild climate.

Nord de l'Islande

Le nord de l'Islande est divisé entre fjords et péninsules. Dans la partie occidentale, il n'y a plus de volcanisme actif. Dans l'est, au contraire, la terre siffle, bouillonne, produit de la vapeur et des sources chaudes ; surtout autour du lac Mývatn, où le volcanisme montre son côté le plus spectaculaire. Akureyri, la quatrième plus grande ville d'Islande, surprend avec plusieurs musées et un climat relativement doux.

Nordisland

Mehrere Fjorde und Halbinseln gliedern den Norden Islands. Im westlichen Teil gibt es keinen aktiven Vulkanismus mehr. Ganz anders in Richtung Osten, dort dampft und zischt es vielerorts und in Schlammtöpfen brodelt eine kochend heiße Masse vor sich hin. Vor allem rund um den Mývatn-See zeigt sich der Vulkanismus von seiner spektakulärsten Seite. Islands viertgrößte Stadt Akureyri überrascht mit einigen Museen und einem relativ milden Klima.

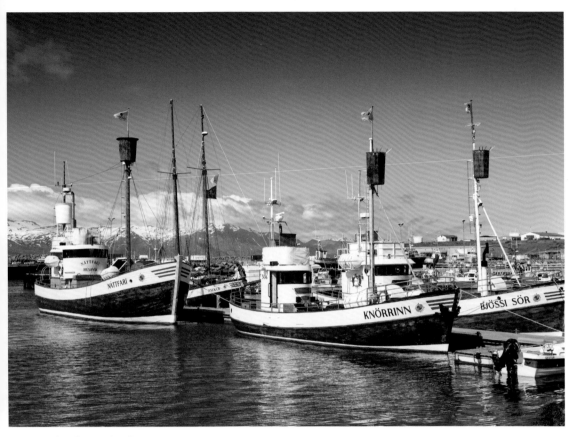
Whale watching boats, Húsavík

Norte de Islandia

Varios fiordos y penínsulas dividen el norte de Islandia. En la parte occidental ya no hay actividad volcánica. En el este ocurre todo lo contrario, allí hierve el agua y silba en muchos lugares y en las piscinas de barro una masa hirviente burbujea ante sí misma. Especialmente en los alrededores del lago Mývatn es donde la actividad volcánica muestra su lado más espectacular. La cuarta ciudad más grande de Islandia, Akureyri, sorprende con varios museos y un clima relativamente templado.

Islanda Settentrionale

Diversi fiordi e penisole dividono il nord dell'Islanda. Nella parte occidentale non c'è più alcun vulcanismo attivo. Molto diverso a est, vapori e sibili qui e là e nelle pozze di fango ribolle una massa fumante. Soprattutto intorno al lago di Mývatn il vulcanismo mostra il suo lato più spettacolare. Akureyri, la quarta città più grande d'Islanda, sorprende per i suoi numerosi musei e il clima relativamente mite.

Noord-IJsland

Diverse fjorden en schiereilanden verdelen het noorden van IJsland. In het westelijke deel is er geen actief vulkanisme meer. Dat is in het oosten wel anders: daar stoomt en sist het op veel plaatsen en ligt in de modder een kokend hete massa te borrelen. Vooral rond het meer van Mývatn laat het vulkanisme zich van zijn spectaculairste kant zien. Akureyri, de naar inwonertal vierde stad van IJsland, verrast met enkele musea en een relatief mild klimaat.

Near Sauðárkrókur, Skagafjörður

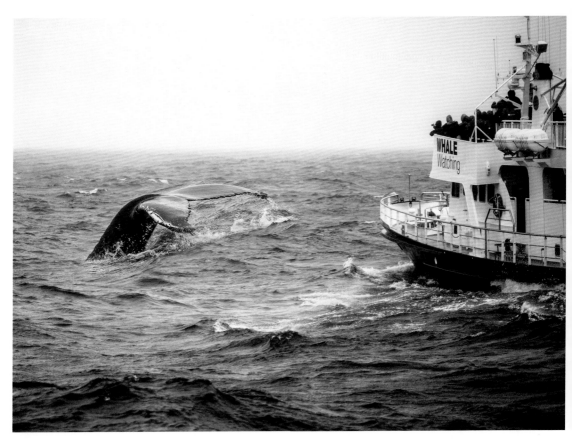

Humpback whale

Humpback Whales

Humpback whales live in all of the world's oceans. In summer, they can be found in the polar seas, including off Iceland, and in winter they migrate to tropical and subtropical waters. The whale owes its name to the hump it forms when diving. In a final flourish, it stretches its tail completely out of the water. Humpback whales have been protected worldwide since 1966.

Baleines à bosse

Les baleines à bosse vivent dans tous les océans. En été, on les trouve dans les mers polaires, y compris au large de l'Islande, alors qu'elles passent l'hiver dans les eaux tropicales et subtropicales. Elles doivent leur nom à la bosse qu'elles forment en plongée, projetant complètement leur queue hors de l'eau. Les baleines à bosse sont protégées dans le monde entier depuis 1966.

Buckelwale

Buckelwale leben in allen Ozeanen. Im Sommer trifft man sie in den polaren Meeren, also auch vor Island an, den Winter verbringen sie in tropischen und subtropischen Gewässern. Seinen Namen verdankt der Wal dem Buckel, den er beim Abtauchen bildet. Dabei reckt er die Schwanzflosse komplett aus dem Wasser. Seit 1966 stehen Buckelwale weltweit unter Schutz.

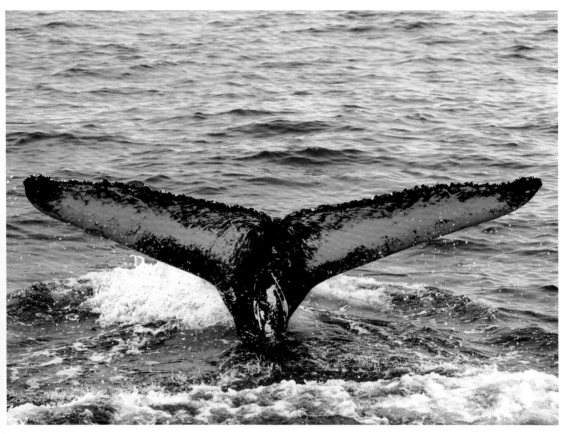

Humpback whale

Ballenas jorobadas

Las ballenas jorobadas viven en todos los océanos. En verano se encuentran en los mares polares, incluso frente a Islandia y,en invierno pasan su tiempo en aguas tropicales y subtropicales. La ballena debe su nombre a la joroba que forma al bucear. Estira la cola completamente fuera del agua. Las ballenas jorobadas están protegidas en todo el mundo desde 1966.

Megattere

Le megattere vivono in tutti gli oceani. In estate si trovano nei mari polari, anche al largo dell'Islanda, e in inverno trascorrono il loro tempo in acque tropicali e subtropicali. La balena deve il suo nome alle grandi pinne pettorali che utilizza durante le immersioni. La coda fuoriesce completamente dall'acqua. Le megattere sono protette in tutto il mondo dal 1966.

Bultruggen

In alle oceanen leven bultrugwalvissen. In de zomer zijn ze te vinden in de poolzeeën, ook voor de kust van IJsland, en in de winter brengen ze hun tijd door in tropische en subtropische wateren. De walvis dankt zijn naam aan de bult die hij vormt tijdens het duiken. Daarbij strekt hij zijn staartvin volledig boven het water. Bultruggen zijn sinds 1966 wereldwijd beschermd.

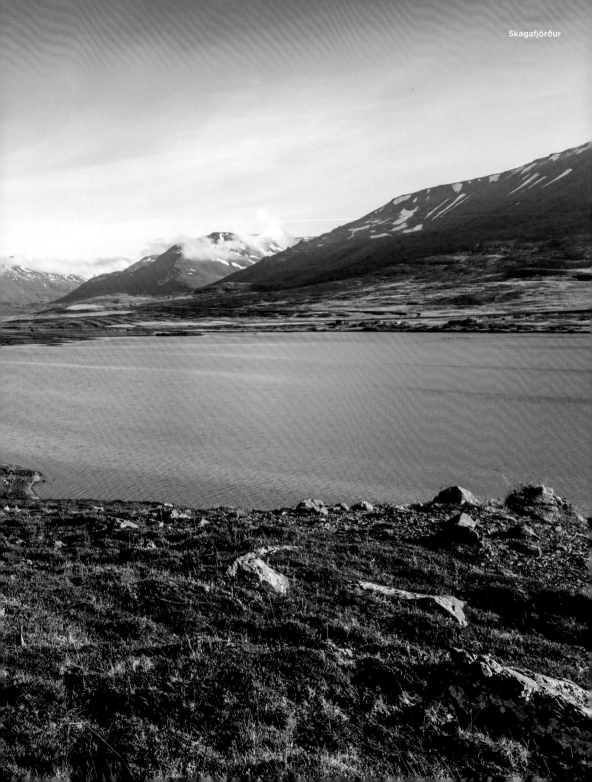

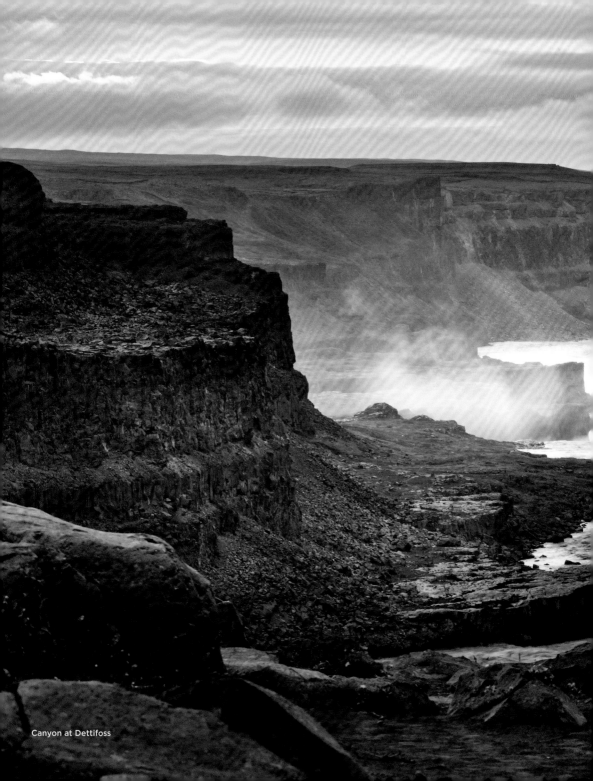

Canyon at Dettifoss

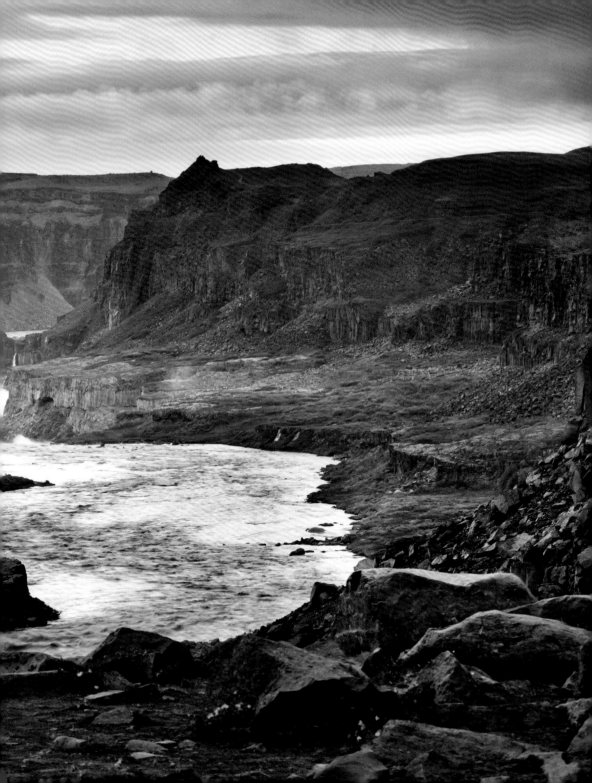

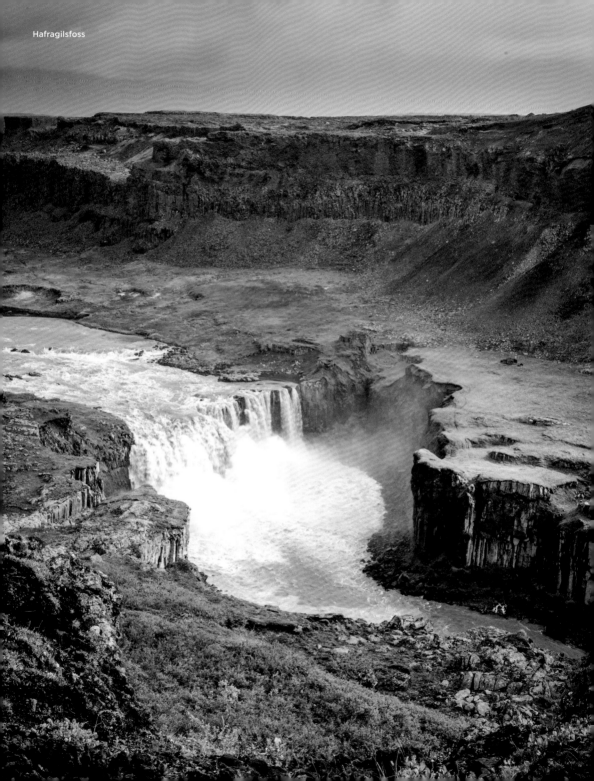
Hafragilsfoss

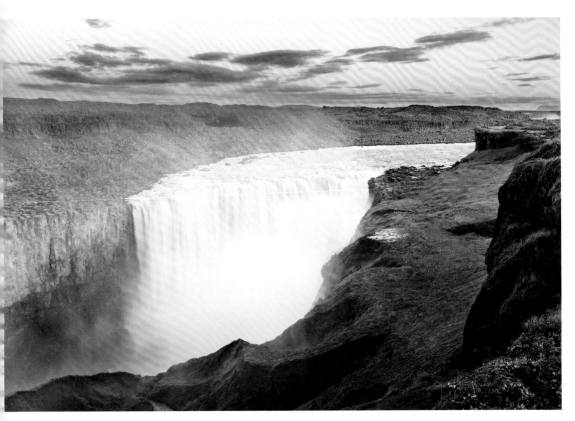

Dettifoss

Dettifoss

The river Jökulsá á Fjöllum is fed by the meltwater of Vatnajökull. At first, the Jökulsá flows slowly, but it later forms Iceland's largest erosion gorge, 500 metres wide and up to 120 metres deep. Every second, 1500 cubic metres of water plunge down the waterfall of Dettifoss into the gorge with elemental force.

Dettifoss

La rivière Jökulsá á Fjöllum est alimentée par l'eau de fonte du Vatnajökull. Son cours débute en douceur, mais plus en aval il forme une gorge de 500 m de large allant jusqu'à 120 m de profondeur. Chaque seconde, 1500 m³ d'eau plongent dans la plus grande gorge d'érosion d'Islande, à Dettifoss, avec force et brutalité.

Dettifoss

Der Fluss Jökulsá á Fjöllum wird vom Schmelzwasser des Vatnajökull gespeist. Anfangs fließt die Jökulsá gemächlich dahin, doch im weiteren Verlauf bildet sie eine 500 m breite und bis zu 120 m tiefe Schlucht. In diese größte Erosionsschlucht Islands stürzen am Dettifoss mit Urgewalt jede Sekunde 1500 m³ Wasser in die Tiefe.

Dettifoss

El río Jökulsá á Fjöllum se alimenta del agua de deshielo de Vatnajökull. En un principio, el Jökulsá fluye lentamente, pero más tarde forma un barranco de 500 m de ancho y hasta 120 m de profundidad. Cada segundo, 1500 m³ de agua se sumergen con fuerza elemental en las profundidades del mayor cañón erosionado de Islandia, ubicado en Dettifoss.

Dettifoss

Il fiume Jökulsá á Fjöllum è alimentato dalla neve sciolta del Vatnajökull. All'inizio il fiume Jökulsá scorre lento, ma in seguito forma una gola larga 500 m e profonda fino a 120 m. Ogni secondo 1500 m³ di acqua si inabissano con forza primordiale nelle profondità della più grande gola di erosione d'Islanda a Dettifoss.

Dettifoss

De rivier de Jökulsá á Fjöllum wordt gevoed door het smeltwater van de Vatnajökull. Aanvankelijk stroomt de Jökulsá langzaam, maar later vormt hij een 500 meter brede en tot 120 meter diepe kloof. In de diepte van de grootste erosiekloof van IJsland bij Dettifoss stort elke seconde 1500 m³ water met geweld omlaag.

Mývatn

Mývatn is one of the sunniest places in Iceland: precipitation and cold north winds are held off by the surrounding mountains. Green meadows spread along its banks, and the farms breed sheep and horses. The lake is known for its rich bird life, especially the various species of ducks. But Mývatn means "mosquito lake", and the name is justified—at least at times.

Mývatn

Mývatn est l'un des endroits les plus ensoleillés d'Islande, car les précipitations et les vents froids du nord sont retenus par les montagnes environnantes. Le long de ses rives s'étendent des prairies vertes où l'on pratique l'élevage de moutons et de chevaux. Le lac est connu pour sa riche faune aviaire, en particulier pour les différentes espèces de canards. Mais Mývatn signifie également « lac aux moustiques », une appellation méritée, au moins à certaines périodes de l'année.

Mývatn

Der Mývatn ist einer der sonnigsten Orte Islands, Niederschläge und kalte Nordwinde werden von den umliegenden Bergen abgehalten. An seinen Ufern breiten sich grüne Wiesen aus, die Bauernhöfe betreiben Schaf- und Pferdezucht. Bekannt ist der See für sein reiches Vogelleben, vor allem für die verschiedenen Entenarten. Mývatn bedeutet aber auch Mückensee, und diesen Namen trägt er – zumindest zeitweise – zu Recht.

Mývatn

Mývatn es uno de los lugares más soleados de Islandia. Las montañas circundantes frenan la precipitación y los vientos fríos del norte . A lo largo de sus orillas se extienden verdes praderas, donde se crían ovejas y caballos. El lago es conocido por su rica avifauna, especialmente por las diversas especies de patos. Pero Mývatn también significa lago de los mosquitos, y el nombre le hace justicia, al menos de momento.

Mývatn

Mývatn è uno dei luoghi più soleggiati d'Islanda, le precipitazioni e i venti freddi del nord sono tenuti a bada dalle montagne circostanti. Prati verdi si estendono lungo le sue rive, nelle fattorie si allevano pecore e cavalli. Il lago è noto per la sua ricca avifauna, in particolare per le varie specie di anatre. Ma Mývatn significa anche lago delle zanzare, e giustamente porta questo nome – almeno a periodi.

Mývatn

Mývatn is een van de zonnigste plekken van IJsland - neerslag en koude noordenwinden worden tegengehouden door de omliggende bergen. Langs de oevers strekken groene weiden zich uit, op de boerderijen worden schapen en paarden gefokt. Het meer staat bekend om zijn vogelrijkdom, vooral zijn grote verscheidenheid aan eendensoorten. Maar Mývatn betekent ook muggenmeer en heeft deze naam - in elk geval tijdelijk - niet voor niets.

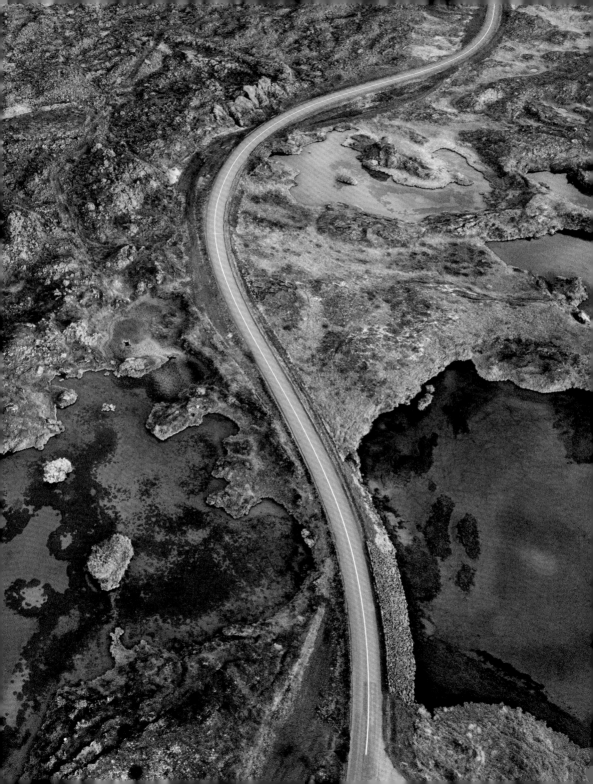

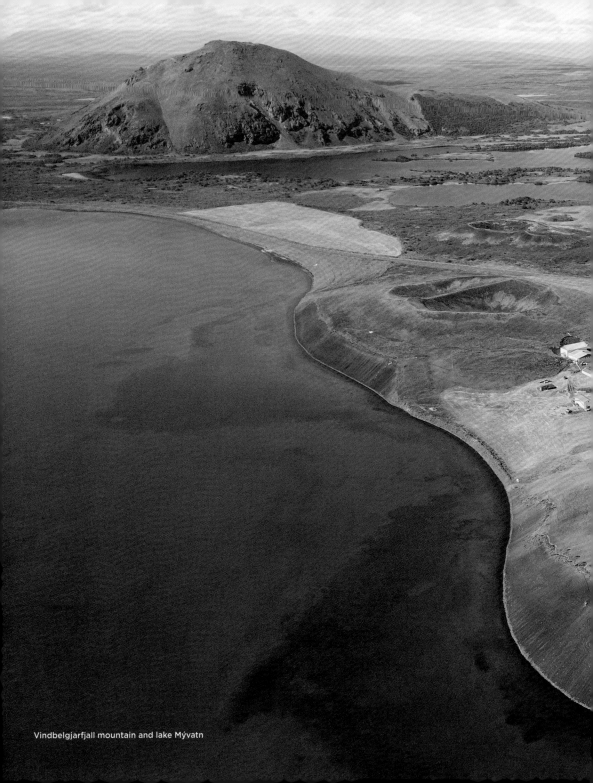

Vindbelgjarfjall mountain and lake Mývatn

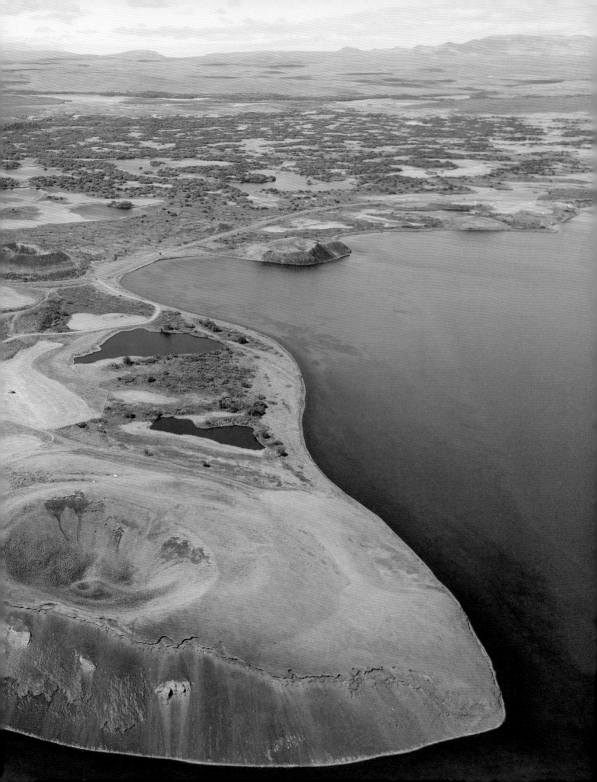

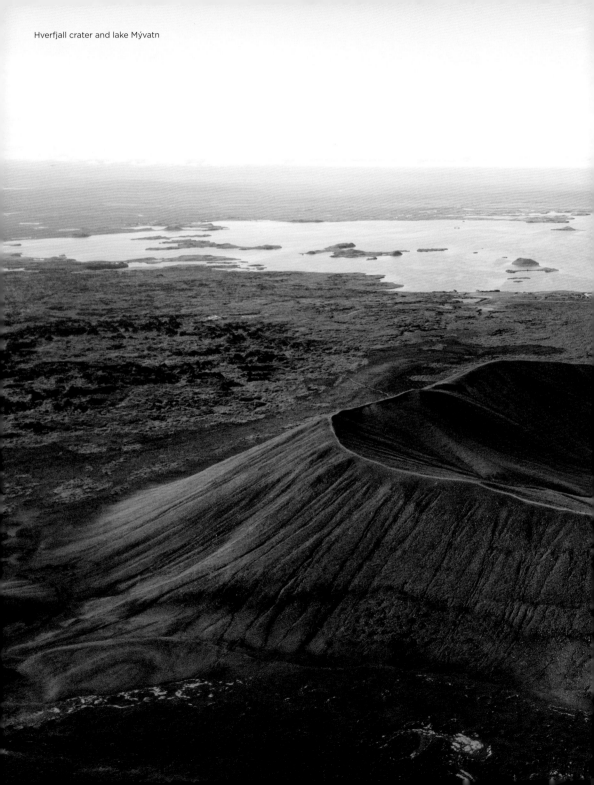
Hverfjall crater and lake Mývatn

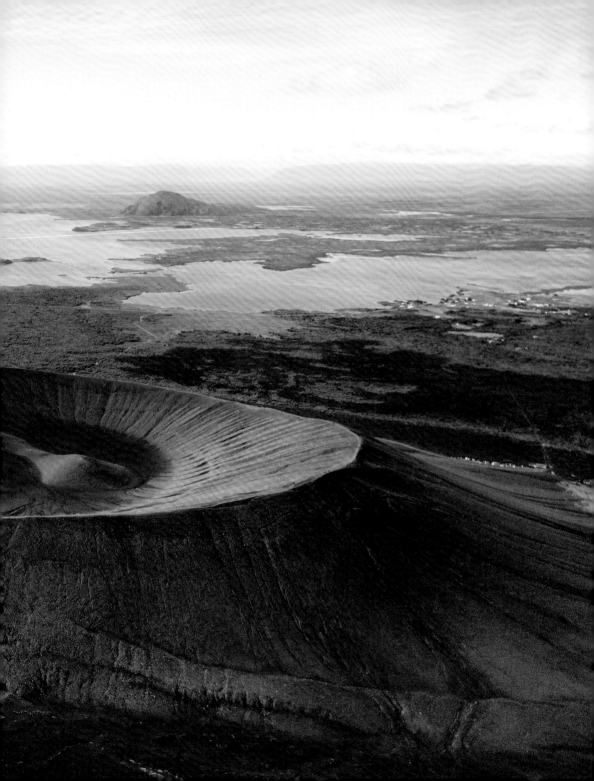

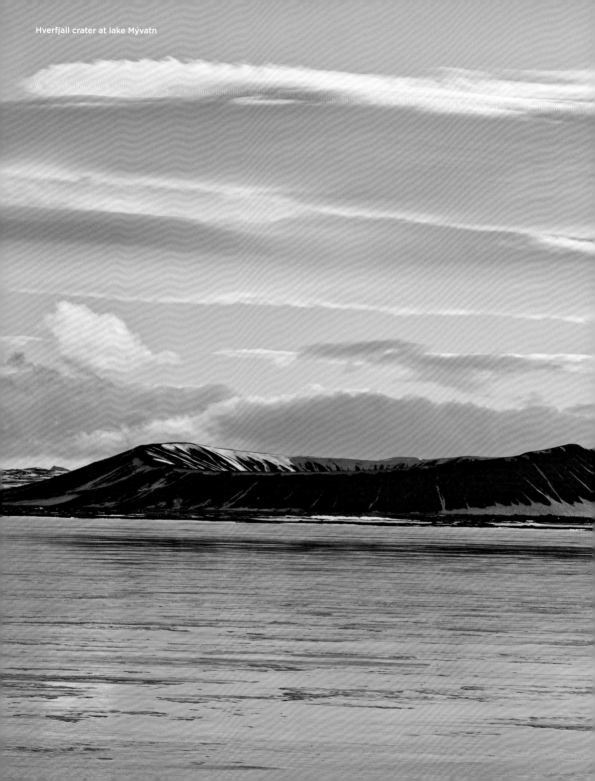
Hverfjall crater at lake Mývatn

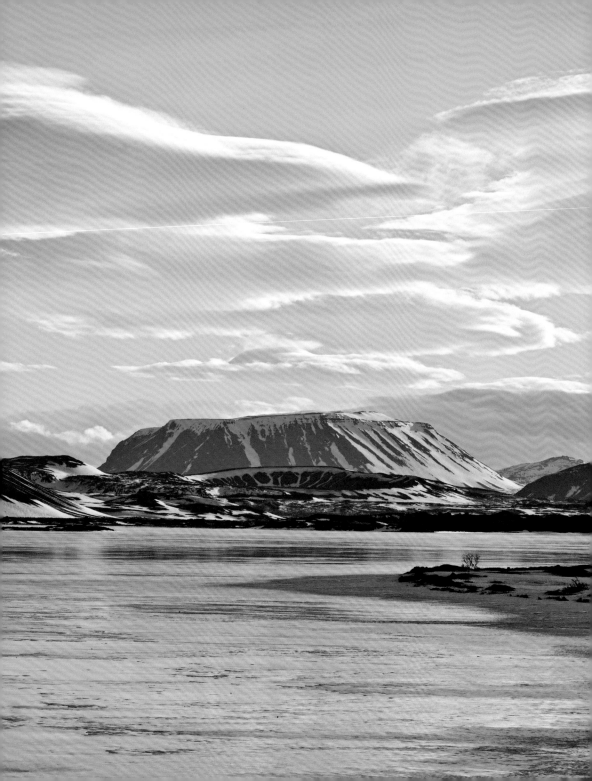

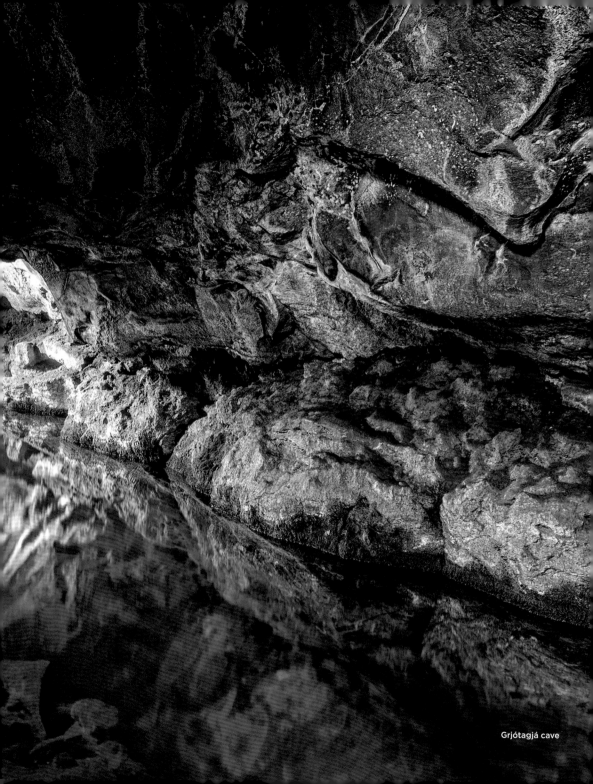
Grjótagjá cave

Dimmuborgir National Park

Dimmuborgir

Volcanic activity is common around Mývatn, since the lake and its wetlands sit astride the Eurasian and North American continental plates. Dimmuborgir, on the eastern shore of the lake, is a labyrinth of black, heavily eroded pillars of lava that often resemble mythical creatures. Dimmuborgir was formed around 2000 years ago by a dammed-up lava lake.

Dimmuborgir

Il y a beaucoup d'activité volcanique dans les environs de Mývatn, car les plaques continentales eurasienne et nord-américaine s'éloignent ici l'une de l'autre. Dimmuborgir, sur la rive est du lac, est un labyrinthe de tours de lave noire, fortement érodées, qui font parfois penser à des créatures mythiques ; la zone a été formée il y a environ 2000 ans, suite à l'érosion d'un lac de lave.

Dimmuborgir

Rund um den Mývatn gibt es vielfältige vulkanische Aktivitäten, denn hier driften die eurasische und die nordamerikanische Kontinentalplatte auseinander. Dimmuborgir am Ostufer des Sees ist ein Labyrinth aus schwarzen, stark erodierten Lavatürmen, die oft an Fabelwesen erinnern. Entstanden ist Dimmuborgir vor rund 2000 Jahren durch einen aufgestauten Lavasee.

Dimmuborgir

Alrededor de Mývatn hay mucha actividad volcánica, porque aquí, las placas continentales de Eurasia y América del Norte se separan. Dimmuborgir, en la orilla oriental del lago, es un laberinto de torres de lava negra muyerosionadas, que a menudo recuerdan a criaturas míticas. Dimmuborgir se formó hace unos 2000 años por un lago de lava embalsado.

Dimmuborgir

Intorno a Mývatn ci sono molte attività vulcaniche, perché qui si incontrano le placche continentali eurasiatica e nordamericana. Dimmuborgir sulla riva orientale del lago è un labirinto di torri di lava nere, pesantemente erose, che spesso ricordano le creature mitiche. Dimmuborgir è stato formato circa 2000 anni fa da un lago lavico arginato.

Dimmuborgir

Er is veel vulkanische activiteit rond het Mývatn-meer, omdat de Euraziatische en Noord-Amerikaanse continentale platen hier uit elkaar drijven. Het natuurreservaat Dimmuborgir aan de oostoever is een labyrint van zwarte, zwaar geërodeerde lavatorens die er vaak uitzien als fabelwezens. Dimmuborgir werd ongeveer 2000 jaar geleden gevormd door een opgestuwd lavameer.

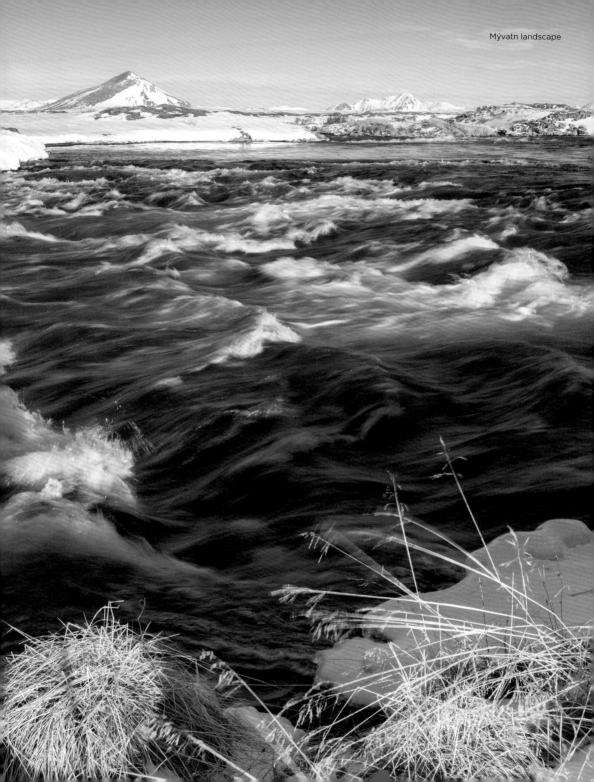

Mývatn landscape

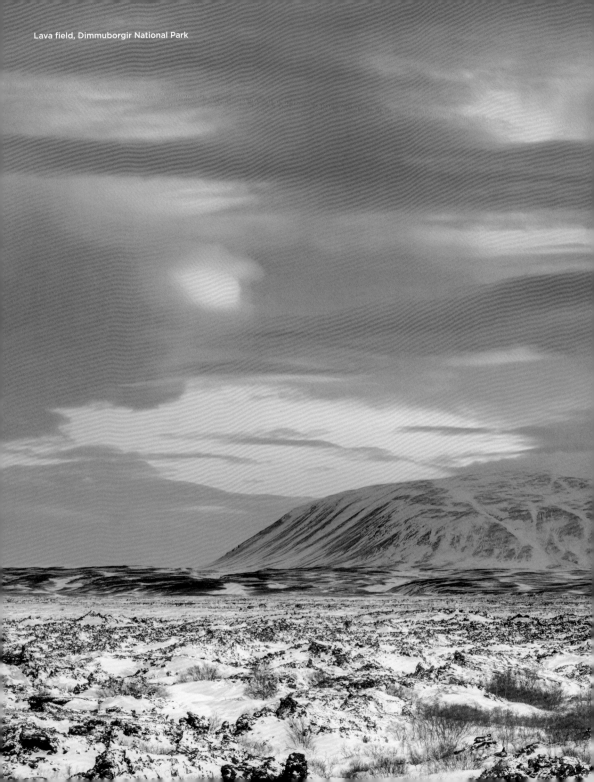
Lava field, Dimmuborgir National Park

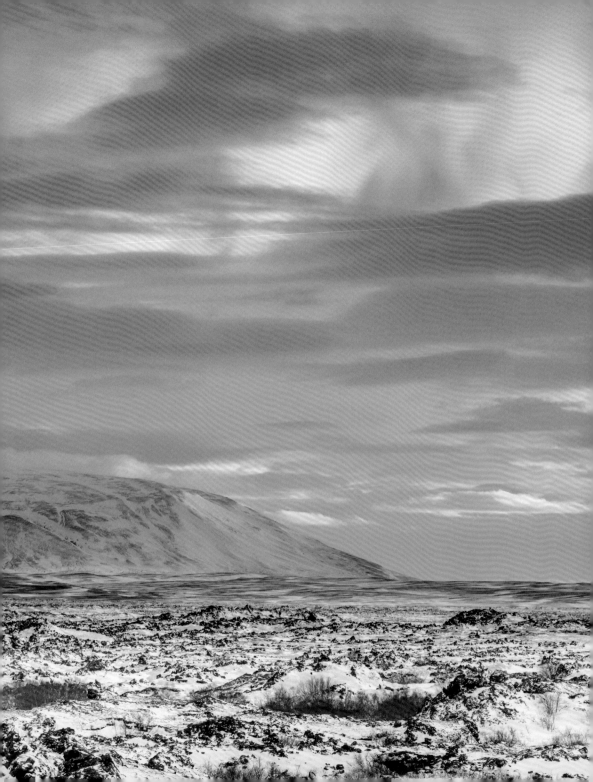

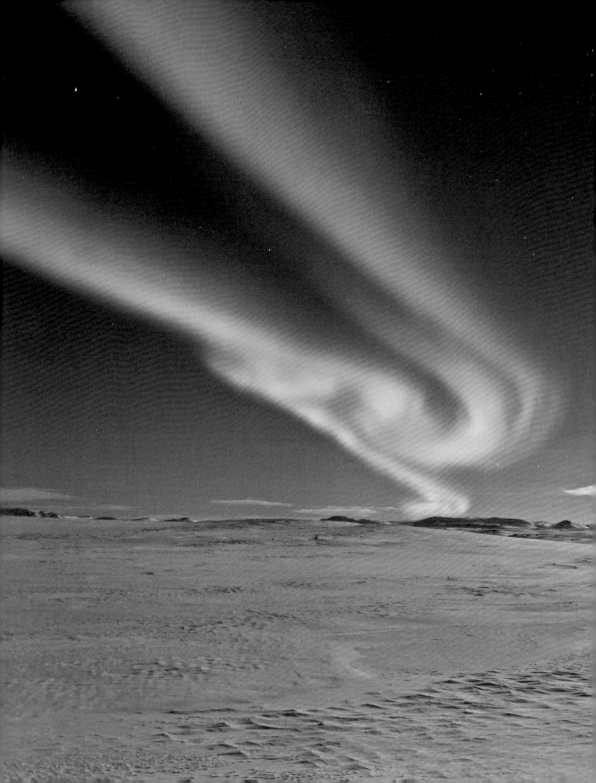

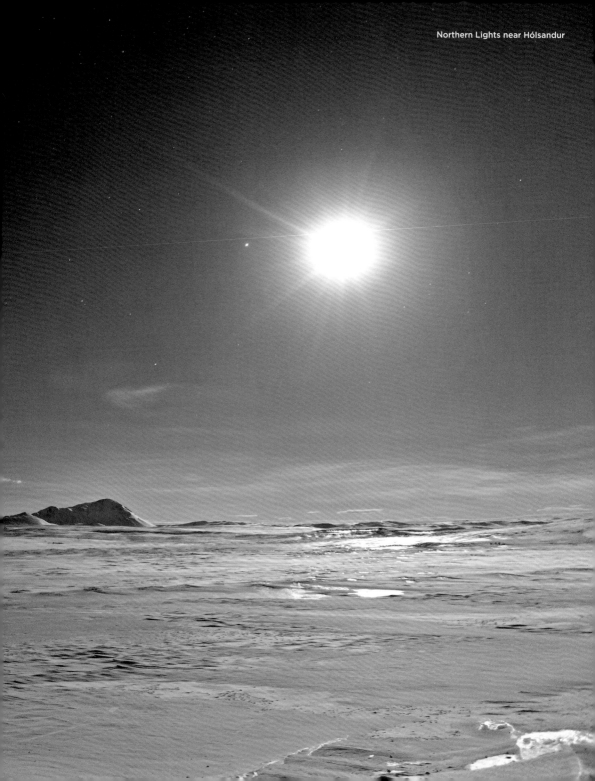

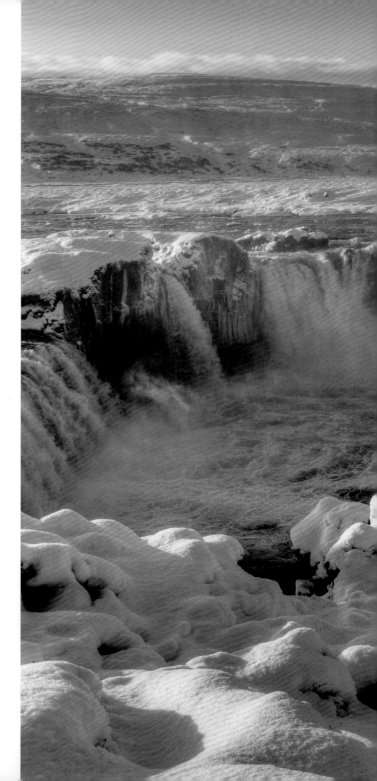

Goðafoss

The water of Goðafoss falls between Akureyri and Mývatn from a height of only 11 metres, though its crescent-shaped cliff edge spans about 150 metres. It was allegedly given its name, which means "waterfall of the gods," in the year 1000, when Christianity was introduced into Iceland. At that time, the goði Thorgeir is said to have thrown his idols of the old Norse gods into the waterfall.

Goðafoss

La cascade de Goðafoss, entre Akureyri et Mývatn, mesure seulement 11 m de hauteur, mais le bord de la falaise s'étend sur une large arche d'environ 150 m. Il aurait reçu le nom de Götterwasserfall en l'an 1000, lors de l'introduction du christianisme. À cette époque, le diseur de loi Þorgeir aurait jeté les idoles de ses anciens dieux dans la cascade.

Goðafoss

Das Wasser des Goðafoss stürzt zwischen Akureyri und Mývatn zwar nur 11 m in die Tiefe, doch die Abbruchkante verläuft in einem weiten Bogen über rund 150 m. Den Namen Götterwasserfall erhielt er angeblich im Jahr 1000, als das Christentum eingeführt wurde. Damals soll der Gode Thorgeir seine Götterbilder in den Wasserfall geworfen haben.

Goðafoss

El agua de Goðafoss cae entre Akureyri y Mývatn a una profundidad de tan solo 11 m, pero el borde del acantilado discurre en un amplio arco de unos 150 m. Al parecer se le dio el nombre de "Cascada de los dioses" en el año 1000, cuando se introdujo el cristianismo. En ese momento se dice que el goði Þorgeir arrojó sus imágenes de dioses a la cascada.

Goðafoss

L'acqua di Goðafoss cade tra Akureyri e Mývatn ad una profondità di soli 11 m, ma il bordo della scogliera scorre in un arco largo oltre 150 m circa. Si dice che il nome "cascata degli dei" sia stato dato nell'anno 1000, quando fu introdotto il cristianesimo. A quel tempo si dice che il goði Þorgeir abbia gettato le sue immagini degli dei nella cascata.

Goðafoss

Het water van de Goðafoss valt tussen Akureyri en Mývatn welswaar slechts 11 meter omlaag, maar wel in een brede boog over een rand van zo'n 150 meter. Naar verluidt kreeg hij de naam 'godenwaterval' in het jaar 1000, toen het christendom werd ingevoerd. Op dat ogenblik zou de wetspreker Thorgeir zijn afgodsbeelden in de waterval hebben gegooid.

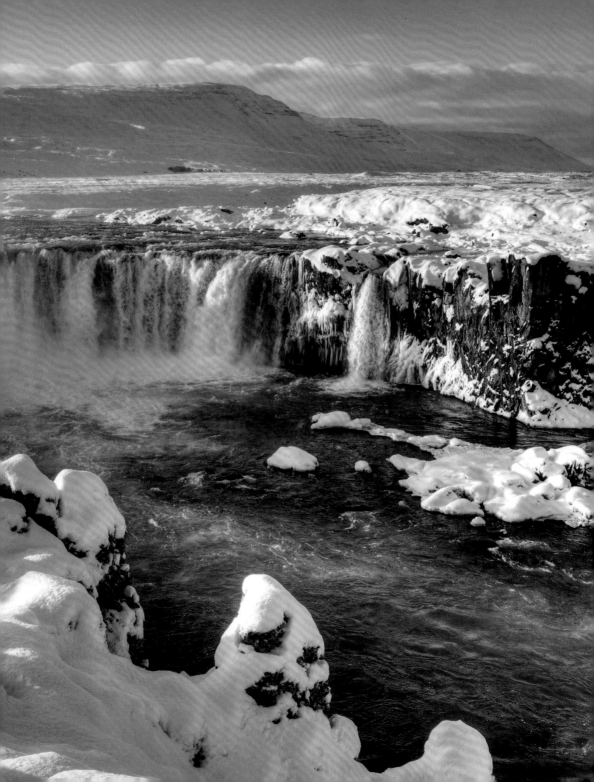

Eyjafjörður

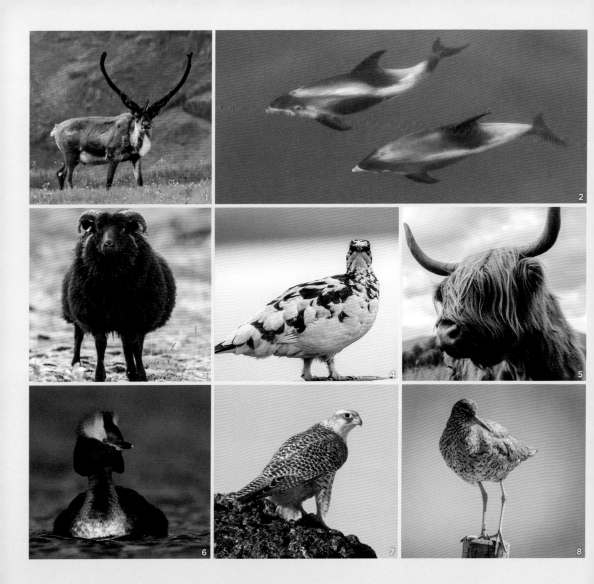

Wildlife

1 Reindeer, **2** White-beaked dolphins,
3 Sheep, **4** Ptarmigan, **5** Highland cattle,
6 Horned grebe, **7** Gyrfalcon, **8** Common
redshanks, **9** Arctic fox, **10** Seals, **11** Young
Arctic foxes, **12** Orca, **13** Golden plover,
14 Razorbills, **15** Greylag goose,
16 Collared ducks, **17** Seals

Faune

1 Renne **2** Dauphins à bec blanc **3** Mouton
4 Lagopède **5** Highland **6** Grèbe esclavon
7 Faucon gerfaut **8** Chevalier gambette
9 Renard arctique **10** Phoques
11 Jeunes renards arctiques **12** Orque
13 Pluvier doré **14** Petits pingouins
15 Oies cendrées **16** Arlequins plongeurs
17 Phoques

Wildtiere

1 Rentier, **2** Weißschnauzendelfine,
3 Schaf, **4** Schneehuhn, **5** Hochlandrind,
6 Ohrentaucher, **7** Gerfalke, **8** Rotschenkel,
9 Polarfuchs, **10** Seehunde, **11** junge
Polarfüchse, **12** Orca, **13** Goldregenpfeifer,
14 Tordalken, **15** Graugans,
16 Kragenenten, **17** Seehunde

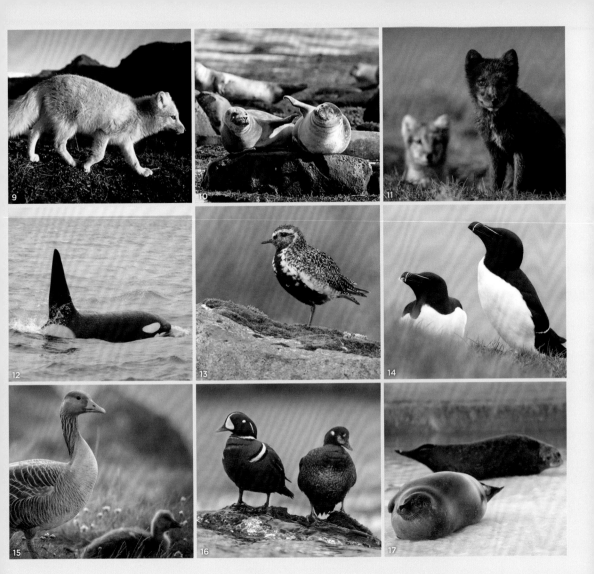

Vida silvestre

1 renos, **2** delfines de pico blanco,
3 ovejas, **4** lagópodos, **5** ganado de
las tierras altas, **6** zampullín cuellirrojo,
7 halcón gerifalte, **8** archibebe común,
9 zorro ártico, **10** focas, **11** zorros árticos
jóvenes, **12** orca, **13** chorlito dorado,
14 alcas tordas, **15** ganso común, **16** patos
arlequín, **17** focas.

Animali selvatici

1 Renna, **2** Lagenorinco rostrobianco,
3 Pecora, **4** Pernice bianca, **5** Vacca
Highlander, **6** Svasso cornuto, **7** Girfalco,
8 Pettegola, **9** Volpe artica, **10** Foca,
11 Cuccioli di volpe artica, **12** Orca,
13 Piviere dorato, **14** Gazze marine,
15 Oca selvatica, **16** Morette arlecchino,
17 Foche

Wilde dieren

1 rendier, **2** witsnuitdolfijnen, **3** schaap,
4 sneeuwhoen, **5** Schotse hooglander,
6 kuifduiker, **7** giervalk, **8** tureluur,
9 poolvos, **10** zeehonden, **11** jonge
poolvossen, **12** orka, **13** goudplevier,
14 alken, **15** grauwe gans,
16 harlekijneenden, **17** zeehonden

Rauðhólar, Jökulsárgljúfur National Park

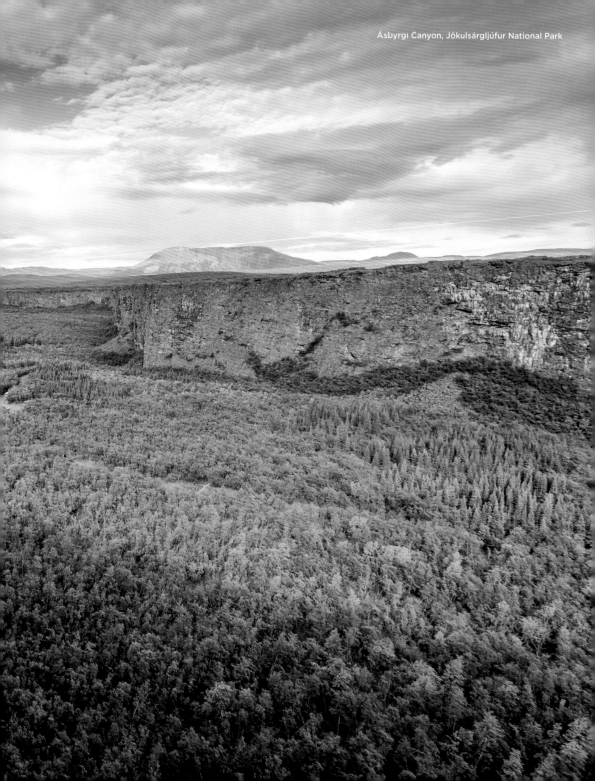

Ásbyrgi Canyon, Jökulsárgljúfur National Park

Hljóðaklettar stone formations, Jökulsárgljúfur National Park

Hljóðaklettar

A detour on Road 862 and a hike lead to the basalt rocks of Hljóðaklettar. These lava pillars were formed by eruptions 8000 years ago and stimulate the imagination with their unusual shapes, which have been honed over time by erosion. You might recognise a troll, a church, and all kinds of strange mythical creatures in the stone.

Hljóðaklettar

Un détour sur la route 862 puis une randonnée sont nécessaires pour atteindre les rochers basaltiques de Hljóðaklettar. Des colonnes de lave y ont été formées par des éruptions il y a 8000 ans et stimulent l'imagination par leur forme inhabituelle, créée par l'érosion au fil du temps. On peut ainsi y reconnaître un troll, une église ou toutes sortes de créatures mythiques étranges.

Hljóðaklettar

Ein Abstecher auf der Straße 862 und eine Wanderung führen zu den Basaltfelsen von Hljóðaklettar. Die Lavasäulen sind durch Eruptionen vor 8000 Jahren entstanden und regen durch ihre ungewöhnliche Form, die im Laufe der Zeit durch Erosion entstanden ist, die Fantasie an. So glaubt man einen Troll, eine Kirche und allerlei merkwürdige Fabelwesen zu erkennen.

Hljóðaklettar stone formations, Jökulsárgljúfur National Park

Hljóðaklettar

Un desvío por la carretera 862 y una excursión conducen a las rocas de basalto de Hljóðaklettar. Las columnas de lava se formaron por erupciones hace 8000 años y estimulan la imaginación con su forma inusual, que ha sido creada por la erosión gracias al paso del tiempo. Así, uno cree reconocer a un trol, una iglesia y toda clase de extrañas criaturas míticas.

Hljóðaklettar

Una deviazione sulla strada 862 e un'escursione conducono alle rocce basaltiche di Hljóðaklettar. Le colonne laviche sono state formate dalle eruzioni di 8000 anni fa e stimolano la fantasia con la loro forma insolita, creata dall'erosione nel corso del tempo. Si intravede così un troll, una chiesa e tutti i tipi di strane creature mitiche.

Hljóðaklettar

Een omweg over weg 862 en een wandeling leiden naar de basaltrotsen van Hljóðaklettar. De lavazuilen werden 8000 jaar geleden door uitbarstingen gevormd en prikkelen de fantasie met hun ongewone vormen die in de loop der tijd door erosie zijn ontstaan. Zo meent men een trol, een kerk en allerlei vreemde fabelwezens te herkennen.

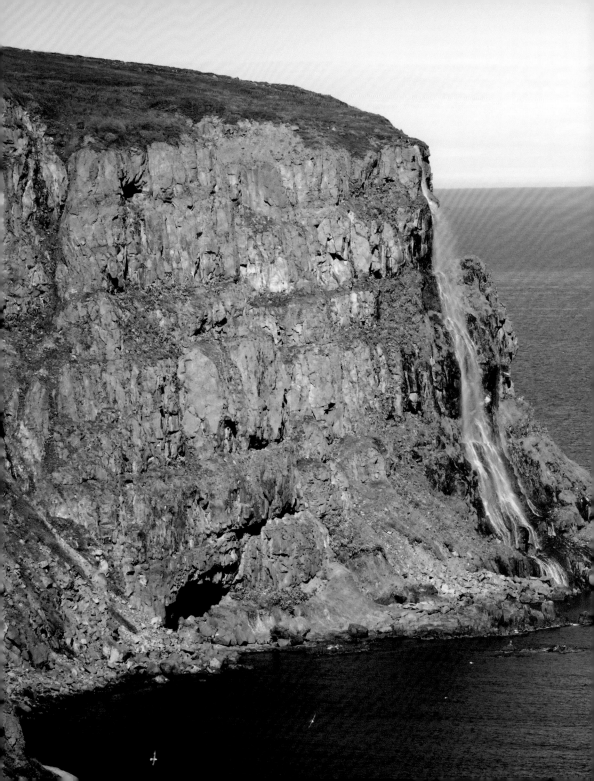

Migandi

Old pier, Sauðárkrókur

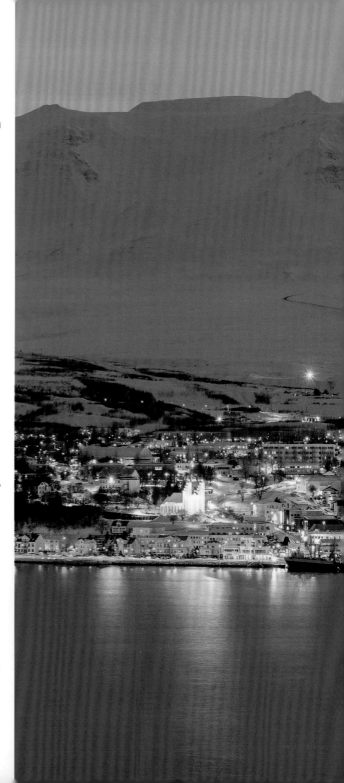

Akureyri

Akureyri is located almost on the Arctic Circle, and yet enjoys a mild climate. The city's best-known landmark is the simple concrete structure of the Akureyrarkirkja, designed—like the Hallgrímskirkja in Reykjavík—by state architect Guðjón Samúelsson. The small historical town centre, the art museum, and the Nonnahús, where the writer Jón Sveinsson grew up, are all worth a visit.

Akureyri

Akureyri est quasiment située sur le cercle polaire arctique, mais son climat est étonnement doux. Le monument le plus célèbre de la ville est l'Akureyrarkirkja, une église à la structure simple en béton conçue par l'architecte national Guðjón Samúelsson – à qui l'on doit également la Hallgrímskirkja à Reykjavík. À voir : le petit centre historique, le musée d'art et le Nonnahús, où l'écrivain Jón Sveinsson a grandi.

Akureyri

Akureyri liegt fast am Polarkreis und überrascht doch mit mildem Klima. Wahrzeichen der Stadt ist der schlichte Betonbau der Akureyrarkirkja, Staatsarchitekt Guðjón Samúelsson hat sie ebenso wie die Hallgrimskirche in Reykjavík entworfen. Sehenswert sind der kleine historische Ortskern, das engagierte Kunstmuseum und das Nonnahús, in dem der Schriftsteller Jón Sveinsson aufgewachsen ist.

Akureyri

Akureyri está casi en el Círculo Polar Ártico y sin embargo tiene un clima templado. El punto de referencia de la ciudad es la sencilla estructura de hormigón del Akureyrarkirkja o iglesia de Akureyri, diseñada por el arquitecto nacional Guðjón Samúelsson que también diseñó la iglesia de Hallgrímur, en Reikiavik. Vale la pena visitar el pequeño centro histórico de la ciudad, el museo de arte comprometido y el Nonnahús, donde creció el escritor Jón Sveinsson.

Akureyri

Akureyri si trova quasi sul Circolo Polare Artico, ma ha un clima mite. I punti di riferimento della città sono la semplice struttura in cemento dell'Akureyrarkirkja, progettata dall'architetto nazionale Guðjón Samúelsson e la Hallgrímskirkja di Reykjavík. Da visitare sono il piccolo centro storico, il museo d'arte e il Nonnahús, dove è cresciuto lo scrittore Jón Sveinsson.

Akureyi

Akureyi ligt bijna op de poolcirkel en heeft toch een gematigd klimaat. Het herkenningsteken van de stad is het strakke betonnen gebouw van de Akureyrarkirkja, ontworpen door staatsarchitect Guðjón Samúelsson die ook de Hallgrímskirkja in Reykjavik tekende. Bezienswaardig zijn de kleine historische binnenstad, het kunstmuseum en het Nonnahús, waar de schrijver Jón Sveinsson opgroeide.

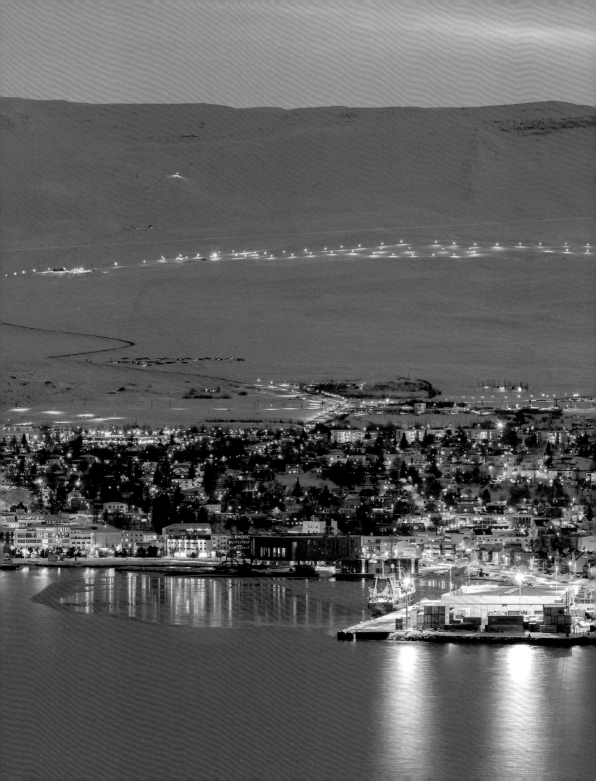

Farmhouse, Skagafjörður

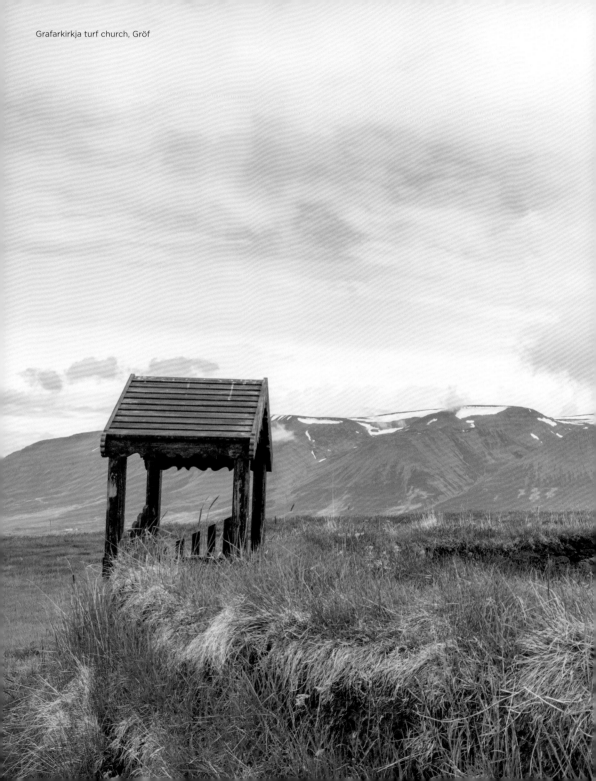
Grafarkirkja turf church, Gröf

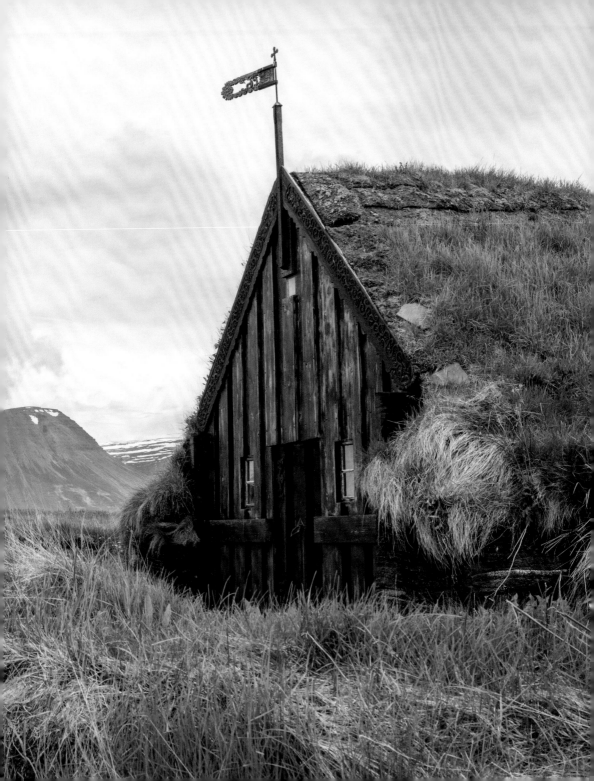

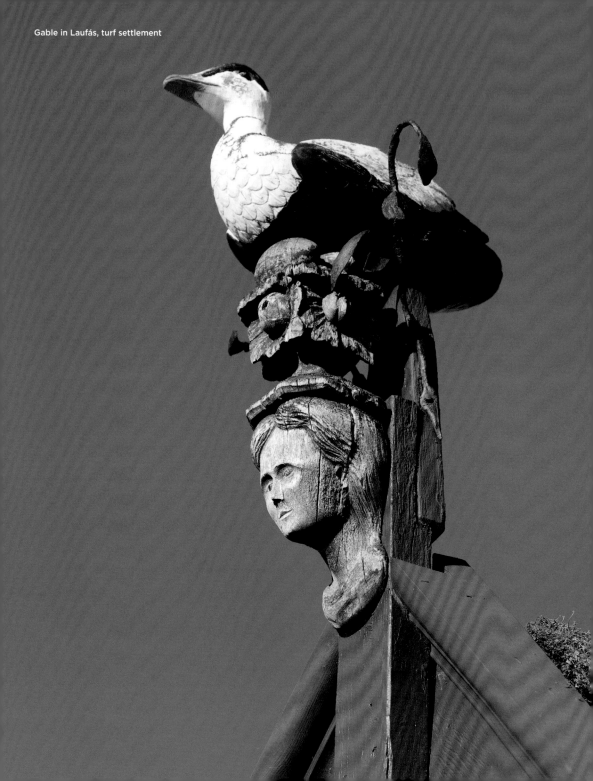
Gable in Laufás, turf settlement

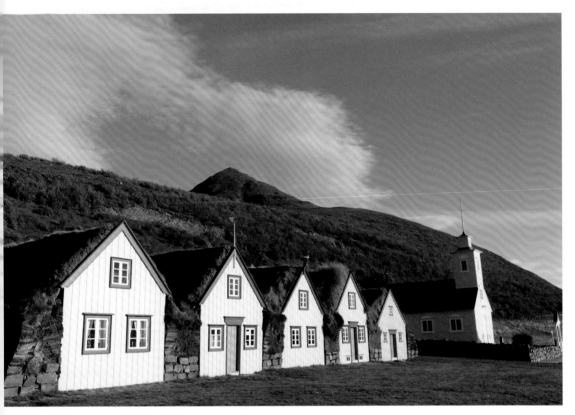

Laufás, turf settlement

Laufás

This sod building, typical of traditional Icelandic architecture, has had a façade of white boards since the end of the 19th century. The oldest parts of the farm probably date from the 16th century, when up to 30 people would live there, cultivating the fields, fishing, and collecting eiderdown. The farm was inhabited until 1936.

Laufás

Ces maisons d'herbes islandaises typiques ont une façade couverte de panneaux blancs et datent de la fin du xixᵉ siècle, mais les parties les plus anciennes de cette ferme remontent probablement au xviᵉ siècle. Jusqu'à 30 personnes vivaient à Laufás, cultivant les champs, pêchant et ramassant le duvet d'eider. La ferme était encore habitée jusqu'en 1936.

Laufás

Der typisch isländische Grassodenhof hat eine mit weißen Brettern verkleidete Front vom Ende des 19. Jahrhunderts. Doch die ältesten Teile des Hofes stammen vermutlich aus dem 16. Jahrhundert. Auf dem Gehöft wohnten bis zu 30 Menschen, die die Felder bewirtschafteten, fischen gingen und Eiderentendaunen sammelten. Noch bis 1936 war der Hof bewohnt.

Laufás

La típica granja de casas de césped islandesa tiene una fachada cubierta con pizarras blancas de finales del siglo XIX. Pero las partes más antiguas del conjuntoprobablemente daten del siglo XVI. Hasta 30 personas vivían en la granja, cultivando los campos, pescando y recogiendo plumas de éideres. La granja estuvo habitada hasta 1936.

Laufás

Il tipico cortile erboso islandese ha una facciata rivestito di tavole bianche della fine del XIX secolo. Ma le parti più antiche della fattoria risalgono probabilmente al XVI secolo. Fino a 30 persone vivevano nella fattoria, coltivando i campi, andando a pescare e raccogliendo piume di edredoni. La fattoria è stata abitata fino al 1936.

Laufás

Deze typisch IJslandse turfboerderij heeft een laat-19e-eeuwse voorgevel van witte planken. Maar de oudste delen van de boerderij stammen waarschijnlijk uit de 16e eeuw. Er konden wel 30 mensen op de boerderij wonen, die de akkers bewerkten, gingen vissen en eiderdons verzamelden. De boerderij was tot 1936 nog bewoond.

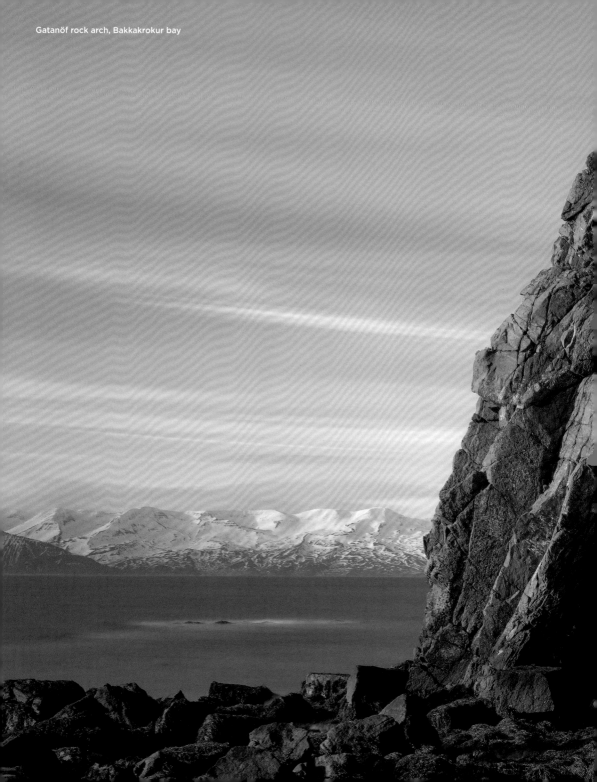
Gatanöf rock arch, Bakkakrokur bay

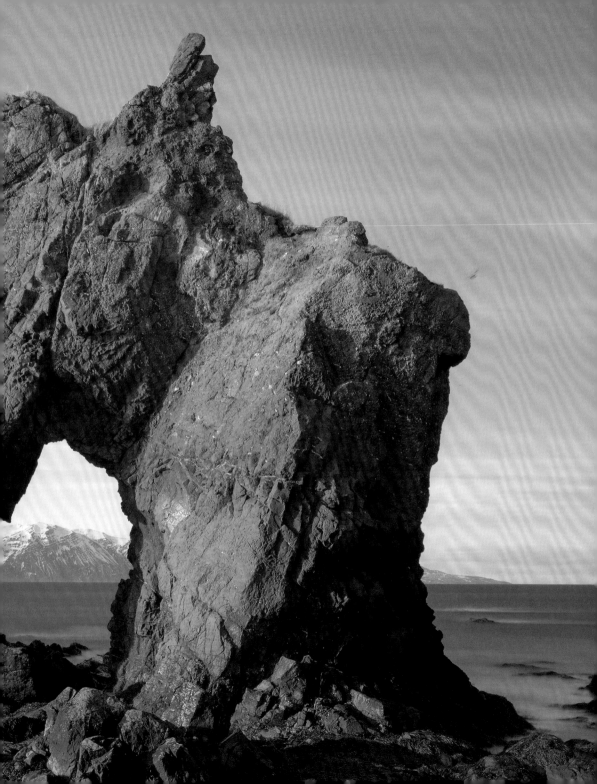

Icelandic horse, Húsavík area

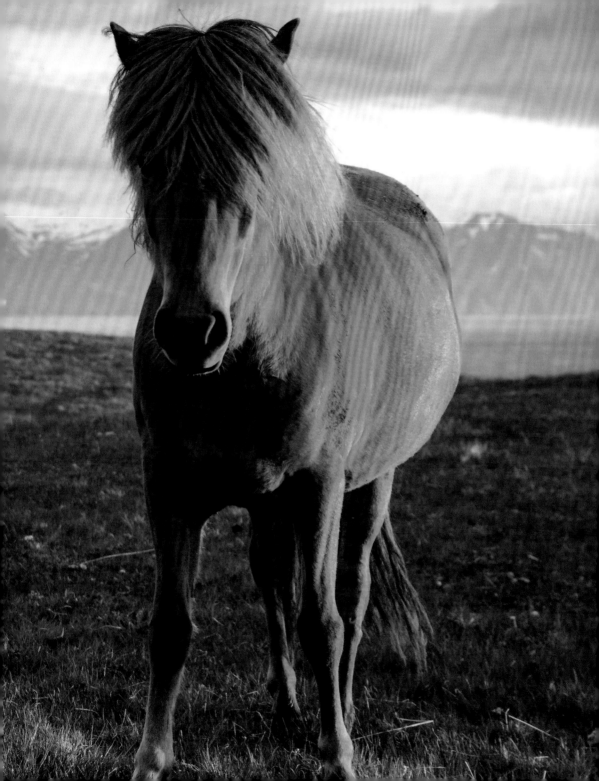

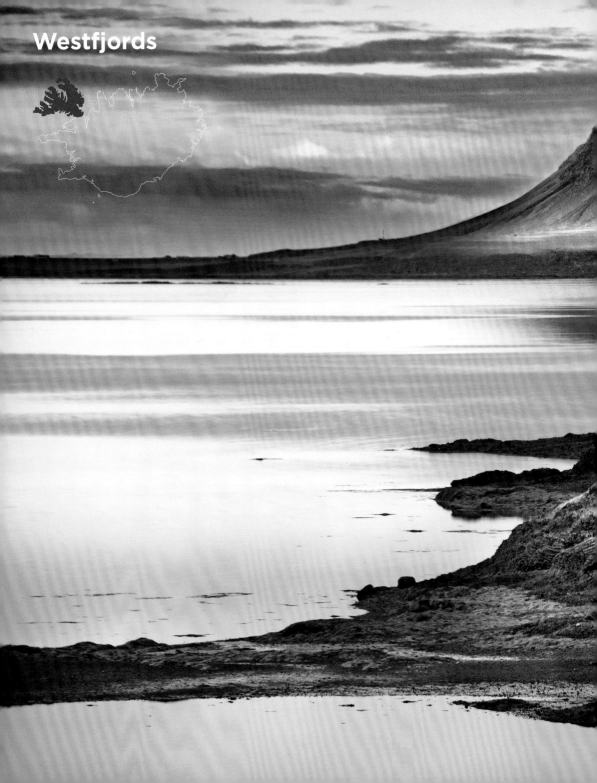

Westfjords

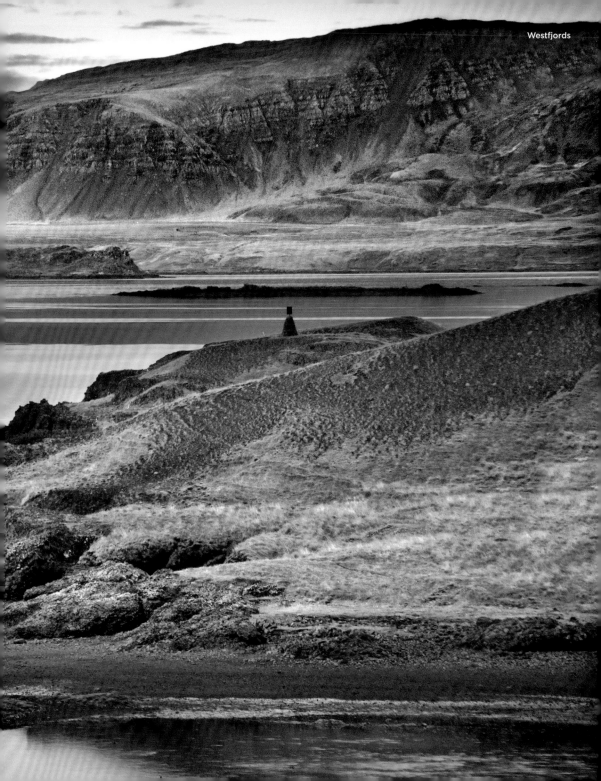

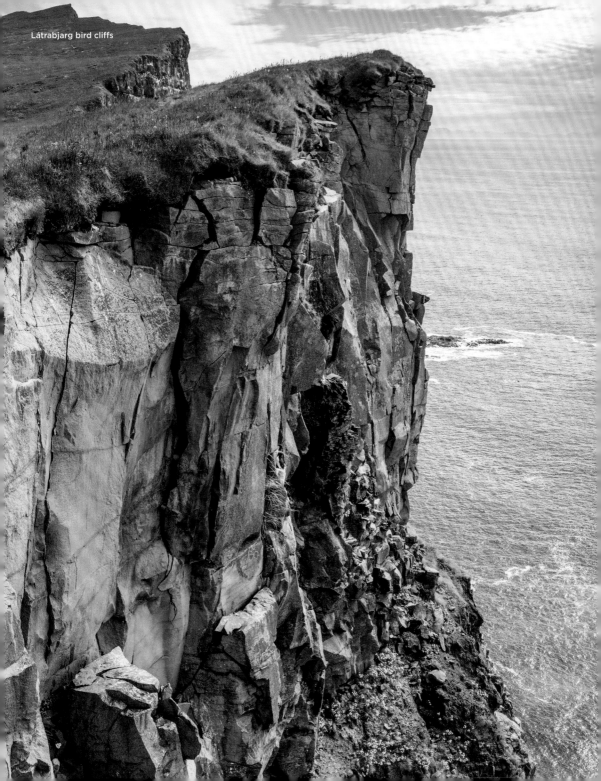

Látrabjarg bird cliffs

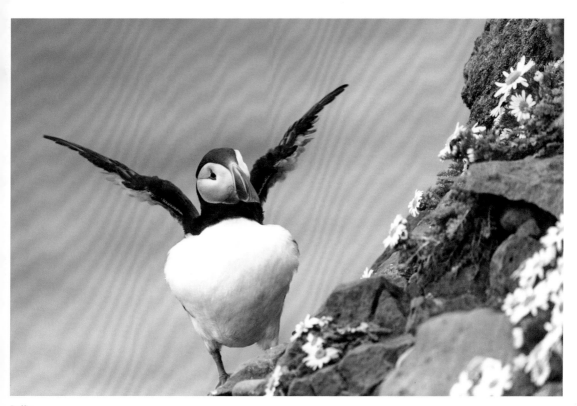

Puffin

Westfjords

The 9400 square kilometres of the Westfjords are something of an annex, connected to the mainland by a narrow strip only a few kilometres wide. In the past, the area was economically prosperous due to the fishing industry, but now tourism is an important source of income for the region's few residents. Those who seek solitude will find it in these uninhabited expanses.

Fjords de l'Ouest

Les 9400 km² que mesurent les Fjords de l'Ouest ressemblent à une presqu'île, car la connexion terrestre avec le reste du territoire n'est que de quelques kilomètres de large. Dans le passé, l'industrie de la pêche nourrissait l'économie de la région; aujourd'hui, le tourisme est également une source importante de revenus pour les quelques habitants. Ceux qui cherchent la solitude la trouveront dans les étendues inhabitées.

Westfjorde

Die 9400 km² großen Westfjorde wirken wie ein Annex, die Landverbindung ist nur wenige Kilometer breit. Früher hatte die Gegend vor allem wegen der Fischereiindustrie wirtschaftliche Bedeutung, inzwischen ist der Tourismus wichtige Einnahmequelle für die wenigen Bewohner. Wer Einsamkeit sucht, findet sie in den unbewohnten Weiten.

Fiordos occidentales

Los 9400 km² de los extensos fiordos occidentales constituyen un anexo, la conexión terrestre tiene solo unos pocos kilómetros de anchura. En el pasado, la zona era de importancia económica principalmente debido a la industria pesquera, pero ahora el turismo es una importante fuente de ingresos para los pocos habitantes restantes. Aquellos que buscan la soledad la encontrarán en las extensiones despobladas.

Fiordi dell'ovest

I 9400 km² dei fiordi dell'ovest fungono da punto contiguo, il collegamento con la terraferma è largo solo pochi chilometri. In passato, l'area era di importanza economica soprattutto per l'industria della pesca, ma ora il turismo è un'importante fonte di reddito per i pochi abitanti. Chi cerca la solitudine la troverà nelle distese disabitate.

Westfjorden

De 9400 km² grote Westfjorden zien eruit als een aanhangsel – de landverbinding is maar een paar kilometer breed. Vroeger was het gebied vooral vanwege de visserij van economisch belang, maar nu vormt het toerisme een belangrijke bron van inkomsten voor de weinige inwoners. Wie eenzaamheid zoekt, vindt die op de onbewoonde vlaktes.

Puffins

Beloved for their cute "facial expressions", puffins are available in souvenir shops as wooden or plush figures. Even if several million of these auks still live in the North Atlantic, the species is considered endangered. Most nest on rocky cliffs in Iceland. They line up their prey—small fish—one behind the other in their beaks.

Macareux moines

Considérés comme particulièrement mignons grâce à leur «expression faciale», les macareux moines sont déclinés sous forme de peluches ou de figurines en bois dans les magasins de souvenirs. Même si plusieurs millions d'oiseaux vivent encore dans l'Atlantique Nord, l'espèce est considérée comme en voie de disparition. La plupart d'entre eux nichent sur des rochers en Islande. Leurs proies sont de petits poissons qu'ils alignent les uns derrière les autres dans leurs becs.

Papageitaucher

Auf Menschen wirken sie wegen ihres „Gesichtsausdrucks" putzig, deshalb gibt es sie in Souvenirläden als Holz- oder Plüschfiguren. Auch wenn im Nordatlantik noch mehrere Millionen der Alkenvögel leben, gilt die Art als gefährdet. Die meisten nisten auf Felsen in Island. Ihre Beute, kleine Fische, sortieren sie im Schnabel hintereinander.

Frailecillos

A la gente le gustan debido a su "expresión facial", por lo que están disponibles en tiendas de recuerdos como figuras de madera o de felpa. Aunque varios millones de aves de rapiña aún viven en el Atlántico Norte, la especie está considerada en peligro de extinción. La mayoría anida en las rocas de Islandia. Su presa son los peces pequeños, que clasifica dentro del pico uno tras otro.

Pulcinelle di mare

Chiunque le trova carine per le loro "faccine", per questo motivo sono disponibili nei negozi di souvenir come figure di legno o come peluche. Anche se nell'Atlantico settentrionale vivono ancora diversi milioni di uccelli, la specie è considerata a minaccia di estinzione. La maggior parte nidifica sulle rocce in Islanda. Le loro prede, pesciolini, vengono smistati nel becco uno dopo l'altro.

Papegaaiduikers

Ze zien er door hun 'gezichtsuitdrukking' koddig uit voor mensen en daarom zijn ze in souvenirwinkels verkrijgbaar als houten of pluche figuren. Hoewel er nog enkele miljoenen alken in de Noord-Atlantische Oceaan leven, wordt de soort als bedreigd beschouwd. De meeste nestelen op rotsen in IJsland. Hun prooi van kleine vissen sorteren ze in de snavel netjes achter elkaar.

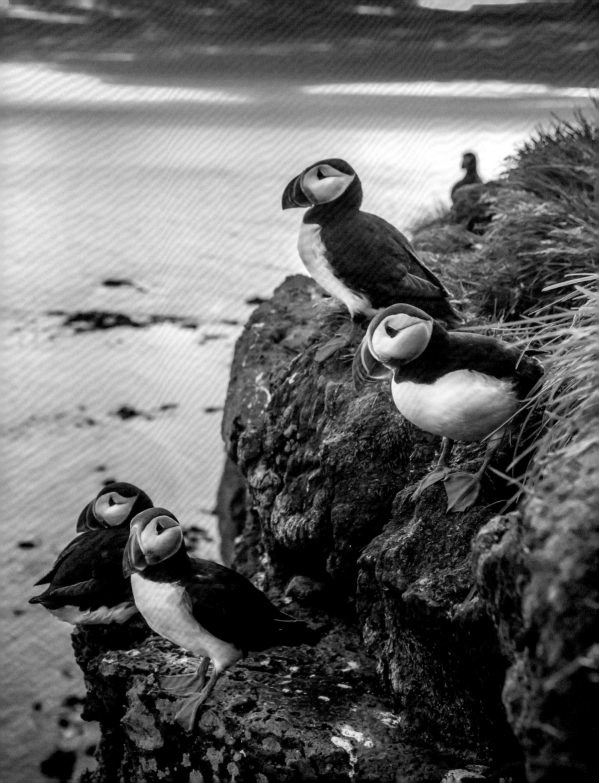

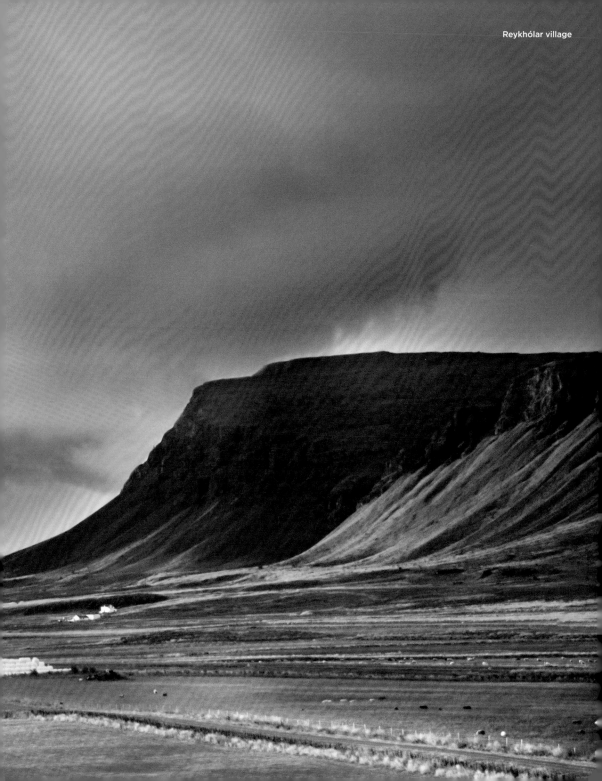

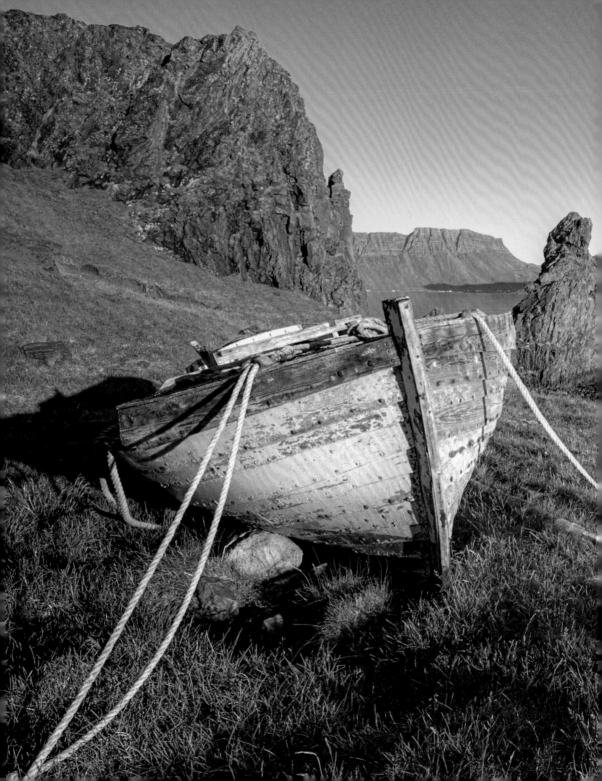

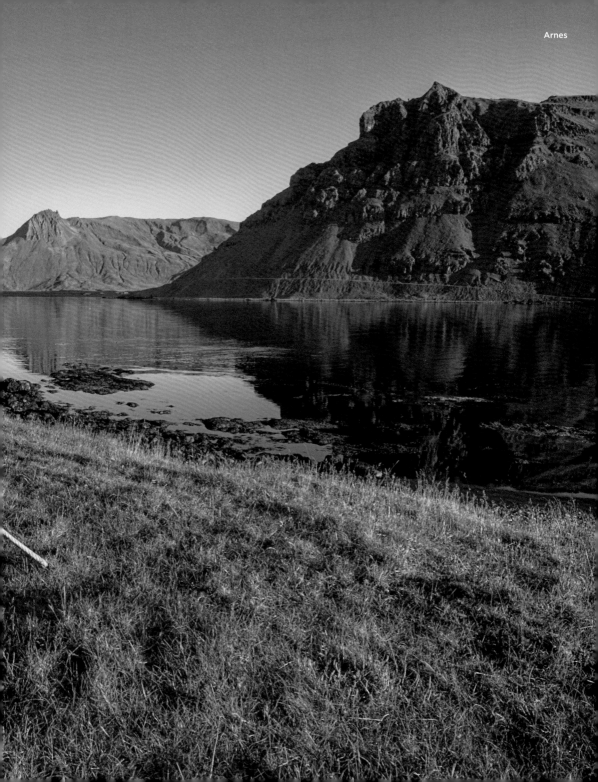

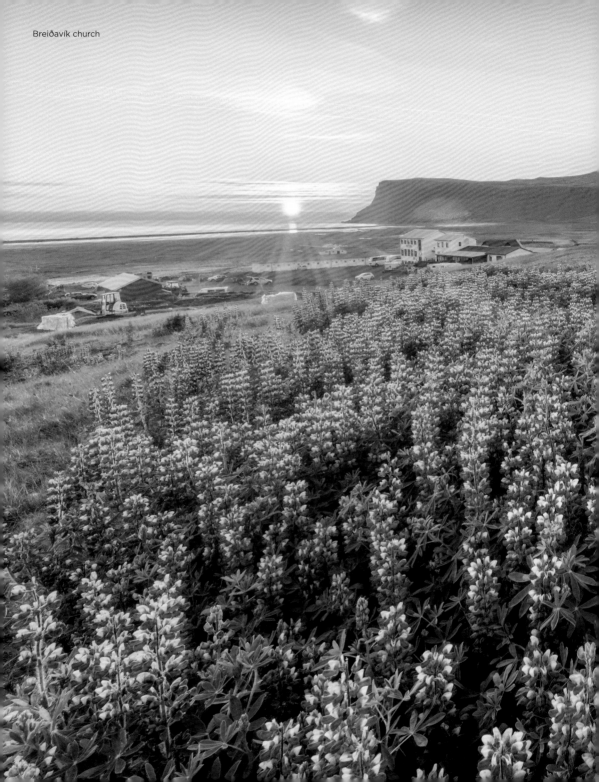

Breiðavík church

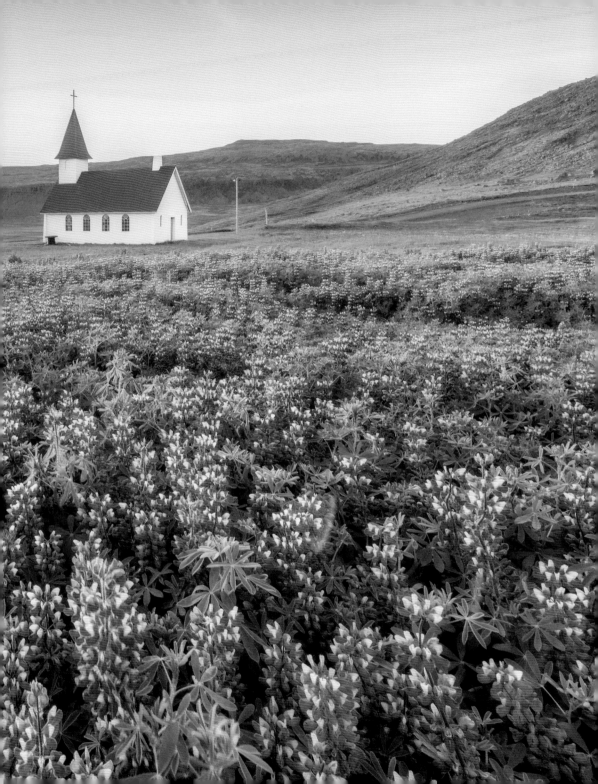

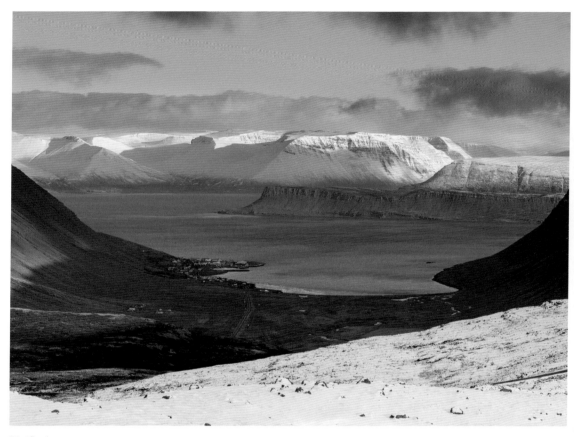
Westfjords

Hornstrandir

Hardly any other region of Iceland is as lonely and remote as the Hornstrandir peninsula. In the past, settlements formed around the rich fishing grounds in the North Atlantic, but now the area is largely deserted, at least in winter. Only holidaymakers in search of solitude venture out to the nature reserve. The region offers an astonishingly rich variety of vegetation.

Hornstrandir

Quasiment aucune région d'Islande n'est aussi isolée que la péninsule de Hornstrandir. Dans le passé, des habitants s'y étaient établis en raison de la richesse des zones de pêche dans l'Atlantique Nord, mais le lieu est maintenant déserté – au moins en hiver. Seuls les vacanciers en quête de solitude aiment se rendre dans cette réserve naturelle, à la végétation étonnamment riche.

Hornstrandir

Wohl kaum eine Region Islands ist so abgelegen und einsam wie die Halbinsel Hornstrandir. Menschliche Besiedlung gab es früher wegen der reichen Fischgründe im Nordatlantik, inzwischen ist die Gegend zumindest im Winter menschenleer. Nur Einsamkeit suchende Urlauber kommen gern in das Naturreservat. Sie finden eine erstaunlich reiche Vegetation vor.

Hornstrandir Nature Reserve

Hornstrandir

Casi ninguna otra región de Islandia es tan remota y solitaria como la península de Hornstrandir. En el pasado hubo asentamientos humanos debido a las ricas zonas de pesca en el Atlántico Norte, ahora la zona está desierta, al menos en invierno. Solo a los turistas que buscan soledad les gusta venir a la reserva natural. Encontrará una vegetación asombrosamente rica.

Hornstrandir

Quasi nessun'altra regione dell'Islanda è così remota e solitaria come la penisola di Hornstrandir. In passato era abitata grazie anche alle ricche zone di pesca nell'Atlantico del Nord, ora la zona è deserta, almeno in inverno. Solo i turisti in cerca di solitudine amano venire in questa riserva naturale per la sua vegetazione incredibilmente ricca.

Hornstrandir

Bijna geen enkele regio van IJsland is zo afgelegen en eenzaam als het schiereiland Hornstrandir. In het verleden waren er menselijke nederzettingen vanwege de rijke visgronden in de Noord-Atlantische Oceaan, maar nu is het gebied in elk geval in de winter verlaten. Alleen vakantiegangers die op zoek zijn naar eenzaamheid komen graag naar het natuurreservaat. U vindt er een verbazingwekkend rijke vegetatie.

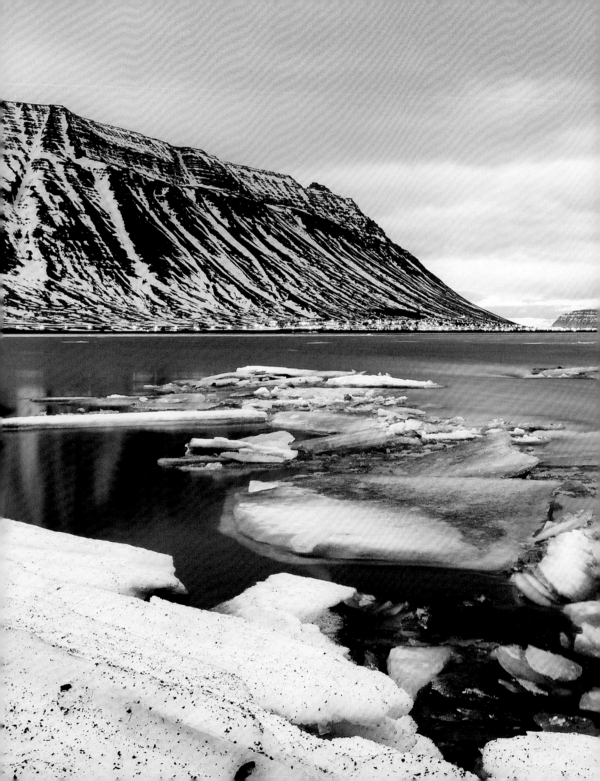

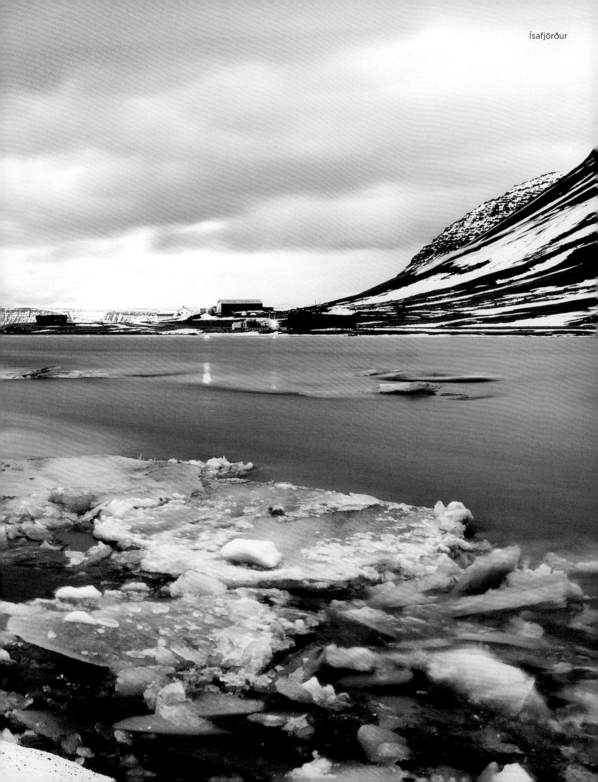

Ísafjörður

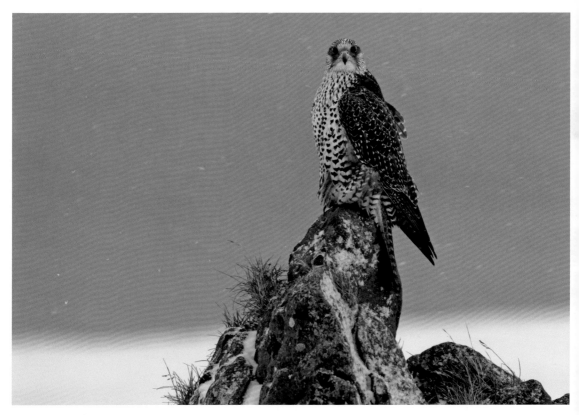

Gyrfalcon

Gyrfalcons

Gyrfalcons are rarely seen outdoors, even if they live everywhere in Arctic and subarctic regions. In Iceland's Westfjords, with a bit of luck, ornithologists can witness for themselves the hunting skills of the falcons, most of whom feed on ptarmigans. When swooping down on their prey, they can reach up to 200 kilometres per hour.

Faucons gerfauts

Bien que les faucons gerfauts vivent partout dans les régions arctiques et subarctiques, il est rare de pouvoir les observer dans la nature. Dans les fjords de l'ouest de l'Islande, avec un peu de chance, les ornithologues peuvent toutefois admirer les compétences de chasse des faucons, dont la plupart se nourrissent de lagopèdes. Lorsqu'ils descendent en piqué sur leurs proies, ils peuvent atteindre 200 km/h.

Gerfalken

Gerfalken sind nur selten in freier Natur zu beobachten, auch wenn sie überall in arktischen und subarktischen Regionen leben. In Islands Westfjorden können sich Ornithologen mit etwas Glück von den Jagdkünsten der Falken überzeugen, die sich überwiegend von Schneehühnern ernähren. Beim Sturzflug auf die Beute erreichen sie bis zu 200 km/h.

Halcones gerifaltes

Los halcones gerifaltes apenas se venen libertad, aunque vivan en todas partes en regiones árticas y subárticas. En los fiordos occidentales de Islandia, con un poco de suerte, los ornitólogos pueden observar por sí mismos las habilidades de caza de los halcones, la mayoría de los cuales se alimentan de lagópodos. Cuando caen en picado sobre la presa, alcanzan hasta 200 km/h.

Girfalchi

I girfalchi sono raramente avvistati in natura, anche se vivono ovunque nelle regioni artiche e subartiche. Nei fiordi occidentali dell'Islanda, con un po' di fortuna, gli ornitologi possono osservare la tecnica di caccia dei falchi, la maggior parte dei quali si nutrono di pernice bianca. Quando inseguono la preda, raggiungono fino a 200 km/h.

Giervalken

Giervalken zijn zelden in het wild te zien, ook al leven ze overal in de arctische en subarctische gebieden. Op de IJslandse Westfjorden kunnen ornithologen met een beetje geluk zelf de jachtkunsten van de valken waarnemen, die zich meestal voeden met sneeuwhoenen. Bij de duikvlucht op hun prooi bereiken ze snelheden tot 200 km/u.

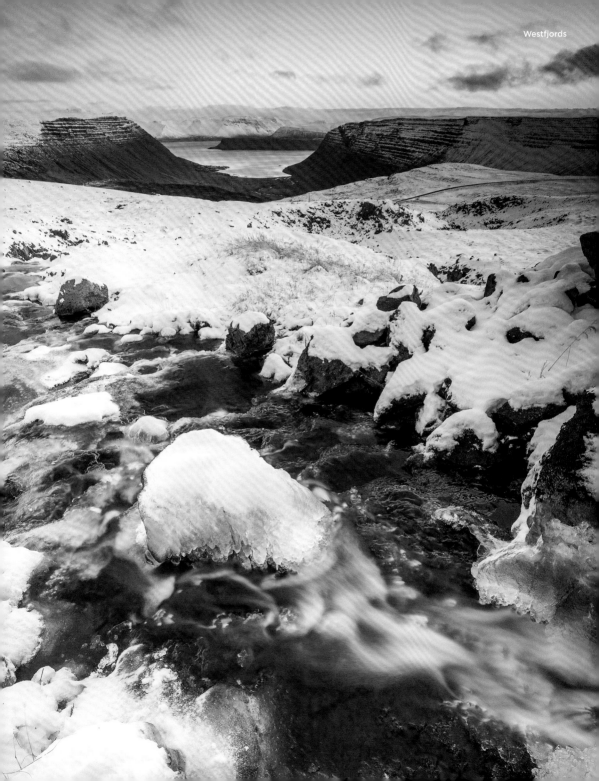

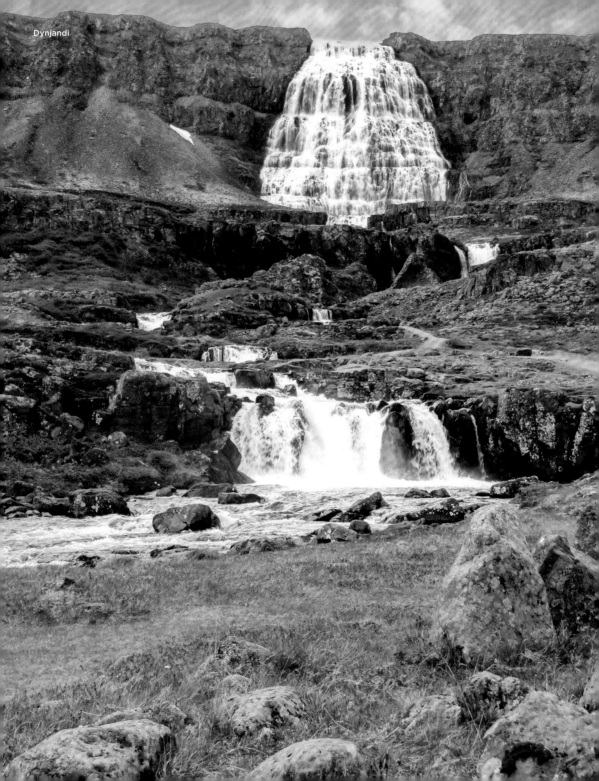
Dynjandi

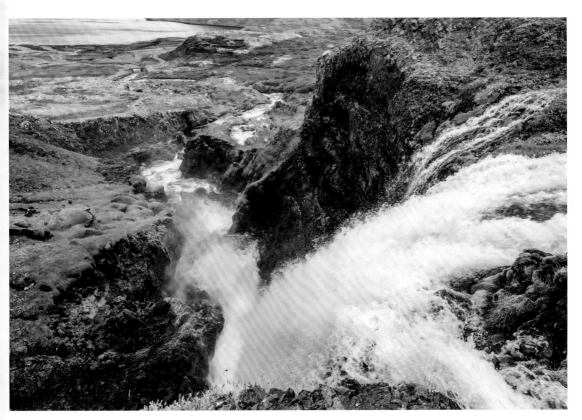

Dynjandi

Dynjandi Waterfall
The Dynjandi waterfall is rightly called "The Thundering" or "The Groaning". Thirty metres wide at the top, 60 below, the waterfall drops 100 metres over several cascades. On the way up to the top step, you pass seven smaller waterfalls.

Cascade de Dynjandi
La cascade de Dynjandi est surnommée à juste titre « Le Tonnerre » : ses masses d'eau tombent en plusieurs cascades d'une hauteur de 100 m. En haut, elle mesure 30 m de large, en bas, elle atteint 60 m. Le chemin qui monte jusqu'à l'escalier supérieur permet également d'observer sept petites cascades.

Dynjandi-Wasserfall
Der Dynjandi-Wasserfall trägt seinen Namen „Der Donnernde" oder „Der Dröhnende" zu Recht. 100 m stürzen seine Wassermassen über mehrere Kaskaden breit aufgefächert in die Tiefe. An der Spitze ist er 30 m breit, unten erreicht er eine Breite von 60 m. Beim Aufstieg zur obersten Stufe passiert man sieben kleinere Wasserfälle.

Cascada Dynjandi
La cascada de Dynjandi se llama con razón "El Trueno" o "El Gemido". Con una altura de 100 m, sus masas de agua caen en la profundidad sobre varias cascadas. En la cima tiene 30 m de ancho, por debajo alcanza una anchurade 60 m. En el camino hasta el nivel superior se pasan siete cascadas más pequeñas.

Cascata di Dynjandi
La cascata di Dynjandi è giustamente chiamata "la tonante". Le sue masse d'acqua cadono in profondità su diverse cascate per 100 m. La parte superiore è larga 30 m, quella inferiore raggiunge una larghezza di 60 m. Salendo fino al salto più alto si passano sette cascate più piccole.

Dynjandi-waterval
De Dynjandi-waterval wordt terecht 'de donderende' of 'de dreunende' genoemd. Zijn watermassa's storten over meerdere watervallen 100 meter de diepte in. Aan de bovenzijde is hij 30 meter breed, aan de onderzijde 60 meter. Tijdens de klim naar de bovenste trede passeert u zeven kleinere watervallen.

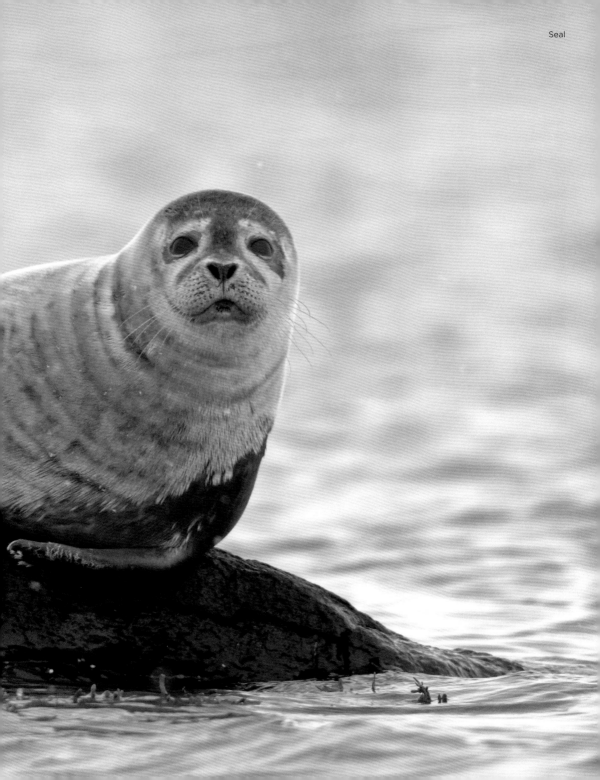

Rauðisandur, Patreksfjörður

Patreksfjörður

The rocky arch in a bay near Patreksfjörður reveals a view of a stony beach. Patreksfjörður is the capital of a municipality in the Westfjords with only a few hundred inhabitants. Iceland also offers the opportunity to observe seals in their natural habitat: they come to rocks off the coast to warm themselves after the hunt.

Patreksfjörður

L'arc rocheux de la baie près de Patreksfjörður donne sur une plage de pierre. Patreksfjörður est la capitale d'une municipalité des Fjords de l'Ouest qui ne compte que quelques centaines d'habitants. L'Islande offre également la possibilité d'observer les phoques dans leur habitat naturel. Après avoir pêché, ils aiment se réchauffer sur les rochers au large de la côte.

Patreksfjörður

Der Felsbogen in einer Bucht nahe Patreksfjörður eröffnet den Blick auf einen steinigen Strand. Patreksfjörður ist der Hauptort einer Gemeinde in den Westfjorden, die nur wenige hundert Einwohner hat. Gelegenheit, Robben in ihrer natürlichen Umgebung zu beobachten, gibt es auch auf Island. Gerne wärmen sie sich nach Beutezügen auf Felsen vor der Küste.

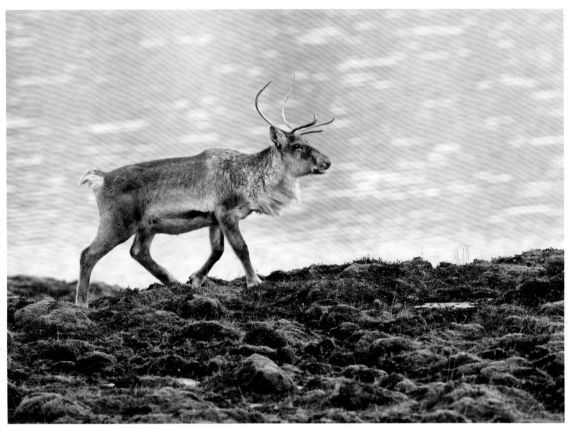

Reindeer

Patreksfjörður

El arco rocoso de una bahía cerca de
Patreksfjörður abre la vista a una playa
pedregosa. Patreksfjörður es la capital de
un municipio de los fiordos occidentales
con solo unos pocos cientos de habitantes.
Islandia también ofrece la oportunidad de
observar focas en su hábitat natural, a las
queles gusta calentarse después de un
atracón en las rocas de la costa.

Patreksfjörður

L'arco roccioso in una baia vicino a
Patreksfjörður apre la vista su una spiaggia
sassosa. Patreksfjörður è il capoluogo di
un distretto dei fiordi occidentali con solo
poche centinaia di abitanti. L'Islanda offre
inoltre la possibilità di osservare le foche
nel loro habitat naturale. A loro piace
riscaldarsi dopo la caccia sulle rocce al
largo della costa.

Patreksfjörður

De rotsboog in een baai in de buurt van
Patreksfjörður opent het uitzicht op een
strand vol stenen. Patreksfjörður is de
grootste plaats van een gemeente in de
regio Westfjorden en telt slechts een
paar honderd inwoners. IJsland biedt ook
de mogelijkheid om zeehonden in hun
natuurlijke habitat te observeren. Na hun
jacht op prooi warmen ze zich graag op
rotsen voor de kust op.

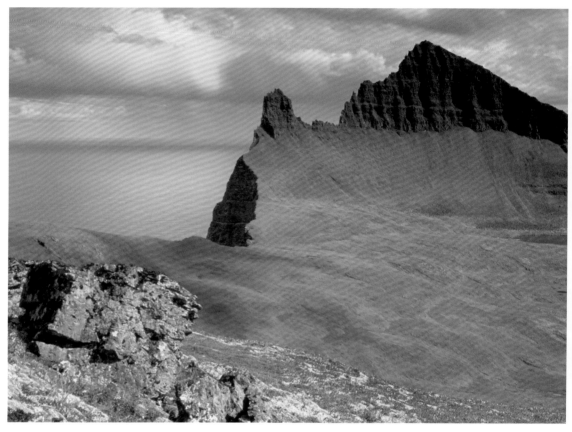

Kálfatindur peak, Hornstrandir Nature Reserve

Arctic Fox

The Hornstrandir peninsula in the Westfjords is home to the Arctic fox, which can be observed here in the wild. Snowy white in winter, the fox changes its coat in summer to a perfect camouflage of brown-beige. A highly adaptable animal capable of travelling long distances, the Arctic fox probably came to Iceland over the frozen pack ice at the end of the last Ice Age.

Renard arctique

La péninsule de Hornstrandir, dans les Fjords de l'Ouest, est l'habitat du renard arctique, que l'on peut observer à l'état sauvage. En hiver, son pelage est blanc, en été, il est brun-beige : un camouflage parfait. Le renard arctique est très adaptable et peut parcourir de longues distances ; il est d'ailleurs probablement arrivé en Islande par la banquise gelée.

Polarfuchs

Die Halbinsel Hornstrandir in den Westfjorden gehört zum Habitat des Polarfuchses, der hier in freier Wildbahn beobachtet werden kann. Im Winter trägt er ein weißes Fell, im Sommer ist er, eine perfekte Tarnung, braun-beige. Er ist sehr anpassungsfähig und kann über weite Distanzen wandern. So kam er einst vermutlich über gefrorenes Packeis nach Island.

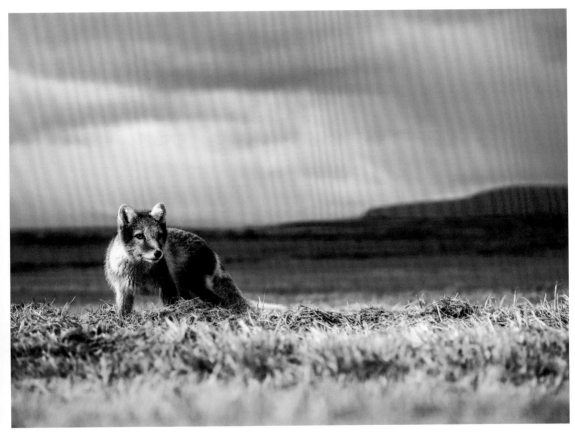

Arctic fox

Zorro ártico

La península de Hornstrandir en los fiordos occidentales pertenece al hábitat del zorro ártico, que se puede observar aquí en estado salvaje. En invierno lleva una bata blanca, en verano es un camuflaje perfecto, marrón-beige. Es muy adaptable y puede viajar largas distancias. Así es como probablemente llegó a Islandia a través de la banquisa.

Volpe artica

La penisola di Hornstrandir nei fiordi occidentali appartiene all'habitat della volpe artica, che si può osservare qui allo stato brado. In inverno la pelliccia è bianca, in estate in perfetta tenuta mimetica, marrone-beige. Si adatta facilmente e può percorrere lunghe distanze. Questo è il modo in cui probabilmente è arrivata in Islanda attraversando le banchise.

Poolvos

Het schiereiland Hornstrandir in Westfjorden behoort tot het leefgebied van de poolvos, die hier in het wild te zien is. In de winter heeft hij een witte vacht, in de zomer is die beigebruin voor een perfecte camouflage. Hij kan zich heel goed aanpassen en kan lange afstanden afleggen. Zo kwam hij vermoedelijk over bevroren pakijs naar IJsland.

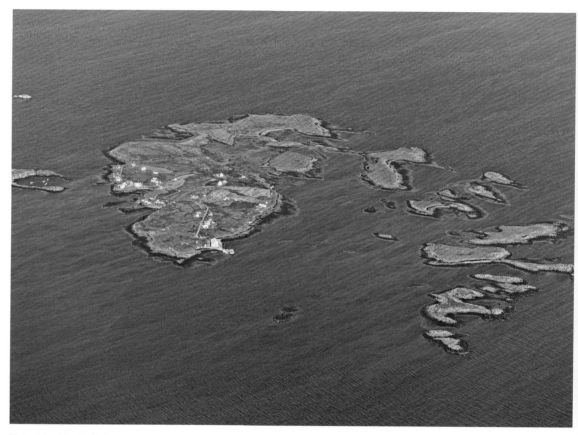

Flatey island, Breiðafjörður

Flatey

Few people live on Flatey, the largest island in Breiðafjörður between the Westfjords and the Snæfellsnes peninsula. But it plays an important role in Iceland's literary history: the famous medieval manuscript *Flateyjarbók* was kept here for a long time. The island also housed the country's first public library.

Flatey

Peu de gens vivent sur Flatey, la plus grande île de Breiðafjörður, située entre les Fjords de l'Ouest et la péninsule de Snæfellsnes. Mais elle joue un rôle important dans l'histoire littéraire de l'Islande puisque le célèbre manuscrit médiéval *Flateyjarbók* y a longtemps été conservé. La première bibliothèque publique se trouvait également sur l'île.

Flatey

Nur wenige Menschen leben auf Flatey, der größten Insel im Breiðafjörður zwischen den Westfjorden und der Halbinsel Snæfellsnes. Aber sie spielt in der Literaturgeschichte Islands eine wichtige Rolle: So wurde lange Zeit die berühmte mittelalterliche Handschrift *Flateyjarbók* hier aufbewahrt. Auch die erste öffentliche Bücherei stand auf der Insel.

Flatey island

Flatey

Pocas personas viven en Flatey, la isla más grande de Breiðafjörður, entre los fiordos occidentales y la península de Snæfellsnes,pero juega un papel importante en la historia literaria de Islandia: el famoso manuscrito medieval *Flateyjarbók* se mantuvo aquí durante mucho tiempo. La primera biblioteca pública también estaba en la isla.

Flatey

Poche abitanti vivono a Flatey, l'isola più grande di Breiðafjörður tra i fiordi occidentali e la penisola di Snæfellsnes. Ma svolge un ruolo importante nella storia letteraria islandese: il famoso manoscritto medievale *Flateyjarbók* è stato conservato qui per molto tempo. Anche la prima biblioteca pubblica si trovava su quest'isola.

Flatey

Er wonen maar weinig mensen op Flatey, het grootste eiland van de Breiðafjörður tussen de regio Westfjorden en het schiereiland Snæfellsnes. Maar het speelt een belangrijke rol in de literatuurgeschiedenis van IJsland: het beroemde middeleeuwse manuscript *Flateyjarbók* werd hier lange tijd bewaard. De eerste openbare bibliotheek bevond zich ook op het eiland.

Fish drying

Dried Fish

The importance of dried fish, long a staple food in many countries, cannot be overestimated. In Iceland, salting, drying, and preserving fish—mostly cod—has a long tradition and great economic significance. Pieces of dried fish are a typical snack, even for children.

Poisson séché

L'importance du poisson séché est tout à fait capitale. Il a toujours été la principale denrée alimentaire dans de nombreux pays, dont l'Islande, où la tradition du salage, du séchage et de la conservation du poisson, principalement du cabillaud, revêt une grande importance économique. Les morceaux de poisson séché sont une collation habituelle, même pour les enfants.

Trockenfisch

Die Rolle von Trockenfisch kann gar nicht hoch genug eingeschätzt werden. Er dient seit je in vielen Ländern als Hauptnahrungsmittel. Auch in Island ist die Tradition, Fische, meist Kabeljau, zu salzen, zu trocknen und so zu konservieren, von großer wirtschaftlicher Bedeutung. Trockenfischstückchen sind ein selbstverständlicher Snack schon für Kinder.

Wolffish

Pescado seco

Los rollos de pescado seco no pueden subestimarse. Siempre ha sido el alimento principal en muchos países. También en Islandia, la tradición de salar, secar y conservar el pescado, sobre todo el bacalao, tiene una gran importancia económica. Los trozos de pescado seco son un piscolabis natural incluso para los niños.

Pesce essiccato

Il pesce essiccato è non va sottovalutato. È sempre stato il principale alimento in molti paesi. Anche in Islanda la tradizione della salagione, dell'essiccazione e della conservazione del pesce, soprattutto del merluzzo, è di grande importanza economica. I pezzi di pesce essiccato sono uno spuntino amato anche dai bambini.

Gedroogde vis

De rol van gedroogde vis kan niet worden overschat. Hij is in veel landen al sinds lang het belangrijkste levensmiddel. Ook in IJsland is de traditie van het zouten, drogen en conserveren van vis, vooral kabeljauw, van groot economisch belang. Stukjes gedroogde vis zijn al voor kinderen een normaal tussendoortje.

Látrabjarg

At the westernmost end of Iceland are the largest nesting cliffs in Europe. About 14 kilometres long and up to 450 metres high, the Látrabjarg is home to millions of seabirds. One million puffins alone come here to breed; the screaming in the summer months is deafening.

Látrabjarg

À l'extrémité ouest de l'Islande, les fjords sont réputés pour leurs falaises d'oiseaux parmi les plus grandes d'Europe. D'environ 14 km de long et de près de 450 m de haut, le Látrabjarg est un refuge pour un nombre immense d'oiseaux de mer: un million de macareux y nichent. Durant les mois d'été, leurs cris sont assourdissants.

Látrabjarg

Am äußersten westlichen Ende Islands erstreckt sich in den Westfjorden der größte Vogelfelsen Europas. Rund 14 km lang und bis zu 450 m hoch, ist der Látrabjarg Heimat für Millionen Seevögel, allein eine Million Papageitaucher nisten hier. Das Geschrei in den Sommermonaten ist ohrenbetäubend.

Látrabjarg

En el extremo más occidental de Islandia, los fiordos occidentales albergan los acantilados de aves más grandes de Europa. De unos 14 km de largo y hasta 450 m de altura, el Látrabjarg es el hogar de millones de aves marinas, un millón de frailecillos anidan aquí entre otras especies. Los graznidos en los meses de verano son ensordecedores.

Látrabjarg

All'estremità occidentale dell'Islanda, i fiordi occidentali ospitano le più grandi scogliere ornitologiche d'Europa.
Lungo circa 14 km e alto fino a 450 m, il Látrabjarg ospita milioni di uccelli marini, solo le pulcinelle che nidificano qui sono un milione. Il chiasso nei mesi estivi è assordante.

Látrabjarg

Op het uiterst westelijke punt van IJsland liggen op de Westfjorden de grootste vogelklippen van Europa. De Látrabjarg is ongeveer 14 km lang en tot 450 meter hoog en huisvest miljoenen zeevogels – hier nestelen alleen al een miljoen papegaaiduikers. Het gekrijs is in de zomermaanden oorverdovend.

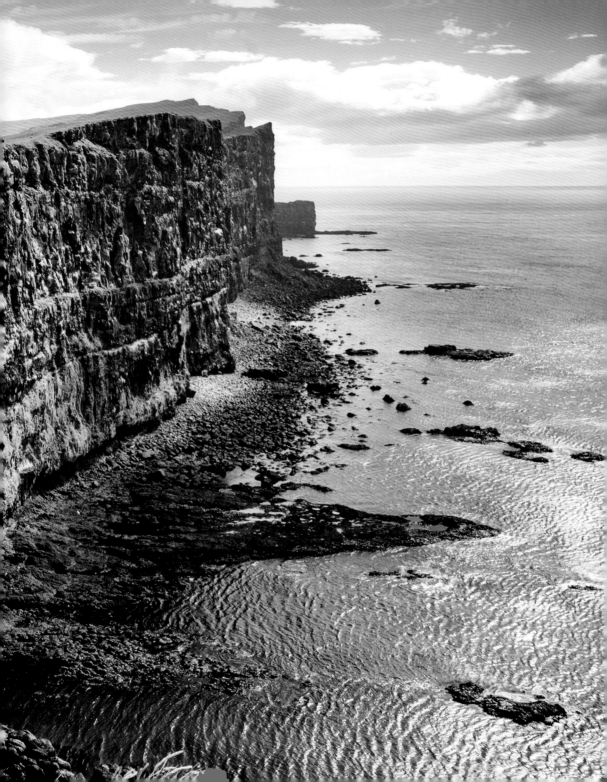

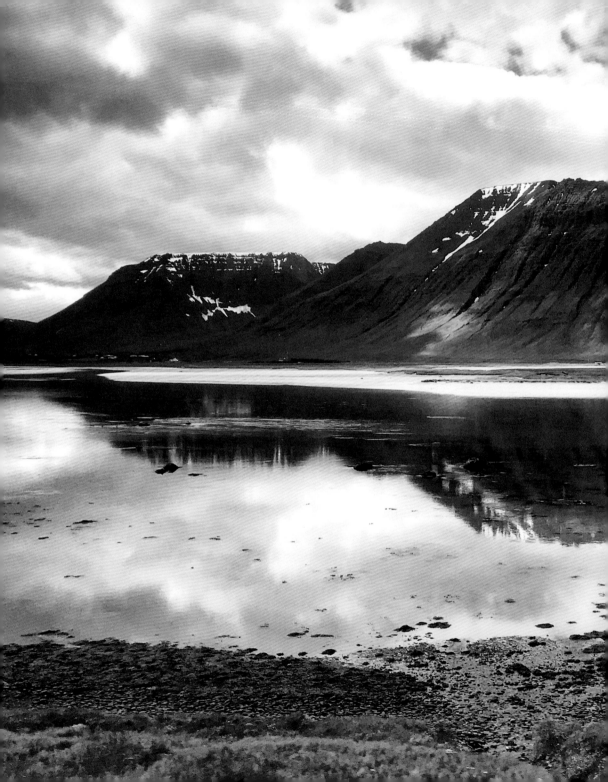

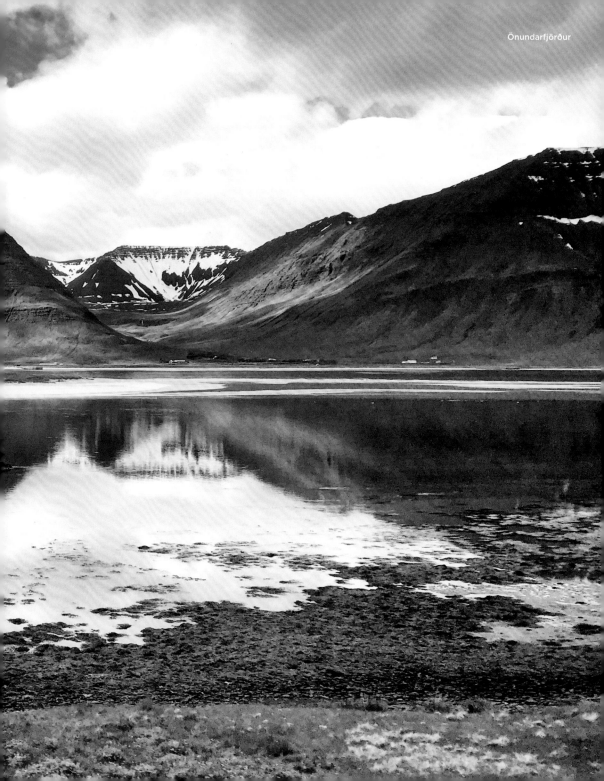

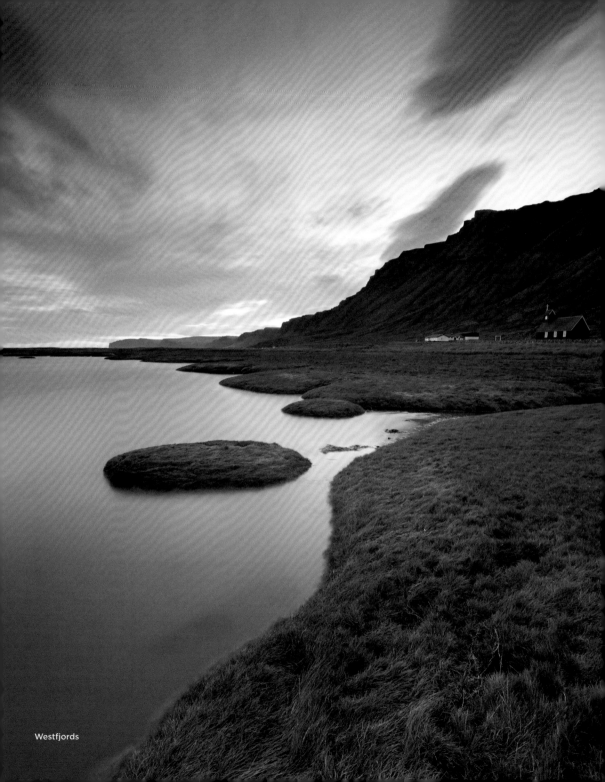

Westfjords

Ocean pools, Djúpavík

Djúpavík

Djúpavík was not always as lonely and deserted as this photograph suggests. For a time, trade flourished on the eastern coast of the Westfjords: herring fishing was profitable, a large fish factory was built, and hundreds of people found work—until the herring disappeared. Today, ruins and a museum remind us of the great bygone times.

Djúpavík

La région de Djúpavík n'a pas toujours été si déserte. Pendant une courte période, le commerce a prospéré sur la côte est des Fjords de l'Ouest grâce à la pêche au hareng. Une grande usine de transformation du poisson a été construite, employant des centaines de personnes, jusqu'à ce que les ressources s'épuisent. Aujourd'hui, des ruines et un musée nous rappellent cette époque prospère.

Djúpavík

So einsam und verlassen, wie die Aufnahme aus der Gegend von Djúpavík suggeriert, war es hier nicht immer. Für kurze Zeit blühte an der Ostküste der Westfjorde das Gewerbe: Der Heringsfang war ertragreich, eine große Fischfabrik wurde gebaut, Hunderte fanden Arbeit – bis die Heringe ausblieben. Heute erinnern Ruinen und ein Museum an die große Zeit.

Djúpavík

No siempre fue tan solitario y desierto como sugiere la grabación de la zona de Djúpavík. Durante un corto tiempo el comercio floreció en la costa este de los fiordos occidentales: la pesca del arenque fue rentable, se construyó una gran fábrica de pescado, cientos de personas encontraron trabajo – hasta que los arenques desaparecieron. Hoy en día las ruinas y un museo nos recuerdan los buenos tiempos.

Djúpavík

La zona di Djúpavík non sempre è stata solitaria e deserta come nell'immagine. Per un breve periodo il commercio fiorì sulla costa orientale dei fiordi occidentali: la pesca dell'aringa era proficua, fu costruita una grande pescheria, centinaia di persone trovarono lavoro – fino a quando le aringhe non scomparvero. Oggi le rovine e un museo ci ricordano i grandi tempi andati.

Djúpavík

Het was hier niet altijd zo eenzaam en verlaten als de foto uit de omgeving van de Djúpavík suggereert. Gedurende een korte tijd bloeide de handel aan de oostkust van de Westfjorden: de haringvangst was winstgevend, er werd een grote visfabriek gebouwd en honderden mensen vonden werk – tot de haring wegbleef. Vandaag de dag herinneren ruïnes en een museum ons aan die goede tijden.

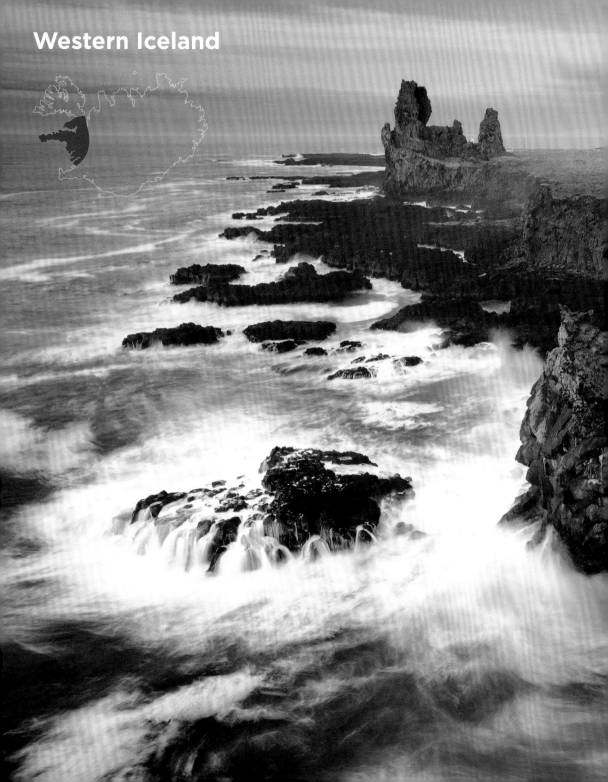

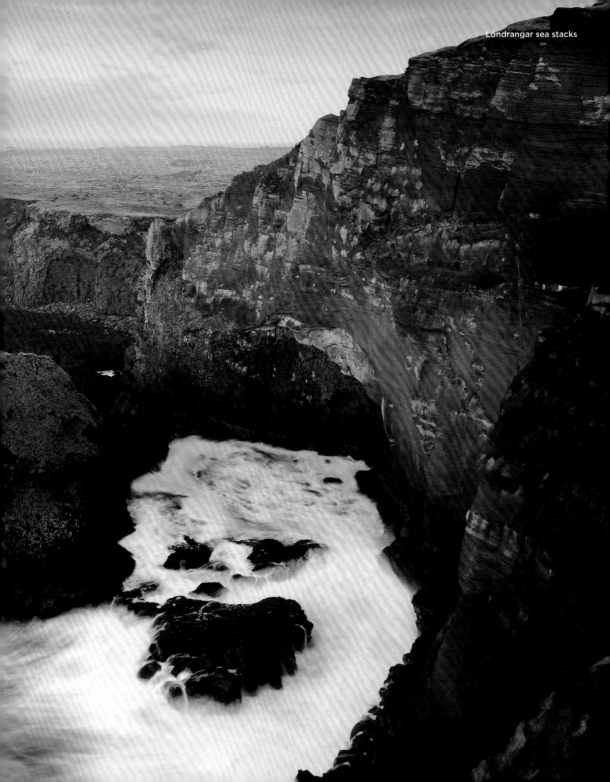
Löndrangar sea stacks

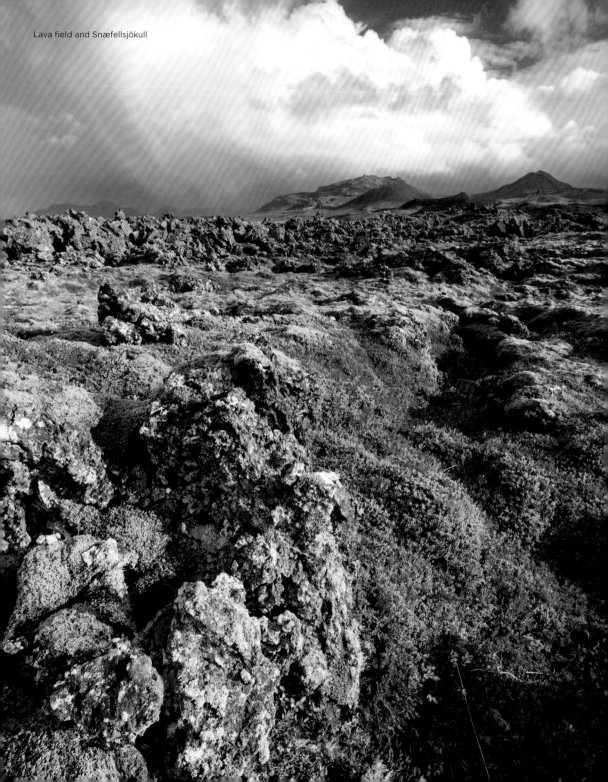
Lava field and Snæfellsjökull

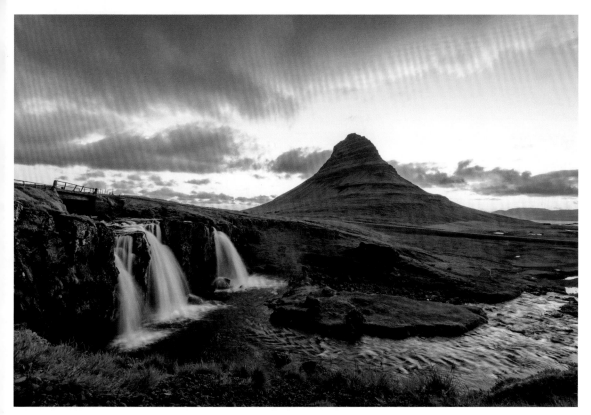

Lava field and Snæfellsjökull

Western Iceland

When the weather is good, a visitor can look out from Reykjavík and see the Snæfellsnes peninsula stretching westwards into the Atlantic Ocean. Crowned by the mythical, glaciated Snæfellsjökull volcano, the peninsula is dotted by small coastal towns. Wild mountains and spectacular waterfalls dominate its eastern end.

Ouest de l'Islande

Lorsque le temps est dégagé, il est possible d'apercevoir depuis Reykjavík la péninsule de Snæfellsnes, qui s'étend vers l'ouest dans l'océan Atlantique, ainsi que le mythique volcan Snæfellsjökull et la calotte glaciaire qui trône en son sommet. La péninsule est parsemée de petites villes côtières ; à l'est, on y trouve des montagnes sauvages et des chutes d'eau spectaculaires.

Westisland

Bei gutem Wetter von Reykjavík aus zu sehen, erstreckt sich die Halbinsel Snæfellsnes weit nach Westen in den Atlantik. An der Spitze thront der mythische, übergletscherte Snæfellsjökull. Rund um die Halbinsel reihen sich kleine Küstenorte, im Osten locken wilde Bergzüge und spektakuläre Wasserfälle.

Oeste de Islandia

Cuando hace buen tiempo, la península de Snæfellsnes se extiende hacia el oeste desde Reikiavik hasta el Océano Atlántico. El mítico Snæfellsjökull encumbra la cima. La península está rodeada por pequeños pueblos costeros, al este linda con montañas salvajes y espectaculares cascadas.

Islanda Occidentale

Quando il tempo è bello, la penisola di Snæfellsnes si estende verso ovest nell'Oceano Atlantico da Reykjavík. Il mitico Snæfellsjökull trona in cima. La penisola è circondata da piccole città costiere, a est da montagne selvagge e da spettacolari cascate.

West-IJsland

Bij mooi weer is vanuit Reykjavik te zien hoe het schiereiland Snæfellsnes zich westwaarts uitstrekt tot in de Atlantische Oceaan. Op de top troont de mythische, vergletsjerde Snæfellsjökull. Het schiereiland is omgeven door kleine kustplaatsen, in het oosten lokken wilde bergketens en spectaculaire watervallen.

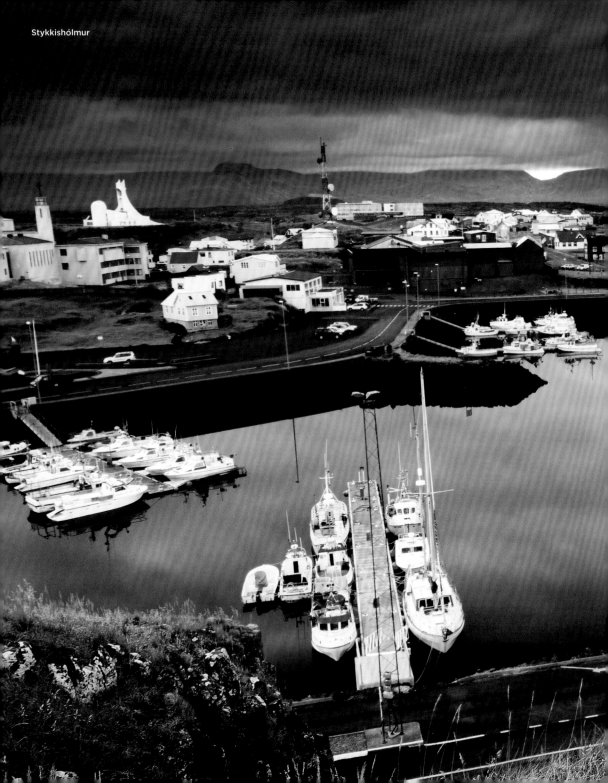

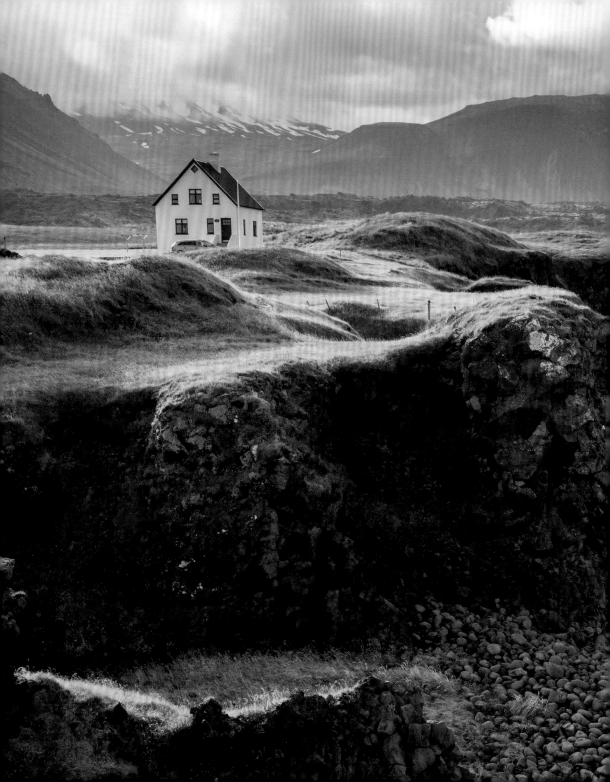

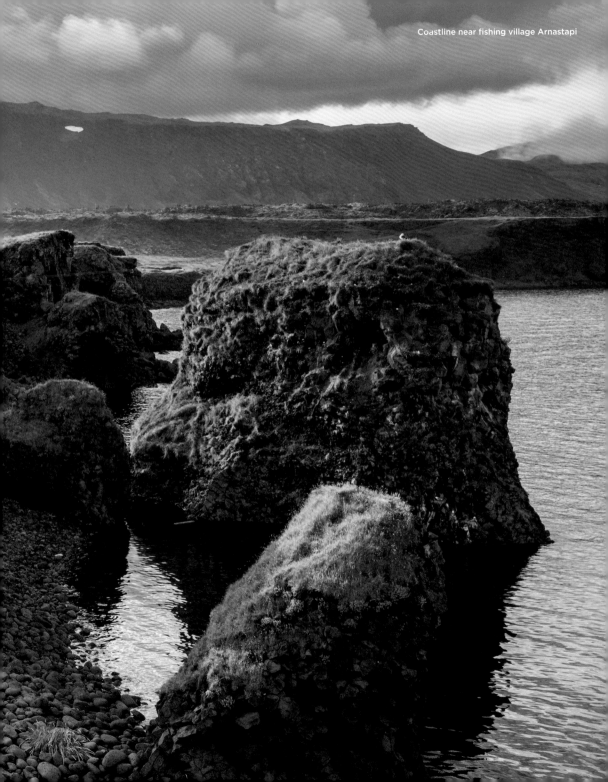
Coastline near fishing village Arnastapi

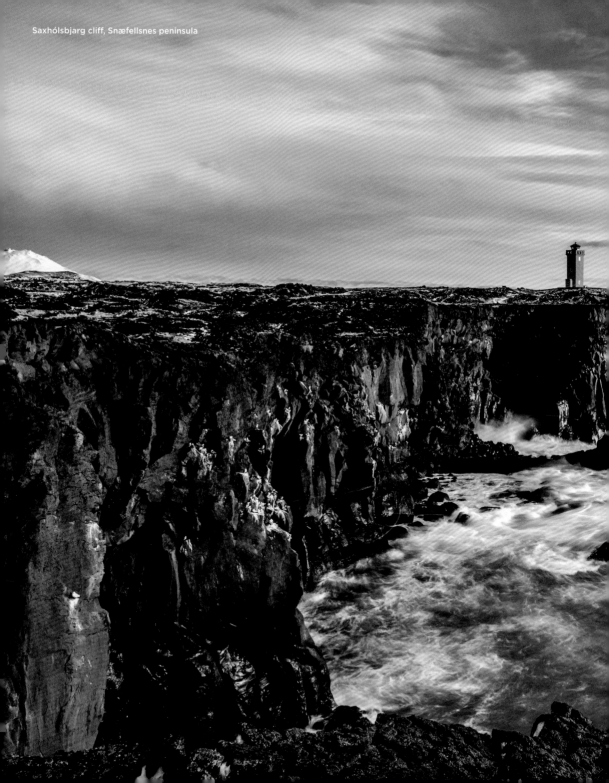

Saxhólsbjarg cliff, Snæfellsnes peninsula

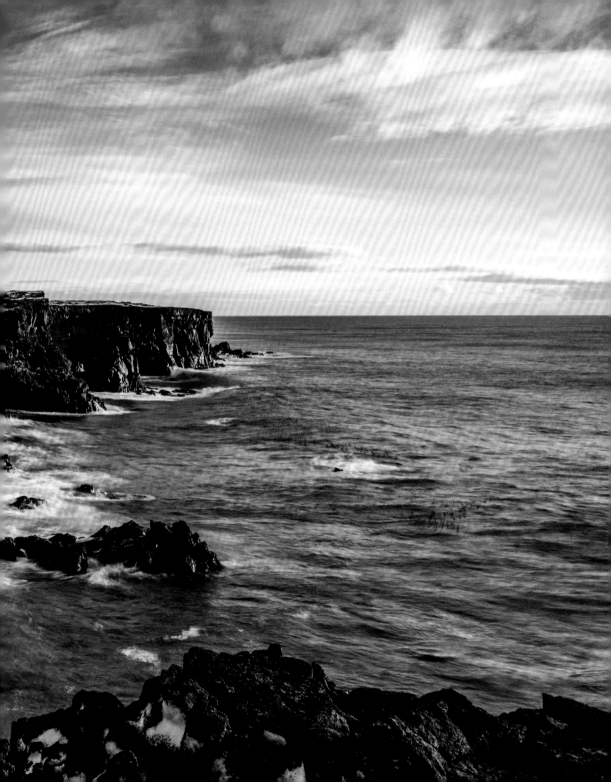

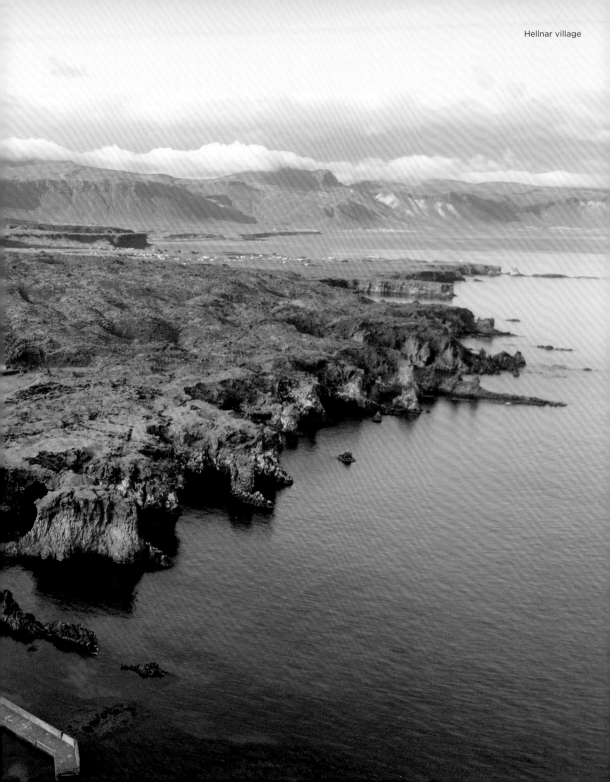

Hellnar village

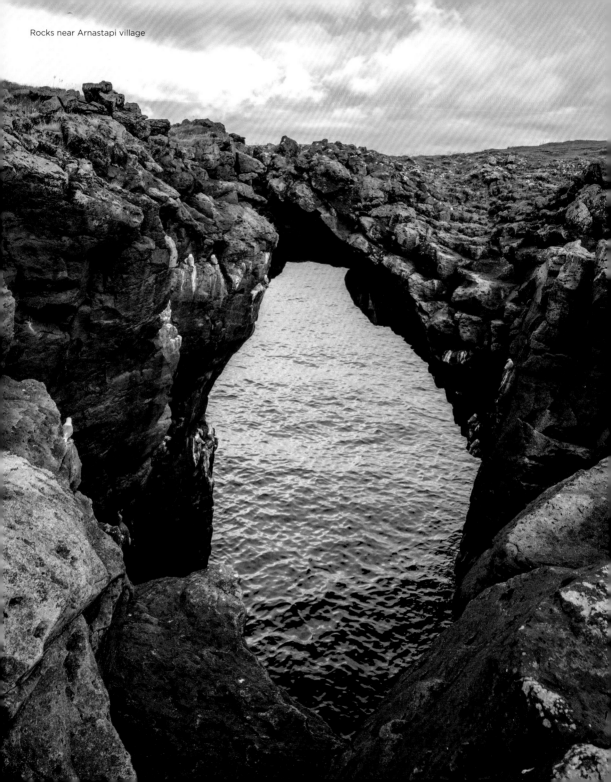
Rocks near Arnastapi village

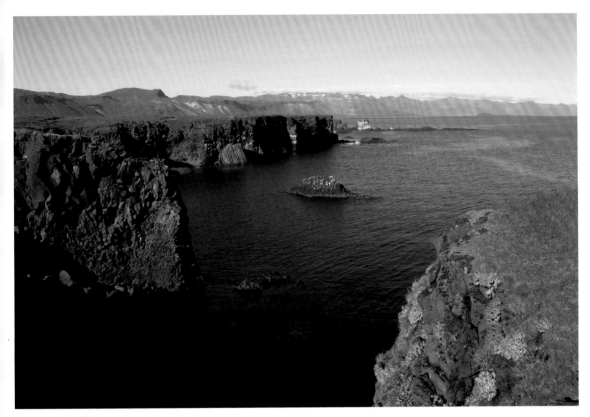

Arnastapi, Faxaflói bay

Arnarstapi

On the southern coast of the Snæfellsnes peninsula lies Arnarstapi, known for its fishing industry. Herring fishing still plays a role in the economy today, although tourism is becoming increasingly important as well. The natural beauty of the rugged, highly eroded coast offers many spectacular subjects for photographers, such as rock bridges and open caves.

Arnarstapi

Sur la côte sud de la péninsule de Snæfellsnes se trouve Arnarstapi, devenue une importante destination de pêche, notamment de harengs. Le tourisme y est en développement, car la beauté naturelle de la côte accidentée et fortement érodée offre de nombreux points de vue spectaculaires, tels que des arches de roche ou des grottes ouvertes jusqu'au sommet.

Arnarstapi

An der Südküste der Halbinsel Snæfellsnes liegt Arnarstapi, das der Fischfang bedeutend gemacht hat. Auch heute spielt die Heringsfischerei noch eine Rolle. Zunehmend wichtig ist der Tourismus, denn die Naturschönheiten der schroffen, stark erodierten Küste bieten zahlreiche spektakuläre Fotomotive wie Felsbrücken und nach oben offene Höhlen.

Arnarstapi

En la costa sur de la península de Snæfellsnes se encuentra Arnarstapi, que se ha convertido en un importante destino de pesca. La pesca del arenque todavía juega un papel importante hoy en día. El turismo es cada vez más importante, ya que la belleza natural de la costa escarpada y muy erosionada ofrece numerosas fotografías espectaculares, como puentes de roca y cuevas abiertas a la cima.

Arnarstapi

Sulla costa meridionale della penisola di Snæfellsnes si trova Arnarstapi, che è diventata un'importante destinazione di pesca. La pesca dell'aringa svolge ancora oggi un ruolo notevole. Il turismo sta diventando sempre più importante, in quanto la bellezza naturale della costa frastagliata e fortemente erosa offre numerosi motivi fotografici spettacolari come ponti di roccia e grotte aperte verso l'alto.

Arnarstapi

Aan de zuidkust van het schiereiland Snæfellsnes ligt Arnarstapi, dat belangrijk is geworden door de visserij. De haringvangst speelt nog steeds een grote rol. Toerisme wordt steeds belangrijker, omdat de natuurlijke schoonheid van de ruige, sterk geërodeerde kust talrijke spectaculaire fotografische motieven biedt, zoals rotsbruggen en grotten die aan de bovenkant open zijn.

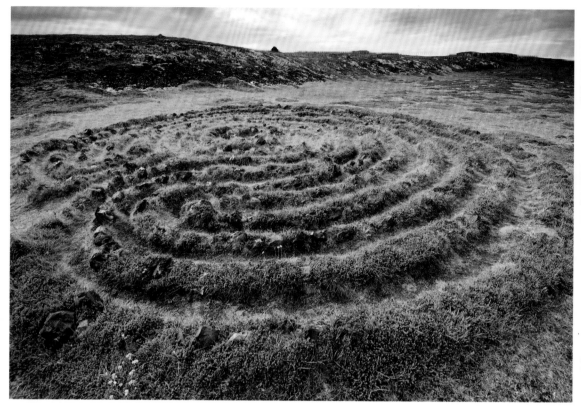

Snæfellsnes peninsula

Ingjaldshólskirkja

Near Hellissandur stands the Ingjaldshólskirkja, the oldest stone church in the country. The history of Ingjaldshóll goes back to the 10th century, and many stories and legends are told about the village – not surprising, considering that it sits nearly in the shadow of the mighty Snæfellsjökull, the most mysterious, legendary mountain in Iceland.

Ingjaldshólskirkja

À côté du village d'Hellissandur se dresse l'Ingjaldshólskirkja, la plus ancienne église en pierre du pays. L'histoire du village remonte au xᵉ siècle. On raconte de nombreux récits et légendes sur ce lieu – ce qui n'est pas surprenant, car la puissante Snæfellsjökull, la montagne la plus mystérieuse et légendaire d'Islande, trône à l'horizon.

Ingjaldshólskirkja

Bei Hellissandur steht die Ingjaldshólskirkja, die älteste Steinkirche des Landes. Die Geschichte des Ortes reicht bis ins zehnte Jahrhundert zurück. Viele Geschichten und Sagen werden über Ingjaldshóll erzählt – nicht verwunderlich, denn am Horizont thront der mächtige Snæfellsjökull, der geheimnisvollste, sagenumwobenste Berg Islands.

Ingjaldshólskirkja

Cerca de Hellissandur se encuentra la iglesia de Ingjaldshóll, la más antigua del país construida en piedra. La historia del pueblo se remonta al siglo X. Se cuentan muchas historias y leyendas sobre Ingjaldshóll – no es de extrañar, ya que el poderoso Snæfellsjökull, la montaña más misteriosa y legendaria de Islandia, preside el horizonte.

Ingjaldshólskirkja

Nei pressi di Hellissandur si trova la Ingjaldshólskirkja, la più antica chiesa in pietra del paese. La storia del villaggio risale al X secolo. Molte storie e leggende raccontano di Ingjaldshóll – non sorprende, quindi che il possente Snæfellsjökull, la montagna più misteriosa e leggendaria d'Islanda, troneggia all'orizzonte.

Ingjaldshólskirkja

In de buurt van Hellissandur staat de Ingjaldshólskirkja, de oudste stenen kerk van het land. De geschiedenis van het dorp gaat terug tot de 10e eeuw. Er worden veel verhalen en legendes verteld over Ingjaldshóll. Dat is niet verwonderlijk, want aan de horizon rijst de machtige Snæfellsjökull op, de geheimzinnigste, meest legendarische berg van IJsland.

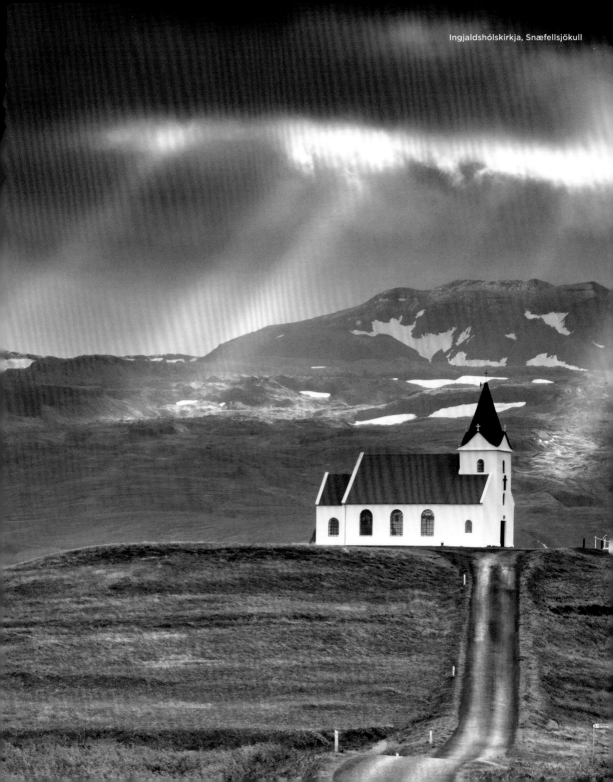

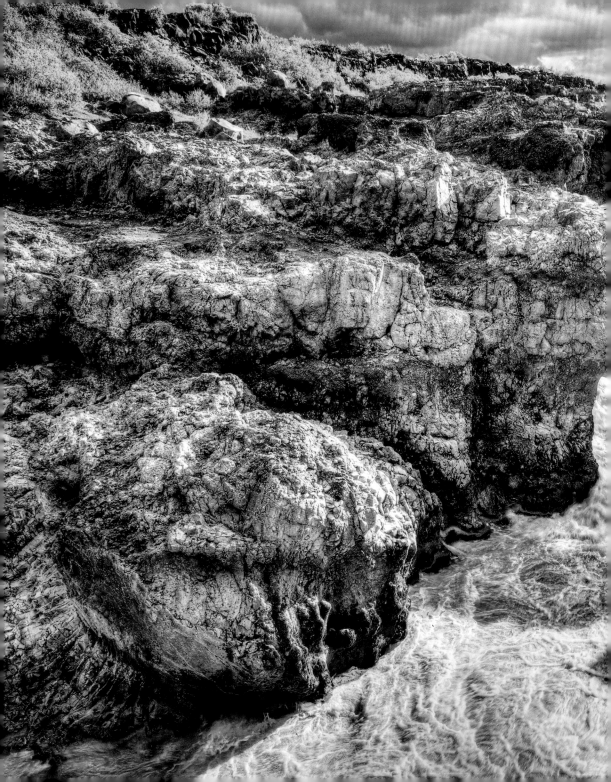

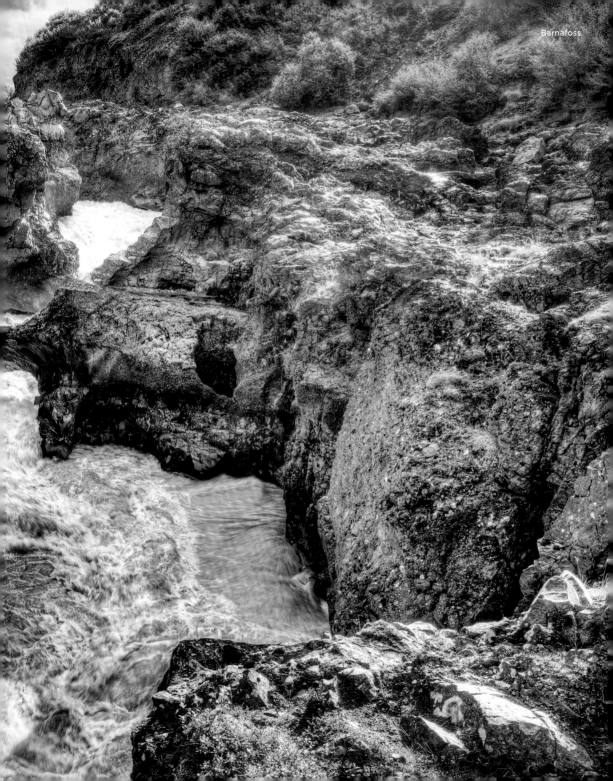
Barnafoss

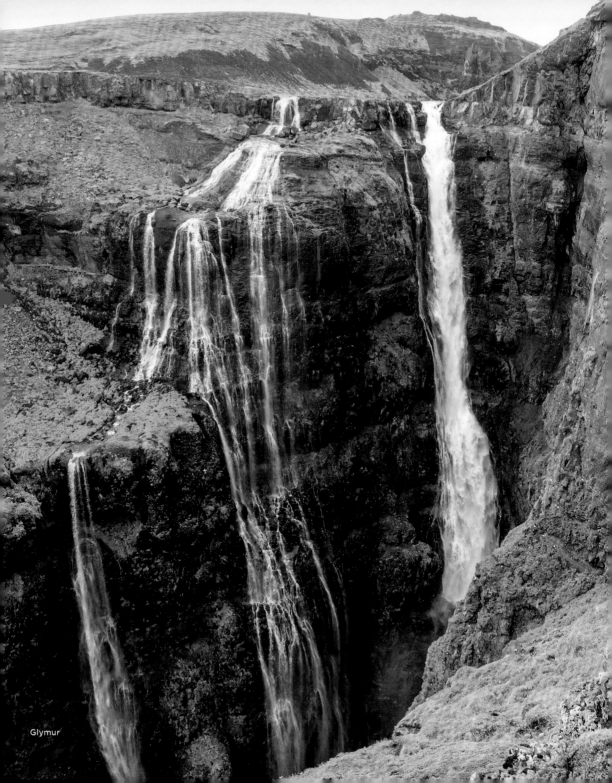

Glymur

Glymur

Glymur

At 198 metres, the Glymur is the second-highest waterfall in Iceland. It is part of the Botnsá River, which flows into Hvalfjörður. Marked trails along the eastern bank offer a beautiful view of the waterfall. It is also possible to climb to the highest point and enjoy the view of the surrounding mountains.

Glymur

Avec une hauteur de 198 m, le Glymur est la deuxième plus haute chute d'eau d'Islande. Il appartient à la rivière Botnsá, qui se jette dans Hvalfjörður. Les sentiers balisés à l'est offrent un beau panorama sur la chute. Il est également possible de grimper jusqu'au point le plus haut et de profiter de la vue sur les montagnes environnantes.

Glymur

Mit 198 m Höhe ist der Glymur der zweithöchste Wasserfall Islands. Er gehört zum Fluss Botnsá, der sich in den Hvalfjörður ergießt. Man kann auf markierten Pfaden zur Ostseite wandern, die einen schönen Blick auf den Fall bietet. Es ist auch möglich, bis zum höchsten Punkt zu klettern und von dort die Sicht auf die umliegende Bergwelt zu genießen.

Glymur

Con una altura de 198 m, la cascada Glymur es la segunda más alta de Islandia. Pertenece al río Botnsá, que desemboca en el Hvalfjörður. Se puede caminar por senderos señalizados hacia el lado este, lo que ofrece una hermosa vista del salto. También es posible subir al punto más alto y disfrutar de la vista de las montañas circundantes.

Glymur

Con un'altezza di 198 m, il Glymur è la seconda cascata più alta d'Islanda. Appartiene al fiume Botnsá, che sfocia nel Hvalfjörður. Si può camminare su percorsi segnati sul lato est, che offre una bella vista della cascata. È inoltre possibile salire fino al punto più alto e godere della vista delle montagne circostanti.

Glymur

Met 198 meter hoogte is de Glymur de op één na hoogste waterval van IJsland. Hij hoort bij de Botnsá-rivier, die uitmondt in de Hvalfjörður. U kunt er op gemarkeerde paden naar de oostzijde wandelen, die een prachtig uitzicht op de waterval biedt. Het is ook mogelijk om naar het hoogste punt te klimmen en daar te genieten van het uitzicht op de omliggende bergen.

Hraunfossar

The Hraunfossar are a whole system of waterfalls on the Hvítá. Small falls pour into the river over a length of 700 metres, seeming to come directly from the lava field Hallmundarhraun, hence the waterfall's name, which means "lava falls". A pedestrian bridge overlooks the Hraunfossar as well as the neighbouring Barnafoss, the "children's waterfall".

Hraunfossar

Les Hraunfossar, sur la Hvítá, sont un ensemble de chutes d'eau ; de petites cascades se déversent ainsi dans la rivière sur une longueur de 700 m. Ils semblent venir directement du champ de lave Hallmundarhraun – d'où son nom, « les cascades de la lave ». Un pont piétonnier surplombe les Hraunfossar ainsi que la Barnafoss, « la cascade des enfants ».

Hraunfossar

Ein ganzes System von Wasserfällen sind die Hraunfossar am Lauf des Hvítá. Über eine Länge von 700 m ergießen sich kleine Fälle in den Fluss. Sie scheinen direkt aus dem Lavafeld Hallmundarhraun zu kommen, daher der Name „Lavafälle". Von einer Fußgängerbrücke lassen sich die Hraunfossar ebenso überblicken wie der benachbarte Barnafoss, der „Kinderwasserfall".

Hraunfossar

Los Hraunfossar son todo un sistema de cascadas es en el curso del Hvítá. Pequeñas cascadas caen al río en una longitud de 700 m. Parece que vienen directamente del campo de lava Hallmundarhraun, de ahí su nombre, "cascadas de lava". Una pasarela peatonal domina los Hraunfossar, así como la vecina Barnafoss, la "cascada de los niños".

Hraunfossar

I Hraunfossar sono un intero sistema di cascate sull'Hvítá. Piccole cascate si riversano nel fiume per una lunghezza di 700 m. Sembrano provenire direttamente dal campo lavico Hallmundarhraun, da cui il nome "cascate della lava". Un ponte si affaccia sui Hraunfossar e sulla vicina Barnafoss, la "cascata dei bambini".

Hraunfossar

De Hraunfossar aan de Hvítá zijn een heel stelsel van watervallen. Over een lengte van 700 meter storten kleine watervallen de rivier in. Ze lijken rechtstreeks afkomstig te zijn uit het lavaveld Hallmundarhraun, vandaar de naam 'lavavallen'. Vanaf een voetgangersbrug kijkt u uit over de Hraunfossar en de aangrenzende Barnafoss.

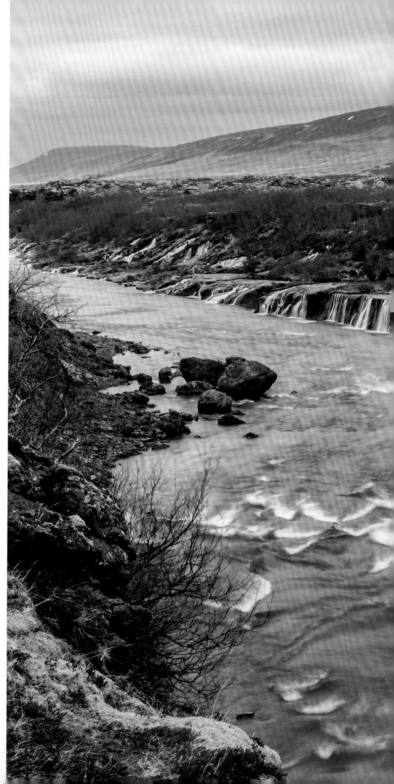

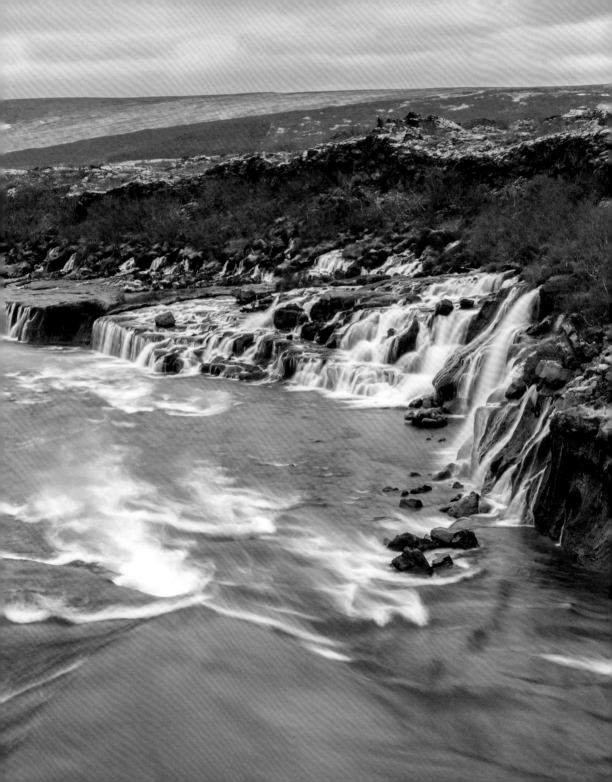

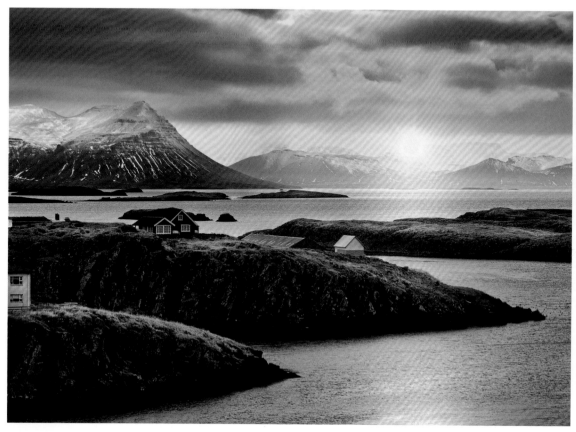
Stykkishólmur

Stykkishólmur

Because of its natural harbour,
Stykkishólmur became an important fishing
and trading town early on and today is one
of the largest cities in Iceland outside the
capital region. The mighty pyramid-shaped
Kirkjufell dominates the horizon. The ferry
Baldur begins in Stykkishólmur and travels
across Breiðafjörður to Brjánslækur in the
Westfjords.

Stykkishólmur

Grâce à son port naturel, Stykkishólmur est
rapidement devenue une importante ville
de pêche et de commerce. Aujourd'hui,
elle fait toujours partie des plus grandes
villes d'Islande en dehors de la région de la
capitale. La puissante montagne Kirkjufell,
en forme de pyramide, trône à l'horizon.
Stykkishólmur est le point de départ
du ferry *Baldur,* qui navigue à travers
Breiðafjörður jusqu'à Brjánslækur dans les
Fjords de l'Ouest.

Stykkishólmur

Wegen seines natürlichen Hafens gewann
Stykkishólmur schon früh Bedeutung als
Fischer- und Handelsort und gehört heute
zu den größeren Städten Islands außerhalb
der Hauptstadtregion. Am Horizont thront
der mächtige, pyramidenförmige Kirkjufell.
Stykkishólmur ist Startpunkt für die
Fähre *Baldur* über den Breiðafjörður nach
Brjánslækur in den Westfjorden.

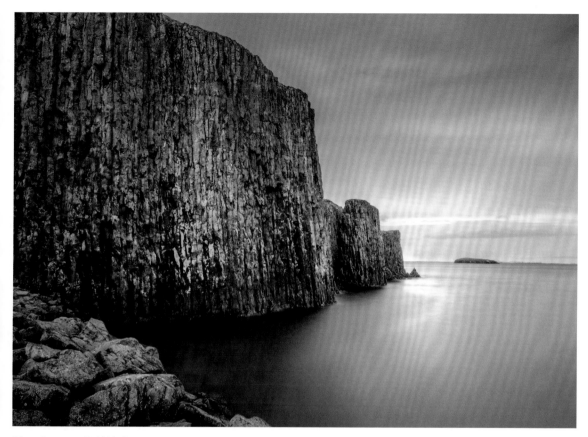

Súgandisey, near Stykkisholmur

Stykkkishólmur

Debido a su puerto natural, Stykkishólmur adquirió importancia como ciudad pesquera y comercial desde muy temprano y hoy en día pertenece a las ciudades más grandes de Islandia fuera de la región de la capital. El poderoso pico Kirkjufell en forma de pirámide presideel horizonte. Stykkishólmur es el punto de partida del ferry *Baldur* que atraviesa Breiðafjörður hasta Brjánslækur, en los fiordos occidentales.

Stykkishólmur

Grazie al suo porto naturale Stykkishólmur ha guadagnato in passato importanza come una città di pesca e di commercio e oggi appartiene alle grandi città dell'Islanda al di fuori della regione della capitale. Il possente Kirkjufell a forma di piramide si erge imponente all'orizzonte. Stykkishólmur è il punto di partenza per il traghetto *Baldur* attraverso Breiðafjörður fino a Brjánslækur nei fiordi occidentali.

Stekkishólmur

Vanwege zijn natuurlijke haven won Stykkishólmur al vroeg aan betekenis als vissers- en handelsstad. Tegenwoordig behoort het tot de grotere steden van IJsland buiten de hoofdstedelijke regio. Aan de horizon verrijst de machtige piramidevormige Kirkjufell. Stykkishólmur is het vertrekpunt van de veerboot *Baldur* over de Breiðafjörður naar Brjánslækur in de Westfjorden.

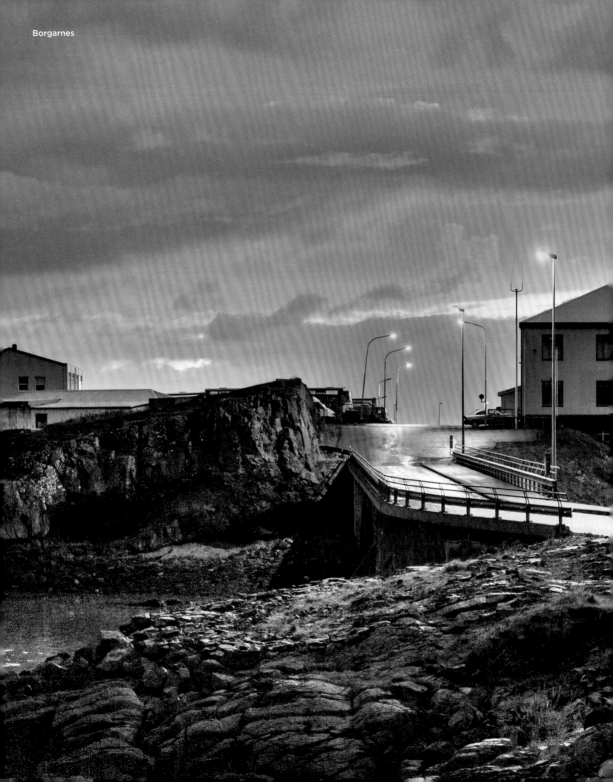

Borgarnes

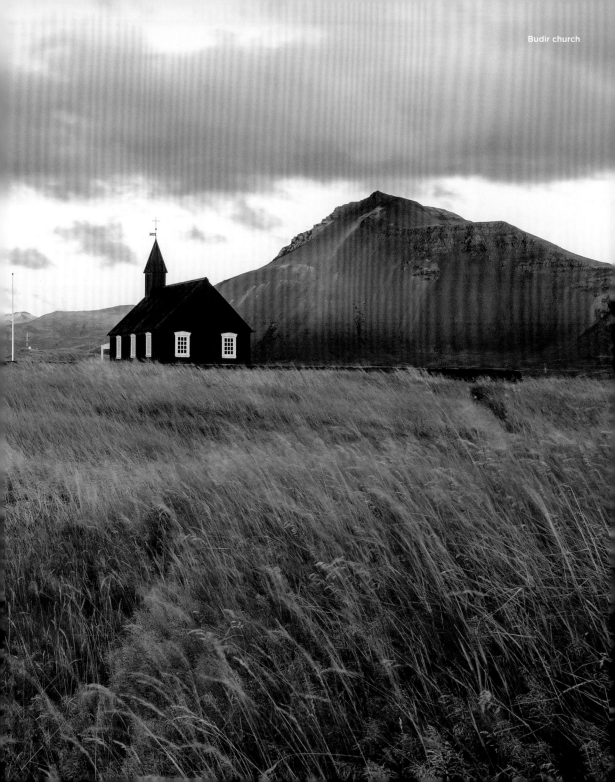

Budir church

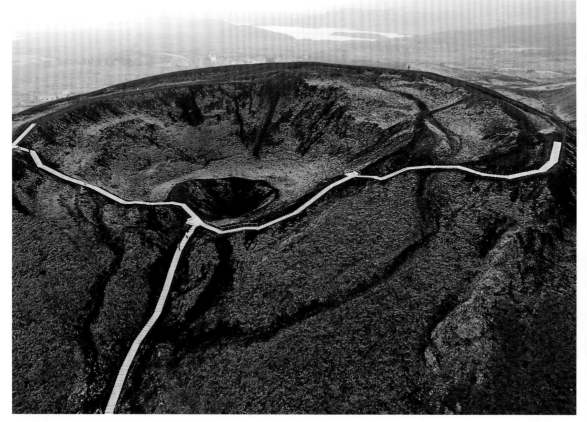

Grábrók crater

Grábrók Craters

The Grábrók craters are part of an extensive volcanic system called Ljósufjöll, which stretches over 90 kilometres from the north of the Snæfellsnes peninsula to the Borgarnes area. Although the last eruption occurred a thousand years ago, the volcanic system is still considered active. Visitors can descend to the Grábrók craters near Bifröst University.

Cratères de Grábrók

Les cratères de Grábrók font partie d'un vaste système volcanique, le Ljósufjöll, qui s'étend sur 90 km du nord de la péninsule de Snæfellsnes jusqu'à la région de Borgarnes. Bien que la dernière éruption se soit produite il y a 1000 ans, il est toujours considéré comme actif. Il est possible de descendre jusqu'aux cratères de Grábrók, près de l'Université de Bifröst.

Grábrók-Krater

Die Grábrók-Krater gehören zu einem ausgedehnten Vulkansystem, dem Ljósufjöll, das sich über 90 km vom Norden der Halbinsel Snæfellsnes bis in die Gegend von Borgarnes zieht. Zwar liegt der letzte Ausbruch 1000 Jahre zurück, dennoch gilt das Vulkansystem als aktiv. Man kann in die Grábrók-Krater in der Nähe der Hochschule Bifröst hinabsteigen.

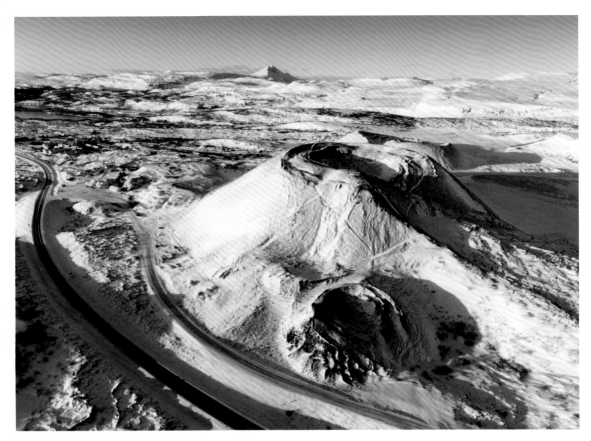

Grábrók crater

Cráteres de Grábrók
Los cráteres de Grábrók forma parte de un extenso sistema volcánico, el Ljósufjöll, que se extiende a lo largo de 90 km desde el norte de la península de Snæfellsnes hasta la zona de Borgarnes. Aunque la última erupción ocurrió hace 1000 años, el sistema volcánico todavía se considera activo. Se puede descender hasta los cráteres de Grábrók, cerca de la Universidad de Bifröst.

Crateri di Grábrók
I crateri di Grábrók fanno parte di un vasto sistema vulcanico, il Ljósufjöll, che si estende per oltre 90 km dal nord della penisola di Snæfellsnes alla zona di Borgarnes. Sebbene l'ultima eruzione sia avvenuta 1000 anni fa, il sistema vulcanico è ancora considerato attivo. Si può scendere ai crateri di Grábrók vicino all'Università di Bifröst.

Grábrók-kraters
De Grábrók-kraters maken deel uit van een uitgebreid vulkanisch stelsel, Ljósufjöll, dat zich over een lengte van ruim 90 km van het noorden van het schiereiland Snæfellsnes naar het gebied rond Borgarnes uitstrekt. Hoewel de laatste uitbarsting 1000 jaar geleden plaatsvond, geldt het vulkanische stelsel nog als actief. U kunt in de buurt van de universiteit van Bifröst afdalen naar de Grábrók-kraters.

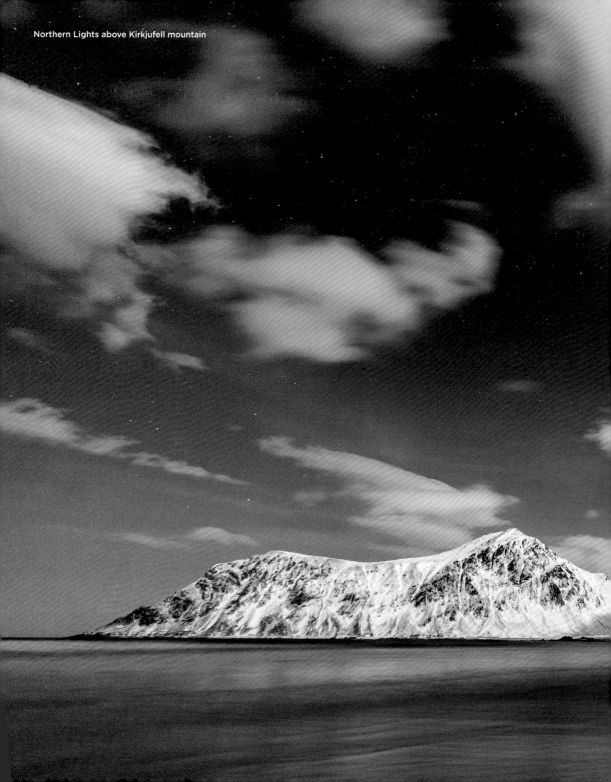

Northern Lights above Kirkjufell mountain

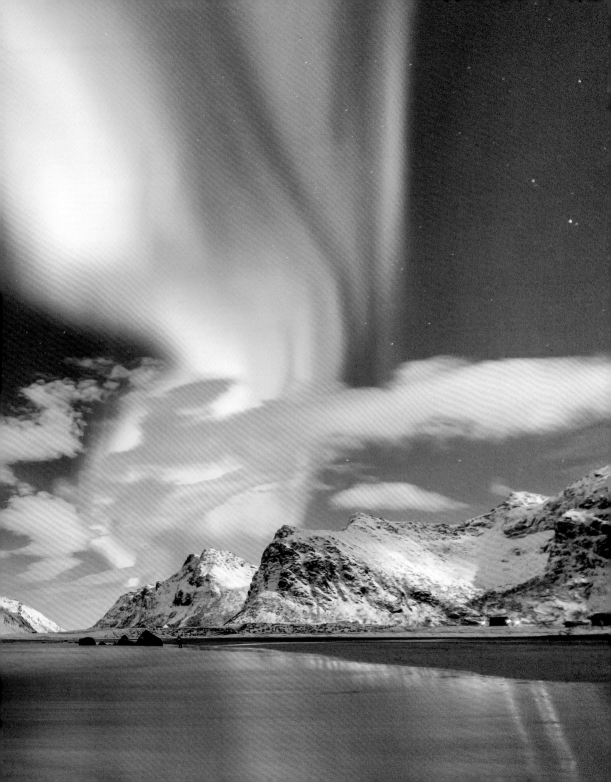

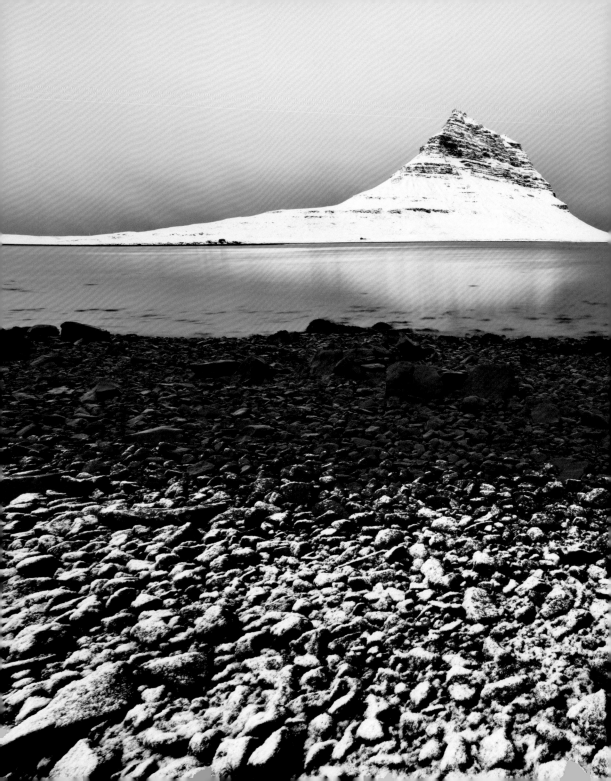

Kirkjufell mountain

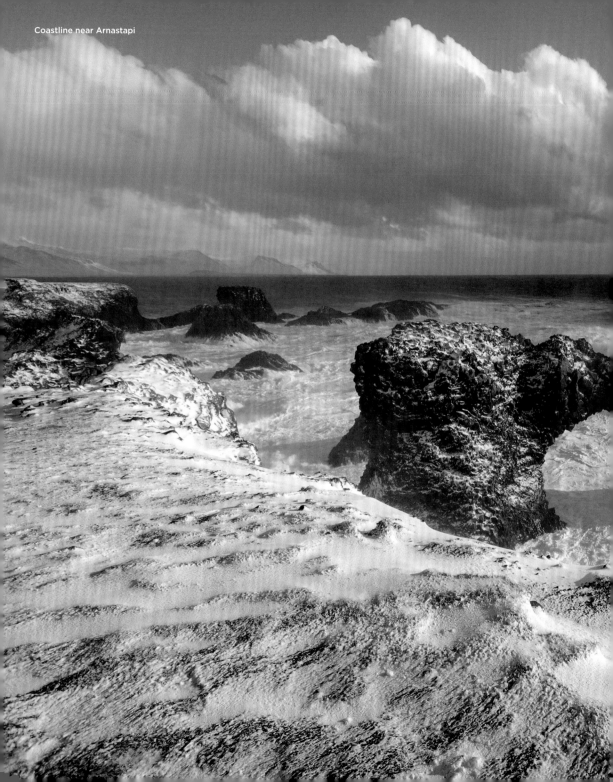

Coastline near Arnastapi

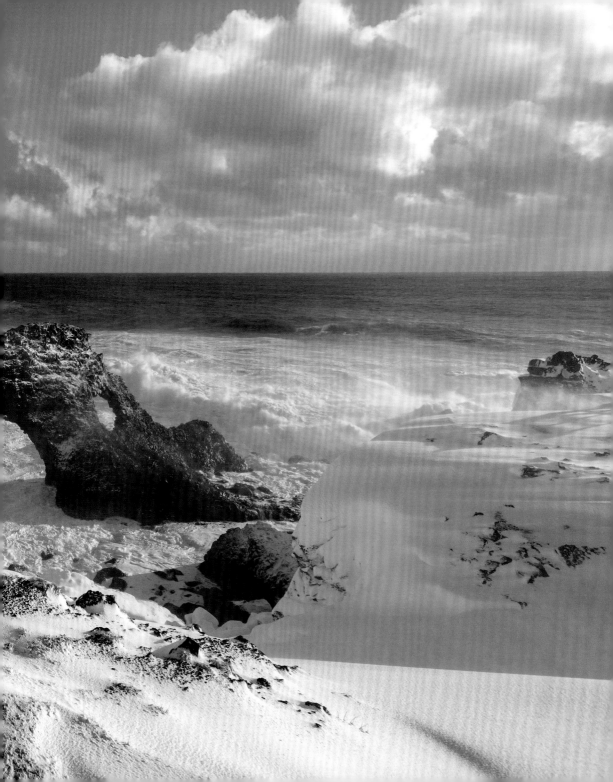

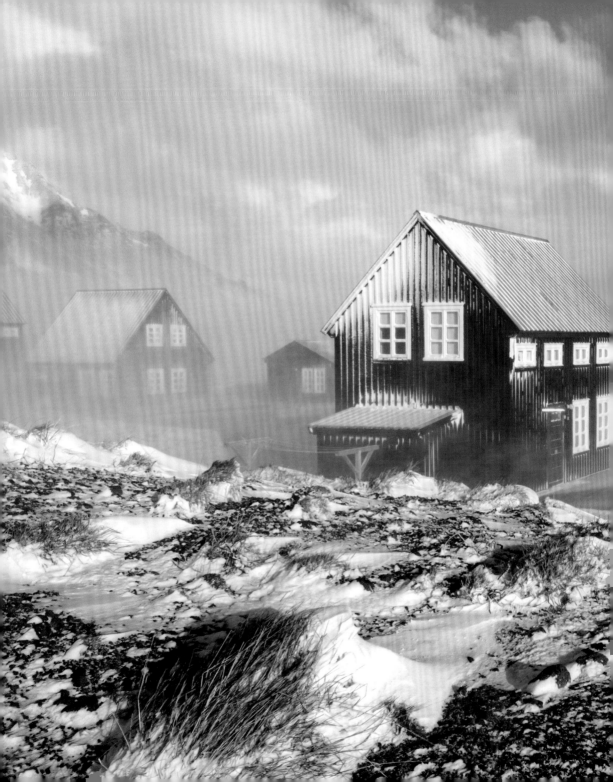

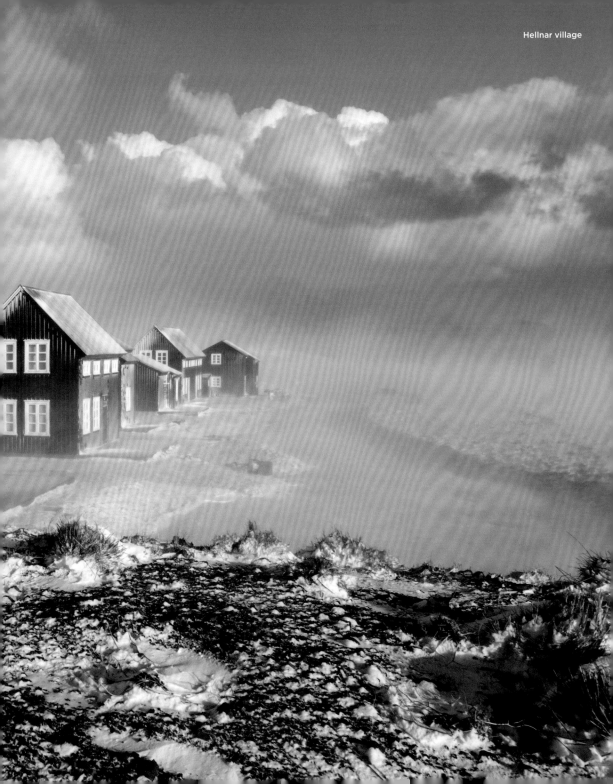

Hellnar village

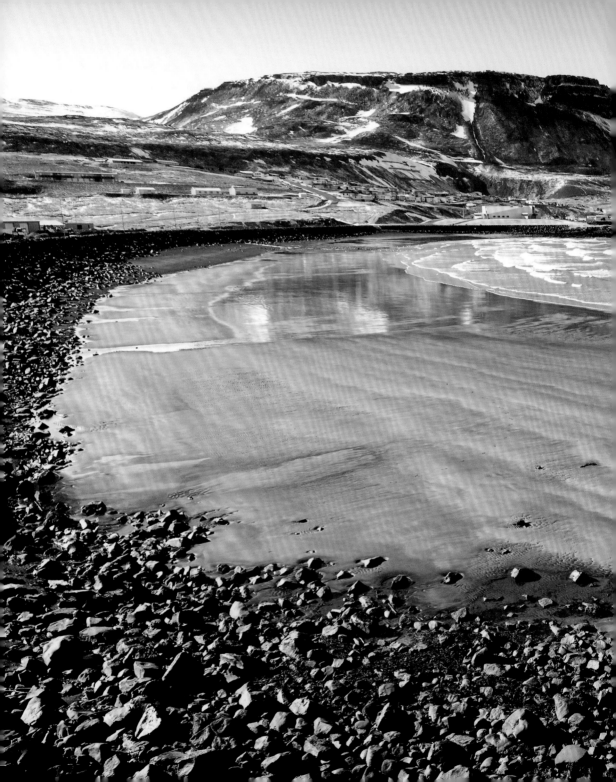

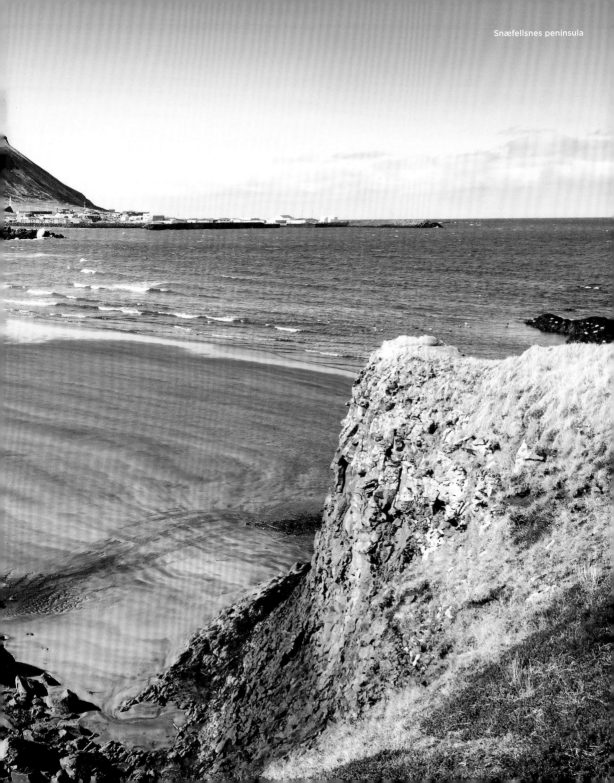

Seals

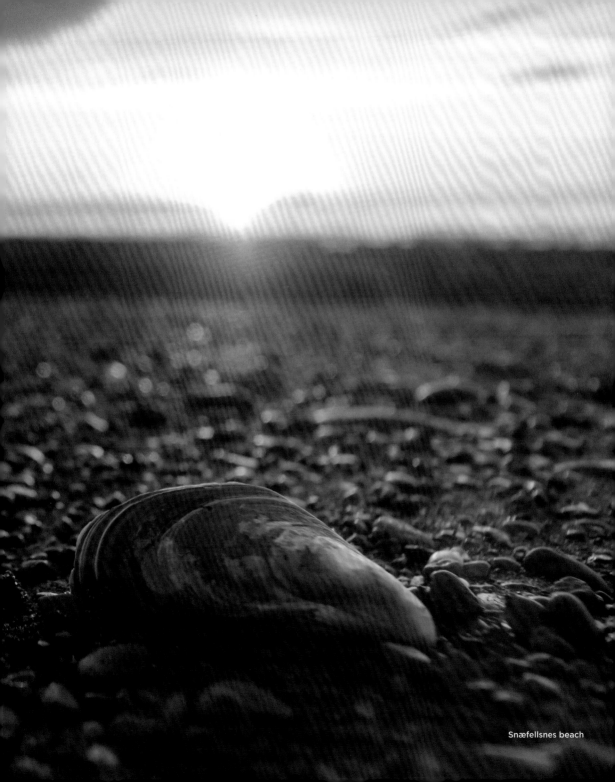

Snæfellsnes beach

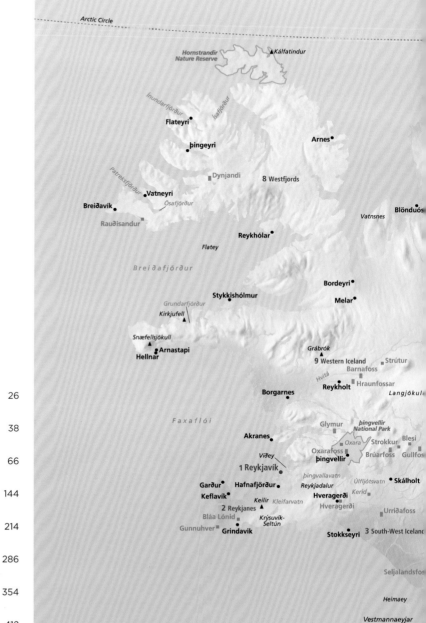

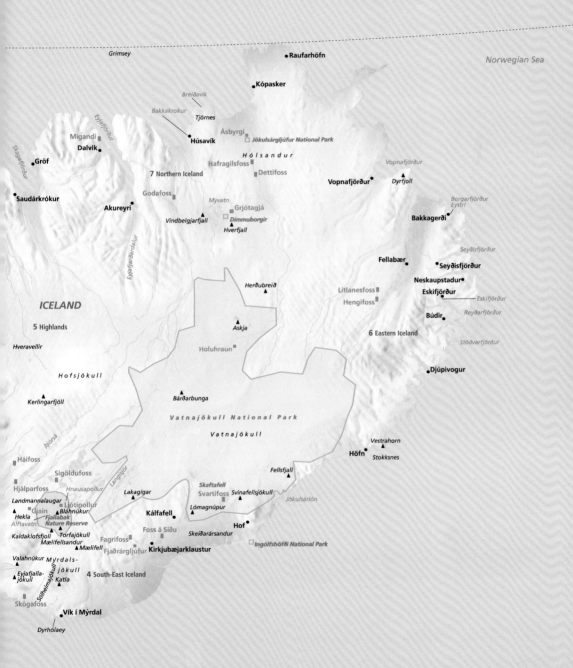

Grimsey

Norwegian Sea

•Raufarhöfn

•Kópasker

Breiðavík

Bakkakrokur Tjörnes

Ásbyrgi
Húsavík Jökulsárgljúfur National Park

Migandi Hólsandur

Dalvik Vopnafjörður

Skagafjörður Hafragilsfoss
Gröf 7 Northern Iceland Dettifoss Vopnafjörður Dyrfjoll

Saudárkrókur Godafoss Borgarfjörður
Eystri

Akureyri Mývatn Grjótagjá
Vindbelgjarfjall Dimmuborgir Bakkagerði
Hverfjall

Seyðisfjörður

Herðubreið Fellabær Seyðisfjörður
Neskaupstadur•
Litlanesfoss Eskifjörður
ICELAND Hengifoss Eskifjörður

5 Highlands Askja Reyðarfjörður
Búðir
Hveravellir 6 Eastern Iceland Stöðvarfjörður
Holuhraun

Hofsjökull •Djúpivogur

Kerlingarfjöll Bárðarbunga

Vatnajökull National Park
Vatnajökull

Vestrahorn
Háifoss Höfn Stokksnes

Sigöldufoss Fellsfjall
Hjálparfoss Hnausapollur Skaftafell Jökulsárlón
Landmannalaugar Lakagígar Svartifoss Svinafellsjökull
Ljótipollur Lómagnúpur
Hekla Gjain Bláhnúkur
Alftavatn Fjallabak Foss á Síðu
Kaldaklofsfjoll Nature Reserve
Torfajökull Skeiðarársandur Ingólfshöfði National Park
Mælifellsandur Fagrifoss
Valahnúkur Fjaðrárgljúfur Kirkjubæjarklaustur
Myrdals- Mælifell
Eyjafjalla- jökull
jökull Katla 4 South-East Iceland

Skógafoss

Vík í Mýrdal

Dyrhólaey

Index

Photo credits

KÖNEMANN

© 2020 koenemann.com GmbH

www.koenemann.com

© Éditions Place des Victoires

6, rue du Mail – 75002 Paris

www.victoires.com

Dépôt légal : 1er trimestre 2020

ISBN 978-2-8099-1782-6

Series Concept: koenemann.com GmbH

Responsible Editor: Jennifer Wintgens

Picture Editing: Petra Ender, Sarah Fischer

Layout: Regine Ermert

Colour Separation: PrePress, Cologne

Text: Bernhard Mogge, Christian Nowak

Front cover: Getty Images/Arctic-Images

Printed in China by Shyft Publishing/Hunan Tianwen Xinhua Printing Co., Ltd

978-3-7419-2520-7